재난과 치유
Catastrophe and Recovery

국립현대미술관
National Museum of Modern and Contemproray Art, Korea

Contents

목차

발간사
≪재난과 치유≫ 전시를 개최하면서

코로나19는 전 세계를 강타하고, 인간 사회를 뿌리부터 흔들고 있습니다. 눈에 보이지도 않는 미물이 주는 파장은 너무 큽니다. 2020년 이래 1년여 동안 코로나19는 재난의 상징으로 많은 희생을 요구하고 있습니다. 바이러스 확진자는 벌써 1억 4천만 명(2021년 5월 기준)을 헤아리게 하고 있으며, 사망자 숫자만 해도 290만 명을 돌파했습니다. 유럽에서만 사망자의 숫자가 100만 명을 넘어섰을 정도입니다. 일찍이 상상해보지 않은 재난입니다. 현재 백신을 개발하여 약간의 희망을 주고 있지만, 그래도 갈 길은 멀다고 여겨집니다. 국립현대미술관은 코로나19 시대에 '재난'과 '치유'라는 주제의 전시를 마련했습니다. 미술가들은 재난 상황을 어떻게 감당하고 있는지, 그와 같은 재난을 어떻게 해석하여 작품에 담았는지, 살펴보는 전시입니다. 하기야 인류의 역사는 재난과 함께 해왔다고 해도 과언은 아닐 듯합니다. 자연재해도 있지만 전쟁이나 도시에서의 대형 사고도 끊이지 않고 있습니다. 재난은 피한다고 없어지는 것이 아니어서 팬데믹 시대에 새로운 성찰을 요구하기도 합니다. 예술가들은 재난을 어떻게 보았을까요.

조선시대 후기에 유행한 감로도(甘露圖)를 생각해 봅니다. 3단 구도의 회화형식은 아주 독특한 특성을 보이고 있습니다. 바로 하단부에 동시대의 일상 생활 풍속을 사실적으로 표현했기 때문입니다. 게다가 비명횡사한 망자들을 표현했고, 더불어 그들을 위무하기 위한 목적을 담았습니다. 고난에 처한 사람들을 위한 그림이라는, 의의가 매우 크다 하겠습니다. 사실 조선 후기에 감로도가 유행했다는 것은 그만큼 그 시대가 살기 어려웠다는 방증이기도 합니다. 그럼에도 불구하고 역사상 보기 어려운 형식의 감로도는 시사하는 바 적지 않습니다. 이번 코로나19 사태를 맞으면서 신 감로도를 그리워하게 했습니다. 전통의 창조적 계승이라는 차원도 생각하게 합니다.

이번 《재난과 치유》는 역병의 어제와 오늘, 집콕-홀로 같이 살기, 전염과 거리 두기, 고난과 함께 살기 등 열쇳말을 염두에 두고 꾸미고자 했습니다. 재난을 주제로 한 작품, 사실 우리 미술계에서 이런 주제로 작업한 작가는 많지 않습니다. 재난과 함께 살면서도 이와 같은 무거운 주제는 멀리 있기도 했습니다. 바로 코로나19가 준 과제이기도 합니다. 그렇다고 재난에만 머물러 있을 수도 없습니다. 미술의 기능 가운데 치유가 있습니다. 재난 극복, 아주 중요한 개념입니다. 예술과 함께 고난을 극복하고, 희망의 세계로 나아가기를 기대합니다.

《재난과 치유》를 위하여 소중한 작품을 출품해 주신 작가 여러분과 여러 기관 관계자분들께 감사드립니다. 특히 삼성미술관 리움, 한솔제지, 갤러리현대, 가나문화재단, 아라리오갤러리, 글래드스톤 갤러리, 스프루스 마거스, 갤러리바톤, 모린 페일리, 사디 콜즈 HQ, 조현갤러리, 전주국제영화제 등에 진심으로 감사의 말씀을 올립니다. 이제 코로나19를 극복하고 예술과 함께 하는 새로운 세계를 꿈꿔봅시다.

윤범모
국립현대미술관장

Foreword
Upon the opening of the exhibition
Catastrophe and Recovery

COVID-19 has taken the world by storm and shaken the foundations of human society. The impact that tiny, imperceptible microbes have on our lives is larger than we would like to think. Over the year or so since its outbreak in 2020, COVID-19 has risen as a symbol of catastrophe and demanded many sacrifices. The global number of confirmed cases has already surpassed 140 million (as of May 2021), with an appalling death toll of 2.9 million—1 million in Europe alone. This pandemic has been a catastrophe the likes of which we had never imagined. The recent development of vaccines has shed a beacon of light, but it seems it is still a long way out of the woods. In response to this age of global pandemic, the MMCA has organized an exhibition under the theme of 'catastrophe' and 'recovery,' examining how artists are dealing with this state of disaster and how they've captured and interpreted like catastrophes into their works. It wouldn't be an exaggeration to say that, over the course of history, humans have always been accompanied by disasters. From natural disasters to wars and mass-casualty accidents in cities, not all disasters can be avoided by being careful, hence, today's pandemic prompts renewed attention to the phenomenon of catastrophes. It has made me wonder what artists of the past made of the disasters of their time.

I thought about *gamnodo*, Buddhist paintings characterized by a unique three-part composition that were popular in the late Joseon period. The bottom sections of these paintings feature realistic illustrations of everyday customs at the time. The paintings also depict the spirits of those who died accidentally or prematurely, for the purpose of pacifying their souls. *Gamnodo* held great significance in that they were dedicated to those who suffered in life, and their popularity in the late Joseon period attests to the level of effort it took to survive at the time. Despite this popularity, the paintings have been historically hard to find, which suggests a lot in and of itself. I've come to imagine a new form of *gamnodo* and think about the creative succession of tradition in the face of the COVID-19 pandemic.

The exhibition *Catastrophe and Recovery* was put together with certain key phrases in mind: "the past and the present of epidemics;" "staying in—living alone and together;" "contagion and distancing," and "living with hardships." There actually aren't many artists in the Korean art scene who work with disaster as their theme. While we constantly encounter various disasters in life, the subject has remained distant, perhaps due to its weight. This very realization is another conundrum COVID-19 has presented us with to solve. With that said, however, we cannot dwell on catastrophe forever. One of art's many powers is that of healing. Finding a cure, especially in the context of a disaster, is an extremely important issue. It is our hope that the works in this exhibition will help us overcome our current hardships and stride into a hopeful future.

I would like to extend my gratitude to the many artists and organizations that have loaned their valuable works for this exhibition, and special thanks go to Leeum, Samsung Museum of Art, Hansol Paper, Gallery Hyundai, Gana Foundation for Arts and Culture, Arario Gallery, Gladstone Gallery, Sprüth Magers, Gallery Baton, Maureen Paley, Sadie Coles HQ, Johyun Gallery, and JEONJU International Film Festival. At this time, let us rise above the catastrophe that is COVID-19 as we dream of a new world in which art and life can merge seamlessly together.

Youn Bummo

Director, National Museum of Modern and Contemporary Art, Korea (MMCA)

기획의 글
전염의 시대, 예술이라는 언어

양옥금
국립현대미술관 학예연구사

Curatorial Essay
An Era of Contagion and the Language of Art

Okkum Yang
Curator, National Museum of Modern and
Contemporary Art, Korea (MMCA)

인류에게 모두의 생명을 위협하고 삶의 근간을 뒤흔드는 지금과 같은
팬데믹은 처음이 아니다. 인간이 무리를 이루고 터전을 일구며 농경 생활을
시작한 이래 발병했던 무수한 질병들 중 집단 전체를 파국으로 치닫게
했던 많은 경우가 전염병이었다. 그동안 지속적으로 창궐했던 이 역병은
자연재해, 전쟁과 테러 그리고 사회적, 인적 재앙을 포괄하는 '재난'의
일부로 인간의 실존을 위협하면서 오랜 역사 속에 존속해왔다.

근대를 기점으로 과학기술과 산업의 발전을 토대로 인간은 물리적인
거리를 단축시키고, 세계 곳곳에 흩어진 영토를 연결하고 재편해왔다.
여기에 인터넷의 발명과 보급은 정보의 속도전 속에 가히 '거리의 소멸
(abolition of distance)' [1]을 가시화시켰다. 이 소멸된 거리의 이면에는
인간만이 지구의 주인이라는 의식과 공존이라는 섭리에 대한 망각이
존재했다.

인류는 그동안 겪어왔던 감염병들과는 또 다른 유형의 재난 앞에서
기후와 생태, 그리고 문명의 삶이 더 이상 이전과 동일한 방식으로
존재하지 않고 운행되지 않음을 자각한다. 이러한 현실에서 우리는 현재를
고찰하고 삶의 가치를 재설정하고 이후의 삶에 대해 새롭게 상상할 수
있는 인식의 틀을 갖춰야 할 때가 도래했음을 깨닫는다.

«재난과 치유»는 전 지구적인 팬데믹의 상황을 동시대적인 관점에서
살펴보고 현재에 대한 탐구와 성찰을 통해 미래에 대한 모색을 제시하고자
기획되었다. 현재진행형의 팬데믹을 주제로 전시를 기획한다는 것은
복합적인 난제를 야기했다. 그중 하나는 초국가적 재난에 대한 담론을
만들어내고, 인식체계의 변화를 이끌어내는 사유의 결과를 보여줄
수 있기까지 '충분한 시간'이 지나야 가능하다는 것이다. 무엇보다
상황의 추이를 종합적으로 바라볼 수 있는 보다 다각적인 연구와
논의가 필요하다는 것이다. 그리고 지금과 같은 전염의 시대에 '전시'는
유효한가에 대한 질문과 고민 역시 여전하다. 그럼에도 불구하고 길게
오래도록 지속되는 예측불허의 팬데믹을 기록하고 숙고하며 현재의

The current COVID-19 pandemic is not the first of its kind to threaten human life and shake the foundations of our existence. Many diseases have erupted since humankind first began living in groups, cultivating land, and practicing an agrarian lifestyle, and many times they have threatened the very fabric of whole communities. The plagues that have continued to threaten human existence throughout history fall into the category of "catastrophes," which encompasses natural disasters as well as war, terrorism, and other forms of social, human-made calamities.

Since the advent of the modern era, advancements in science, technology, and industry have allowed humans to shorten physical distances and to connect and reorganize territories dispersed throughout the world. The invention and dissemination of the internet has achieved this "abolition of distance" [1] by facilitating the exchange of information at breakneck speeds. On the other side of this abolished distance, there is the perception that humans alone are masters of the Earth and our forgetting of the principle of coexistence.

Faced with a form of disaster that is distinct from the infectious diseases of the past, humankind has become aware that the climate, ecosystem, and our forward-driving lives no longer exist or function in the same way as before. In this reality, we see that the time has come for us to reflect on the present; re-establish our values; and develop a cognitive framework that will allow us to imagine future life in new ways.

Catastrophe and Recovery was aimed to examine the global COVID-19 pandemic from a contemporary perspective and share ideas for the future based on explorations of and reflections on the present. Developing an exhibition around the theme of a pandemic that is still taking place posed a complex mix of difficulties. One was the sense that "sufficient time" needs to pass before a discourse can be formed on a supranational catastrophe and results can emerge from the contemplations that give rise to changes in our knowledge systems. Most crucially, there was the idea that more research and discussions were needed in multifaceted ways to survey the situation more comprehensively. Questions and concerns remain about whether the exhibition is appropriate in a time of continued contagion like today. In curating this exhibition, we believed it is meaningful for us to record and reflect on this unpredictable pandemic that has persisted for a long time now, and to speak out artistically about the effects and changes that the current disaster has brought about for individuals and societies.

Consisting of five subject matters in all, Catastrophe and Recovery starts by examining from multiple perspectives the signs and phenomena that have accompanied the eruption and spread of the COVID-19 virus. "Signs and Symptoms" shares artwork that records and reinterprets the social and individual phenomenon associated with the pandemic, as the participating artists portray the ways in which the virus and human beings have coexisted and we have gone about their lives under catastrophic circumstances. In Korea, one of the defining terms of the pandemic era has been jipkok, or "shut-in." "Jipkok, Homebound Together" shows how this phenomenon that has physical distanced people from one another has ironically made us sense how connected we are. The reality facing socially disadvantaged people who are unable to stay isolated even during times isolation is called for forces us to confront the

재난이 개인과 사회에 미친 영향과 변화를 예술적으로 발화하는 것은
유의미한 일이라고 믿으며 이번 전시를 기획하였다.

　　모두 다섯 개의 소주제로 구성된 «재난과 치유»는 코로나19 발생과
확산을 둘러싼 징후와 현상을 다양한 관점에서 고찰하는 것으로부터
시작된다. ‹징후와 증상›에서 작가들은 팬데믹의 사회적, 개인적 현상들을
기록하고 재해석한 작품을 통해 바이러스와 인간의 공존, 재난의 상황
속에서 살아가는 우리의 모습을 그린다. ‹집콕, 홀로 같이 살기›는 팬데믹
시대를 대변하는 대표적인 용어가 된 '집콕'이 사람들 간의 물리적 거리를
만들었지만 아이러니하게 모두가 연결되어 있음을 보여준다. 그리고
각자의 불가피한 고립이 요구되는 이 시대에 격리가 불가능한 삶을 사는
사회 취약층의 현실은 재난 속의 불평등을 인식하게 한다. ‹숫자와 거리›는
팬데믹 상황에서 중요한 위치를 갖게 된 '수'와 '거리'를 재해석한다. 숫자는
현재를 투영하는 기준이 되거나 통계, 데이터와 함수관계 속에서 정보
이상의 다중적 의미를 갖는다. ‹여기의 밖, 그곳의 안›은 문명이 질주를
잠시 멈춘 시간 속에서 삶의 공간들을 다시 바라보도록 한다. ‹유보된
일상, 막간에서 사유하기›는 인류가 겪어온 재난에 대한 사유와 인간과
이외의 생명종(生命種)이 공존하는 삶에 대한 성찰과 인식체계의 전환을
제안한다.

징후와 증상

코로나19를 비롯한 감염병은 생물학적이고 보건의료적인 사건인 동시에
사회적, 정치적, 경제적 현상이다. [2] ‹징후와 증상›에서는 근대 이후
더욱 짧은 주기로 발생하는 신종 감염병이 출현하게 된 징후와 코로나19
팬데믹 전후로 발생하는 사회적, 개인적 현상들을 기록하고, 재해석한
작업을 선보인다.

열한 명의 사진가들로 구성된 신디케이트(Syndicate)는 사회적
아젠다별로 만들어지는 프로젝트 팀이다. 이번 코로나 에디션은 2020년
3월 코로나로 인해 오류를 일으키기 시작한 세계의 이미지를 수집하기
위해 조직되었다고 밝힌다. [3] 이들은 코로나19 팬데믹 시초에서
현재(2021. 5.)까지의 기록을 통해 감염병의 대유행으로 드러난 경제와
노동의 구조적 문제, 취약계층과 돌봄, 여성과 젠더, K-방역의 역설,
공공성과 불평등의 이슈 등 다양한 층위의 사회적 현상들을 사진과
영상으로 구성하였다. "재난의 시작은 평등할지 몰라도, 그 결과는
불평등하다." [4] 고 말하는 이들은 개인의 곤궁과 사회적 문제들 촘촘하게
기록하고 엮어 보여준다.

　　요제프 보이스(Joseph Beuys)의 ‹곤경의 일부›(1985) Fig.1 는
"재난과 치유"라는 전시 제목을 가장 압축적으로 보여주는 작품이다.
이 작품은 1985년 런던 안소니 도페이 화랑에서 전시되었던 ‹곤경›의
일부를 개별 작품으로 제작한 것이다. 인체에 담요를 두른 듯한 펠트의
형상은 보호의 의미를 지닌다. 이것은 실제 작가 자신이 2차 세계대전에서
비행기 추락사고로 죽음의 위기에 처했던 당시 그를 구했던 타타르
유목민이 사용했던 펠트를 이용한 작업으로 인간 생명에 대한 보호와
조난으로부터의 회복을 상징한다.

　　아니카 이(Anicka Yi)는 이번 전시에서 기계 생물의 움직임을
보여주는 설치작품, ‹인간으로부터의 인간 해방›(2019) Fig.2 을 선보인다.
작가는 그동안 곰팡이, 다양한 인종의 체취, 곤충, 박테리아와 같은
비전통적이며 살아 있는 공생적 유기체들을 소재로 다루며 과학기술과
생물학적인 결합을 시도하면서 생명의 변이, 성장과 죽음이라는 주제를
실험적인 방식으로 보여주었다. 이런 그의 작업들은 다중감각(multi-
sensory)의 경험과 진화 생물학이 융합되어 하나의 풍부한 생물학적

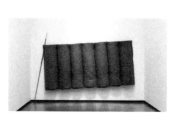

Fig.1　요제프 보이스, ‹곤경의 일부›
Joseph Beuys, *Plight Element*
1985.

Fig.2　아니카 이, ‹인간으로부터의 인간 해방›
Anicka Yi, *Releasing the Human from the Human*
2019.

inequality of catastrophes. "Numbers and Distance" reinterprets the numbers and distances that have assumed an important role in the pandemic situation. Numbers provide a standard to reflect the present while also possessing multiple meanings beyond the mere information within statistics, data, and functional relations. "Outside Here, Inside There" encourages us to look again at the space of life as civilization's headlong race has been forced to a halt. "Daily Life Deferred, Contemplations during a Pause" proposes changes to our perceptual systems as we contemplate the disasters that humankind has experienced and reflect on coexistence between humans and other beings of life.

Signs and Symptoms

In addition to being biological and medical, contagious diseases like COVID-19 are also social, political, and economic phenomena. [2] The section "Signs and Symptoms" presents artwork that records and reinterprets some of the signs of the novel infectious diseases that have emerged in ever shorter cycles since the arrival of the modern era, as well as the individual and social phenomena that arose around the time of the COVID-19 pandemic.

Syndicate, a group made up of 11 current or former news photographers, is a project team that organizes around social agenda areas. Its "COVID-19" edition was reportedly put together in March 2020 to collect images of a world that had begun to malfunction due to the pandemic. [3] Its members produce photographs and videos to show social phenomena at different levels based on records from the pandemic's

beginnings to the present (May 2021): the structural economic and labor issues laid bare by the pandemic; vulnerable segments of the population; issues of caregiving, women and gender; the ironies of "Korean-style disease control"; and issues of public service and inequality. "Catastrophes may start out equal, but their results are unequal," [4] they argue, recording and compiling detailed photographs that illustrate societal issues and the plight faced by individuals.

Plight Element (1985) [Fig.1] by Joseph Beuys illustrates the exhibition title's concepts of "catastrophe and recovery" in their most encapsulated form. The work was developed as part of *Plight*, which was shown at the Anthony d'Offay Gallery in London in 1985. Its felt shape, which resembles a blanket wrapped around a human form, harbors a sense of protection. It was made with the felt used by the Tatar nomads who rescued the artist from near death when his airplane crashed during World War II.

For this exhibition, Anicka Yi presents *Releasing the Human from the Human* (2019) [Fig.2] , an installation work that shows the movements of a mechanical organism. The artist works with non-traditional materials such as mold, the body odors of different groups of people, insects, bacteria, and living symbiotic organisms. Attempting a biological combination of science and technology, she has completed experimental work on themes of life's mutations, growth, and death over her artistic career. Her works combine multisensory experiences with evolutionary biology to form a rich landscape of biological fiction. They have also proposed a new form of discourse in the realm of artificial intelligence and machine learning—introducing the concepts

Fig.3 이진주, ‹사각 死角›
Lee Jinju, *The Unperceived*
2020.

Fig.4 전인경, ‹바이러스의 시간과 공간›
JEON, IN-KYUNG, *Time and Space of the Virus*
2021.

Fig.5 김지아나, ‹COVIDUS-기울어진 계
Jiana Kim, *COVIDUS–Tilted Sta*
2021.

픽션의 풍경을 형성하도록 한다. 이것은 또한 인공지능과 기계 학습의 영역에서 새로운 담론을 제안하며 기계 생태계(machine ecosystem)와 지능의 감각 생태학(the sensorial ecology of intelligence) 개념을 소개한다. 비가시적이거나 미시적으로 공생하는 박테리아, 혹은 바이러스뿐만 아니라 기계 생물과 기계 지능과 같이 인간이 아닌 생명체에 대한 작가의 관심과 탐구는 포스트휴먼의 개념에서 일컫는 첨단과학기술의 발전으로 만들어진 다양한 혼종적 상황과 자연 세계에 대한 인간의 개입 능력의 확장 가능성에 대한 동시대적 현상들을 보여준다.

이진주는 ‹사각 死角›(2020) Fig.3 을 통해 작가 자신의 기억과 주변 이미지의 편린들을 낯설게 조합하여 팬데믹의 시대에 우리를 둘러싼 현상과 더 나아가 삶과 죽음의 의미를 대면하게 한다. 세밀한 묘사와 사실적 표현으로 그려진 일상의 오브제들과 뿌리내리지 못한 식물들, 그리고 무엇인가에 몰입된 인물들의 움직임은 상황과 상황 사이가 분절되고, 그 사이에 새로운 맥락과 의미가 생성되면서 복합적이고 상징적인 내러티브를 구축한다. ‘사각’이라는 작품 제목은 삶 속에서 필연적으로 존재하는 ‘사각지대’를 함의한다. 이것은 전 코로나19 팬데믹은 인류적인 재난이지만 각자에게 다른 깊이와 유형으로 다가오는 비가시적인 고통의 이면을 보여준다.

전인경과 김지아나는 다른 유기체의 살아 있는 세포 안에서만 활동하는 생물과 무생물의 중간적 존재인 바이러스를 다룬다. 전인경의 ‹바이러스의 시간과 공간›(2021) Fig.4 은 코로나바이러스를 만다라 도상과 성운의 이미지와 교차하는 화면으로 구성하였다. 작가는 코로나바이러스를 퇴치해야 할 질병의 근원으로 보기보다는 거시적인 관점에서 우주에서 벌어지고 있는 생명의 문제라는 차원에서 접근한다. 김지아나는 전시장의

깊고 긴 계단에 설치된 ‹COVIDUS-기울어진 계단›(2021) Fig.5 을 통해 눈에 보이지 않지만 강력한 힘으로 확산되는 바이러스, 그리고 이와 유사하게 팬데믹을 계기로 더욱 촘촘하게 연결되는 온라인 네트워크의 밀집과 확장 현상을 오버랩시켜 조형적으로 구현한다. 한국 현대사와 밀착된 주제의 작업을 지속해온 박영균은 감염병이 뒤덮은 현대 사회의 한 단면을 회화로 재현한다. 이번에 전시되는 ‹연결›(2021) Fig.6 을 통해 작가는 정치적, 역사적 대립과 갈등 속에 건설되는 군사기지가 자연환경을 파괴하고 평화를 깨뜨리고 있는 상황과 팬데믹을 연결 지으며 사회적 쟁점에 대한 고찰을 관찰자이자 참여자의 시점에서 그린다.

오원배는 오랫동안 ‘인간의 실존 상황’이라는 주제를 구상적인 경향의 작업으로 견지해 왔다. 정연한 묘사가 동반되는 수사적 표현이 없이 메마른 붓질로 그려진 인물들의 제스처와 분절된 채 부품의 상태로 보여지는 거대한 관(pipe), 그리고 화면 전면에 흩어진 일상의 오브제들은 뒤덮어 버린 일상과 사회적 난제를 암시한다. Fig.7 성능경은 작가의 어린 시절의 기억을 소환하여 ‘손 씻기’라는 단순하고 기본적인 행위를 통해 여전히 종식되지 않은 전염병의 시대를 표현한다. Fig.8 이것은 중세 유럽에 창궐해 ‘하늘이 내린 재앙’이라고 불리었던 페스트의 대유행 속에서 유대인들이 그들의 율법에 따라 행했던 ‘손 씻기’를 환기시키기도 한다.

Fig.6 박영균, ‹연결›
Park Young Gyun, *Connection*
2021.

Fig.7 오원배, ‹무제›
Oh Wonbae, *Untitled*
2020-2021.

Fig.8 성능경, ‹손 씻기›
Sung Neung Kyung, *Handwashing*
2021.

of the "machine ecosystem" and the "sensorial ecology of intelligence." Extending to bacteria and viruses that coexist at invisible or microscopic levels, as well as to different "life forms" such as mechanical organisms and mechanical intelligence, the artist's interest in and exploration of non-human life illustrate contemporary phenomena related to the expansive potential of humankind's capability to intervene in the natural world and the different hybrid situations brought out by advancements in cutting-edge technology, as described by the "post-human" concept.

In *The Unperceived* (2020) [Fig.3], Lee Jinju combines fragments of her own memories and surrounding images in unfamiliar ways, leading us to confront the phenomena that surround us in the pandemic era as well as the meaning of life and death. The everyday objects rendered in a detailed, realistic style; the uprooted plants; and the intently focused movements of figures create a complex and symbolic narrative as new contexts and meanings are formed in the contextual discontinuities between situations. The "unperceived" in the title refers to the dead zones that are inevitably present in our lives. This work shows another side of the unseen suffering of the COVID-19 pandemic, which, though a disaster for all humankind, still differs in its forms and depth for individual people.

Jeon In-kyung and Jiana Kim both focus on viruses as something between "animate" and "inanimate," functioning intermediately within the cells of another living organism. Jeon's *Time and Space of the Virus* (2021) [Fig.4] consists of canvases showing the COVID-19 virus juxtaposed with mandalas and nebulae. Rather than viewing the virus as the cause of a disease that needs to be eradicated, the artist approaches it from a larger-scale perspective, seeing it in terms of how life unfolds in the universe. Through her work *COVIDUS-Tilted Staircase* (2021) [Fig.5], which is installed in a long and deep-set staircase in the gallery, Kim aesthetically presents the virus—something invisible that is capable of spreading rapidly—by overlapping it with the similarly visualized clustering and expansion of online networks, which have only become more densely connected as a result of the pandemic. Park Young Gyun, an artist whose past work has focused on themes closely associated with contemporary Korean history, uses the medium of painting to represent aspects of a modern society that has been overtaken by contagion. With this exhibition's work *Connection* (2021) [Fig.6], the artist draws a link between the pandemic and the ways in which the construction of a military base amid political and historical divisions and conflicts has been destroying the environment and peace. Approaching the theme from the positions of observer and participant, he uses painting to represent his examination of social conflicts.

Oh Wonbae has long adhered to a figurative approach, producing his artwork on the theme of "humankind's existential situation." Through the gestures of figures rendered with dry brushstrokes in an orderly, unembellished fashion; large pipes that seem like disconnected components of something larger; and objects from everyday life scattered throughout his canvases, he alludes to the societal dilemmas of a normality turned on its head. [Fig.7] Sung Neung Kyung recalls his own early childhood memories as he represents the still unfolding pandemic era using the simple and basic act of handwashing. [Fig.8]

Fig.9 써니킴, ‹이동›
Sunny Kim, *Migration*
2021.

Fig.10 써니킴, ‹푸른 시간›
Sunny Kim, *Blue Hour*
2019.

Fig.11 써니킴, ‹돌 던지기›
Sunny Kim, *Playing Stones*
2020.

집콕, 홀로 같이 살기

외출을 자제하고 집에서 대부분의 시간을 보낸다는 의미의 '집콕'은 팬데믹의 시대를 대변하는 용어가 되었다. 전염병의 위협으로부터 살아남기 위한 최선의 방편으로 우리는 자발적 혹은 사회적 요구에 의해 집콕하게 되었고 이 과정에서 삶의 많은 부분들이 온라인 플랫폼으로 급격하게 이행했다. 코로나19가 만든 이 같은 격리는 사람들 사이의 물리적 거리를 만들었지만 또 다른 면에서는 역설적으로 우리가 모두 연결되어 있다는 사실을 일깨웠다. "주변과 연결되어 있다는 것은 사회적 존재라는 인간의 본질을 유지하는 일이다. 사회에 속하지 않는다는 것은 따라서 인간이 유적 존재-인류로서 소외됨을 뜻한다." (5) 는 말처럼 개인의 고립은 사회와 인간이 맺는 연결이 얼마나 중요한 것인지 깨닫게 한다.

시각 예술가들은 홀로 살아가는 삶에 상대적으로 익숙한 사람들이다. 작업의 형태와 다루는 매체에 따라 그 정도가 다르겠지만 기본적으로 예술가들은 홀로 사유하고, 작업하는 유형의 패턴을 유지하는 어떤 부족(tribe)에 가깝다. 그럼에도 불구하고 이번 팬데믹 속에서 강요된 '격리'는 작가들에게 역시 그동안 경험해보지 못한 또 다른 난관으로 다가왔다. 회화 작업을 지속해온 써니킴(Sunny Kim)은 코로나19 대유행 초기부터 장기화되는 어느 시점까지 한동안 실제로 거의 붓을 들지 못했다. 이번에 전시되는 대형 회화 작업 ‹이동›(2021) Fig.9 과 ‹푸른 시간›(2019) Fig.10 작업은 불가피하게 이동과 격리를 지속하게 된 팬데믹 전후 상황 속에서 작가의 내면에 침잠되었던 기억들을 건져 올려 현재와 엮어 만든 내면의 풍경이다. 또한 작가는 이 시간 동안 관성적으로 다뤄 왔던 회화에 대한 고민 속에서 새롭게 시도한 작업의 결과로 제작된 영상을 함께 선보인다. Fig.11

안드레아 지텔(Andrea Zittel)은 광고, 디자인, 일러스트에 대한 관심에서 출발한 A-Z 빌보드(Billboard) 연작 중 대표작을 선보인다. Fig.12 2013년도에 제작된 이 작품은 지금과 같이 사회와 개인의 관계가 명확하게 규정되기 어려운 시기에 "사회 안에 살 것인가 바깥에서 살 것인가?(To live within or without society?)"라는 직설적인 물음을 던진다. 리우 와(Liu Wa)는 전 지구적인 대유행의 상황 속에서 벌어지는 인터넷 소비문화를 보여준다. Fig.13 코로나19가 급속도로, 그리고 광범위하게 확산되면서 많은 도시들이 일시적 폐쇄가 지속되는 가운데 종말론적 불안에서 벗어나고자 하는 차원에서 사람들의 인터넷 소비는 더욱 증가되었다. 여기에 끊임없이 변화하고 전파되는 정보와 아이디어를 지칭하는 인터넷 밈(meme)이 빠르게 퍼졌다. 리우 와는 팬데믹 상황에서 벌어지는 비일상에 가까운 일상의 감정을 헐리우드 영화의 장면과 작가 주변을 기록한 영상과 결합하여 밈의 형식을 빌려 표현한다. 현실에서 코로나바이러스가 퍼져나간다고 한다면 밈은 시공간을 초월한 인터넷 공간에서 그 휘발력을 갖는다.

프란시스 알리스(Francis Alÿs)는 도시지정학에 대한 탐구를 바탕으로 국가, 대륙, 인종 간의 경계를 작업의 주제로 다루며, 사회적 문제들을 관찰자 시점에서 섬세하게 바라보고 깊이 성찰하며 행동하는 예술가로 알려져 있다. 이번 전시에서 작가는 신작 ‹금지된 걸음›(2020) Fig.14 을 선보인다. 2020년 10월에 홍콩 라마(Lamma)섬을 배경으로 제작된 이 작품에는 숲 어딘가에 버려진 듯한 사각의 콘크리트 건축물 위를 더듬거리듯 걷는 한 남자가 등장한다. 사각의 콘크리트는 난간 하나 없이 그 경계를 벗어나는 순간 아래로 추락하는 공간이다. 좁은 사각 공간의 경계를 염두한 듯, 불안정하게 걷는 영상 속의 장면은 숲의 정적

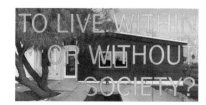

Fig.12 안드레아 지텔, ‹무제(사회 안에서 살 것인가 바깥에서 살 것인가?)›
Andrea Zittel, *Untitled (To live within or without society?)*
2013.

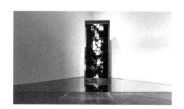

Fig.13 리우 와, ‹2020년은 나에게›
Liu Wa, *2020 Got Me Like*
2020.

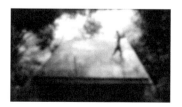

Fig.14 프란시스 알리스, ‹금지된 걸음›
Francis Alÿs, *Prohibited Steps*
2020.

His work evokes the religious custom of handwashing practiced among Jewish populations during the Black Death, a plague described as a "disaster handed down by Heaven" for the way it ravaged medieval Europe.

Jipkok, Homebound Together

Jipkok is a Korean term loosely translatable into English as "shut-in"; it literally refers to someone who refrains from going out and spends most of their time at home. That term has now come to represent the pandemic era. Whether voluntarily or as a result of societal demands, many have adopted the *jipkok* life as the best way of surviving the threat of illness. In the process, many aspects of our lives have migrated rapidly to online platforms. This form of isolation inflicted by COVID-19 has created physical distance among people, but it has also ironically made us aware of how interconnected we all are. It has been said that "our connections to what surrounds us are what sustains our essence as social beings. To not belong to a society thus signifies the being's alienation as a species-being." [5] In this way, an individual's isolation makes one aware of how vitally important the connections formed between society and individuals are.

Visual artists are relatively accustomed to the solitary life. While it varies with the form of artwork and medium an artist practices in, artists are a tribe that follows a pattern of thinking and working alone. Yet the kind of isolation forced on them by the pandemic has posed a challenge different to those these artists may have encountered in the past. From the early stages of the COVID-19 pandemic to months after, painter Sunny Kim

barely lifted her brush. The large paintings exhibited here—*Migration* (2021) [Fig.9] and *Blue Hour* (2019) [Fig.10]—are inner landscapes created by the artist as she knitted deeply held memories with the present around the time of the pandemic, when she was forced into a series of journeys and quarantines. She also presents a video work created as part of a new experiment to move away from the painting medium that she had come to approach in habitual ways. [Fig.11]

Andrea Zittel contributes a represented work from her *Prototypes for Billboards A-Z West* series, which started out of her interest in advertising, design, and illustrating. [Fig.12] Completed in 2013, this work poses a frank question for those of us living in a time in which it is difficult to clearly define the relationship between society and the individual, asking "To live within or without society?" Liu Wa shows the pandemic's Internet consumption culture. [Fig.13] As the rapid, widespread proliferation of COVID-19 has sent many cities into protracted lockdowns, consumption of internet-based content has only increased among people seeking to let go of their apocalyptic worries. One aspect of this has been the rapid spread of online memes that are being constantly created and proliferated on social media throughout the pandemic. Liu draws on the social media meme format by combining Hollywood film scenes and footage from her own surroundings to show ordinary emotions that border on the extraordinary. While the COVID-19 virus spreads in the real world, memes show their volatility in online environments that transcend time and space.

Francis Alÿs focuses on the theme of "borders" between countries, continents, and ethnicities through his artistic

Fig.15 홍진훤, ‹Injured Biker›
Jinhwon Hong, *Injured Biker*
2021.

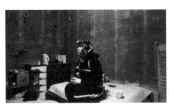

Fig.16 무진형제, ‹결구›
Moojin Brothers, *The Last Sentence*
2015.

Fig.17 차재민, ‹미궁과 크로마키›
Jeamin Cha, *Chroma-Key and Labyrinth*
2013.

속에 들려오는 나즈막한 새소리와 대조를 이루며 유약한 인간인 우리에게 닥친 팬데믹의 불확실성과 위태로움을 시적으로 보여준다.

전시가 개막된 이후에도 여전히 종식되지 않은 이 신종감염병은 늘 존재해 왔지만 드러나지 않았던 많은 사회적, 구조적 차원의 문제들을 표면 위로 끌어 올렸다. 팬데믹은 마치 '시약(試藥)'[6]처럼 언택트와 뉴노멀의 그늘 아래 존재하는 사회안전망에 대한 이슈들을 드러내었다. 홍진훤의 작업은 집콕과 언택트의 삶이 가능하기 위해서 행해지는 대표적인 플랫폼 노동자의 현재를 다룬다.[Fig.15] "누군가의 안전은 누군가의 위험을 담보로 성립된다."는 작가의 말처럼 4차산업혁명과 디지털 플랫폼 가속화의 미명 아래 배달, 택배 노동자들은 공허하게 반복 재생되는 코로나19 방역 수칙을 뒤로하고 고된 움직임을 반복한다. 무진형제의 〈결구〉(2015)[Fig.16]와 차재민의 〈미궁과 크로마키〉(2013)[Fig.17]는 디지털 기술을 매개로 질주해 온 현대사회의 이면에 존재하는 부조리와 오늘과 같은 비대면 시대에 '접촉자(contact)'이자 '유지, 보수자(maintainer)'로서 살아가는 노동의 불평등 문제를 각기 다른 영상 언어로 상기시킨다.

숫자와 거리

'일일확진자', '격리해제', '사망자', '국내현황', '세계현황', '거리두기단계' 이 모든 숫자 정보는 코로나19 위기 경보와 동반되면서 '오늘'을 말해주는 바로미터가 되었다. "아침에 일어나자마자 즉석에서 숫자 변화를 확인하고 계산하는 것은 보통 뭔가가 잘못되었다는 징후이다."[7]라는 파올로 조르다노의 말처럼 숫자는 즉각적인 정보이자 그 이상의 의미를 가지며 팬데믹의 상황에서 중요한 위치를 확보한다.

이번 전시를 위해 제작한 이지원(아키타입)의 〈팬데믹 다이어그램〉 (2021)[Fig.18]은 대유행 기간 동안 축적된 다양한 통계자료와 데이터들을 수집하고 분석하여 그래픽적으로 시각화한 작업이다. 열 개의 패널과 웹사이트로 구성된 이 작품은 여성 고용 추이, 플랫폼 노동자 고용 가입 현황, 콜센터 좌석 배치도, 서울지역 아동학대 월평균 현황 등의 다이어그램을 통해 사회적 불평등, 차별과 혐오 그리고 사회안전망의 사각지대에 놓인 계층의 삶과 사회적 취약 구조 깊숙이 침투된 불평등과 오류들을 직관적으로 드러낸다. 최태윤은 그라피티, 드로잉, 설치, 그래픽영상, 프린트 작업이 결합된 벽화작업을 선보인다. 작가는 현재와 같이 절망적인 상황에서 우리가 현재를 직시하고 미래를 예측할 수 있는 숫자들 간의 관계와 수의 세계에 주목한다.[Fig.19] 이것은 조르다노가 언급했던 "수학은 숫자의 학문이 아니라 관계의 학문"[8]이라는 말과 맞닿아 있다.

리암 길릭(Liam Gillick)의 신작인 〈상승하는 역설〉(2020)[Fig.20]은 18세기 수학자 귀도 그란디(Guido Grandi) 수열로 알려진 무한 등비급수와 연관된 작품이다. 무한 등비급수는 '1'과 '-1'을 번갈아 더하는 무한합으로 이것을 어떤 방법으로 사용하는가에 따라 결과가 도출된다. 길릭은 그의 작품에 괄호의 위치에 따라 도출되는 값이 달라지는 수식을 사용하여 붉은색과 파란색으로 나누어 구성하였다. 수직적인 작품의 양쪽 끝에 위치한 '0'과 '1'이라는 숫자는 팬데믹이라는 복합적인 상황 속에서 마주했던 '삶'과 '죽음'을 암시한다. 이는 또한 포스트 코로나 시대에 우리가 마주할 다양한 변수와 조건을 끊임없이 대입하고 그 과정에서 삶의 대안을 모색하는 과정을 담는다. 미야지마 타츠오(Tatsuo Miyajima)의 숫자는 보다 추상적이고, 철학적인 개념 아래 존재한다.

Fig.18 이지원 (아키타입), 〈팬데믹 다이어그램〉
Jiwon Lee (archetypes), *The Unequal Pandemic*
2021.

Fig.19 최태윤, 〈마법 같은 수의 세계: 빛과 어둠의 역함수〉
Taeyoon Choi, *Magical World of Numbers: Inverse Function of Light and Darkness*
2021.

Fig.20 리암 길릭, 〈상승하는 역설〉
Liam Gillick, *Elevated Paradox*
2020.

explorations of urban geopolitics. He is well known for closely examining social issues from an observer's standpoint, reflecting deeply, and taking action. For this exhibition, he shares his new work *Prohibited Steps* (2020) Fig.14 . Filmed in October 2020 against the backdrop of Hong Kong's Lamma Island, it shows a man walking unsteadily atop a seemingly abandoned rectangular concrete building somewhere in the woods. There is no railing; the structure forms a space where a person who steps outside of its boundaries plummets immediately to earth. This scene is a poetic illustration of the uncertain and precarious condition amid the pandemic that has descended on human beings, forming a contrast with the twittering of birds that cuts through the forest's stillness as the man perilously treads along, seemingly conscious of the the boundaries of his narrow rectangle.

A novel contagion that had yet to end by the time this exhibition opened, COVID-19 has brought to the surface many social and structural issues that have always covertly existed. Like a reagent, [6] the current pandemic has, in particular, revealed within the social safety net flaws that lurk in the shadows of the so-called "new normal" of the "untact era" ("untact" being a term coined in Korea to refer to socially distanced, contactless activities). The work of Jinhwon Hong focuses on the present situation of workers on some of the chief platforms that make "shut-in" and "untact" life possible. Fig.15 "One person's safety presumes another person's risk," the artist has said. In the name of "the Fourth Industrial Revolution" and "digital platform acceleration," delivery workers must carry out arduous repeated motions, made to forgo COVID-19 prevention

guidelines with this ceaseless and empty repetition. The Moojin Brothers' *The Last Sentence* (2015) Fig.16 and Jeamin Cha's *Chroma-Key and Labyrinth* (2013) Fig.17 use different cinematic languages to respectively evoke the absurdities underlying a contemporary society that has made rapid strides in digital technology and the issue of labor equality among the "contacts" and "maintainers" living in today's "untact" era.

Numbers and Distance

"New daily confirmed cases," "total released from quarantine," "fatalities," "today's domestic and global figures," "social distancing level"—in Korea, all of these bits of numerical information come accompanied by COVID-19 crisis alerts that serve as a barometer for how things are looking each day. Paolo Giordano writes, "To this day, there are mornings when I wake up and I improvise calculations and numeric sequences; it's usually a symptom that something's wrong." [7] Numbers provide immediate information, but they also carry meaning beyond it, which assigns them an important place within the pandemic situation.

Created by Jiwon Lee (archetypes) for this exhibition, *The Unequal Pandemic* (2021) Fig.18 is a graphic visualization based on various statistics and data gathered over the pandemic and analyzed. Consisting of 10 panels and a website, the work uses diagrams showing women's employment trends, worker enrollment in employment platforms, call center seating charts, average monthly reports of child abuse in the Seoul area, and other information to provide an intuitive illustration of social inequality, discrimination, the lives of people neglected by

Fig.21 미야지마 타츠오, ‹카운터 갭›
Tatsuo Miyajima, *Counter Gap*
1989/2019.

Fig.22 김범, ‹무제-친숙한 고통#12›
Kim Beom, *Untitled-Intimate Suffering#12*
2012.

Fig.23 질리언 웨어링, ‹당신의 관점›
Gillian Wearing, *Your Views*
2013-현재(present).

‹카운터 갭›(1989/2019) Fig.21 은 팬데믹이 만들어낸 격리와 거리 두기가 오히려 우리 모두가 연결되어 있다는 사고를 일깨우듯이 숫자가 점차 나타나고 사라지는 모습은 삶과 죽음이 순환하며, 끊임없이 변화하고 '모든 생명은 연결되었다.'는 작가의 철학적 사유를 담고 있다. 김범의 거대한 미로를 형상화한 ‹무제-친숙한 고통#12›(2012) Fig.22 는 여전히 지속되고 있는, 삶 전체가 재난으로 뒤덮여버린 현재와 중첩된다.

여기의 밖, 그곳의 안

인간이 일궈낸 문명 속에 구축된 수많은 도시의 학교, 공항, 공원, 광장, 그리고 미술관도 예외 없이 아직 온전하게 이전의 상태로 돌아가지 못하고 있다. 비대면의 삶은 물리적, 시간적 공간의 경계와 간극을 흐리게 하고 일상의 공간을 다르게 사유하게 한다.

질리언 웨어링(Gillian Wearing)의 ‹당신의 관점›(2013–현재) Fig.23 은 오픈콜 프로젝트로 2013년부터 진행되었다. 팬데믹과 관계없이 시작된 이 작업은 풍경이라는 오랜 전통 장르를 작업함에 있어 하나의 장면을 보여주는 전형적인 방식이 아닌 다양한 사람들이 자신들의 창문을 통해 바라보는 각기 다른 풍경을 수집하고 집적하는 것에서 출발하였다. 작가의 기존 작업들이 공통적으로 사람들 간의 친밀감, 그리고 다양한 협업과 참여가 중요한 요소였던 것처럼 이 작품 역시 누구에게나 열린 방식으로 그들의 관점에서 각자의 풍경을 보여주도록 제안한다. 초국가적인 팬데믹으로 세계 곳곳에서 봉쇄가 지속되는 가운데 어떤 스펙터클도 존재하지 않지만 각자의 창문 너머로 보이는 잔잔한 일상의 풍경이 주는 감동은 지금, 더욱 큰 의미로 다가온다.

서도호는 작업을 지속하는 데 있어 우리를 둘러싼 물리적, 건축적 공간과 그곳을 관통하는 신체적 움직임의 감각을 사유한다 (9)고 말한다. 팬데믹의 상황에서 우리에게 물리적 '접촉'은 굉장한 복잡성을 띠게 되었다. 특히 집이라는 사적인 공간뿐만 아니라 공적인 공간에서 건축의 내부구조의 연결과 단절, 그리고 공간적 변환을 위한 기능을 지닌 손잡이, 스위치, 소켓 등의 일상의 오브제들을 만지는 것은 코로나19 상황 속에서 강박적이고 심지어 두려움을 동반한 행위가 되었다. 건축적 모델링 프로그램의 스크립팅 언어를 이용해 제작된 작가의 신작인 ‹ScaledBehaviour_runOn(doorknob_3.11.1)›(2021) Fig.24 은 이러한 복합적인 상황이 반영되었다. 작품의 제작에 사용된 프로그램은 개미의 움직임이나 건축물 내부에 지어진 거미집의 형상을 참조하며 디지털 모형의 윤곽선을 만들어 내도록 지시되었다. 이렇게 완성된 작업은 시각적으로 마치 혈관 속을 흐르는 혈액의 흐름 혹은, 바이러스가 발현하는 형태를 연상시키면서 팬데믹 시대의 심리상태와 결합된다.

이혜인은 동시대 회화작가들 중 드물게 야외 사생을 통해 '그리기'라는 신체성과 장소성을 수반하는 작업을 지속해 왔다. 이번에 전시되는 2017년작인 ‹페이스타임 HD› 시리즈 Fig.25 는 작가가 사생이 아닌 다른 방식을 통해 풍경을 그리고자 하는 실험이자 기존의 작업에서 확장된 형태로써 제작되었다. 서울에서 작업하는 이혜인은 로스앤젤레스에 거주하는 작가와의 협업을 통해 열 번의 화상통화를 하는 동안 실시간으로 그림을 그리면서 작업을 완성했다. 이 연작은 스마트폰 너머의 실재하는 풍경을 그리지만 그 장소를 그리는 작가는 실제 그곳에 없는 독특한 방식을 취하면서 각기 다른 시간과 장소에 있는 송화자와 수화자의 시차와 거리만큼의 '틈'이 존재하는 이질적인 풍경을 보여준다. 이런 그의 작품은

Fig.24 서도호, ‹ScaledBehaviour_runOn(doorknob_3.11.1)›
Do Ho Suh, *ScaledBehaviour_runOn(doorknob_3.11.1)*
2021.

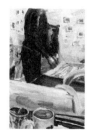

Fig.25 이혜인, ‹페이스타임 HD›
Hyein Lee, *Facetime HD*
2017.

the social safety net, and the imbalances and fallacies deeply ingrained in our structures of social vulnerability. Taeyoon Choi's wall art is a combination of graffiti, drawing, installation, and printmaking in which the artist focuses on the world of numbers and the relationships among them that allow us to confront the present and predict the future during such desperate times as today. [Fig.19] This relates to Giordano's observation that "[M]ath isn't the science of numbers—not really—it's the science of relations." [8]

Elevated Paradox (2020) [Fig.20], a new work by Liam Gillick, relates to Grandi's series, an infinite series discovered by the 18th century mathematician Guido Grandi. This infinite series begets endless sums alternating between "1" and "-1" values and can be used to produce various values depending on the way the method is used. In his work, Gillick uses the colors red and blue, applying a formula in which the values change according to the position of parentheses. The "0" and "1" situated at the top and bottom of the vertically positioned work allude to the complexities of the pandemic and the way it has confronted us with life and death. As it endlessly inputs the different variables and conditions poised to greet us in the post-COVID-19 era, it incorporates a process of seeking out alternatives for our lives. In Tatsuo Miyajima's case, numbers are governed by more abstract, philosophical concepts. Just as the isolation and distancing necessitated by the pandemic have only made us aware of how connected we are, the gradually appearing and disappearing numbers in *Counter Gap* (1989/2019) [Fig.21] express Miyajima's philosophical perspectives that "all life is connected" and that life and death cycle through

our constantly changing reality. Kim Beom visualizes a vast labyrinth in *Untitled-Intimate Suffering#12* (2012) [Fig.22], which overlaps with a reality that continues even now as all of our lives are overtaken by catastrophe.

Outside Here, Inside There

In the countless cities built as part of human's civilizational achievements, nothing—not our schools, airports, parks and plazas, or art museums—has yet been able to fully return to how it was before. The "untact" lifestyle has only further blurred the boundaries and gaps in physical and temporal space, forcing us to think about our environments in different ways.

Your Views (2013–present) [Fig.23] by Gillian Wearing is an open submissions film project that began in 2013. With origins that had nothing to do with the pandemic to come, it began as an attempt to deviate from the traditional landscape art genre's approach of showing a single scene, instead adopting an approach of assembling different landscapes as seen by different people outside of their windows. The artist's previous work had emphasized intimacy among people, centering different forms of collaboration and participation as important elements. Here as well, she adopts a format that is open to everyone, inviting them to show their own landscapes from their own perspective. As countries around the world have been sealing their borders due to the pandemic, it comes across as all the more meaningful to experience the power of these serene everyday landscapes, free of spectacle, that can be seen beyond each person's window.

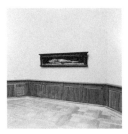

Fig.26 칸디다 회퍼, ‹바젤미술관 IV›
Candida Höfer, *Kunstmuseum Basel IV*
1999.

Fig.27 토마스 스트루스, ‹관람객 11 피렌체›
Thomas Struth, *Audience 11 Florenz*
2004.

화면과 온라인 공간에서 생성되고 존재하는 다양한 사이의 간극처럼
비대면 시대를 살아가는 우리에게 새롭게 다가온다.

　　2020년 코로나19가 급속히 확산된 직후 국립현대미술관은 개관
이래 처음으로 수차례 미술관의 폐쇄와 개방을 반복했다. 문이 닫힌
미술관에 전시된 동시대 미술 작품들은 관람객들 없이 온전히 그 존재를
보여주지 못한 채 화석처럼 고요하게 놓여있었다. 칸디다 회퍼(Candida
Höfer) 사진 속의 살아있는 생명이 부재하는 공간은 팬데믹 시대의
공공장소의 모습을 직접적으로 교차시킨다. 진공상태 속에 존재하는 듯
보이는 ‹바젤미술관 IV›(1999) Fig.26 은 누구나 접근 가능한 전시장의
모습을 낯설고 형이상학적인 풍경으로 만든다. 특히 미술관의 벽에
걸린 한스 홀바인(Hans Holbein)의 ‹무덤 속의 그리스도›는 관람객의
부재로 더 이상 그 아우라를 만들어 내지 못하는 문 닫힌 미술관의
작품의 모습과 다르지 않다. 회퍼의 작품과 함께 이번에 전시되는
토마스 스트루스(Thomas Struth)의 ‘관람객’ 시리즈는 프라도,
생 페테르부르크 등을 배경으로 지속해온 미술관 주제 사진
연작(Museum Photographs) 중 대표작이다. Fig.27 미술관의 작품과
공간에 초점을 맞추기보다 작품을 감상하는 관람객을 피사체로 삼은
‘관람객’ 시리즈는 여행과 이동이 이전처럼 가능하지 않은 이 시대에
회퍼의 사진과 극명한 대조를 이루며 노스탤직한 풍경으로 다가온다.

　　미술관 마당과 로비의 경계에 위치한 서승모 건축가의 파빌리온은
미술관의 외부와 내부를 연결하여 삼각형의 조형을 이룬다. Fig.28 건물의
안과 밖이라는 각기 다른 위치에 놓인 출입구를 통해 진입한 관람객들은
서로 다른 지점에서 유리를 경계로 만나게 된다. 하나의 조형물이면서
건축적 기능을 지닌 이 파빌리온은 팬데믹으로 인해 온전하게 작동하지

못하는 미술관이 관람객과 예술을 매개하는 접점이 되고자 하는 오늘의
능동적인 시도를 상징한다.

유보된 일상, 막간에서 사유하기

근대 이후 인류의 역사 한 가운데에 커다란 변곡점을 그린 코로나19는
우리를 일상이 멈춰버린 오랜 막간 (10) 에 머물게 한다. 1980년대 이후
질주해온 세계화의 추세 역시 팬데믹 앞에 중단되었고 많은 나라들은
국경을 봉쇄하고 불가피하게 ‘격리’를 지속하고 있다. 공간의 정지만이
아니라 시간도 잠시 정지했다. (11) 최근 빈번하게 발생하는 신종 감염병의
출현은 인류세와 같은 환경파괴와 생태환경의 변화와 직접적으로 맞닿아
있다. “전염병의 진화는 근대 문명의 발전과 동일한 궤적을 그린다.” (12) 고
한다. 현재의 비일상적인 삶은 인간이 오랫동안 지속해온 질주의 결과가
팬데믹이라는 부메랑이 되어 돌아왔음을 깨닫게 한다. 여전히 유보된
일상에서 우리는 인간 이외의 삶이 공존하는 이 지구에 대한 인식체계의
전환이 절실한 시점에 이르렀음을 느낀다.

　　허윤희는 종이나 전시장 또는 특정 공간의 벽에 주로 목탄을 사용하여
드로잉을 하는 작업들을 20여 년 동안 지속해 왔다. 자신의 기억과 일상에
대한 질문과 사유를 담은 수행적인 작업은 어떤 ‘중간적 매체(medium)’를
거치지 않고 작가의 호흡과 손의 결이 직접적으로 전달되는 형태의
드로잉 이미지들로 완성되었다. 허윤희의 기존작들이 자신의 개인적 삶과
경험에서 비롯되었다면 최근작에서는 자연과 공동체의 삶에 대한 깊은
탐구가 반영되었다. ‹빙하가 녹고 있다›(2021) Fig.29 는 멸종위기에 처해
있는 한국 자생 식물의 모습을 녹아내린 북극의 유빙(流氷)이 떠다니는
풍경과 병치시킨다. 이 작품은 서서히, 하지만 우리가 인지하는 것보다

Fig.28　서승모, ‹소실선. 바다.›
Seungmo Seo, *Vanishing Line. Sea.*
2021.

Fig.29　허윤희, ‹빙하가 녹고 있다.›
Yun-hee Huh, *Glaciers are melting*
2021.

In his artwork, Do Ho Suh contemplates our surrounding physical and architectural spaces and the sense of physical movement that exists throughout them. [9] In the circumstances of a pandemic, physical contact has taken on a very complex aspect. COVID-19 has created compulsive, even fearful associations with the everyday act of touching objects such as doorknobs, switches, and sockets—elements that serve roles in spatial transitions and in connecting and separating internal architectural structures, not only in the private space of the home but also in public settings. Suh's new work *ScaledBehaviour_runOn (doorknob_3.11.1)* (2021) [Fig.24], which was created using the scripting language of an architectural modeling program, is a reflection of this complex situation. The program was directed to draw the outline of a digital model based on the movements of ants and the shape of a spiderweb formed within an architectural structure. Visually, the resulting work calls to mind the flow of blood through veins or the emergence of a virus, which relates to the psychological states associated with the pandemic era.

Hyein Lee is a contemporary painter who, unusually, has consistently focused on outdoor sketching and its associations with physicality and spatiality. The work shown in this exhibition from her series *Facetime HD* [Fig.25], produced in 2017, was developed as an experiment with and expansion of her past work in which she depicted and expanded landscapes through means other than outdoor sketching. The Seoul-based artist created her work in real time through 10 separate video calls, collaborating with an artist living in Los Angeles. For this series, she adopted a curious approach in which she painted landscapes that existed on the other end of the telephone without actually being in their presence. As a result, she produced disparate landscapes that highlight the gap corresponding to the temporal and spatial distance that exists between a speaker and listener in different times and places. Her work takes on a new sense for those of us living in the "untact" era, echoing the different gaps that form and exist onscreen and in online settings.

As COVID-19 began spreading rapidly in 2020, the National Museum of Modern and Contemporary Art, Korea (MMCA) was forced to close and reopen its doors several times for the first time in its history. Behind its shuttered doors, the works of contemporary art displayed in its galleries sat quietly like fossils, unable to fully show their existence without any viewers to take them in. In the photographs of Candida Höfer, spaces empty of life form direct associations with the way public settings have appeared in the COVID-19 era. *Kunstmuseum Basel IV* (1999) [Fig.26] seems to exist in a vacuum, turning the museum setting, theoretically accessible to everyone, into a foreign and metaphysical landscape. *The Body of the Dead Christ in the Tomb* by Hans Holbein the Younger, which hangs within the museum, is no different from the works in closed galleries, unable to create their aura with no visitors to view them. Exhibited alongside Höfer's work, the *Audience* series by Thomas Struth is a piece from his series of museum-themed photographs, created on an ongoing basis at the Museo Nacional del Prado in Madrid, the State Hermitage Museum in Saint Petersburg, and elsewhere. [Fig.27] Rather than focusing on the artwork within the museum as a space, the *Audience* series turns its lens on the viewers appreciating the artwork,

Fig.30 노은님, ‹나뭇잎 배 타는 사람들›
Eun Nim Ro, *Blatt Boat Fahret*
1987.

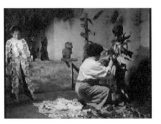

Fig.31 노은님, ‹내 짐은 내 날개다›
Eun Nim Ro, *Meine Flügel sind meine Last*
1989.

훨씬 더 빠른 속도로 사라지는 이 빙하들처럼 인류도 결국 사라질 수 있음을 알리는 위태로운 풍경이다. 작가는 이름도 기억되지 못한 채 영원한 사라짐 앞에 놓인 식물들을 그리고 기록하며 '무명이어도 어여쁘고 향기롭기만 한 그 얼굴들이 사라져 버리지 않기'를 기원한다. 미술관 벽에 그려진 이 그림은 작가에 의해 지워지는 (사라지게 하는) 과정을 하나의 퍼포먼스로 보여주면서 '소멸'의 의미를 더욱 강렬하게 증폭시킨다.

1970년에 독일로 이주한 노은님은 국내에서 보다 유럽에서 먼저 이름을 알렸고 회화를 기반으로 하면서 퍼포먼스, 설치, 조각, 공공미술 등 장르와 매체를 유연하고 자유롭게 넘나드는 과감한 작업을 보여준다. 작가는 "자연은 항상 원을 만들며 계속 원점으로 돌아간다. 난 근본적으로 인간과 동물, 식물이 다르지 않다고 생각한다. 이들 모두는 이 세상에 잠시 살다가 간다는 것과, 폭력과 죽음을 두려워한다는 공통점을 가지고 있다. 자연에는 항상 우연과 필연이 함께 공존한다."[13]라는 언명처럼 인간과 그 외의 생명에 대해 동등한 가치를 부여하며 경외와 동조를 표한다. 노은님의 이 같은 자연과 삶에 대한 세계관은 ‹나뭇잎 배 타는 사람들›(1987) Fig.30 과 ‹내 짐은 내 날개다›(1989) Fig.31 에서 보여지듯이 사람과 자연의 양쪽 경계를 오가거나 자웅동체의 모습을 띤 원시적이며 단순화된 형상으로 그려진다. 이들은 나무의 잎사귀도 되고, 물고기도 되고 또 한 마리의 새도 될 수 있는 가능성[14]을 가진 시적이고 상징적인 존재들로 작가는 이를 통해 재난으로 얼룩진 현대문명의 복잡다단한 삶 가운데서 단순함의 미학과 예술적 상상력의 가치를 일깨운다.

조나단 호로비츠(Jonathan Horowitz)의 ‹아포칼립토[15] 나우›(2009) Fig.32 는 할리우드 재난 영화의 역사에 관한 다큐멘터리와 각기 다른 출처에서 발췌된 영화 장면들을 엮어 제작된 영상이다. 기후변화,

테러리즘, 그리고 미국 영화배우이자 감독인 멜 깁슨의 ‹패션 오브 크라이스트(The Passion of the Christ)› 메이킹 영상과 성서에 묘사된 종말(the Apocalypse)이 평행적인 내러티브로 구성된 이 작품은 실재와 허구를 오가며 세계적인 파괴와 재난이 거대한 위협이자 궁극적인 두려움인 동시에 역설적인 판타지로 다가오도록 한다. 작품 제목의 "아포칼립토"는 세상의 종말을 뜻하는 "아포칼립스(apocalypse)"를 떠올리게 한다. 미국의 인문학자 워런 몬탁(Warren Montag)은 코로나19가 세계 곳곳에서 일으킨 일련의 사태를 '아포칼립스'라고 부르는데 여기서의 의미는 세계의 파국을 말하는 것이 아니라 이전까지 잠재되었고, 숨겨져 있던 것들이 어떤 급작스러운 계기를 통해 막대한 후과를 동반하면서 드러낸다는 의미 [16] 와 연관 지을 수 있다.

영화감독 봉준호의 단편영화 ‹인플루엔자›(2004) Fig.33 는 제5회 전주국제영화제가 열린 2004년에 제작된 작품이다. 인플루엔자는 사전적 의미로 유행성 감기나 사상적, 경제적 유행을 상징한다. 이 작품은 불황의 장기화로 사회적 취약계층이 무너져버린 삶 속에서 무감각하게 퍼져가는 폭력의 전이를 은유한다. 영상 전반에서 보이는 CCTV의 카메라 시선은 무심하고 냉혹한 현실을 메마른 시선으로 바라보게 하여 더욱 부조리한 현실과 그 잔인함을 배가시킨다. 이 작품은 팬데믹, 혹은 바이러스를 직접적으로 다루는 작업이라기보다는 사회의 취약한 구조 내부에서 인플루엔자처럼 퍼져가는 감염의 또 다른 형태를 보여준다.

이영주의 ‹표범의 눈›(2021) Fig.34 과 ‹검은 눈›(2019) Fig.35 은 지구적 위기를 다루는 영상 작업 시리즈이다. 작가는 단편 애니메이션 전반에 자연사 박물관의 사실적이지만 박제된 듯한 표현 기법을 의도적으로 도입함으로써 역사적 사실을 전달하는 어법을 차용한다. ‹표범의 눈›은

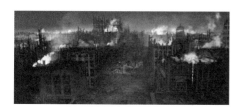

Fig.32 조나단 호로비츠, ‹아포칼립토 나우›
Jonathan Horowitz, *Apocalypto Now*
2009.

Fig.33 봉준호, ‹인플루엔자›
BONG Joon-ho, *Influenza*
2004.

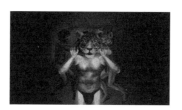

Fig.34 이영주, ‹표범의 눈›
Young Joo Lee, *Jaguar's Vision*
2021.

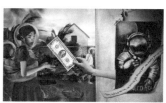

Fig.35 이영주, ‹검은 눈›
Young Joo Lee, *Black Snow*
2019.

the landscapes evoking nostalgia as they form a stark contrast with Höfer's photographs at a time when people are not free to move about as they have before.

Located between the museum courtyard and lobby, a pavilion designed by architect Seungmo Seo forms a triangular composition. [Fig.28] With entrances and exits at different positions inside and outside the museum building, it causes the visitors entering it to encounter the glass boundary at different points. As a work of art that also serves an architectural role, the pavilion symbolizes the museum of today, which is unable to fully perform its role due to the pandemic, yet continues actively attempting to provide a mediating point of contact between viewers and art.

Daily Life Deferred, Contemplations during a Pause

Creating an enormous inflection point in the modern history of humankind, the COVID-19 pandemic has forced us into a long "pause" in which our daily lives have come to a stop. [10] The trend of globalization that had continued at such a breathless pace since the 1980s has been forced to a halt by the pandemic, and countries everywhere have had to seal their borders. It is not only space but also time that has become temporarily suspended. [11] The frequent emergence of novel infectious diseases bears direct ties with the environmental destruction and ecosystem changes exemplified by the concept of the "Anthropocene." "The evolution of infectious diseases shares the same trajectory with advancements in modern civilization," it has been claimed. [12] The abnormal quality our lives today have taken on shows that the results of humanity's

long breakneck rush has boomeranged back in the form of a pandemic. With daily life still deferred, we sense that we have arrived at point at which we desperately need a change in our system of awareness of the Earth, which we share with other non-human life.

For over 20 years, Yun-hee Huh has produced drawings by using charcoal on paper affixed to the walls of a gallery or other specific site. Expressing questions and thoughts about her memories and day-to-day life, the featured performative artwork takes the form of images conveyed directly by the rhythms and texture of the artist's hand without any intervening medium. Where Huh's past work originated in her individual life and experience, her recent pieces reflect her deep contemplation and exploration of nature and community life. Her work *Glaciers are melting* [Fig.29] juxtaposes images of endangered indigenous Korean flora with landscapes of melted ice floes from the North Pole. This work is a perilous landscape that expresses how humanity too is disappearing like the Earth's glaciers— slowly, yet also far faster than we realize. The artist's painting records plants threatened with extinction, even their names unremembered, as she expresses her hope that those "nameless yet lovely and fragrant faces will not simply fade away." Painted on the museum's wall, the image shows the process of erasure (disappearance) by the artist as kind of performance, further amplifying the sense of annihilation.

Eun Nim Ro immigrated to Germany in 1970, making a name for herself in Europe before gaining attention in Korea. She has shown a bold approach to her work, which is based in painting but also makes free and flexible use of different genres

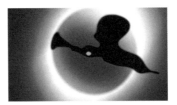

Fig.36 염지혜, ‹검은 태양 X : 캐스퍼, 마녀, 그리고 물구나무종›
Ji Hye Yeom, *Black Sun X : Casper, Witch, and Handstanderus*
2021.

자연의 일부로 살아왔던 인간이 자신의 욕망으로 인해 신성하게 여기던 표범으로 상징되는 (남아메리카에서 표범은 신적인 존재) 자연에 해를 가하고, 자연의 지배자로 스스로의 자리를 확보 하였으나 그 후 벌어지는 인간과 자연 사이의 지배와 종속, 인간 집단 내부에서 벌어지는 갈등을 표출하면서 인류의 존재 방식에 대한 질문을 던진다.

염지혜는 이번 신작 ‹검은 태양 X : 캐스퍼, 마녀, 그리고 물구나무종›(2021) Fig.36 에서 현재로 이어지는 ‘재난’의 궤적을 추적하면서 대중문화로 폭넓은 관심을 받아온 만화 영화 캐릭터와 중세 흑사병 이후 봉건제에서 자본주의로 이행되는 시기에 자행된 마녀사냥, 그리고 식물을 통해 새로운 사유를 추구하는 인간종인 물구나무종 등 서로 연관성을 찾기 어려운 서사의 파편들을 검은 태양이라는 함축적 제목 아래 연결하고 직조한다. 이 작품은 팬데믹이 여전히 멈추지 않은 상태로 장기화되면서 삶 자체가 재난이 되어버린 지금, 우리에게 재난은 눈앞의 난제를 극복하는 것이라기보다 다양한 유형의 재난과 살아갈 수밖에 없음을 일깨우고 인간 이외의 다양한 생명종들과 공존하는 방식에 대해 사유할 것을 이야기한다. 이러한 포스트휴먼적 담론은 기술의 발전으로 가능해진 기술-미래적 비전뿐만 아니라 인간과 그 외 종(種)이 공진화하는 상황 속에서 그동안 우리의 인식의 범위 안으로 진입하지 못했던 인간 외의 생명들 및 새롭게 출현할 주체들과 맺게 될 관계에 대한 사유이자 상상의 문제 [17] 이기도 하다.

에이샤-리사 아틸라(Eija-Liisa Ahtila)는 무빙 이미지와 다채널 설치를 기반으로 젠더, 성, 식민주의와 폭력 그리고 최근에는 인간과 자연의 관계를 주제로 하는 작업을 해오고 있다. ‹사랑의 잠재력›(2018) Fig.37 은 거대한 크기의 LED 구조물을 포함한 무빙 이미지와 조각이

결합된 하이브리드 작품이다. 세 개의 섹션이 각기 다른 관점과 접근방식으로 구성된 이 작품은 인간 이외의 생물들에 대한 애정과 공감의 잠재력을 다룬다. 이것은 다양한 감정들이 살아있는 생물과 인간 간의 위계 구조를 해체함으로써 생명종에 대한 공감과 연민을 불러낸다.

90년대 초부터 프랑스를 근거지로 30여 년간 활동했던 이배는 다양한 숯을 이용하여 조각, 설치, 그리고 회화 작품을 제작해 왔다. 숯은 오랫동안 우리 생활에 에너지원으로 사용되었다. 전통적으로 숯은 정화, 영원, 청결 등을 상징한다. 작가는 멀리 타국에서 이 같은 다층적 의미를 가진 전통적인 재료를 통해 자신의 정신적 원천을 찾았고 나무가 타고 남은 가장 본질적 천연소재에 존재감을 부여했다. 죽음에서 삶으로, 소멸에서 생성으로의 순환을 상징하는 이배의 ‹불로부터›(2021) Fig.38 는 이번 전시에서 하얀 한지가 깔린 바닥 위에 커다란 숯 조각이 놓이고, 매달린 공간으로 초대한다. 그곳에서 우리는 오직 나무의 정수로 남겨진 ‘숯의 숲’을 소요하며 여전히 깊게 드리워진 팬데믹의 그늘을 벗어나 이후의 삶을 위한 회복과 치유의 시간을 갖게 될 것이다.

16세기까지 인간은 자연의 위협과 재앙이라는 억압 속에서 삶을 이어갔다. 그러나 17세기 이후 사람들은 기후, 풍토, 식생, 지형의 특성에 적응할 수 있도록 삶의 방식을 만들어 나갔고 자연은 과학과 기술을 통해 인간이 이용할 수 있는 대상으로 위치가 변경되었다. [18] 현대로 진입한 인류사에서 인수 공통 감염병의 잦은 출현과 급변하는 생태환경의 변화는 ‘인간과 자연은 물론 인간들 사이의 다양한 관계 역시 재조직되어야 한다는 것을 받아들일 때에 이르렀음’ [19] 을 깨닫게 한다. 일상이 멈춰버린 지금의 막간에서 우리는 인간과 그 외의 생물종과 공생하기 위한 관계의 설정을 다시 하고 포스트 코로나 시대를 위한 인식체계의 유연한 전환이

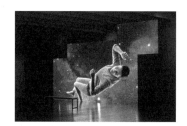

Fig.37 에이샤-리사 아틸라, ‹사랑의 잠재력›
Eija-Liisa Ahtila, *POTENTIALITY FOR LOVE*
2018.

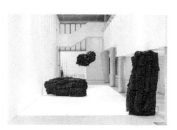

Fig.38 이배, ‹불로부터›
Lee Bae, *Issu du feu*
2021.

and media such as performance, installation, sculpture, and public art. "Nature is forever returning to the start in a circle," she has said. "I fundamentally believe that human beings, animals, and plants are no different from one another. All of them share a common trait in that they exist on this earth for a short time before traveling on, and all of them fear violence and death. Happenstance and necessity always coexist in nature." [13] Reflecting this belief, she expresses senses of awe and sympathy, assigning equal value to human beings and other forms of life. Her views on nature and life are represented through primitive and simplified figures that possess hermaphroditic qualities or blur the boundaries of human and nature, as seen in her works *Blatt Boat Fahret* (1987) [Fig.30] and *Meine Flügel sind meine Last* (1989) [Fig.31]. With these poetic and symbolic entities, which could potentially be tree leaves, fish, or birds, [14] the artist awakens us to the value of an aesthetic of simplicity and artistic imagination amid a complex, catastrophe-marred modern civilization.

Apocalypto [15] *Now* (2009) [Fig.32] by Jonathan Horowitz was created by editing together a documentary on the history of Hollywood disaster films and scenes taken from other film sources. With a narrative combining parallel threads about climate change and terrorism with depictions of the apocalypse from the Bible and scenes from the making of Australian-American actor/director Mel Gibson's film The *Passion of the Christ*, this video work blurs the boundaries between reality and fiction so that catastrophe and the destruction of the world come across not only as an enormous threat but also as an ironic form of fantasy. The word "apocalypto" in the title evokes

the idea of the apocalypse, or the end of the world. US theorist Warren Montag has used the term apocalypse to describe the different events caused around the world by the COVID-19 pandemic; it can be related not to the world's destruction per se, but to the sense of latent phenomena that existed in the past and are now manifesting with massive consequences after the eruption of some unexpected development. [16]

Influenza (2004) [Fig.33], a short film by preeminent Korean film director BONG Joon-ho, was produced the same year that the 5th JEONJU International Film Festival was held. While its dictionary definition is a viral illness, the word "influenza" is also used to denote an ideological or economic trend. This work metaphorically represents the senseless spread of violence during a protracted recession and how the lives of vulnerable members of society are ruined. The fact that the film takes the form of closed-circuit television (CCTV) video only amplifies the film's sense of absurdity and cruelty, as they force us to confront a harsh and apathetic reality through a cold gaze. Rather than approaching the topic of a pandemic or virus as such, the work shows a different form of infection that spreads, metaphorically, like influenza through the vulnerable structures of society.

Jaguar's Vision (2021) [Fig.34] and *Black Snow* (2019) [Fig.35] by Young Joo Lee are both series of video works that focus on global crises. Over the course of both series, Lee's short animated works draw upon the language used to share historical facts as they make deliberate use of the realistic yet artificial representation methods of a natural history museum. *Jaguar's Vision* poses questions about the ways in which humanity lives as it uses the symbol of the jaguar—regarded at certain

이루어져야 한다. 코로나19는 여전히 진행 중인 팬데믹이다. 우리는 이 재난 앞에서 많은 생명을 잃었고 이들을 애도할 시간도 없이 '전염의 시대'라는 긴 터널을 통과하고 있다. 이 전 지구적 재난 앞에서 예술이라는 언어로 치환된 의미들이 위안과 회복의 메시지가 되어 깊고, 고요하게 전해지길 바란다.

(1) 이영석, 『잠시_멈춘 세계 앞에서』, 푸른역사, 2020, 152쪽에서 저자는 "근대 과학이 여기 저기 흩어진 영토의 결합을 공고하게 만든다. 이제 원거리는 증기력과 전신과 전기로 상쇄된다. '거리의 소멸 abolition of distance'이 가시화된 것이다."라고 언급하였다.

(2) 김창엽, 「'사회적인 것'으로서 코로나: 과학과 정치 사이에서」, 김수련 외, 『포스트 코로나 사회, 팬데믹의 경험과 달라진 세계』, (주)글항아리, 2020, 109쪽.

(3) 신디케이트: 코로나 에디션(Syndicate: COVID-19 Ed.) 전시장 벽면 소개글 인용.

(4) 신디케이트 작가 노트 중 마지막 부분 인용.

(5) 오하나, 「돌봄—인류 살리기로서의 돌봄에 대한 상상」, 공성식 외 공저, 추지현 엮음, 『마스크가 말해주는 것들—코로나19와 일상의 사회학』, 돌베개, 2020, 136쪽.

(6) 장진범, 「민주주의—민주주의자로서 비상사태를 상대하기」, 공성식 외 공저, 추지현 엮음, 앞의 책, 241쪽. 장진범은 "코로나19는 이 사태 이전에도 늘 존재했지만 이런저런 이유로 '밀실'에 은폐되어 있던'(closed) 우리 사회의 이면들을 더 이상 회피할 수 없도록 가시화하는 일종의 시약(試藥) 노릇을 한다."라고 기술하였다.

(7) 파올로 조르다노, 『전염의 시대를 생각한다.』, 김희정 옮김, 은행나무, 2020, 12쪽.

(8) 파올로 조르다노, 위의 책, 13쪽.

(9) 서도호 작가 노트 참조.

(10) 파올로 조르다노, 앞의 책, 10쪽.

(11) 이영석, 앞의 책, 197쪽.

(12) 이영석, 「대유행병, 역사는 되풀이되는가」, 앞의 책, 89쪽.

(13) 노은님, 「SPECIAL ARTIST 노은님」, 『아트인컬처』, 2017년 12월 호, 91쪽.

(14) Eun Nim Ro, *Blatt Werke*, Katalog zur Ausstellung im Kunstverein Oldenburg und im Übersee-Museum Bremen (Hannover: Verlag Heinz Thiel, 1988), 11.

(15) 아포칼립토(Apocalypto)는 그리스어로 '새로운 출발, 시작'을 의미하며 2006년 미국의 배우이자 영화감독인 멜 깁슨의 영화 제목이기도 하다.

(16) 공성식 외 공저, 추지현 엮음, 앞의 책, 241쪽 참조.

(17) 신상규 외, 『포스트휴먼이 몰려온다』, 아카넷, 2020, 22쪽. 신상규는 "포스트휴먼 담론은, […] 우리가 전통적인 인간과의 관계뿐 아니라 지금까지 온전하게 인정받지 못했거나 혹은 새롭게 출현할 인간/비인간 주체들과 구체적으로 어떻게 관계를 맺을 것인가를 상상하는 문제이기도 하다."라고 기술하였다.

(18) 이영석, 앞의 책, 143쪽.

(19) 추지현, 「비대면—시공간에 대한 상이한 감각」, 공성식 외 공저, 추지현 엮음, 앞의 책, 38쪽.

points in history when human beings lived as part of nature as a sacred being (jaguars are venerated as godlike creatures in parts of South America)—to show the ways in which we have harmed nature due to our desires. It represents the relationship of control and subordination that has unfolded as humans have cemented their role as dominators of nature, as well as resulting conflicts within human populations.

In her new work *Black Sun X : Casper, Witch, and Handstanderus* (2021) ^{Fig.36}, Ji Hye Yeom traces the trajectory of catastrophes from their nascence to the present as she weaves together fragments of seemingly unrelated narratives under the "Black Sun" title, combining a comic book film character who has received widespread attention in popular culture, the witch hunts that occurred during the transition period between feudalism and capitalism in the wake of the Black Death, and the "Handstanders," a group of people who find new ways of thinking through plants. The work speaks to how, at a time when the pandemic continues unabated and life itself has become a disaster of sorts, this catastrophe has forced us to realize the necessity of living with different forms of disaster rather than simply overcoming immediate problems and how we need to consider ways of coexisting with non-human life. This sort of post-human discourse is a matter of contemplating and imagining relationships with non-human life-forms that have not found their way into the scope of our perception (as well as with other actors that may emerge in the future). This involves imagining co-evolution as involving humans and other species rather than simply being a techno-futuristic development made possible by advancements in innovation. [17]

Eija-Liisa Ahtila uses moving images and multi-channel installation to create work that focuses on gender, sexuality, colonialism, and violence—and, most recently, on the relationship between humans and nature. *POTENTIALITY FOR LOVE* ^{Fig.37} is a hybrid work of moving image and sculpture that uses an enormous LED structure. With three sections taking different perspectives and approaches, the work focuses on the human potential for affection toward and communion with non-human life. It inspires sympathy and compassion toward all living species as it deconstructs a hierarchical structure between humans and organisms that harbors a wide range of emotions.

Lee Bae, who has been based in France since the early 1990s, uses different forms of charcoal to produce works of sculpture, installation, and painting. For a long time, charcoal was used as a mundane object, a source of energy. Traditionally, it has symbolized purification, eternity, and cleanliness; people would even grind it up and drink it to treat their ailments. Living far away from his Korean homeland, Lee found spiritual wellspring within this traditional material and its multilayered meanings, instilling a sense of presence in this natural material produced as the aftereffect of burning wood. Symbolizing the cycle from death to life and from extinction to creation, his work *Issu du feu* (2021) ^{Fig.38} invites this exhibition's viewers into a setting where large pieces of charcoal have been set down or suspended over white sheets of Korean *hanji* paper laid out on the ground. Wandering through this "charcoal forest" made up of remnants of the very essence of wood, we gain an opportunity for recovery and healing—something that will serve us in the future, when we have finally moved beyond the

pandemic's unending shadow.

Until the 16th century, human life was susceptible to the threat of nature and the oppression of catastrophe. But in the 17th century, people began develop ways of life that allowed them to adapt to their environment's climate, natural features, vegetation, and topographic characteristics; nature was assigned a new role as something that humans could exploit through science and technology. [18] As humankind entered the modern era, the frequent occurrence of zoonotic contagion and rapid changes in the environment forced us to realize that we had "arrived at a moment where we must recognize the need for the reorganization of different relations, not only between humans and nature but also among human beings." [19] In this present "pausing" of "normal life," we sense the need to reorient our relationships so that human beings can coexist with other species, as well as the need for a flexible shift in our knowledge systems toward a post-COVID-19 era. The COVID-19 pandemic is still unfolding at this moment. We have lost many lives to this catastrophe, and we find ourselves passing through the long tunnel of the "era of contagion" without any time to grieve their loss. Hopefully, in this global catastrophe, we can draw on the power of art to remember today and profoundly and serenely share a message of recovery and respite for our ravaged minds.

(1) Lee Young Suk, *Briefly_Before a World That Has Stopped* (Seoul: Pureun Yeoksa, 2020). On p. 152, Lee writes, "Modern science has solidified the combining of scattered territories. Today, distances are offset by steam power, telegraphy, and electricity. The 'abolition of distance' has been rendered visible."

(2) Kim Chang Yup, "COVID-19 as the "Social': Between Science and Politics," in Kim Suryeon et al., *Post-COVID Society: The Pandemic Experience and a Changed World* (Paju: Geulhangari, 2020), 109.

(3) From the wall text of *Syndicate: COVID-19 Ed.*.

(4) From the last section of Syndicate's "Artist Notes."

(5) Oh Hana, "Caregiving: Imagining Caregiving as Saving Humanity" in Gong Seongsik et al., *The Things That the Mask Tells Us: COVID-19 and Everyday Sociology*, ed. Chu Jihyeon (Paju: Dolbegae, 2020), 136.

(6) Jang Jin-bum, "Democracy: Approaching the State of Emergency as Democrats" in Gong Seongsik et al., op. cit., 241. Jang Jin-bum writes, "COVID-19 has functioned as a kind of reagent visualizing the undersides of our society—things that always existed before this situation but remained shut away in back rooms for various reasons—in such a way that we can no longer sidestep them."

(7) Paolo Giordano, *How Contagion Works: Science, Awareness and Community in Times of Global Crises*, trans. Alex Valente, (London:Wiedenfeld & Nicolson, 2020).

(8) Paolo Giordano, ibid.

(9) From "Artist Notes."

(10) Paolo Giordano, op. cit.

(11) Lee Young Suk, op. cit., 197.

(12) Lee Young Suk, "New Contagious Diseases: Is History Repeating Itself?," op. cit., 89.

(13) Eun Nim Ro, "SPECIAL ARTIST Eun Nim Ro," *Art in Culture*, December 2017, 91.

(14) Eun Nim Ro, *Blatt Werke*, Katalog zur Ausstellung im Kunstverein Oldenburg und im Übersee-Museum Bremen (Hannover: Verlag Heinz Thiel, 1988), 11.

(15) Meaning a "new beginning" in Greek, Apocalypto was also the title of a 2006 film by Australian-American actor/director Mel Gibson.

(16) Gong Seongsik et al., op. cit., 241.

(17) Shin Sanggyu et al., *Post-Humanity Is Coming On* (Seoul: Acanet, 2020), 22. Shin writes, "Post-human discourse [. . .] is a matter of imagining not simply our traditional relationships with [other] humans, but also how we can concretely form relationships with human/non-human actors who have not been fully recognized to date, or who will newly emerge in the future."

(18) Lee Young Suk, op. cit., 143

(19) Chu Jihyeon, "Untact: Different Sense of Time and Space" in Gong Seongsik et al., op. cit., 38.

신디케이트: 코로나 에디션
Syndicate: COVID-19 Ed.

신디케이트는 아젠다별로 결성되는 프로젝트팀이다.
서사가 사라지고 파편화된 세계의 숨겨진 연결고리를 찾아 시각화한다.
코로나 에디션은 2020년 3월 코로나로 인해 오류를 일으키기 시작한
세계의 이미지를 수집하기 위해 조직되었다.

신디케이트 구성원
GUM Unknown Zéro 브롤 라나놀자 라인 No.20 이동건
웃는남자 코리 하루 / 기훈센 양영
드론: 박민석

Formed according to different agendas, Syndicate is a project
group dedicated to finding and visualizing hidden links in
today's fragmented world from which narrative has disappeared.
COVID-19 Ed. of the group was established to collect images
of the malfunctioning world since the outbreak of COVID-19
in March 2020.

어두웠지만 밝게 빛나는
Dark, yet shining

2019. 1. 제주

2018. 11. 제주

2001. 7. 중국 상공
사진: NASA
2001년 7월 NASA Terra위성에 포착된 중국 위에 형성된 거대한
황사폭풍

2019. 9. 인도네시아 보르네오 상공
사진: NASA
2019년 9월 보르네오에서 발생한 화재.
벌목 쓰레기를 태우다 발생한 것으로 보고 있다.

1

오래 전 자연은 두렵고 경이로운 대상이었지만, 과학의 발전과 함께 자연은 '정복'과 '극복'의 대상이 되었다.
비약적으로 증가한 인간수명과 인구수로 더 많은 식량과 더 많은 살 곳이 필요해졌다.

육식을 하는 인류에게, 면적 대비 효율이 높은 공장식 축산은 필연이었다.

밀집된 환경 안에서 면역체계가 약한 가축 동물에게 바이러스가 확산되고 있다.

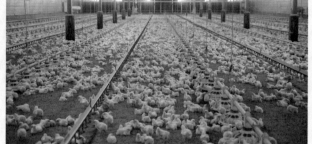

2021. 3. 경상북도 상주 [영상]

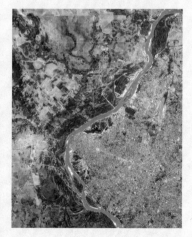

(위) 2017. 10. 파라과이 상공
(아래) 2020. 10. 파라과이 상공
사진: NASA
파라과이 수도 아순시온을 지나는 파라과이강의
2017년 10월과 2020년 10월.
2019년부터 1년 간 파괴된 아마존 열대우림만
축구장 1백 2십만 개의 넓이에 육박한다.

"인간들이 재난을 피해 이주하듯 동물뿐 아니라
바이러스까지 재난을 피해 탈출해요. 서식지가
파괴되면서 인간 곁으로 왔고 바이러스는 동물의 몸에
올라와서 이동했죠"
– 반다나 시바(Vandana Shiva)

2015. 9. 한강

2017. 8. 남양주

2013. 2. 제주

2

2021년 5월 21일은 한국에 코로나19 첫 확진자가 발생한 후 488일이 되는 날이다.

2020. 3. 인천국제공항
사진: 국토지리정보원

2020. 3. 인천국제공항
사진: 국토지리정보원

2020. 3. 11. 대구

2021. 4. 안양역 주변 [영상]

2021. 4. 서울 강남

새로운 바이러스는 예상보다 강력했다. 국경이 봉쇄되고, 도시 간 이동에 제한이 걸렸다. 촘촘히 연결되어 끊임없이 움직이던 이 세계는 고립된 섬들로 바뀌었다.
'새로운 일상(New Normal)'의 시작이었다.

2020. 6. 인천국제공항 제1터미널 [영상]

2020. 4. 여의도

2020. 9. 6. 서울 광화문

2020. 3. 23. 하나은행 딜링룸

2020. 6. 3. 서울중앙고등학교

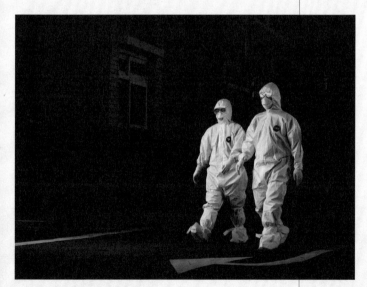

2020. 3. 11. 대구 동산병원

2020. 7. 23. 인천국제공항

2021. 3. 22. 서울구로역

3

비대면은 온라인 주문을 폭발시켰다.
반면 자영업은 큰 피해를 봤다.
스마트폰만 있으면 일을 할 수 있는 시절이 왔다.
누구인지는 중요하지 않다. 지속적이고 안정적인
노동력이 중요할 뿐.

2021. 3. 서울 구로역

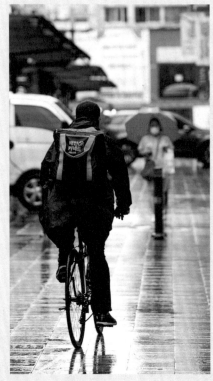

2020. 9. 서울 종로

2021. 2. 서울 송파 물류단지

2021. 3. 이천 물류센터

2020. 4. 충북 진천 물류센터

2021. 3. 서울 명동 [영상]

AI의 팔다리가 된 AI #3

AI의 팔다리가 된 AI #2

AI의 팔다리가 된 AI #1

4

이른바 4차 산업혁명은 코로나 시절 위기의 인류를 구원할 듯 다가온다. 혁명을 통해 낡은 세계는 사라지고 새로운 세계는 태어난다.

2020. 데이터센터
사진: 네이버 클라우드

2021. 1. 서울 황학동

2021. 2. 서울 여의도

2020. 7. 정부서울청사

대체되는 신체 #1
영상제공 : 현대차, Boston Dynamics

대체되는 신체 #2
영상제공 : StradVision

2021. 2. 서울 여의도

5

서울의 25평 아파트를 사기 위해서는, 한 푼도 안 쓰고 36년이
걸린다. 30%를 저축하면 118년이 걸린다.
(평균 임금 3,360만 원 기준, 경제정의실천시민연합 2021. 1.)

2021. 4. 서울 잠실

공짜 점심은 없다. 당신의 편리함은 언제나
'무엇'과 교환되고 있다. 그 무엇은 누군가의
노동력일 수도 있고, 누군가의 이익일 수도 있다.
이제 정보는 돈이다.

2020. 4. 서울 개포 재건축부지

2020년 3월 전 세계 증시는 폭락했다.
1년 후 역사상 최고점을 갈아치웠다. 코인, 영끌, 빚투,
동학개미가 매일 기사 제목을 장식했다.

올해 3월 11일 미국 뉴욕증권거래소에 상장한 쿠팡의 첫날
시총은 100조원을 돌파했다.

2021. 4. 서울 반포

2021. 3. 하나은행 딜링룸

2020. 8. 서울 종로 금거래소

위기는 기회와 함께 오지만,
기회를 잡을 기회는 평등하지 않다.

2021. 3. 서울 강남 [영상]

2021. 4. 서울 잠실

2021. 4. 서울 압구정동

2021. 4. 서울 여의도

2021. 3. 서울 종로구

2021. 3. 서울 성북구

2021. 3. 서울 성북구

2021. 3. 서울 종로구

2021. 3. 서울 종로구

1996년생이에요. 대학교에서 연극을 전공하고
배우로 활동했어요. 작년 11월부터 ‹창작집단 우리
집›을 만들어 활동하고 있어요. 코로나19 이후로
공연이 무산되길 반복했죠. 공연이 더 어려워진
요즘은 아르바이트를 구하는 것도 어려워졌죠.
최근에 구한 아르바이트는 동대문에서 포장하는
일이에요. 올해 1월 첫째 주 이후로 일을 구할 수가
없었어요. 생활비를 보태주던 엄마도 코로나19가
심할 때 해고가 되었죠. 수입이 없는 2–3개월은
많이 힘들었어요.

이소윤

배우, 구직자

2021. 3. 서울 종로구

2021. 3. 서울 종로구

2018년부터 몸이 안 좋았어요. 내 상태를 본 의사가
검사하기 전부터 이건 암이라고 말하더라고요.
암 말기라고 했어요. 생계를 꾸려야 하는 상황이라
일을 구해야 했어요. 겨우 파견직으로 아르바이트
일을 구해서 하고 있는 데 8월경 확진자가 많이
나올 때였어요. 원청이 아니라 파견회사에서 전화가
왔더라고요. 회사에 오는 녹즙 배달 하는 사람이
확진자였는데, 같이 엘리베이터를 탔었거든요.
원청에선 기다리라 해놓곤 연락이 없었어요. 이후에
출근해서 사무실을 이동하면서 일했는데 부장 같은
사람이 "당신 뭐 하는 사람이냐"라고 호통을 쳤어요.
나를 마치 바이러스 취급해서 굉장히 난처했죠.

정지혜

기획자, 아픈몸 당사자

2021. 3. 서울 김포공항

1986년생. 13년 차 항공 승무원입니다. 코로나19가
터지고 비행 스케줄이 취소되기 시작했어요. 회사
운영이 어렵다고 3월부터 남은 휴가를 쓰라는
이야기가 나왔죠. 작년 5월 휴업 시작 이후 9월
한 달 비행했고, 올해는 3월 한 달 근무했어요.
제가 다니는 곳은 기본급이 낮아서 승무원들이 비행을
많이 할수록 월급을 많이 받는 구조예요. 휴업이
시작됐을 때 수면 위로 드러났죠. 다른 일을 새로
시작하려고 해도 이 업무는 경력 인정이 잘
안 돼요. 정부지원금이 끊기면 무급휴업을 하게 된다는
소문이 돌고 있어 불안합니다.

정지은

항공 승무원

2021. 3. 김포공항 국제선터미널

2021. 3. 경기도 안산

1999년생입니다. 일본에서 유학 중 코로나19가
터지고 학교에 가지 못하는 상황이었어요. 일본
대학은 휴학 유지금을 내야 했어요. 돈을 내고
계속 있을 수 없어서 중퇴하고 작년 5월 한국으로
들어왔어요. 이제 대학 진학보다 는 일단 취업이
우선이에요. 입사 지원 때 '코로나 때문에 일본
유학 도중에 귀국했다. 현재는 어쩔 수 없는 고졸
이다.'라고 설명해도 잘 안됐어요. 잠깐 계약직으로
취업했을 때는 근로계약서 작성조차 안 했어요.

전여진

일본 유학 중 귀국, 청년 구직활동지원금 대상자

2021. 3. 서울 영등포구

2021. 3. 서울 마포구

2021. 3. 서울 마포구

1988년생이고 2014년부터 천안 외곽에 있는
어린이집에서 일하고 있습니다. 코로나19 이후에도
출근은 계속하지만, 휴게시간 없이 근무하고
있어요. 코로나19로 어린이집에 아이들이 조금씩
줄어들면서 저도 잘리는 거 아닌가 하는 불안함이
있어요. 저희가 바이러스 전파자 취급받는 경험도
하죠. 정말 심할 때에는 주말에도 집에만 있었어요.
나 때문에 아이들이 한 명이라도 걸린다고 상상하면
정말 끔찍하더라고요. 신상도 다 털리겠죠. 차라리
내가 아이들로부터 걸리면 욕은 덜 먹겠구나
싶었어요.

김요인
보육교사

1992년생이고 2016년 11월부터 방송작가 일을
시작했어요. 사실상 프리랜서 작가들은 프로그램이
없어지면 잘리는 거고, 퇴직금이 없으니까 일하면서
퇴사를 준비해야 했어요. 실업급여나 4대 보험은
저에게 다 먼 이야기예요. 작가들은 대부분
여성이에요. 배경이 된게 1980–90년대에는 방송사
공채 시험을 봐도 남자 위주로 채용을 해버려서
방송일을 하기가 어려웠으니까 여성들을 데려와서
보조작가로 많이 일을 시켰대요.

김채율
프리랜서 방송작가

2

국내 긱경제(Geek economy)를 주도하는 C사는
3월 2일 라이더들의 건당 수수료를 3,100원에서 2,500원으로
일괄 인하한다. 단가가 시간별로 바뀌는 플랫폼노동의 특성상,
일할 사람이 넘치는 시기에 회사가 취한 일방적 조치다. 낮아진
수수료만큼 수입을 메꾸기 위해 라이더들은 더 많이 더 빨리
달려야 한다.

택배 노조에 따르면 2020년에만 16명의 택배 노동자가 과로로
사망했다.

2020. 8. 서울 노원구
사진: 시사인

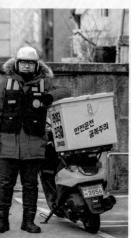

택배가, 오토바이가 아니라
여기 사람이 있다.

2020. 1. 서울 마포구
사진: 시사인

2021. 3. 1. 경기도

2021. 3. 경기도

3

"코로나19 검사 받으란 연락을 받지 못했어요.",
"사장님이 공장 밖으로 나가지 말래요."

올해 초 외국인 노동자 집단감염이 터지자 그때서야 각
지자체는 외국인 대상 코로나19 검사를 의무화하는
행정명령을 내렸다. 국내 발생 1년만이다.

2021. 3. 경기도

2020년 12월 20일 캄보디아 출신 여성 외국인 노동자
속헹 씨가 경기 포천의 한 농가 비닐하우스에서 사망했다.
한파경보가 있었던 날이다. 사망 이틀 전, 숙소에 전력 공급이
끊겼다는 증언이 나왔다.

2021. 3. 경기도

2021. 3. 경기도

90년대 한국은 자국인 노동자들이 3D 업종을 기피하자
외국인 노동자를 받아들이기 시작했다.

2021. 3. 경기도

2021. 3. 경기도

2021. 3. 경기도

2021. 3. 경기도

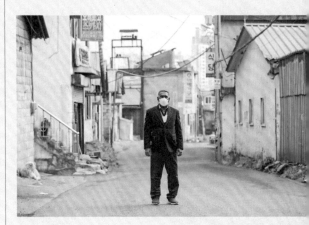

2021. 3. 경기도

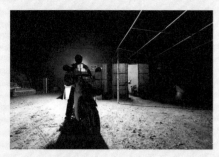

2021. 3. 경기도

2021. 3. 경기도

한국인이 안하는 일을 대신할 사람들,
그들은 처음부터 노동력으로만 가치를 인정받았다.
사람은 거기에 없었다.

2021. 3. 경기도

2021. 3. 경기도

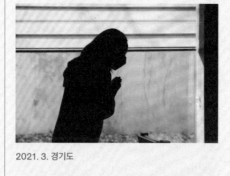

2021. 3. 경기도

2021. 3. 경기도

2021. 3. 경기도

신디케이트: 코로나 에디션의 작품은 국립현대미술관
지원으로 제작되었습니다.
Syndicate: COVID-19 Ed. works were
commissioned by MMCA, Korea.

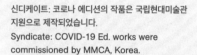

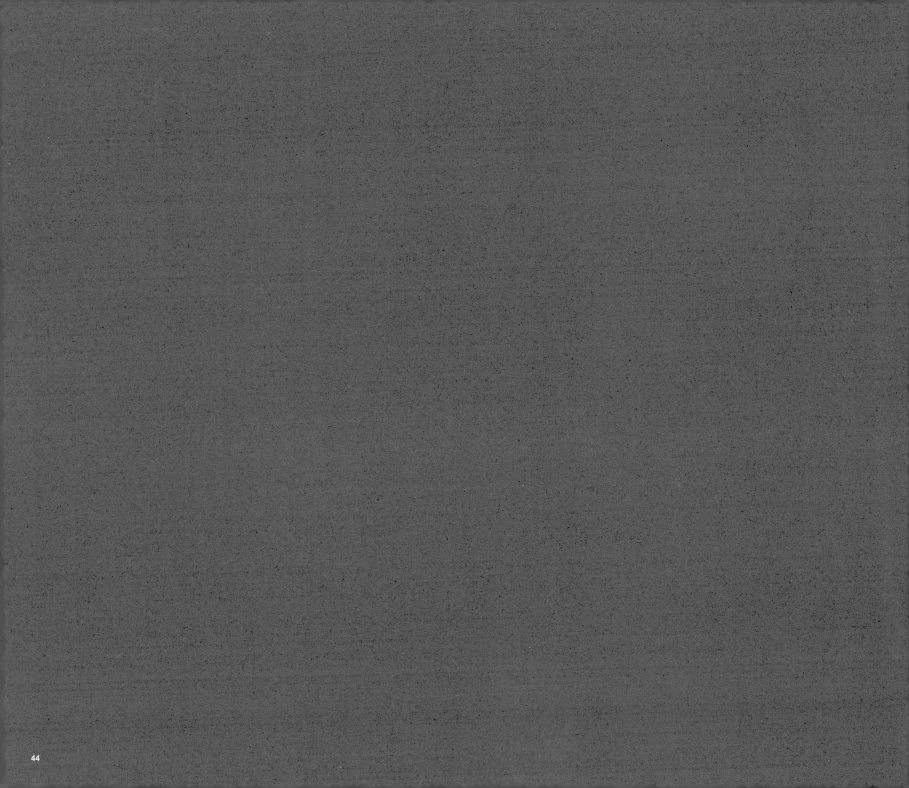

징후와 증상

요제프 보이스
이진주
아니카 이
전인경
김지아나
성능경
박영균
오원배

Signs and Symptoms

Joseph Beuys
Lee Jinju
Anicka Yi
JEON, IN-KYUNG
Jiana Kim
Sung Neung Kyung
Park Young Gyun
Oh Wonbae

‹곤경의 일부›
1985, 펠트, 147×330×41cm.
삼성미술관 Leeum 소장.

요제프 보이스
Joseph Beuys

Plight Element
1985, Seven felt rolls filled with loose felt padding,
147×330×41cm.
Leeum, Samsung Museum of Art Collection.
© Joseph Beuys / BILD-KUNST, Bonn – SACK, Seoul, 2021.

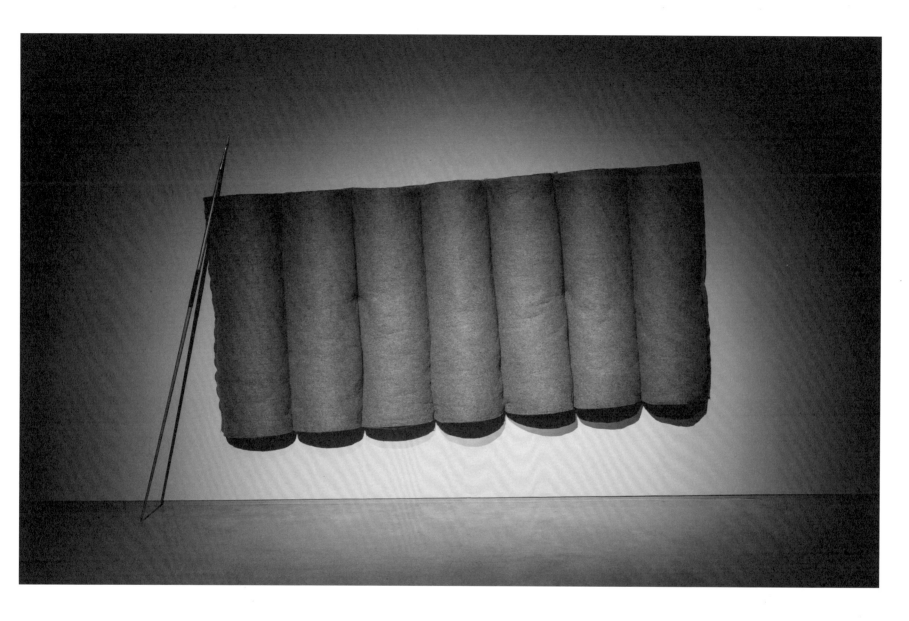

‹사각 死角›
2020, 광목에 채색, 아크릴릭,
122×488cm, 122×488cm, 122×244cm, 122×220cm.
아라리오뮤지엄 소장.
ⓒ 이진주. 작가 및 아라리오갤러리 제공.

The Unperceived
2020, Powdered pigment, animal skin glue, water and acrylic
on unbleached cotton,
122×488cm, 122×488cm, 122×244cm, 122×220cm.
Arario Museum Collection.
ⓒ Lee Jinju. Courtesy of the Artist and Arario Gallery.

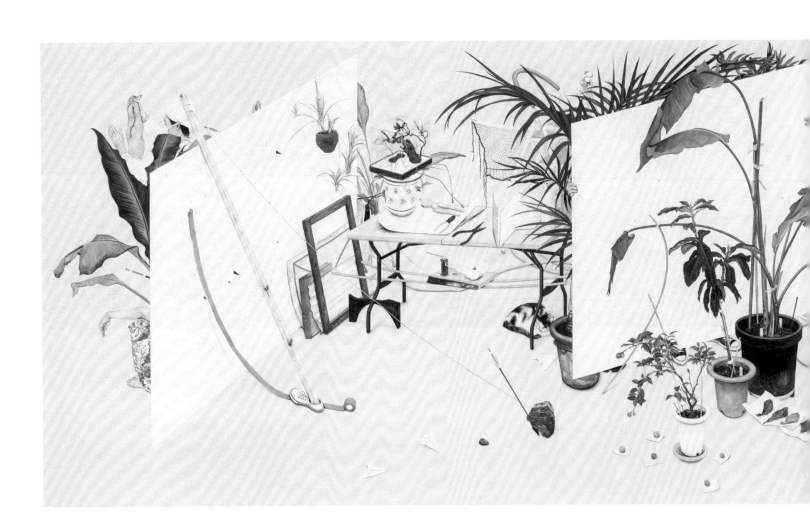

‹사각 死角›
The Unperceived
(Part a)

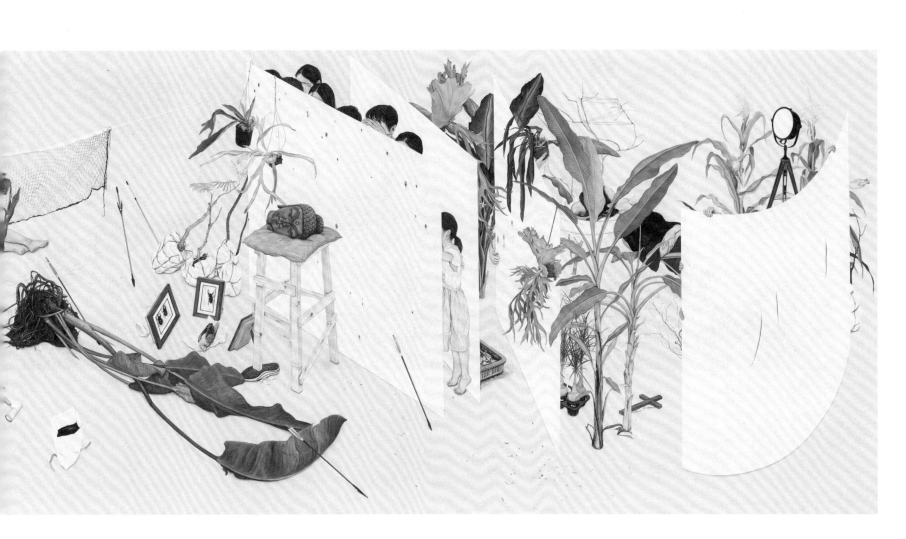

‹사각 死角›
The Unperceived
(Part b)

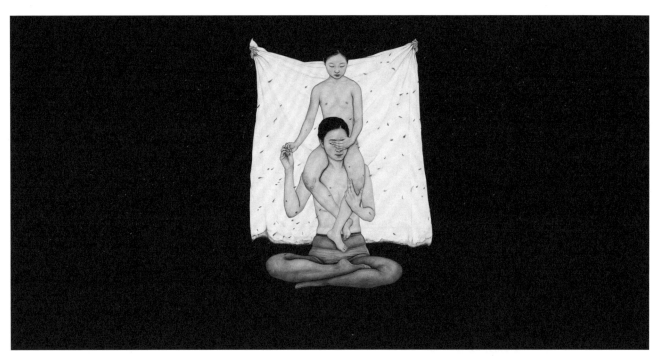

‹사각 死角›
The Unperceived
(Part c)

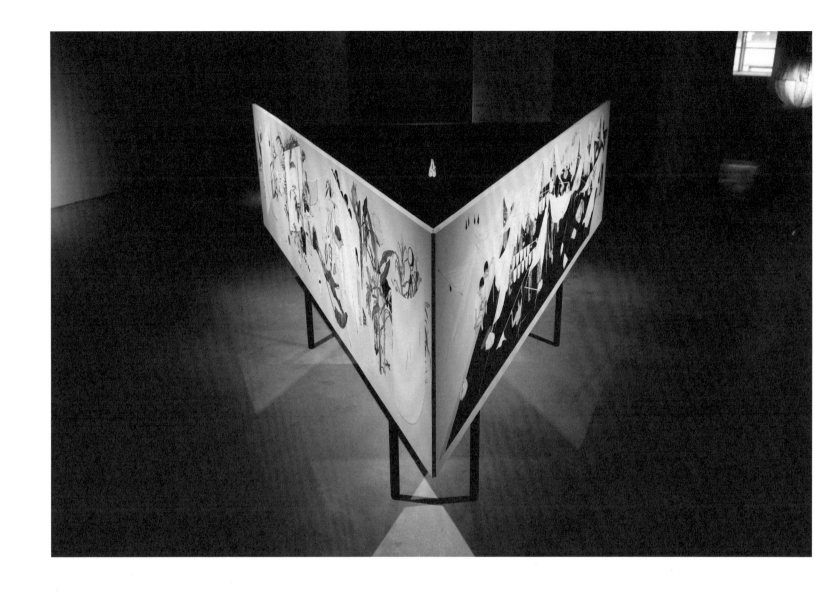

‹사각 死角› 설치 전경　　Installation View of *The Unperceived*

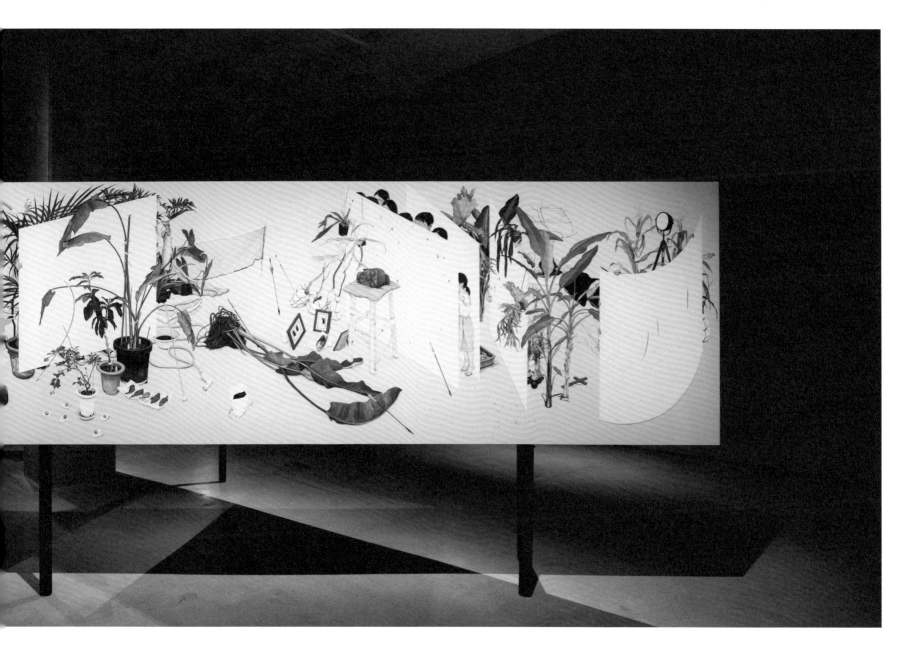

‹깊은 (3면화)›
2014, 광목에 채색, 17×20.5×18.5cm.
© 이진주. 작가 제공.

Deepen (Triptych)
2014, Powdered pigment, animal skin glue and water on
unbleached cotton, 17×20.5×18.5cm.
© Lee Jinju. Courtesy of the Artist.

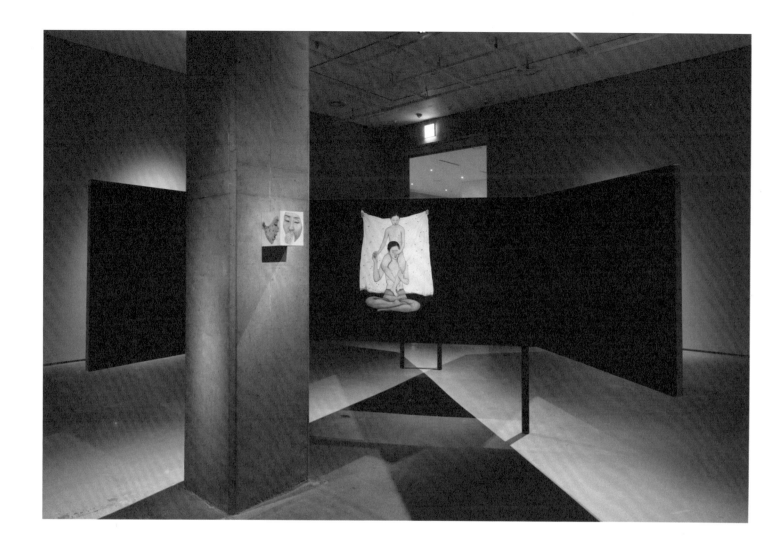

징후와 증상　　　　　　　　〈사각 死角〉과 〈깊은 (3면화)〉 설치 전경　　　　　　　　Installation View of *The Unperceived* and *Deepen (Triptych)*

‹다형성 데이터 구조›
2020, 고밀도 폼, 수지, 우레탄 페인트, 동일 색상의 프레임,
125.7×186.7×12.7cm.
© 아니카 이. 작가 및 글래드스톤 갤러리 뉴욕/브뤼셀 제공.

아니카 이
Anicka Yi

Polymorphic Data Structure
2020, High density foam, resin, urethane paint, and color
matched frame, 125.7×186.7×12.7cm.
© Anicka Yi. Courtesy of the Artist and Gladstone Gallery,
New York and Brussels.

‹인간으로부터의 인간 해방›
2019, 해초, 아쿠아졸, 글리세린, 크레이펠린, 아크릴릭, LED,
애니매트로닉 곤충, 71.1×71.1×71.1cm.
ⓒ 아니카 이. 작가 및 글래드스톤 갤러리 뉴욕/브뤼셀 제공.

Releasing the Human from the Human
2019, Kelp, aquazol, glycerin, crepaline, acrylic, LED, and
animatronic insect, 71.1×71.1×71.1cm.
ⓒ Anicka Yi. Courtesy of the Artist and Gladstone Gallery,
New York and Brussels.

‹인간으로부터의 인간 해방›
2020, 해초, 아쿠아졸, 글리세린, 크레이펠린, 아크릴릭, LED,
애니매트로닉 곤충, 55.9×55.9×55.9cm.
© 아니카 이. 작가 및 글래드스톤 갤러리 뉴욕/브뤼셀 제공.

Releasing the Human from the Human
2020, Kelp, aquazol, glycerin, crepaline, acrylic, LED, and
animatronic insect, 55.9×55.9×55.9cm.
© Anicka Yi. Courtesy of the Artist and Gladstone Gallery,
New York and Brussels.

‹인간으로부터의 인간 해방› 설치 전경
Installation View of *Releasing the Human from the Human*

‹바이러스의 시간과 공간›
2021, 캔버스에 아크릴릭, 150×150cm(3).
작가 소장. 국립현대미술관 지원으로 제작.

전인경
JEON, IN-KYUNG

Time and Space of the Virus
2021, Acrylic on canvas, 150×150cm(3).
Courtesy of the Artist. Commissioned by MMCA, Korea.

‹COVIDUS–기울어진 계단›
2021, 포슬린, 안료, 혼합재료, 가변크기.
작가 소장. 국립현대미술관 지원으로 제작.

김지아나
Jiana Kim

COVIDUS–Tilted Stairs
2021, Porcelain, stain, mixed media, Dimensions variable.
Courtesy of the Artist. Commissioned by MMCA, Korea.

‹COVIDUS-일그러진 지구›
2021, 포슬린, 안료, 혼합재료, 3,000×6,800×4,000cm.
작가 소장. 국립현대미술관 지원으로 제작.

COVIDUS-Distorted Earth
2021, Porcelain, pigment, Mixed media, 3,000×6,800×4,000cm.
Courtesy of the Artist. Commissioned by MMCA, Korea.

⟨손 씻기⟩
2021, 종이에 아카이벌 피그먼트 프린트, 70×50cm(20).
작가 소장. 국립현대미술관 지원으로 제작.

성능경
Sung Neung Kyung

Handwashing
2021, Archival pigment print on paper, 70×50cm(20).
Courtesy of the Artist. Commissioned by MMCA, Korea.

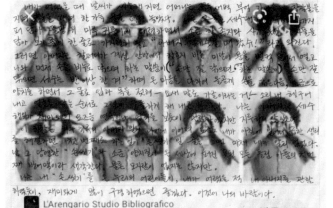

L'Arengario Studio Bibliografico

방문

Klaus Rinke. Zeit/Time - Raum/Space - Körper/Body - Handlungen ...

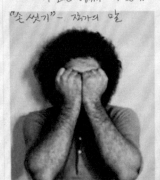

Klaus Rinke | Biography | Thomas ...
thomasbrambilla.com

Klaus Rinke | Beckie Stock

내가 어렸을 때 날씨가 싸늘해지면 어머니는 꼭두새벽 부엌 가마솥에 장작불을 지펴 군불을 때며 한가득 물을 데워 놓았다. 나는 그 물을 세수대야에 두세 바가지 퍼 담아 뜰팡 위 마루 귀퉁이에 대령하면서 소금 한 종지와 사기그릇에 양치물을 담아 보기 좋게 한 줄로 가지런히 놓고 "아버지! 세숫물 떠 놨슈!" 라고 외친다.

그러면 아버지는 할머니가 계신 안방에서 창호지 바른 미닫이문을 벌컥 밀어서 열고 나와 먼저 손을 비누로 닦으며 하는 말씀이 "손만 잘 닦으면 세수는 반 이상 한 겨."하며 온 마음을 다하여 올곧게 손을 닦은 다음, 소금으로 양치를 하면서 그 물로 입과 목을 젖혀 - 요새 말로 가글이라는 거! - 소리 내 헹구어 내고 얼굴을 닦는 순서로 그렇게 골똘하게 해 내곤 하였다. 나는 아버지의 세수 행위가 재미있어 요즈음 연극이나 영화를 보듯이 관람하였지만 지루하지 않았다.

이 하찮은 하루하루의 아버지 일이 나에게 이어져 요즘도 내가 아침에 일어나 급한 생리를 해결하면 첫 번째로 하는 일이 "손 씻기" 일 줄은 그땐 미처 내가 알 리 없었다. 난 그 당연한 "손 씻기"와 소금 양치질이 온 세상에 퍼진 못된 모든 돌림 아픔의 첫 번째 방어막이라 생각한다. 물론 모자람이 없지는 않지만.

나는 내 "손 씻기"를 온 누리의 어린이들이, 내가 어렸을 적 내 아버지를 관람 하였듯이, 재미있게 많이 구경하였으면 좋겠다. 이것이 나의 바람이다.

· 클라우스 링케의 현란한 손동작 사진작업
· 싸이의 "강남 스타일"을 응용한 영국 TV의 손 씻기 공익 방송
· 조지 클루니가 어느 행사장 카메라 앞에서 지나가며 잠시 보여 준
 어린이를 위한 손 씻기 동작
· 이 모든 행위가 내 "손 씻기"작업의 참조가 되었다.

2021. 3. 24 새벽
성 능 경

〈손 씻기〉
2021, 단채널 비디오, 컬러, 사운드, 5분.
작가 소장. 국립현대미술관 지원으로 제작.

Handwashing
2021, Single-channel video, color, sound, 5min.
Courtesy of the Artist. Commissioned by MMCA, Korea.

징후와 증상 〈손 씻기〉 설치 전경 Installation View of *Handwashing*

‹연결›
2021, 캔버스에 아크릴릭, 193×520cm.
작가 소장. 국립현대미술관 지원으로 제작.

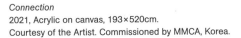

Connection
2021, Acrylic on canvas, 193×520cm.
Courtesy of the Artist. Commissioned by MMCA, Korea.

박영균
Park Young Gyun

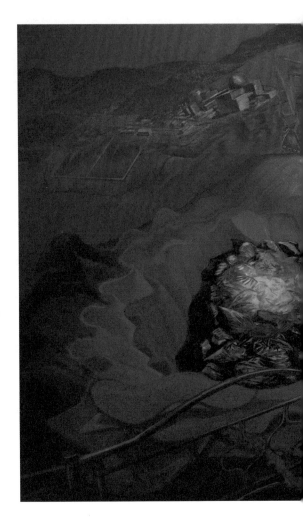

‹무제›
2020-2021, 천에 혼합재료, 270×700cm.
작가 소장. 국립현대미술관 지원으로 제작.

오원배
Oh Wonbae

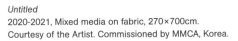

Untitled
2020-2021, Mixed media on fabric, 270×700cm.
Courtesy of the Artist. Commissioned by MMCA, Korea.

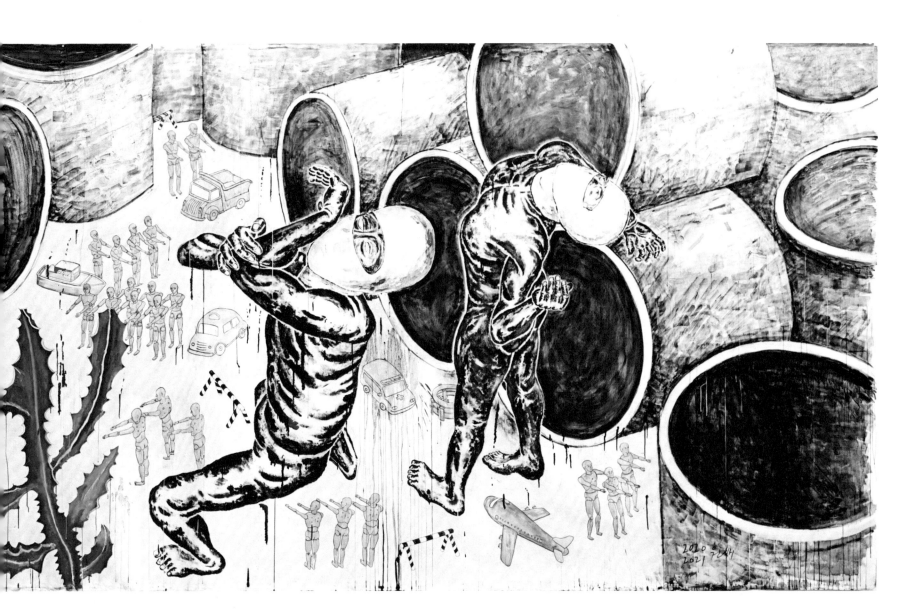

집콕, 홀로 같이 살기

써니킴
안드레아 지텔
리우 와
프란시스 알리스
홍진훤
차재민
무진형제

Jipkok, Homebound Together

Sunny Kim
Andrea Zittel
Liu Wa
Francis Alÿs
Jinhwon Hong
Jeamin Cha
Moojin Brothers

‹푸른 시간›
2019, 캔버스에 아크릴릭, 160×380cm.
작가 소장. 국립현대미술관 지원으로 제작.

써니킴
Sunny Kim

Blue Hour
2019, Acrylic on canvas, 160×380cm.
Courtesy of the Artist. Commissioned by MMCA, Korea.

‹이동›
2021, 캔버스에 아크릴릭, 160×380cm.
작가 소장. 국립현대미술관 지원으로 제작.

Migration
2021, Acrylic on canvas, 160×380cm.
Courtesy of the Artist. Commissioned by MMCA, Korea.

‹돌 던지기›
2020, 단채널 비디오, 컬러, 사운드, 6분 50초.
작가 소장. 국립현대미술관 지원으로 제작.
교복입은 소녀들: 전선우, 장유희, 조영은.
피아노: 전선우.
음악: 모차르트-피아노 소나타 16번.

Playing Stones
2020, Single-channel video, color, sound, 6min. 50sec.
Courtesy of the Artist. Commissioned by MMCA, Korea.
Girls in Uniform: Jeon Seonwoo, Jang Youhee, Jo Youngeun.
Piano: Jeon Seonwoo.
Music: Mozart-Piano Sonata No.16.

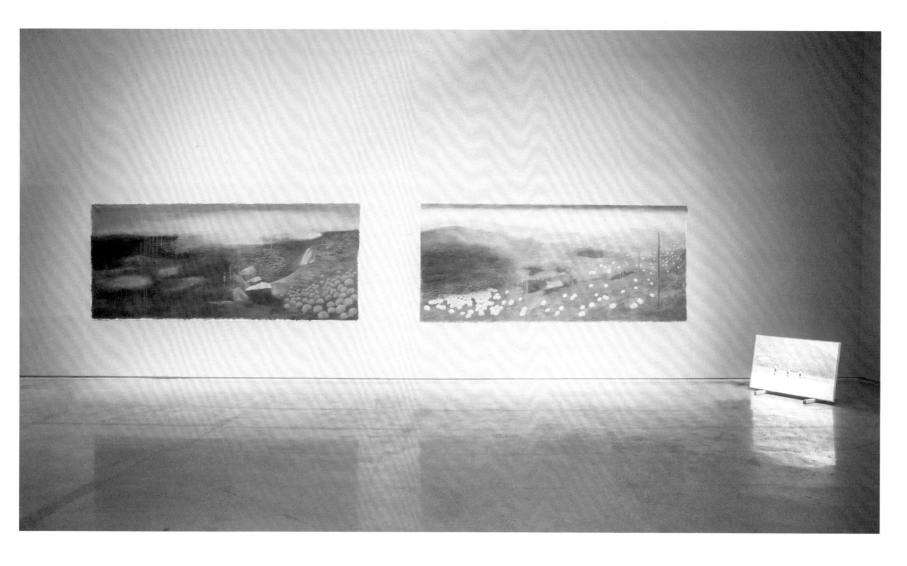

집콕, 홀로 같이 살기 〈푸른 시간〉, 〈이동〉, 〈돌 던지기〉 설치 전경 Installation View of *Blue Hour*, *Migration*, and *Playing Stones*

‹무제(사회 안에서 살 것인가 바깥에서 살 것인가?)›
2013, 철 프레임과 해양 등급 합판 패널에 폴리아크릴릭,
184.2×370.8×5.7cm.
© 안드레아 지텔. 작가 및 스프루스 마거스 제공.

<div align="right">

안드레아 지텔
Andrea Zittel

</div>

Untitled (To live within or without society?)
2013, Polyacrylic on marine grade plywood panel with steel
frame, 184.2×370.8×5.7cm.
© Andrea Zittel. Courtesy of the Artist and Sprüth Magers.

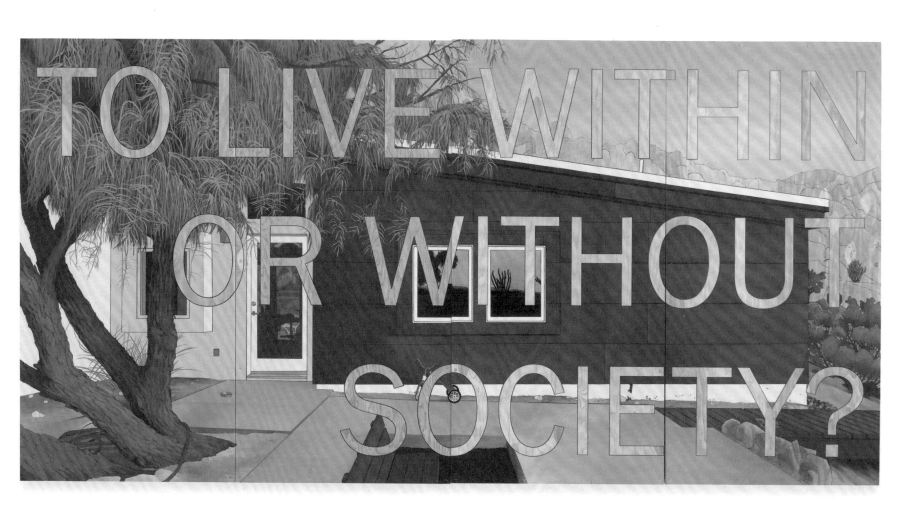

‹2020년은 나에게›
2020, 4채널 비디오 설치, 컬러, 사운드, 9분.
리우 와 제공.

2020 Got Me Like
2020, Four-channel video installation, color, sound, 9min.
Courtesy of Liu Wa.

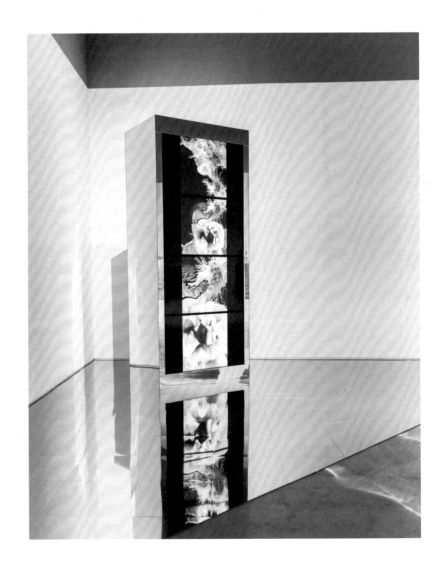

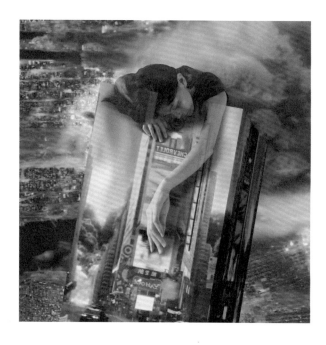

‹금지된 걸음›
라마섬, 홍콩, 2020,
단채널 비디오, 컬러, 사운드, 3분 22초.
작가 소장.

프란시스 알리스
Francis Alÿs

Prohibited Steps
Lamma Island, Hong Kong, 2020,
Single-channel video, color, sound, 3min. 22sec.
Courtesy of the Artist.

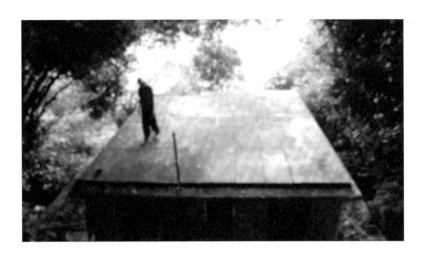

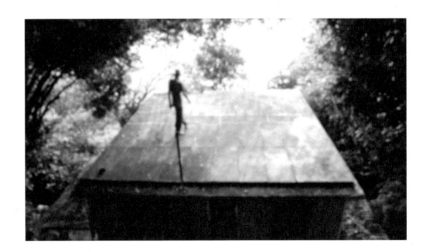

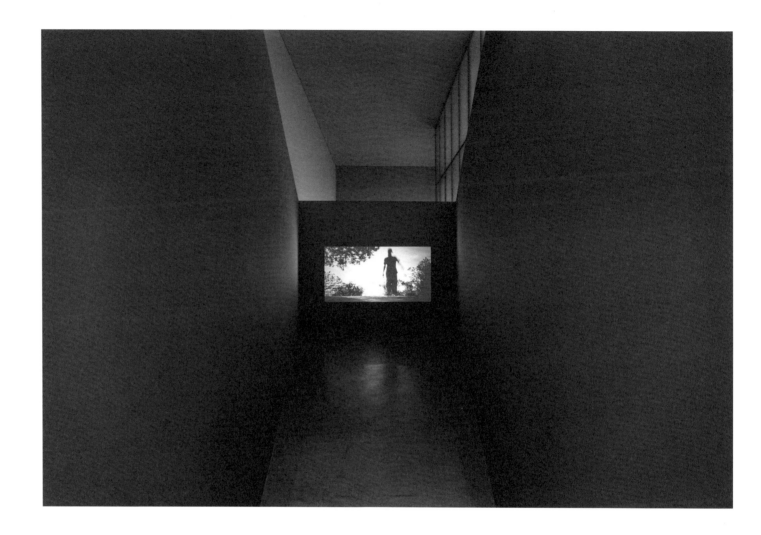

‹금지된 걸음› 설치 전경 Installation View of *Prohibited Steps*

‹Injured Biker›
2021, 3d WebGL+crawling on web page, 가변크기.
작가 소장. 국립현대미술관 및 로지스틱스 지원으로 제작.
프로듀서: 신은진.

홍진훤
Jinhwon Hong

Injured Biker
2021, 3d WebGL+crawling on web page, Dimensions variable.
Courtesy of the Artist. Commissioned by MMCA, Korea and Logistics.
Producer: Eunjin Regina Shin.

〈스타 라이더스〉
2020, 피그먼트 프린트, 90×120cm.
작가 소장. 국립현대미술관 지원으로 제작.

Star Riders
2020, Pigment print, 90×120cm.
Courtesy of the Artist. Commissioned by MMCA, Korea.

‹미궁과 크로마키›
2013, 단채널 비디오, 컬러, 사운드, 15분 15초.
국립현대미술관 소장.

차재민
Jeamin Cha

Chroma-Key and Labyrinth
2013, Single-channel video, color, sound, 15min. 15sec.
MMCA Collection.

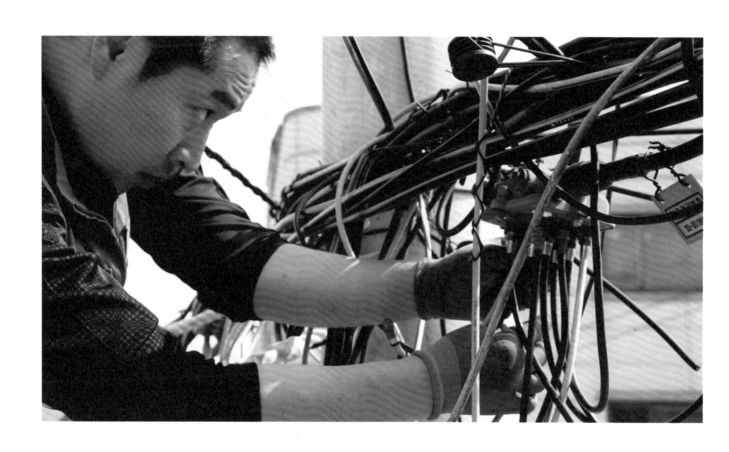

‹결구›
2015, 단채널 비디오, 컬러, 사운드(스테레오), 11분 41초.
작가 소장.

무진형제
Moojin Brothers

The Last Sentence
2015, Single-channel video, color, sound (stereo), 11min. 41sec.
Courtesy of the Artist.

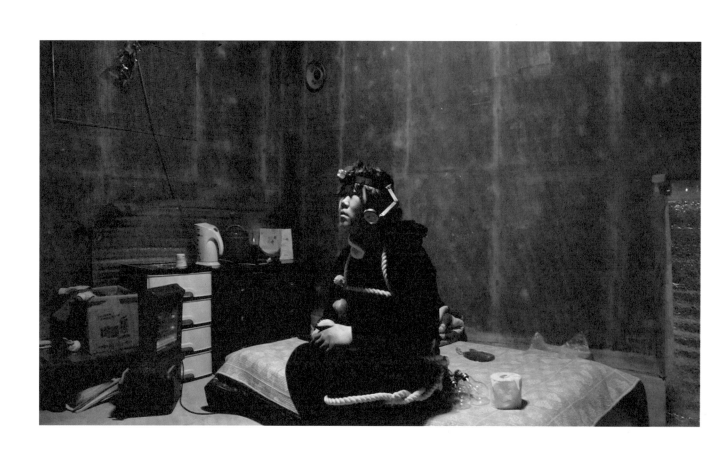

숫자와 거리

이지원(아키타입)
최태윤
리암길릭
미야지마 타츠오
김범

Numbers and Distance

Jiwon Lee (archetypes)
Taeyoon Choi
Liam Gillick
Tatsuo Miyajima
Kim Beom

‹팬데믹 다이어그램›
2021, 종이 패널에 실크스크린 인쇄, 웹사이트
(www.unequal-pandemic.com), 가변크기.
작가 소장. 국립현대미술관 지원으로 제작.
웹 개발: 조은지.

이지원 (아키타입)
Jiwon Lee (archetypes)

The Unequal Pandemic
2021, Silkscreen on paper panel, Website
(www.unequal-pandemic.com), Dimensions variable.
Courtesy of the Artist. Commissioned by MMCA, Korea.
Web Development: Eunji Jo.

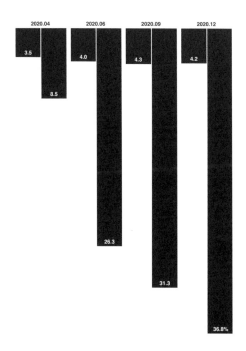

2020.04 2020.06 2020.09 2020.12

3.5

8.5

4.0

4.3

4.2

26.3

31.3

36.8%

Fig 1. 고용형태에 따른 실직 경험률

지난 1년간 실직 경험률은 고용형태에 따른 차이가 컸다.
정규직의 실직 경험률은 4.2%인 반면 비정규직은 36.8%에
달했다. 지난해 4·6·9·12월 4차례 실시한 조사에서 정규직의
실직 경험률은 3.5%, 4.0%, 4.3%, 4.2%로 별 차이가
없었지만 비정규직은 8.5%, 26.3%, 31.3%, 36.8%로
급증했다.

「비정규직 10명 중 4명 "1년간 실직 경험"…정규직의 9배」,
경향신문 2021.01.17.

96.1%

Fig 2. 플랫폼 노동 종사자 고용보험 가입 현황

플랫폼 노동 종사자들의 고용보험 가입률은 극히 미약해
음식배달 라이더는 고작 3.9%에 그쳤다. 산재보험 가입률도
대리운전기사 13.6%, 가사도우미 13.6%, 음식배달 라이더의
경우 14.9%, 퀵서비스 라이더 20.4%를 각각 나타냈다.

「'플랫폼 노동자' 실태… 음식배달 라이더 3.9% 고용보험」, 국민일보 2020.10.07.

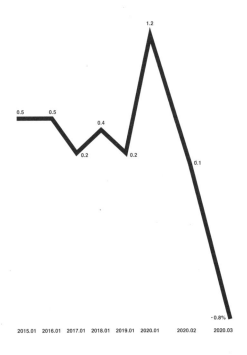

Fig 3.　전년 대비 여성 고용 증감률

코로나19의 사회 전반적 영향에도 불구하고 노동시장의
특정 부문에 영향이 집중되었기 때문에 이와 관련된 계층에서
변화가 더 크게 나타났다. 가장 대표적인 계층이 여성으로, 최근
5년간의 고용이 여성 고용을 위주로 증가하는 추세였다는 것을
고려한다면 코로나19가 여성고용에 미친 영향은 상당히 컸다.
이는 여성들이 대면 서비스와 관련된 업종에 많이 종사하고 있기
때문이다.

통계청 통계개발원, 『한국의 사회동향 2020』, 2020.12.11.

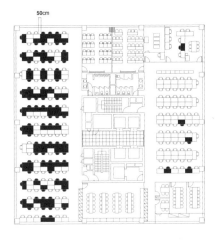

Fig 4.　서울특별시 코리아빌딩 11층의 좌석 배치도

검정색으로 표시된 좌석은 코로나19 양성 판정을 받은 직원이
근무했던 곳이다. '언택트'노동의 정반대에 '닭장노동'이 있다.
거리 두기가 강화될수록 닭장노동도 강화되는 역설이 벌어진다.
밀려드는 상담과 주문을 처리해야 하기 때문이다. 한 사람의
업무공간은 가로×세로 110cm 정도였다. 정부는 옆 사람과
2m의 거리를 유지하라고 권장하지만 콜센터에서 옆 사람과
유지할 수 있는 거리는 50cm가 고작이다.
여러 콜센터를 경험한 한 노동자는 "전국 어느 콜센터를 가도
환경은 비슷할 것"이라고 말했다.

「언택트 시대, 나는 닭장노동을 합니다」, 경향신문 2020.05.02.

10,000,000 300,000

216,000 ₩54,000

Fig 5. 대구광역시 성당동 11평 아파트 월세

대구시는 저소득 여성 노동자의 주거 환경을 개선하고 자립
기반을 마련하려는 취지로 이 아파트를 직접 운영한다. 입주
자격은 대구지역 사업장에 3개월 이상 재직하고, 35세 이하의
결혼하지 않은 여성으로 제한했다.

· 대구 성당동 OO아파트
 11평/보증금 10,000,000원/월세 300,000원
· 대구 성당동 한마음아파트
 11평/보증금 월세4개월분/월세 5만4천원~2만2천원

「대구 한마음아파트 주민 3분의2는 왜 신천지 교인이 됐을까」,
경향신문 2020.03.08.

Fig 6. 코로나19 취약시설 집단감염 추이

지난달, 서울시 송파구 장애인 거주시설 신아원에서 코로나19
집단감염 사태가 일어났다. 확진자는 12일 기준으로 거주인
56명, 종사자 20명으로 총 76명이다. 첫 확진자가 나온 지난달
26일에 신아원은 코호트 격리 조치됐다. 장애인 거주시설
입소자와 종사자의 코로나19 감염률을 비교했을 때, 입소자인
장애인의 감염률이 종사자보다 1.5배에서 2배가량 높았다.

「'집단감염' 신아원, 분산조치 약속 파기하고 3일 만에 다시 시설로?」,
비마이너 2021.01.14.

3.52pt

3.17

3.1

Fig 7. 코로나19에 감염됐을 때 가장 걱정되는 것은 무엇인가?

국민들이 동선 공개를 찬성하고 있지만, 그와 함께 본인이
감염될 경우 동선공개로 인해 비난받을 것에 대한 두려움을
느끼는 정도도 점점 올라가고 있다. '내가 확진자가 됐을 때
주변으로부터 받을 비난·추가 피해'를 두려워하는 정도는 평균
3.52점(5점 만점)이었다. '무증상 감염되는 것' (3.17점),
'증상이 있는데도 자가신고하지 않은 이가 주변에 있는 것'
(3.1점)보다도 점수가 높았다.

「코로나19 동선공개로 '아웃팅' 우려…"동선공개 지침 변경해야"」,
경향신문 2020.05.07.

01.01 –
01.05

01.06 –
01.12

01.13 –
01.19

01.20 –
01.26

01.27 –
02.02

02.03 –
02.09

02.10 –
02.16

02.17 –
02.23

02.24 –
03.01

03.02 –
03.08

03.09 –
03.15

03.16 –
03.17

03.23 –
03.29

03.30 –
04.05

04.06 –
04.12

04.13 –
04.19

04.20 –
04.26

04.27 –
05.03

05.04 –
05.11

05.18 –
05.24

05.25 –
05.31

Fig 8. 코로나19와 혐오표현의 전파

온라인 상에서 인종차별이나 성소수자, 지역혐오 등의 일부
혐오발언은 코로나19의 확산에 따라 영향을 받으며 증가 및
감소하는 모습이 나타남.

■ 1월 하순과 2월 하순에 인종차별 발언이 크게 증가함
✖ 성소수자 관련 부정적 언급 비중은 70%가 넘는 높은
수준이며 특히 5월 초에는 90%에 가까운 부정적 언급이
작성되어 매우 큰 혐오가 드러남
● 지역혐오 언급은 2월 하반기에 크게 증가하였으며, '대구'
관련 언급의 비중이 많음
✚ 신천지 관련 언급은 부정적 비중이 87%로 매우 높은
수준이며, 2월 3주차에 기존대비 4배가량 증가함

국가인권위원회, 『코로나19와 혐오의 팬데믹』, 2020.07.

2020.02

2020.03

2020.04

2020.05

Fig 9. 코로나19 관련 뉴스를 볼 때 어떤 감정을 느끼는가?

코로나19 관련 뉴스를 볼 때 어떤 감정을 느끼느냐는 질문에
불안이라고 대답한 이들은 50~60% 사이를 유지했다.
반면 분노를 느낀다는 응답은 지난 4달간 8%에서 30%로 껑충
뛰었다. 특히 4월에서 5월 사이 분노라고 답한 이들은 16%에서
두 배 가까이 늘어났다. 이 시기 공포를 느꼈다는 대답은
17%에서 오히려 4%로 떨어졌다.

「한국인들 코로나19 감염되면 건강보다 주변 비난을 더 걱정」,
동아사이언스 2020.05.20.

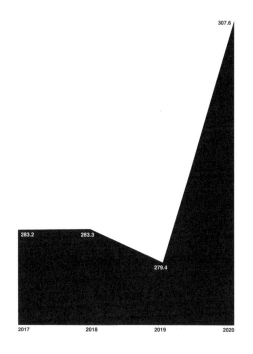

Fig 10. 서울지역 아동학대 월평균 신고 현황

코로나19 확산에 따른 거리 두기 강화로 아이들이 집에 머무는
시간이 많아지면서 신체·정신적인 폭력이나 방치 등 위험에
노출되고 있다. 올해 1월부터 9월까지 접수된 서울 지역
아동학대 신고는 2,768건에 달한다. 올해 9월까지 월평균
307.6건 발생해 지난해(279.4건) 수준을 이미 넘어섰다. 교사
등 신고의무자의 신고가 적어진 점까지 감안하면 올해 아동학대
건수는 지난해보다 대폭 늘어날 것으로 보인다.

「거리 두기로 아동학대 사각지대 더 커져…'긴급돌봄' 늘려야」,
경향신문 2020.12.20.

#두려움	192명
#불평등	142명
#여성노동자	2만2000원~5만4000원
	월 소득 150만원 이하
#낙인	70%
#장애인	44.80%
#페미니스트	월세 5만4천원/보증금 216,000원
#코호트격리	
#방호복	87.9%
#보육교사	최근 5년
#중국인	5인 이하 사업장
#이동경로	코로나19
#정규직	1,924명
#가정폭력	70%

4월 한국노동조합총연맹(한국노총) 여성본부와 중앙연구원이 산하 공공연맹, 금융노조 등의 협조를 받아 조합원 618명을 분석한 '2021년 직장 내 성평등 조직문화 실태조사'에 따르면 여성 노동자의 70%가 "코로나19로 인한 가족 돌봄으로 인해 향후 직장에서 불이익을 받을까 두려움을 느낀다"는 의견으로 집계됐다. 남성 노동자들도 절반이 넘는 53.8%가 가족 돌봄으로 인한 직장 내 불이익을 걱정하는 것으로 파악됐다. 최근 코로나19로 인해 자녀와 관련된 돌봄시설 이용이 불가능해지면서, 다시 가정 내에서 돌봄 노동을 하는 비율이 증가하고 있다.

「The Unequal Pandemic(팬데믹 다이어그램)」은 코로나19라는 재난 상황 속 사회적 소수자와 안전취약계층의 삶에서 발견한 숫자를 기록한 것이다. 엄연히 존재했지만 고립되어왔던 이 숫자들은 2020년 팬데믹으로 인해 가시화되어 지금껏 우리가 살아왔던 삶의 방식에 질문을 던진다.

10개 그래픽 패널과 웹 아카이브로 구성된 「The Unequal Pandemic(팬데믹 다이어그램)」은 한국 사회에서의 불균형과 불평등, 불안과 모순, 차별과 혐오를 측정한 통계자료와 누군가의 경험으로부터 도출한 숫자 및 단위로 이루어졌다.

대한민국에 코로나19가 창궐한 2020년 1월부터의 신문, 통계 자료, 보고서, 논문, 단행본, 성명서 등을 조사했고 여성, 비정규직 및 특수고용 노동자, 성소수자, 장애인, 아동, 이주노동자의 기록을 포함한다. 2021년 5월, 웹 아카이브는 여전히 진행중이다.

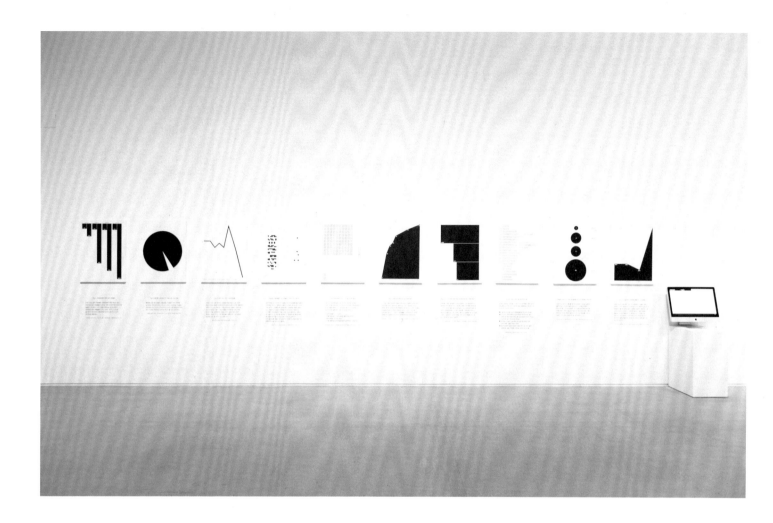

‹팬데믹 다이어그램› 설치 전경 Installation View of *The Unequal Pandemic*

‹마법 같은 수의 세계: 빛과 어둠의 역함수›
2021, 벽에 채색, 펜, 실크스크린, 혼합재료, 400×1,200cm.
작가 소장. 국립현대미술관 지원으로 제작.
작가: 최태윤
스튜디오 매니저: 신재민
프로젝트 코디네이터: 박선호
그래픽 디자인: 유예나
스크린 프린트: SAA / 이산하, 정성훈
코드: 정보현
번역: 최수현
벽화: 조재홍
Special thanks to 카스코 아트 인스티튜트: 커먼스를 향하여, 팩토리2

최태윤
Taeyoon Choi

Magical World of Numbers: Inverse Function of Light and Darkness
2021, Paint and pen drawing on gallery wall, silk screen prints,
mixed media, 400×1,200cm.
Courtesy of the Artist. Commissioned by MMCA, Korea.
Artist: Taeyoon Choi
Studio Manager: Jaemin Shin
Project Coordinator: Sunho Park
Graphic Design: Yena Yoo
Screen Print: SAA / Sanha Lee, Sunghun Jung
Code: Bohyun Jung
Translation: Suhyun Choi
Wall Painting: Jaehong Jo
Special thanks to Casco Art Institute: Working for the Commons, Factory 2

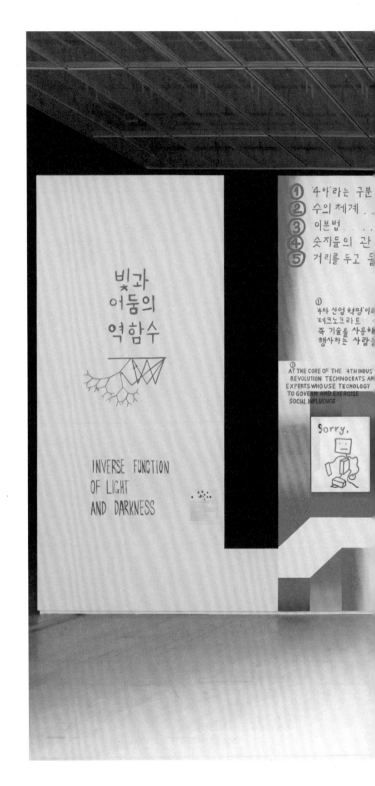

1 ‹미안, 컴퓨터›
2020, 종이에 마커 펜, 68.5×53.5cm.
작가 소장.

2 ‹커뮤니티 코드›
2021, 캔버스에 아크릴릭, 72×56cm.
작가 소장.

3 ‹혁신이 아닌 발명›
2015, 종이에 펜, 잉크젯 프린트, 46×36cm.
작가 소장.

4 ‹코드로 쓴 시-카산드레를 기억하며›
2021, 모니터, 컴퓨터, 자바스크립트로 만든 애니메이션,
가변크기. 작가 소장.

5 ‹거리 두고 돌보기›
2020, 종이에 마커 펜, 72×57cm.
카스코 아트 인스티튜트: 커먼스를 향하여 소장.

6 ‹잘 지내›
2019, 캔버스에 아크릴릭, 45.5×30.2cm.
작가 소장.

7 ‹책꽂이›
2021, 캔버스에 아크릴릭, 61×51cm.
작가 소장.

8 ‹스케이트보드 위 초상화 3›
2019, 스케이트보드에 아크릴릭, 83×21cm.
작가 소장.

9 ‹민들레›
2021, 캔버스에 아크릴릭, 61.5×51.7cm.
작가 소장.

10 ‹서식지와 다시 연결하기›
2020, 종이에 마커 펜, 65×50cm.
작가 소장.

11 ‹플로우차트›
2015, 종이에 잉크, 83.2×63cm.
작가 소장.

12 ‹숫자에 대한 패턴›
2021, 벽에 실크스크린, 가변크기.
작가 소장.

1 *Sorry, computer*
2020, Marker drawing on paper, 68.5×53.5cm.
Courtesy of the Artist.

2 *Community Code*
2021, Acrylic painting on canvas, 72×56cm.
Courtesy of the Artist.

3 *Invention, not Innovation*
2015, Pen drawing and inkjet print on paper,
46×36cm. Courtesy of the Artist.

4 *Code poetry-after Cassandre*
2021, Flatscreen monitor, Computer, animation
made with JavaScript, Dimensions variable.
Courtesy of the Artist.

5 *Care with distance*
2020, Marker drawing on paper, 72×57cm.
Casco Art Institute: Working for the Commons
Collection.

6 *Take care*
2019, Acrylic painting on canvas, 45.5×30.2cm.
Courtesy of the Artist.

7 *Bookshelf*
2021, Acrylic painting on canvas, 61×51cm.
Courtesy of the Artist.

8 *Skateboard portrait 3*
2019, Acrylic painting on skateboard, 83×21cm.
Courtesy of the Artist.

9 *Dandelion*
2021, Acrylic painting on canvas, 61.5×51.7cm.
Courtesy of the Artist.

10 *Reconnect with habitat*
2020, Marker drawing on paper, 65×50cm.
Courtesy of the Artist.

11 *Flowchart*
2015, Ink drawing on paper, 83.2×63cm.
Courtesy of the Artist.

12 *Patterns for numbers*
2021, Silk screen prints on gallery wall,
Dimensions variable. Courtesy of the Artist.

① '4차 산업 혁명'이라는 흐름의 중심에는
'테크노크라트 technocrats'
즉 기술을 사용해 정치적 영향력을
행사하는 사람들이 있다

① AT THE CORE OF THE '4TH INDUSTRIAL REVOLUTION TECHNOCRATS ARE EXPERTS WHO USE TECNOLOGY TO GOVERN AND EXERCISE SOCIAL INFLUENCE

Sorry,

수의 책성과 가공성, 그리고
수로 산정할 수 있는 정보의 관계

UNDerstanding numbers
ABSTRACT AND MALLEABLE
The RELATION
OF INFORMATION

복소수 COMPLEX i+π
실수 REAL π
유리수 RATIONAL
정수 INTEGER -1
자연수 NATURAL 0.1
C R Q Z N
허수 IMAGINARY
무리수 REAL ALGEBRA/수
½

기술은 ㅃ
그 안에서
몇 가지

TECHNOL
HOWEVE
THAT DO

② THE FIRST 'ESS
THE SECOND, 'MAT
THE THIRD, 'GOV

AN AGREEMENT
CODE.

CARE
WITH
DISTANCE

③
빛과 어둠.
소리와 적막
사랑과 무관심

"0.
— 이분법적 구분 0.1.
0.01.
0과 1 사이에는 0.001.
우리의 세계가 0.0001
존재한다. 0.00001

③
LIGHT AND DARK
SOUND AND SILENCE
LOVE AND INDIFFERENCE
A BINARY DISTINCTION
0 AND 1

은 빠르게 변하지만
에서 변하지 않는
-지가 있다

NOLOGY CHAGES QUICKLY
VER. A FEW THINGS
DO NOT CHANGE.

④
THE CHINESE CHARACTERS
LOGARITHMIC FUNCTION 對數
IT IS A 'RELATIONSHIP'
THE SAME CHARACTER USED HERE 對 IS
ALSO USED IN THE WORD 對話 CONVERSATION
LOGARITHMIC FUCTION IS THE CONVERSATION
BETWEEN NUMBERS

③
그러나 제논의
역설과 같이
0과 1은 완전히
하나가 될 수는 없다.

③
LIKE THE ZENOS PARADOXES
0 AND 1 CAN NOT BECOME ONE

RECONNECT
WITH YOUR
HABIT.
HABITAT.
CRITTERS.

첫 번째는 수의 본질이다.
두 번째는 기술의 물성이다.
세 번째는 통치와 관리이다.
그리고 다양한 객체간의
약속이 코드이다.

ESSENCE OF NUMBERS
MATERIALITY OF TECHNOLOGY
GOVERNANCE AND CONTROL

NT BETWEEN OBJECTS IS

④
로그함수의 한자 표기는
對數(대수) 함수이다.
여기서 사용된 對 (대할 대)는
대화에도 쓰이는 동일한 한자이다.
대수 는 숫자와 숫자 간의 대화이다.

⑤
천체물리학 속에서 우리의 존재는
아주 작다 하지만 모든 작은
것들에도 고유의 세계가 있다

⑤
IN ASTROPHYSICS. OUR EXISTANCE IS
TRIVIAL. BUT IN EVERY DUST, A
WHOLE UNIVERSE.

빛 ——→ 적막
소리 ——→ 무관심
사랑 ——→ 어둠

‹새로운 강›
2021, 벽에 비닐, 지름 400cm
작가 및 갤러리바톤 제공.

리암 길릭
Liam Gillick

New Rivers
2021, Vinyl on wall, 400cm(diameter).
Courtesy of the Artist and Gallery Baton.

we went to the same river... we looked into the same river... we walked into the same river... we walked into new rivers...

‹상승하는 역설›
2020, 채색 알루미늄, 700×17×3cm.
작가 및 갤러리바톤 제공.

Elevated Paradox
2020, Colored aluminium, 700×17×3cm.
Courtesy of the Artist and Gallery Baton.

$$1 = 1 + (-1+1) + (-1+1) + (-1+1) + \cdots = 1$$

$$(1-1) + (1-1) + (1-1) + (1-1) + \cdots = 0$$

‹상승하는 역설› 설치 전경, 국립현대미술관 서울 로비
Installation View of *Elevated Paradox,* Lobby, MMCA Seoul

‹카운터 갭›
1989/2019, 발광다이오드, 집적회로, 전선, 철 프레임,
597.6×11×7.3(d)cm.
작가 및 갤러리바톤 제공.

미야지마 타츠오
Tatsuo Miyajima

Counter Gap
1989/2019, L.E.D., IC, electric wire, steel frame,
597.6×11×7.3(d)cm.
Courtesy of the Artist and Gallery Baton.

‹무제-친숙한 고통#12›
2012, 캔버스에 아크릴릭, 397×286cm.
국립현대미술관 소장.

김범
Kim Beom

Untitled-Intimate Suffering #12
2012, Acrylic on canvas, 397×286cm.
MMCA Collection.

여기의 밖, 그곳의 안

질리언 웨어링
서도호
이혜인
칸디다 회퍼
토마스 스트루스
서승모

Outside Here, Inside There

Gillian Wearing
Do Ho Suh
Hyein Lee
Candida Höfer
Thomas Struth
Seungmo Seo

질리언 웨어링
Gillian Wearing

질리언 웨어링(Gillian Wearing)의 ‹당신의 관점(Your Views)›
(2013-현재)은 오픈콜 프로젝트로 2013년부터 시작되었다.

Your Views (2013–present) by Gillian Wearing is an open
submissions film project that began in 2013.

https://yourviewsfilm.com

https://yourviewsfilm.com

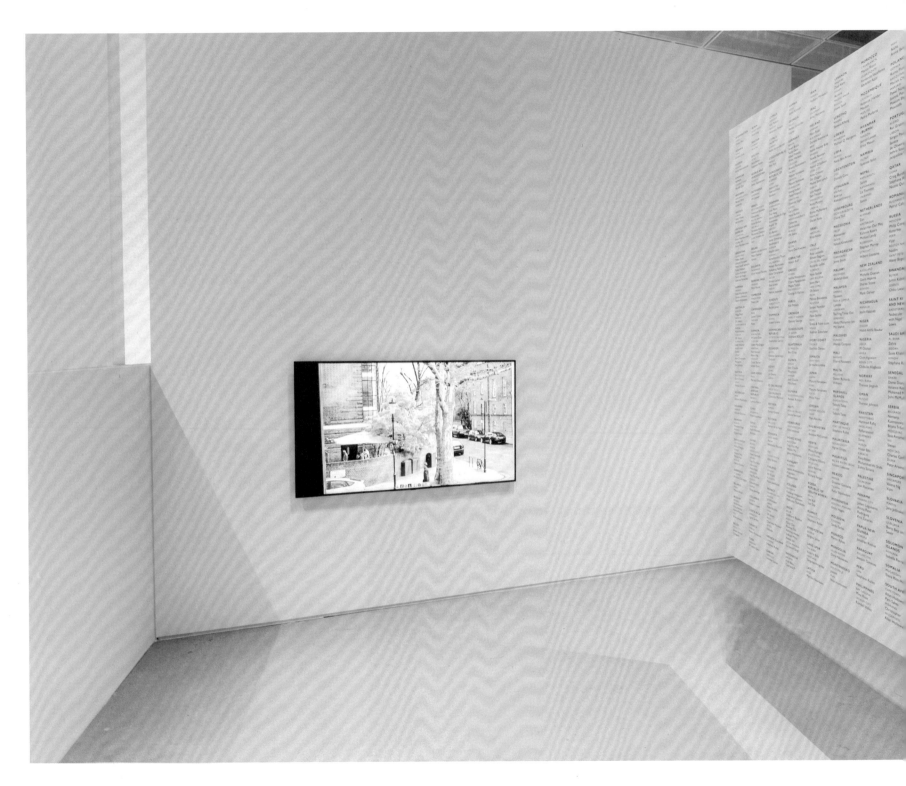

ISLE ...
Jan Frith
LEWES
Anne Bostwick
Paul Cox
Caroline Pick
LIVERPOOL
Onur Orukut
LONDON
Namkhang Anomasiri
Sasha Andrews
Thierry Bal
Olivia Browne
Simon Bianco
Carmen Blanco
Santos
Angus Boulton
Bethe Bronson
Anton Califano
Sebastian Collier
Sarah Cope
Pedro Uviedo Daly
Alice Dass
Laura D'Asta
Zac Dimitrov
Stephen Engelhard
Justin Evans
Johanna Gray
Caroline Gray
Athene Grieg
Levin Haegale
Jason Hart
Doug Haywood
Lisa James
Michael Landy
Clive Lissaman
Carlota Martin
Ariadne Mikou
Clare Morris
Charles Ng
Stuart Pampellone
Christos Patsalis
Katarzyna Perlak
Mark Riley
John Rodgers
Sam Rumbelow
Elenna Santorinaiou
Sebastian Sharples
David Spero
Liene Steinberga
Cesar
Jayne Taylor
Alex Tuckey
Wolfgang Tillmans
Helen Van Der Meij
Andrea Vassalio
Gillian Wearing
Stephen White
Jonathan Wood
Raj Tagnik
Peiyun Zhang
Richard Zeill
Mark Hamill
MANCHESTER
Olivia Glasser
Anoushka Gordon
Damian Hodgeson
MENDIP HILLS
Josh Drury
MODBURY DEVON
Declan Smith
NEWCASTLE
Kiki Patsalis
NEW FOREST
Negar Esfandiary
NOTTINGHAM
Ilia Diakatou
PAIGNTON
Anna Goodchild
PORTLADE
Siobhan Warrington
SELSEY
Sarah Chrisp
SEVEN SISTERS
Andrea Vassalio
SHOREHAM BY SEA
Beatrice Haverich
David Parker
Mike Whelan
ST IVES
Simon Andrews
STOCKPORT
Natalie Bradbury
SUTTON SCOTNEY
Frauke Adams
TALKATON
Nancy J Clemance
David Johnson
WALTON-ON-THE-NAZE
James Lowe
WESTON SUPER MARE
Lucy Taylor
Dara Vainsteins
WILBY
La Rosa Hotel
Owner
WOKING
Catherine Banks

VUOTI
PORTAFERRI
Tory Killen

SCOTLAND
EDINBURGH
Anne Milne
ELLON
Michael Craig
GLASGOW
Nick Walker
ISLE OF HARRIS
BORRISDALE
Pippa Stevens
ORKNEY
Helga Tulloch
SHIELDAIG
Lisa O'Brien

WALES
CARDIFF
Sharon Magill
DEGANWY
Jenni Steele
LLANBRADACH
Martin Udpin
LLECHRYD
Mike Williamson
ST ASAPH
Jo McGregor
TREFNANT
Robin McGregor

UNITED STATES
OF AMERICA
ALBUQUERQUE, NEW
MEXICO
Lisa James
Richard Rand
ALEXANDRIA,
VIRGINIA
Omaari Ashley
ARCADIA,
CALIFORNIA
Cole Lu
ARNOLD, MARYLAND
Tito Oporta
BOISE, IDAHO
John McMahon
BOSTON,
MASSACHUSETTS
Fiona Braillon
BRAINTREE,
MASSACHUSETTS
Qiangiao Fang
CHICAGO, ILLINOIS
Peter Fitzpatrick
EUGENE, OREGON
Michael Boonstra
FAIR HAVEN, NEW
YORK
Jill Kerwick
FORT SALONGA, NEW
YORK
Kelly Butler
GLENSIDE,
PENNSYLVANIA
LeAnn Erickson
HEMET, CALIFORNIA
Stephen Beveridge
HOPEDALE,
MASSACHUSETTS
Abby O'Reilly
IOWA CITY, IOWA
Sandra Louise Dyas
JOHNSON CITY,
TENNESSEE
Scott Contreras-
Koterbay
LONG ISLAND CITY,
NEW YORK
Tierran Morgan
LOS ANGELES,
CALIFORNIA
Mathew Donaldson
Catherine
Goldschmidt
Columbine
Goldsmith
Julia Rome
LAS VEGAS, NEVADA
Lisa James
MATANUSKA GLACIER,
ALASKA
Joseph davis
MANZANITA, OREGON
Stephen Hayes
MELVILLE, NEW YORK
Rachel Schwartz
MIDDLETOWN, NEW
JERSEY
Jill Kerwick
NASHVILLE,
TENNESSEE
Tyler Green
NEWTON, NEW JERSEY
Quinn Leary

Lisa J...
PIKE ROAD
Renise Peters
PORTLAND, OREGON
Rachel Hines
SAN DIEGO,
CALIFORNIA
Alexander Powell
SAN FERNANDO,
CALIFORNIA
Pekinia Piruleta
SAN FRANCISCO,
CALIFORNIA
Chris Jehl
SANTA MONICA,
CALIFORNIA
Tierney Gearon
SEATTLE,
WASHINGTON
Clive Lissaman
SHERMAN,
CONNECTICUT
John Charles
SODA SPRINGS, IDAHO
Kurt Lundblad
SOMERSET, NEW YORK
Ananda Garrison
SYRACUSE, NEW YORK
Joshua Garrett Diabo
Chris Flora
Andrew Freeman
Jeremy Jung
Charlotte Lester
Alex Lievens
Maggie Nhan
Ricardo Santos
Lily Terzis
Seung Young Shin
TAKOMA PARK,
MARYLAND
Elizabeth Carter
TUCSON, ARIZONA
Fiona Braillon
Caroline Cullern
Lisa James
UPPER ST CLAIR,
PENNSYLVANIA
Manoli Despines
WASHINGTON DC,
DISTRICT OF
COLUMBIA
Lisa James
WESTPORT,
CONNECTICUT
Catherine Ross
WINOOSKI, VERMONT
Marion Nelson
WYNCOTE,
PENNSYLVANIA
Chloe Woodrow

URUGUAY
MONTEVIDEO
Santiago Livera

UZBEKISTAN
TASHKENT
Nikita

VANUATU
PORT VILA
Madelaine Beart

VENEZUELA
SAN CRISTOBAL
Ana Gerymar
SAN DIEGO
Jose Juan Lanin
TIA JUANA
Jose Javier Canizalez
Hidalgo

VIETNAM
HANOI
Birgitte Jallov
NHA TRANG
Tin Lung

YEMEN
SANA A
Ebrahim Ahmed
Futaini Abuhadi

ZAMBIA
LUSAKA
Wallen Sinkale

ZIMBABWE
HARARE
Monica Zodwa
Cheru

〈당신의 관점〉 설치 전경
Installation View of *Your Views*

<ScaledBehaviour_runOn(doorknob_3.11.1)›
2021, 폴리에스터 실, 수지, 97.2×76.6×16cm (framed).
© 서도호. 작가 및 레만 모핀 뉴욕/홍콩/서울/런던 제공.
사진: 전택수.

서도호
Do Ho Suh

ScaledBehaviour_runOn(doorknob_3.11.1)
2021, Polyester thread, resin, 97.2×76.6×16cm (framed).
© Do Ho Suh. Courtesy of the Artist and Lehmann Maupin,
New York, Hong Kong, Seoul and London.
Photo by Jeon Taeg Su.

‹페이스타임 HD›
2017, 캔버스에 유채, 45.4×37.9cm(10).
개인 소장.

Facetime HD
2017, Oil on canvas, 45.4×37.9cm(10).
Private Collection.

이혜인
Hyein Lee

여기의 밖, 그곳의 안 ⟨페이스타임 HD⟩ 설치 전경 Installation View of *Facetime HD*

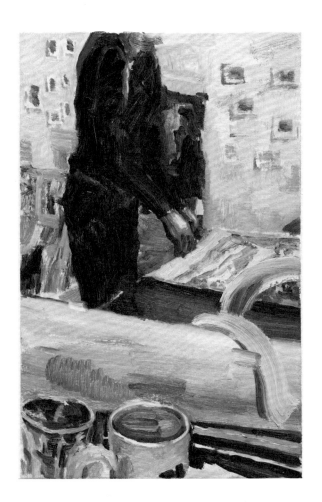

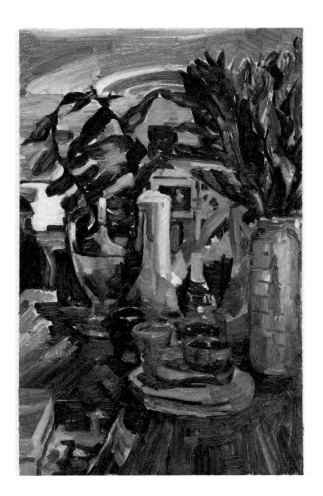

2017. 2. 24. 10:00-12:30(Seoul) / 2017. 2. 23. 17:00-19:30(LA) 2017. 2. 27. 14:30-18:00(Seoul) / 2017. 2. 26. 21:30-25:00(LA)

2017. 3. 2. 23:00-25:30(Seoul) / 2017. 3. 2. 09:00-11:30(NY) 2017. 3. 5. 23:00-26:00(Seoul) / 2017. 3. 5. 09:00-12:00(NY)

2017. 3. 9. 11:00-15:00(Seoul) / 2017. 3. 8. 18:00-22:00(LA)

2017. 3. 11. 15:00-18:00(Seoul) / 2017. 3. 10. 22:00-25:00(LA)

2017. 3. 14. 10:00-12:40(Seoul) / 2017. 3. 13. 18:00-20:40(LA)

2017. 3. 17. 14:30-16:40(Seoul) / 2017. 3. 16. 22:30-24:40(LA)

2017. 3. 21. 09:30-11:15(Seoul) / 2017. 3. 20. 17:30-19:15(LA) 2017. 3. 24. 09:00-11:50(Seoul) / 2017. 3. 23. 17:00-19:50(LA)

칸디다 회퍼
Candida Höfer

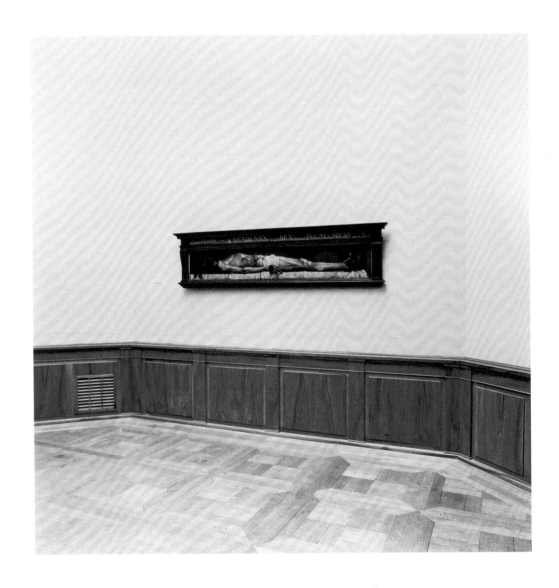

《바젤미술관 IV》
1999, 인화지에 크로모제닉 컬러 프린트, ed. 3/6, 152×152cm.
국립현대미술관 소장.

Kunstmuseum Basel IV
1999, Chromogenic color print on paper, ed. 3/6, 152×152cm.
MMCA Collection.
© Candida Höfer / BILD-KUNST, Bonn - SACK, Seoul, 2021.

〈관람객 11 피렌체〉
2004, 인화지에 크로모제닉 컬러 프린트, ed. 4/10,
179.5×291.5cm.
국립현대미술관 소장. © 토마스 스트루스, (2021).

Audience 11 Florenz
2004, Chromogenic color print on paper, ed. 4/10, 179.5×291.5cm.
MMCA Collection. © Thomas Struth, (2021).

‹소실선. 바다.›
2021, 혼합재료, 250×2,380×2,065cm.
작가 소장. 국립현대미술관 지원으로 제작.

서승모
Seungmo Seo

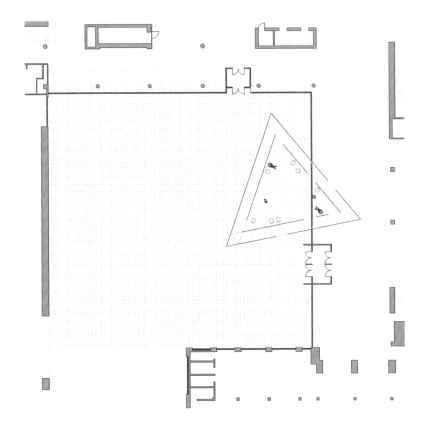

Vanishing Line. Sea.
2021, Mixed media, 250×2,380×2,065cm.
Courtesy of the Artist. Commissioned by MMCA, Korea.

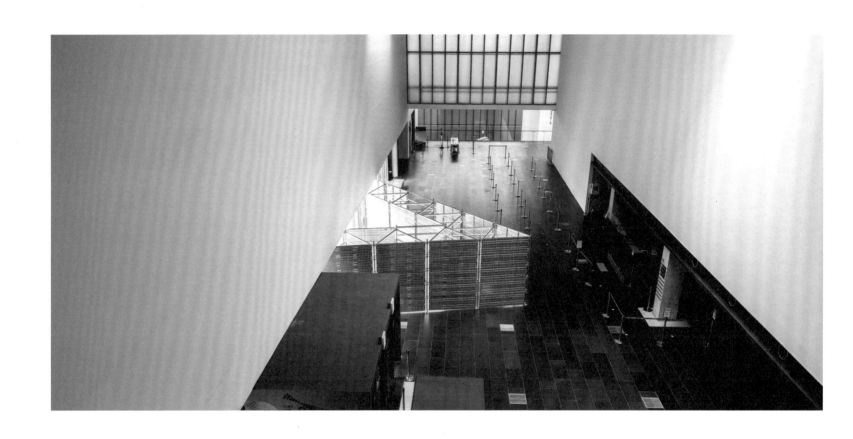

여기의 밖, 그곳의 안 　　　　〈소실선. 바다.〉 설치 전경 　　　　Installation View of *Vanishing Line. Sea.*

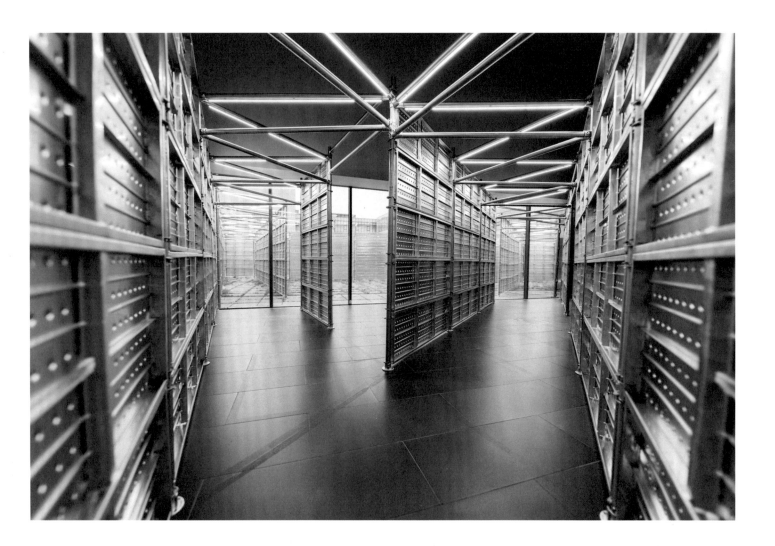

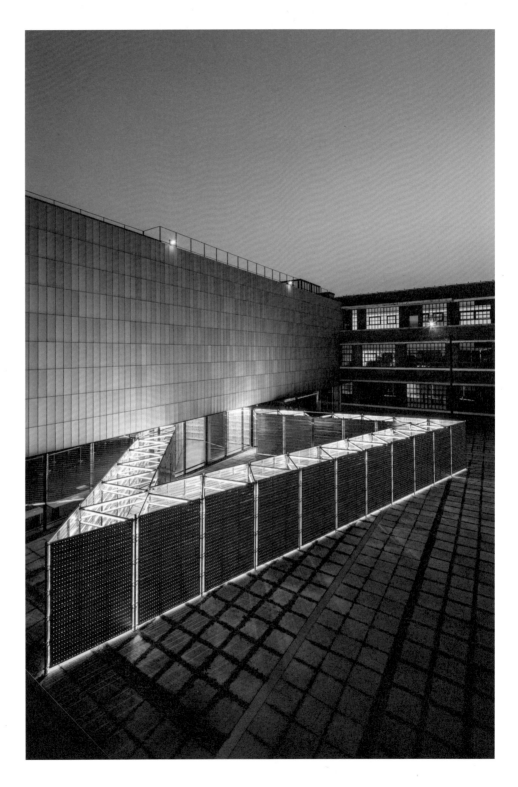

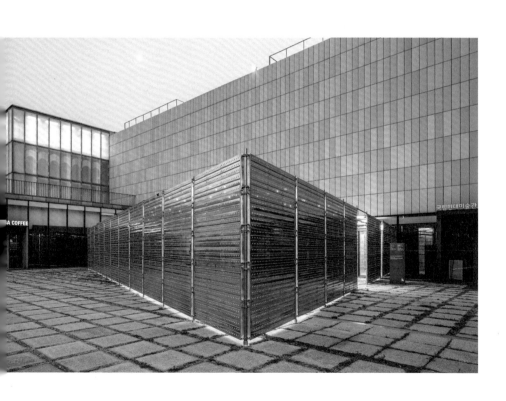

유보된 일상,
막간에서 사유하기

노은님
조나단 호로비츠
봉준호
이영주
염지혜
에이샤–리사 아틸라
허윤희
이배

Daily Life Deferred,
Contemplations during a Pause

Eun Nim Ro
Jonathan Horowitz
BONG Joon-ho
Young Joo Lee
Ji Hye Yeom
Eija-Liisa Ahtila
Yun-hee Huh
Lee Bae

‹나뭇잎 배 타는 사람들›
1987, 한지에 아크릴릭, 206×505cm.
작가 소장.

노은님
Eun Nim Ro

Blatt Boat Fahret
1987, Acrylic on korean paper, 206×505cm.
Courtesy of the Artist.

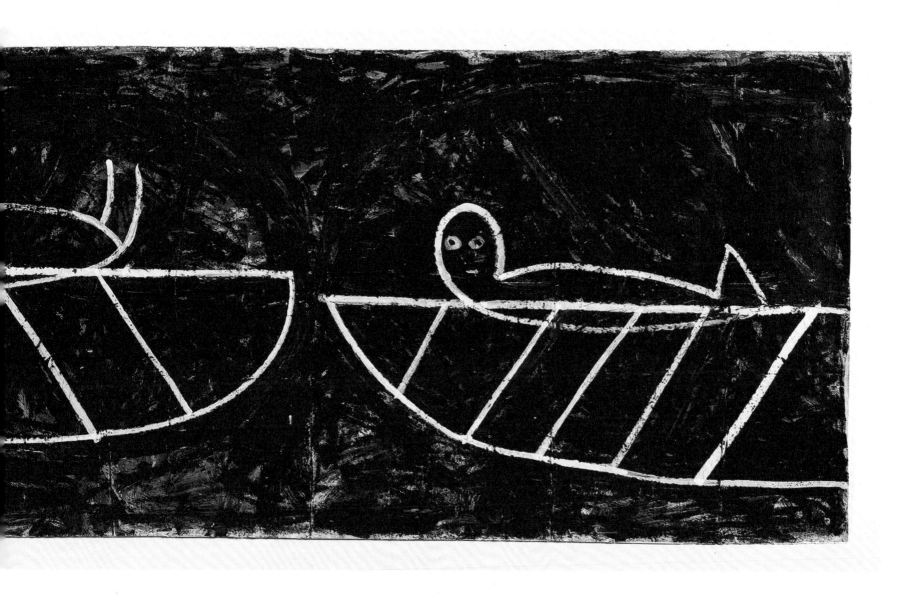

‹해질 무렵의 동물›
1986, 한지에 아크릴릭, 198×260cm.
가나문화재단 소장.

Feuer Tier
1986, Acrylic on korean paper, 198×260cm.
Gana Foundation for Arts and Culture Collection.

‹가을›
1992, 혼합재료, 40×30×7.5cm.
작가 소장.

Herbst
1992, Mixed media, 40×30×7.5cm.
Courtesy of the Artist.

<‹내 짐은 내 날개다›
1989, 단채널 비디오, 컬러, 사운드, 52분.
작가 소장. 함부르크 영화제작소 후원.
감독: 바바라 쿠젠베르크.

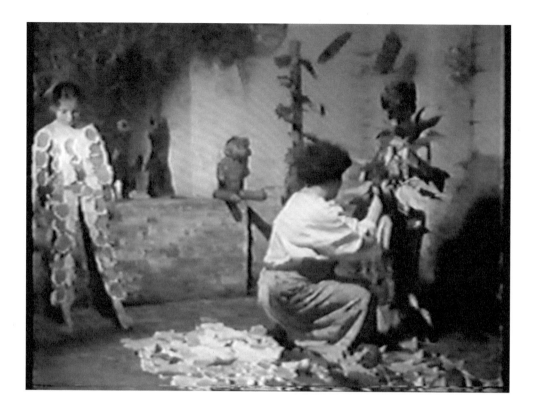

Meine Flügel sind meine Last
1989, Single-channel video, color, sound, 52min.
Courtesy of the Artist. Sponsored by Hamburger Filmbüro.
Directed by Barbara Kusenberg.

‹나뭇잎 배 타는 사람들›, ‹해질 무렵의 동물›,
‹가을›, ‹내 짐은 내 날개다› 설치 전경
Installation View of *Blatt Boat Fahret,*
Feuer Tier, Herbst, and *Meine Flügel*
sind meine Last

<아포칼립토 나우>
2009, 단채널 비디오, 컬러, 사운드, 탄소 상쇄 크레딧에 상응하는
에너지 사용, 가변크기, 19분 48초.
© 조나단 호로비츠. 사디 콜즈 HQ, 런던 제공.

조나단 호로비츠
Jonathan Horowitz

Apocalypto Now
2009, Single-channel video, color, sound; energy use matched
by carbon offset credits, Dimensions variable, 19min. 48sec.
© Jonathan Horowitz. Courtesy of Sadie Coles HQ, London.

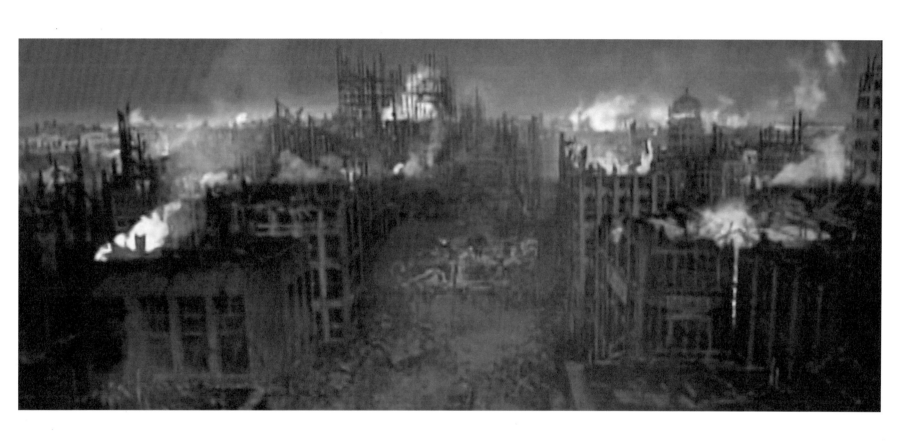

‹아포칼립토 나우› 설치 전경
Installation View of *Apocalypto Now*

<인플루엔자>
2004, 단채널 비디오, 컬러, 사운드, 30분.
전주국제영화제 소장.

봉준호
BONG Joon-ho

Influenza
2004, Single-channel video, color, sound, 30min.
JEONJU International Film Festival Collection.

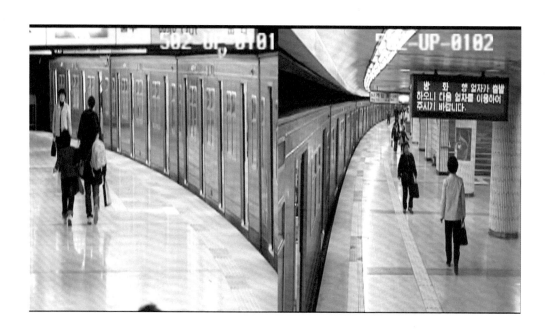

‹표범의 눈›
2021, 디지털 애니메이션, 컬러, 사운드, 3분 50초.
작가 소장, 오치 프로젝트 제공.
사운드: 크리스챤 아미고

이영주
Young Joo Lee

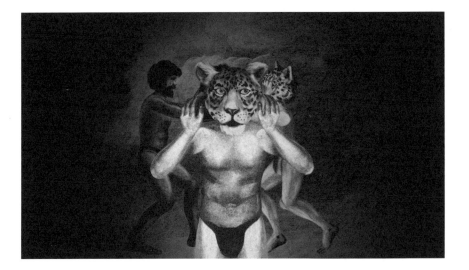

Jaguar's Vision
2021, Digital animation, color, sound, 3min. 50sec.
Courtesy of the Artist and Ochi Projects.
Sound by Cristian Amigo

‹검은 눈›
2019, 디지털 애니메이션, 컬러, 사운드, 11분 10초.
작가 소장, 오치 프로젝트 제공.

Black Snow
2019, Digital animation, color, sound, 11min. 10sec.
Courtesy of the Artist and Ochi Projects.

<‹검은 태양 X : 캐스퍼, 마녀, 그리고 물구나무종›
2021, 단채널 영상, 컬러, 사운드, 19분.
작가 소장. 국립현대미술관 지원으로 제작.

염지혜
Ji Hye Yeom

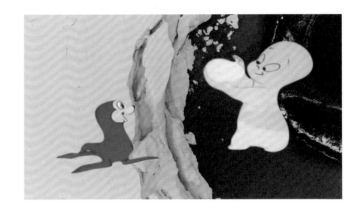

Black Sun X : Casper, Witch, and Handstanderus
2021, Single-channel moving image, color, sound, 19min.
Courtesy of the Artist. Commissioned by MMCA, Korea.

handstanderus will be a support for holding each other tightly, won't they?

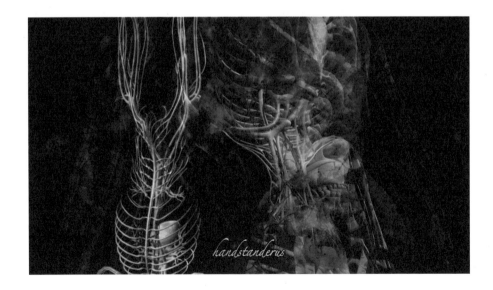

handstanderus

‹사랑의 잠재력›
2018, 3개의 부분으로 구성된 무빙이미지 조각:
 #1 – 22개 DIP LED 모듈로 이루어진 각진 형태의 비디오 조각
 (4K/HD; 7분 54초 반복; 조각 크기 614×384×15cm)
 #2 – '모니터 거울'이 부착된 두 개의 연구 테이블 (4K/HD; 2분 8초,
 3분 6초 반복, 크기 100×72×54cm)
 #3 – 세로 형태의 단채널 프로젝션 (4K/HD; 2분 35초 반복;
 프로젝션 크기 약 400×225cm)
사랑의 잠재력, 에이샤-리사 아틸라.
사진 © 2018 크리스탈 아이, 헬싱키.
매리언 굿맨 갤러리 뉴욕/파리/런던 제공.
사진: 말라 후카넨

에이샤-리사 아틸라
Eija-Liisa Ahtila

POTENTIALITY FOR LOVE
2018, Moving image sculpture in 3 silent parts:
 #1 – Angular video sculpture of twenty-two DIP LED
 modules (4K/HD; 7min. 54sec. loop; sculpture size
 614×384×15cm)
 #2 – Two research tables with attached 'monitor
 mirrors' (4K/HD; 2min. 8sec. and 3min. 6sec. loops; size
 100×72×54cm)
 #3 – Vertical single channel projection (4K/HD; 2min.
 35sec. loop; projection size approx 400×225cm.
POTENTIALITY FOR LOVE by Eija-Liisa Ahtila.
Photos © 2018 Crystal Eye, Helsinki.
Courtesy of Marian Goodman Gallery, New York, Paris, London.
Photo by Malla Hukkanen

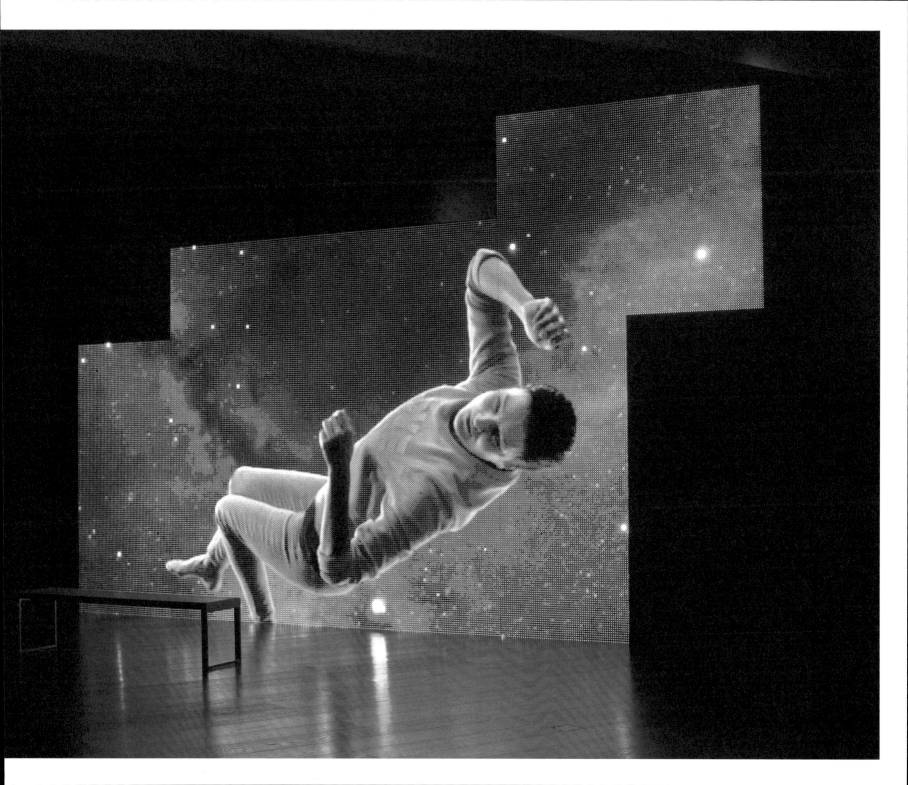

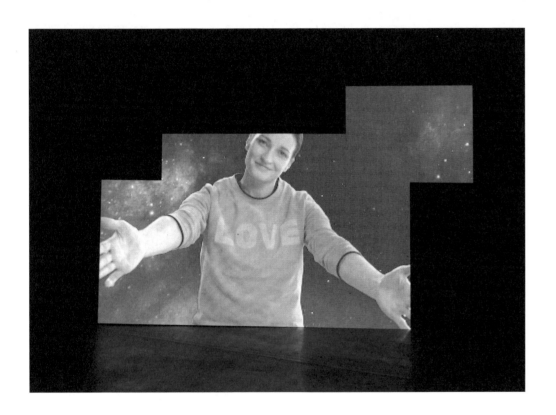

사진: 말라 후카넨
Photo by Malla Hukkanen

사진: 삼포 린코네바
Photo by Sampo Linkoneva

<사랑의 잠재력> 설치 전경
Installation View of *POTENTIALITY FOR LOVE*

‹빙하가 녹고 있다.›
2021, 벽에 목탄, 가변크기.
작가 소장. 국립현대미술관 지원으로 제작.

Glaciers are melting
2021, Charcoal on the wall, Dimensions variable.
Courtesy of the Artist. Commissioned by MMCA, Korea.

허윤희
Yun-hee Huh

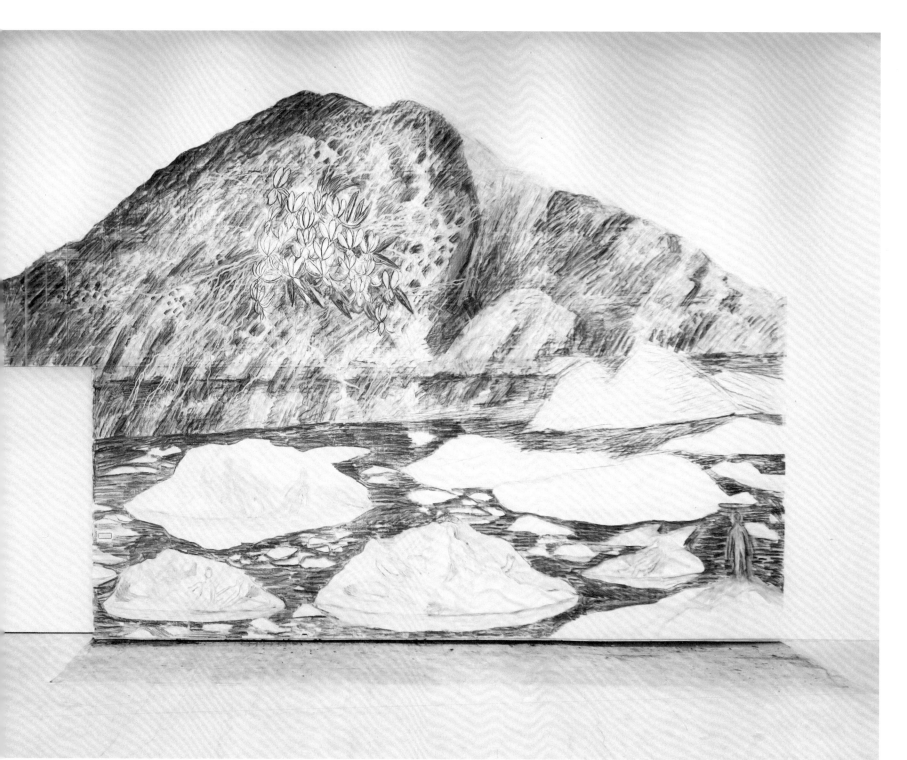

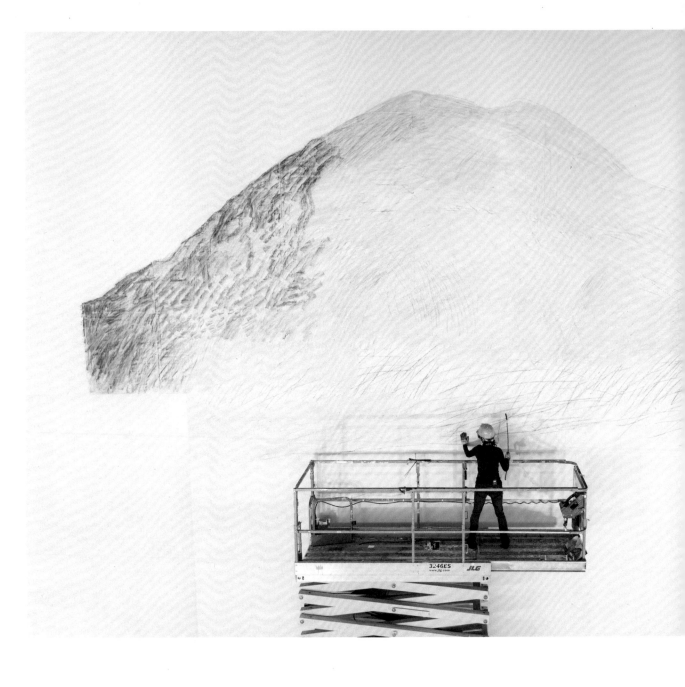

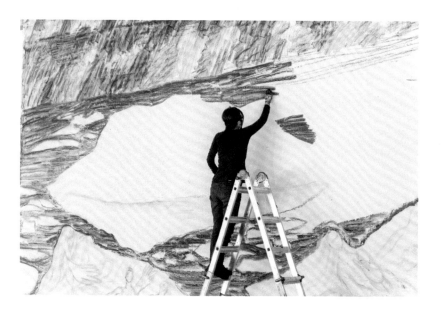

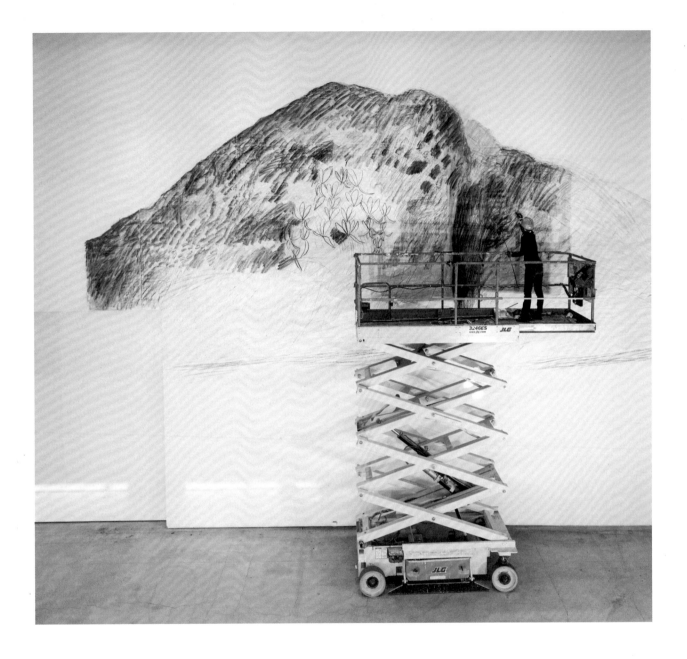

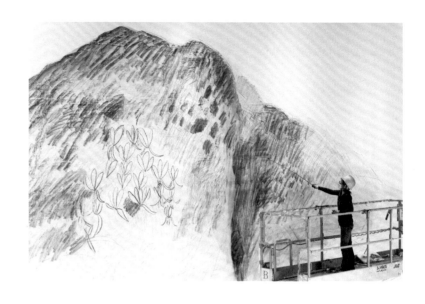

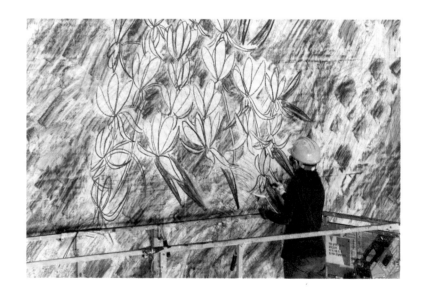

‹불로부터›
2021, 소나무 숯, 가변크기.
작가 소장. 국립현대미술관 지원으로 제작.

Issu du feu
2021, Wooden charcoal, Dimensions variable.
Courtesy of the Artist. Commissioned by MMCA, Korea.

이배
Lee Bae

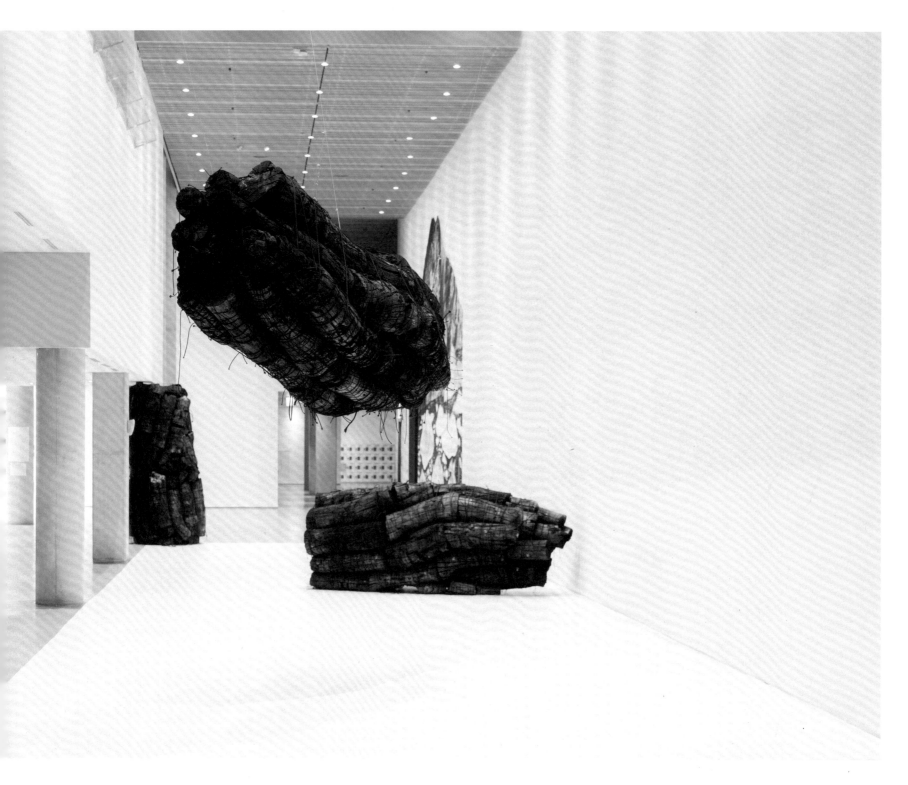

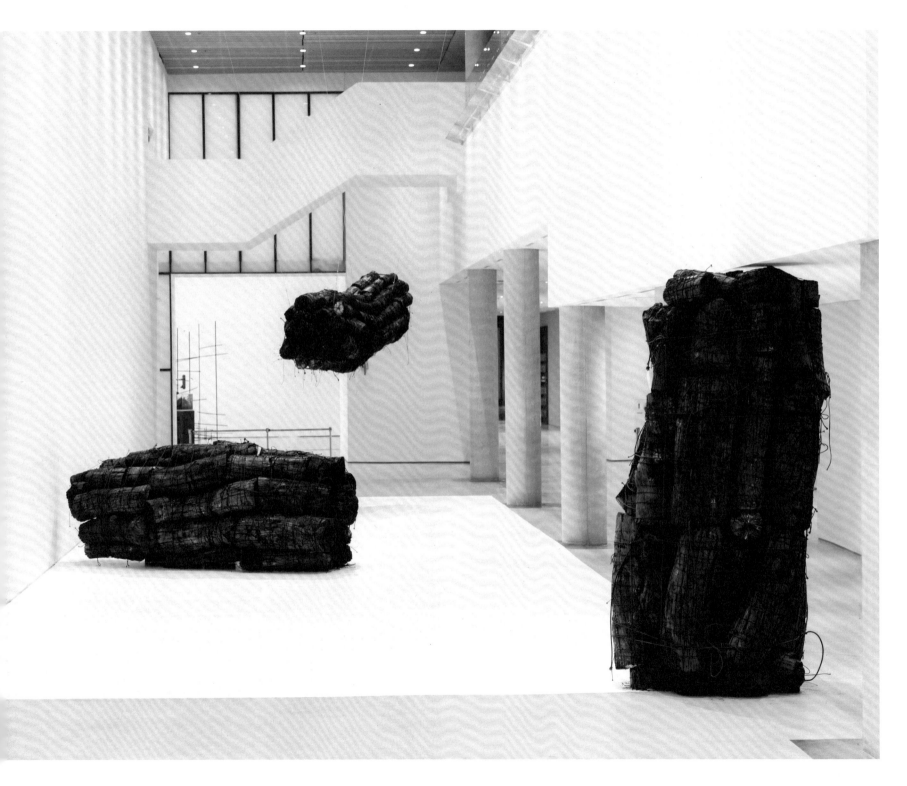

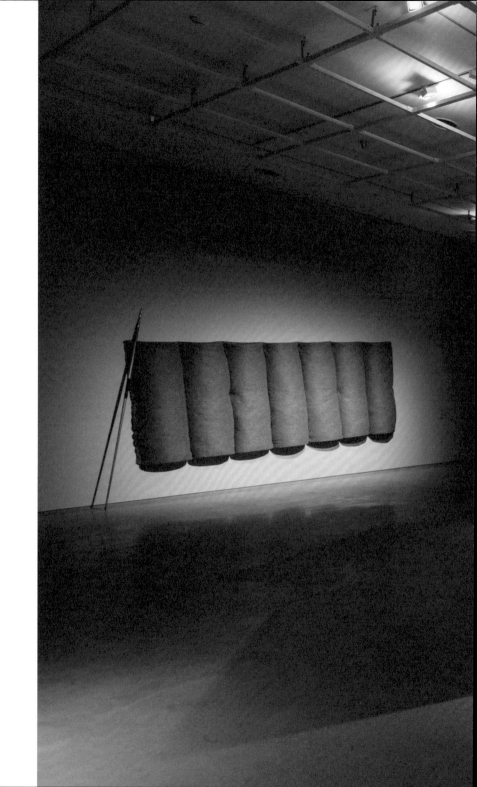

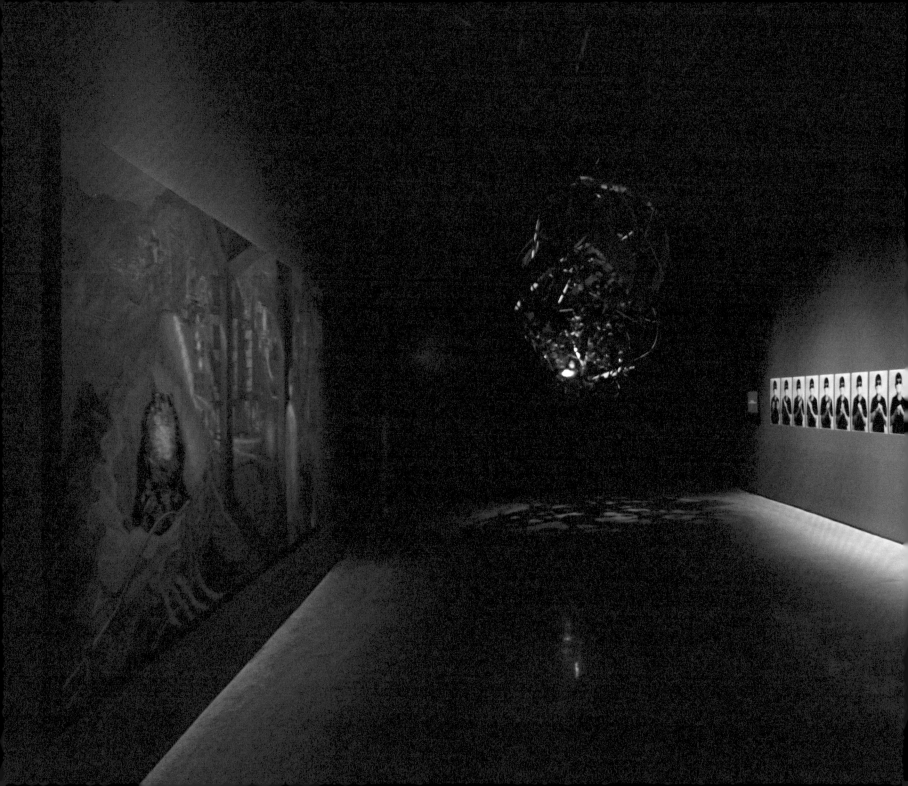

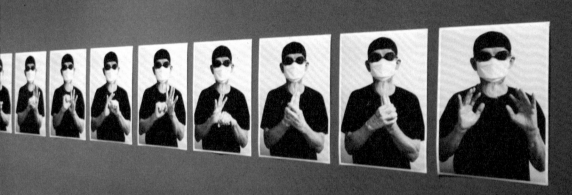

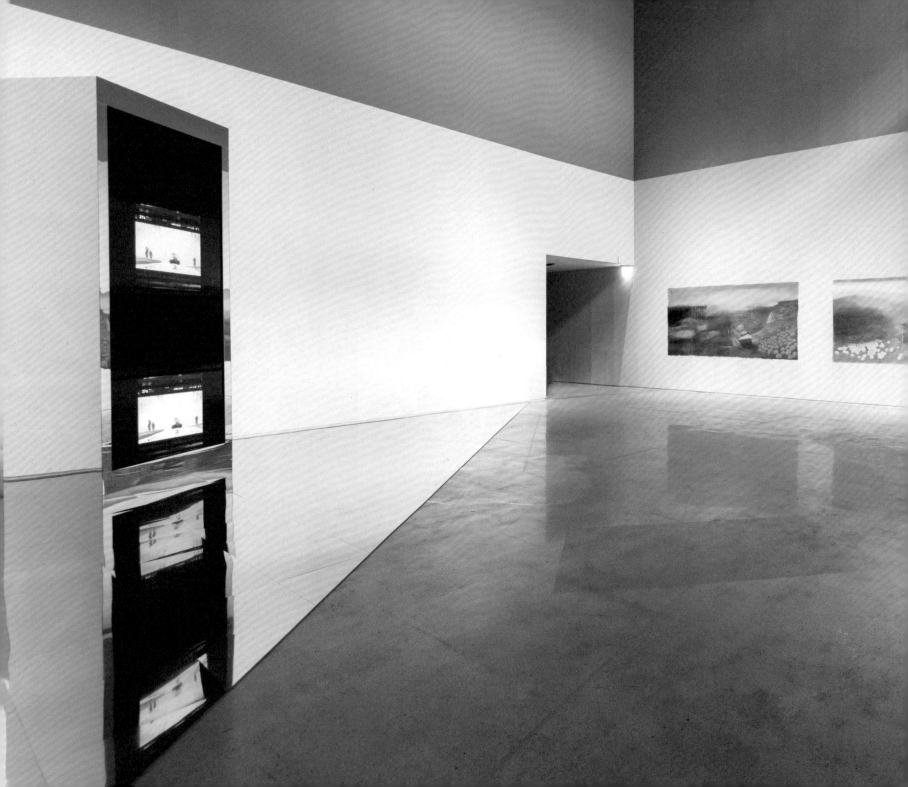

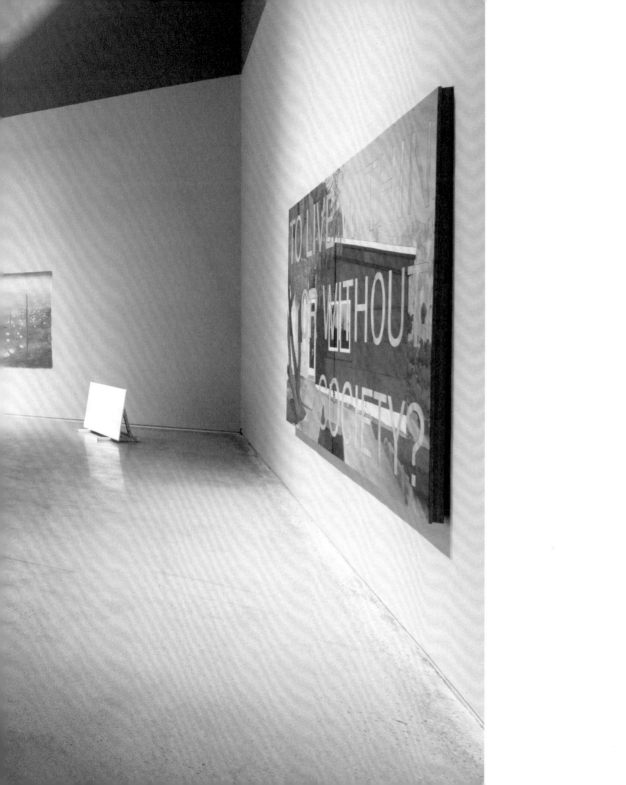

we went to the same river... we looked into

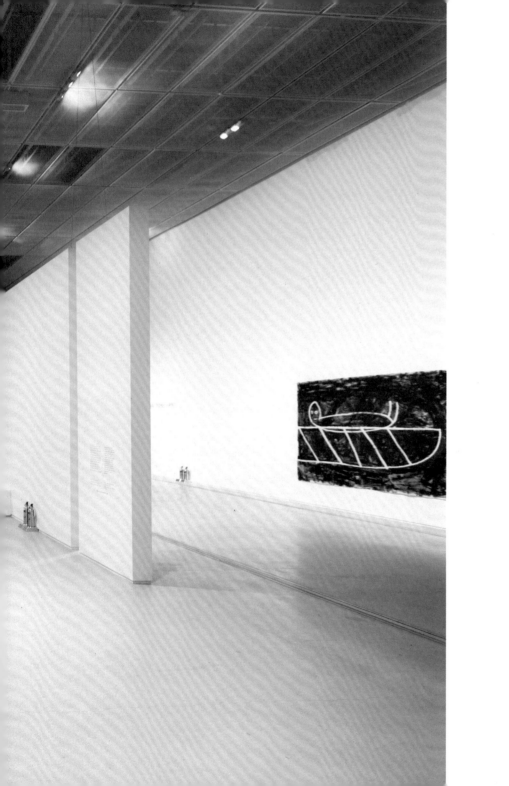

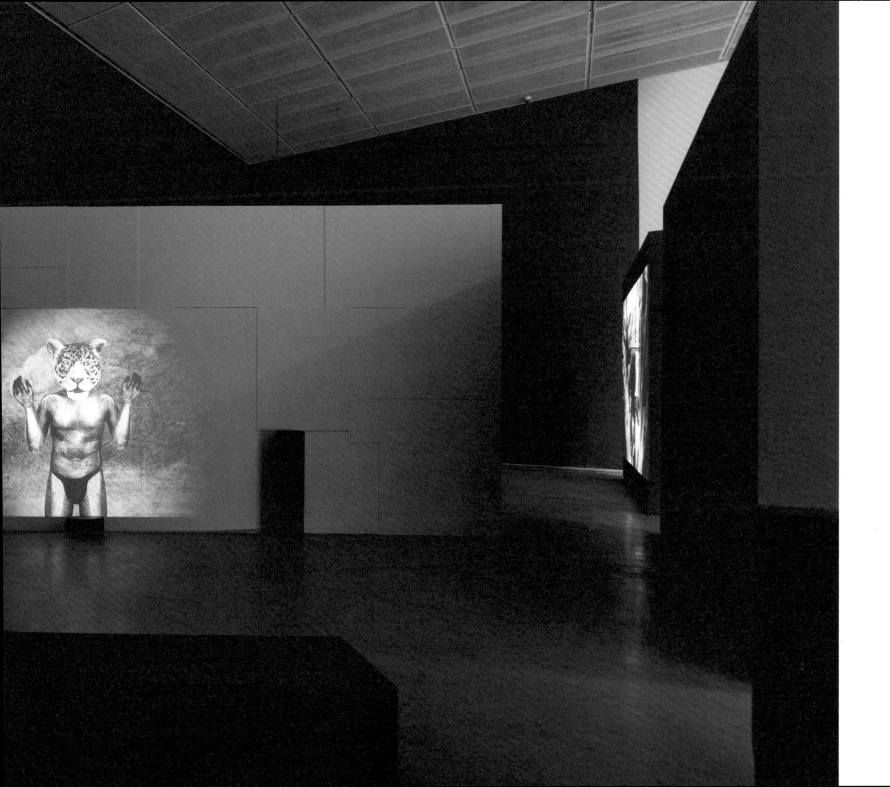

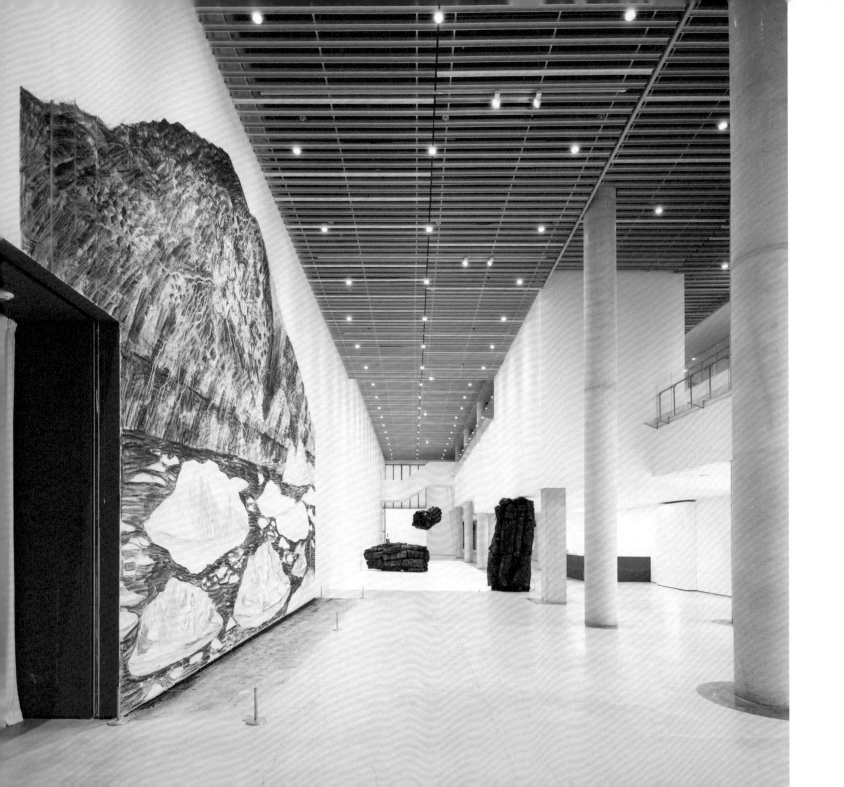

감염병 속에서 진화하는 인류 [1]

정명교

문학평론가
연세대학교 국어국문학과 교수

Human Evolution through Epidemics [1]

Myeong Kyo JEONG

Literary Critic
Professor of Korean Language and Literature, Yonsei University

1. 미래가 없는 인내

옥스퍼드 출판사의 '짧은 소개(Very Short Introductions)' 총서에 포함되어 있는 『팬데믹—매우 짧은 소개(Pendemics—A Very Short Introduction)』에서 감염병에 대한 기술은 다음과 같다.

감염병은 통상 특정한 시기에 예기치 않게 일어나 광범위하게 퍼진 질병 사고를 말한다.[2]

그러니까 감염병은 '사고'다. '사고'의 성격은 '예측할 수 없었다'는 데에 초점이 놓인다. 미리 대비할 수 없고, 원인을 모르니 실상을 파악하는 데에 시간이 걸리고, 대강의 윤곽을 그려보기도 전에 지나가 버린다. 지구상의 생명이 사고를 견딜 수 있는 건 그것이 지나가기 때문이다. 사고는 일회적이다. 그러나 그 영향은 지속적이다. 수많은 사상자가 생기는 것만이 문제가 아니다. 그보다는 사회 자체의 근간을 뒤흔들어버리기 일쑤다.

왜냐하면 그것은 무엇보다 인간 능력에 대한 의심에 보태, 공동체의 기능과 인간 자체에 대한 회의를 야기하기 때문이다. 사람들은 당황하고 인간 이성 저편의 다른 권능에 마음을 의탁하려고 한다. 그리스 역사가 투키디데스(Thucydides)가 기록한 기원전 430-426년의 '아테네 감염병'은 펠로폰네소스 전쟁 도중에 일어나 아테네 시민 25-35 퍼센트의 사망을 초래했다. 그러자 "많은 사람들이 신들이 화가 났다고 믿었는데, 그러나 신을 달래는 어떤 제의도 효과가 없었다."[3]

1. The Patience to Endure—Even without a Future

In the book *Pandemics—A Very Short Introduction* included in Oxford University Press's *Very Short Introductions* series, epidemics are described as follows:

An epidemic is generally considered to be an unexpected, widespread rise in disease incidence at a given time. [2]

Accordingly, an epidemic is an "incidence" of disease, fundamentally "unexpected." It cannot be prepared for and uncovering its true nature takes time due to its unknown origin. An epidemic is often finished before we can even make a rough sketch of it. Life on Earth can withstand these incidents because they are temporary and eventually pass. But while it is true that something incidental is, by definition, a one-time event, an epidemic's effects are long lasting. They can not only sicken many people, but shake society to its very foundations.

The ravages of an epidemic cast doubt on human ability and engender skepticism as to the nature of humanity and the function of community. In times of panic, people resort to forces other than reason. The Greek historian Thucydides described the Plague of Athens (430–426 BC, overlapping with the Peloponnesian War), in which 25 to 30 percent of Athenians died, thusly: "Many people believed in the displeasure of the gods, but the performance of rites to appease them had no effect." [3]

In contemporary times, similar misguided beliefs still exist uncorrected. In *The Plague* (1947), Albert Camus depicted these beliefs as leading his characters astray, and hardly any progress in debunking them has been made today, as can be seen in people's attitudes about the current COVID-19 pandemic.

The protagonist of *The Plague*, a doctor named Bernard Rieux, takes a prototypical existential and ethical position in the face of an inexorable force. His attitude, that of a patience that led nowhere, is one that humans have no choice but to adopt when confronted by a situation in which their smallest hopes are destroyed. Rieux, however, actively lives by this approach as a personal code of conduct. For Camus, this attitude of grappling with a given situation and enduring without false hope is the basic principle of "existential revolt," and can be further subdivided into three precepts.

First, epistemic evidence should be gathered and all lies dismissed. Second, people should participate as "insiders" (members of the group affected by the situation); and third, they must recognize themselves as "outsiders" as well, for it is only then that the prejudice and superstition that lurks within like-minded groups can be overcome. [4]

These three precepts, especially the third, point to the particularity of Camus's stance. Until now, it has been common for our understanding of Camus to stop at the second precept. He is widely known for the expression, "We're all in the same boat," a sentiment that can be explained by his background—he came of age under the hot Algerian sun, feeling oneness with nature. The contrast between this sentiment and Jean Paul Sartre's maxim, "Hell is other people," has been a major discussion point in philosophy.

이러한 '잘못된 믿음'에의 의존은 현대에도 거의 교정되지 않았다. 카뮈(Albert Camus)의 『페스트』(1947)에서도 인물들의 오류의 온상으로 거듭 지목된 것이었다. 오늘의 코로나바이러스에 대한 사람들의 태도에도 뚜렷한 진화는 보이지 않는다.

『페스트』의 주인공 리외는 이런 불가항력적인 사태에 대한 실존적 윤리학을 강렬하게 보여주는 대표적인 인물이다. 그의 태도는 인류에게 최소한의 기대조차도 좌절시키는 상황에 처한 사람들이 겪을 수밖에 없는 "미래가 없는 인내"를 거꾸로 적극적인 행동 수칙으로 삼는 것이다. 즉 헛된 희망을 품지 않고 견디면서 상황과 싸우는 것, 그것이 카뮈적 '반항인'의 기본 원리이다. 이 원리는 그 아래에 세부 원리를 갖는다.

첫째, 모든 거짓을 밀쳐내는 인식적 명증성, 둘째, 문제의 상황에 내부인으로 참여하기, 셋째, 그러나 외부인으로서 자기를 인식하기, 왜냐하면 그럴 때만 집단적 동일성 내에 도사리고 있는 편견과 미신을 극복할 수 있기 때문이다.[4]

이 세부 원리는 카뮈적 태도의 특별함을 가리킨다. 특히 세 번째 원칙 때문이다. 지금까지 카뮈에 대한 이해는 두 번째 단계에 머무른 경우가 태반이었다. 즉 카뮈는 "우리는 한 배에 타고 있다."는 입장의 대표적인 인물로 간주되어 왔고, 이는 카뮈가 알제리의 뜨거운 태양 아래에서 자연과 일체감을 느끼며 자라온 환경에서 기인하는 것이라는 설명으로 설득력을 얻었다. 그리고 "타인은 지옥"이라고 언명했던 사르트르(Jean Paul Sartre)의 태도와 뚜렷한 대조를 이루면서 큰 화제가 되었었다.

그러나 그는 그의 책 전체를 통틀어 "우리는 한 배에 타고 있다."고 말한 적이 없다. "나는 반항한다. 고로 우리는 존재한다.(Je me révolte, donc nous sommes.)"라고 말했을 뿐이다. 카

뮈는 이 말을 『반항인』에서 무려 4번이나 되풀이하였다.[5] 그러면서 스스로 『반항인』은 "이 말에서 시작해서 이 말로 끝난다고 할 수 있다."[6]라고 말했다. 데카르트의 그 유명한 명제. "나는 생각한다. 고로 나는 존재한다.(Je pense, donc je suis.)"의 절묘한 패러디라고 할 수 있는 이 명제는 생각에서 반항(자유의 추구)으로 인간 행위의 중심을 바꾸었고, 동시에 '나'에서 '우리'로 초점을 이동시켰다. 하지만 카뮈의 우리(공동체)에 대한 관점은 흔한 설명처럼 생래적인 것이 아니었다. 자유인으로서 반항하는 '나'의 행동, 그것이 '나'를 '우리'로 이어주는 출발점이 되어야 했다. 그래서 그는 '형이상학적 반항'이라는 절의 마지막 문장을 "저 우리는 혼자다.(Nous sommes seuls.)"[7]라는 말로 메지내렸다. 따라서 '나'와 '우리' 사이에는 공백이 있다. 어떤 방법적 원칙이 '나'를 '우리'로 이끄는가? 카뮈의 스승이었던 장 그르니에(Jean Grenier)에 의하면, 카뮈의 비결은 "명예와 충실성"이 그의 반항의 덕목들이라는 데에 있다.[8] 즉 반항이라는 자유의 추구를 자신을 명예롭게 하는 일과 동일시할 때, 그러한 명예는 이웃에 대한 충실성(즉 공동체에 대한 헌신적인 봉사)을 통해서만 입증될 수 있는 것이다.

2. 추락 너머: 함께 살기와 나의 자유

이상의 검토를 통해서 우리는 감염병의 발생이 인류에 끼친 세 가지 기본적인 여파를 그려볼 수 있다.

하나는 감염병의 급습이 인류의 퇴화를 초래한다는 것이다. 즉 인구를 감소시킬 뿐만 아니라 도덕적·사회적 지반을 무너뜨

Camus, however, never actually stated, "We're all in the same boat" in his writings. Instead, he said, "I revolt. Therefore, we exist [*Je me révolte, donc nous sommes*]." He repeats this phrase four times in the book-length essay *The Rebel*. [5] According to Camus, *The Rebel* begins and ends with this selfsame statement, [6] which can be considered an exquisite parody of Descartes's famous expression, "I think, therefore I am [*Je pense, donc je suis*]," moving the locus of human action from thinking to revolt (the pursuit of freedom), and the agent from "I" to "we." But Camus's "we" (community) is far removed from the common understanding of community as a natural state. In Camus's philosophy, one's act of revolt as a free human being must be the starting point for the link that joins the "I" to the "we." The section in *The Rebel* titled "Metaphysical Revolt" concludes with the statement, "We are alone [*Nous sommes seuls*]." [7] This implies that there is a gap between the "I" and the "we." What methodological principles lead from "I" to "we?" According to Jean Grenier, one of Camus's teachers, honor and faithfulness are key as the virtues behind revolt. [8] That is, when one thinks of revolt as a way of honoring oneself, then such honor can only be demonstrated by being loyal to one's neighbors (e.g., in dedicated service to the community).

2. Beyond the Fall: Collective Life and Individual Freedom

From the above analysis, we can identify three ways in which epidemics have impacted us.

First of all, the sudden outbreak of a contagious disease has a harmful effect. Not only does it reduce the population, but it destroys the foundations of society and general ethics. Panic strikes, threatening social structure, just as it eroded Greek democracy during the Plague of Athens. Medical journalists worried that "The choleraphobia will frighten to death a far greater number of Britons than the monster itself will ever destroy by his actual presence." during the 1830 cholera outbreak in Europe. [9] Cholera was the first contagious disease to cause a worldwide pandemic. In the 1870s, out of fear of cholera, Europe and the United States first restricted travel from India (where the disease was thought to have originated, although now this is uncertain) and went on to suspend all trade with the East. [10] In addition, this fear created an atmosphere of "social stigmatization" that led Americans to regard purportedly "'undesirable immigrants,' such as Russians, Italians, Australians, Hungarians, and Irish" "not only as symbols of disease, but as a menace to American social structure." [11] With the current COVID-19 pandemic, we continue to witness similar incidents, spilling forth like wastewater, with nonsense and absurdity spreading more cruelly than the disease itself.

Until now, however, contagious diseases have either been temporary or human society has accommodated them, as in the case of the flu. So, it is hard to say that there is concrete proof that epidemics really degrade human mental health and the structure of society. Either due to the transience or the accommodation of past diseases, at some point, people have been free of them. We also find clues to achieving better health at every opportunity. An outbreak of malaria in

린다. 우선은 정신적인 공황이 불어닥치고 그 여파로서 사회구조가 위협에 처한다. '아테네 감염병'이 공황상태를 거쳐 그리스 민주주의의 침식을 야기하였다고 할 수 있다면, 1830년대 유럽에서 발생한 콜레라는 당시의 의학 전문기자로 하여금 "콜레라 공포가 콜레라라는 괴물이 할 수 있는 것보다 훨씬 많은 숫자의 인구를 죽음으로 내몰 수 있다."[9]는 점을 걱정하게 했다. 콜레라는 또한 세계적 규모의 감염병의 단초가 된다. 콜레라 공포는 1870년대에 와서 유럽과 미국으로 하여금 콜레라의 진원지로 알려진 인도로부터의 여행(지금의 연구에 의하면, 발생원은 분명치 않다), 더 나아가 동방과의 교류 전체를 제한하는 움직임을 유발했다.[10] 더 나아가 이러한 공포는 "사회적 낙인찍기"의 분위기를 조성하여, 콜레라에 시달린 미국 사람들은 "러시아, 이탈리아, 호주, 헝가리, 아일랜드로부터 온 '원하지 않은 이민자들'"을 "질병의 상징으로서 뿐만이 아니라, 미국 사회구조에 대한 위협"[11]이라고 생각하게 되었다. 현재 전 세계가 겪고 있는 코로나 팬데믹에서도 우리는 온갖 종류의 유사한 해프닝들이 폐수처럼 쏟아지면서, 황당무계한 분위기들이 감염병보다 더 지독하게 번지는 광경을 보았고, 지금도 보고 있다.

그러나 지금까지의 감염병들은 모두 일시적으로 지나가거나 아니면 독감처럼 인간사회에 동화되었다. 그래서 감염병이 인류의 정신과 사회 구조를 결정적으로 퇴화시킨다는 것을 확증할 사태가 실제로 일어났다고 말하기는 어렵다. 그 일시성과 동화성 때문에 사람들은 어느 순간 감염병으로부터 해방된다. 그리고 인류는 약간의 기회에서 갱생의 실마리를 찾는다. 로마의 말라리아는 질병과 환경의 연관성을 검토하게 했다.[12] 환경의 개선을 통해서 감염병의 발생을 억지할 수 있다는 깨달음을 얻게

된 것이다. 질병 자체에 대한 대처보다 질병이 발생할 수 있는 조건들을 관리하는 것이 더 중요하다는 것을 알게 된 것이다. 이러한 관점의 선회는 18세기 중엽에서부터 19세기 사이에 '치료'가 아니라 '위생'을 대책의 근본으로 세우게 하였다.[13] 우리나라에서도 '질병관리본부'의 설립과 '질병관리청'으로의 승격 역시 이러한 관점 전환의 줄기 속에 놓인다.

따라서 감염병이 인류에게 끼친 진정한 영향은, 재앙을 견디고 다시 일어서는 현실 극복의 드라마에 있다고 할 수 있을 것이다. 인류는 이런 드라마를 통해, 단순히 진화(적응)의 원리를 따를 뿐만 아니라 진화 시스템 자체를 진화시킬 수 있는 능력이 있음을 보여주었다. 앞에서 카뮈를 통해 제시한 마지막 두 가지 원칙은 그러한 드라마의 핵심 동인으로 작용하는 인간적 대응들이다.

무엇보다 두 번째 원칙, 즉 '내부자로서 참여하기'가 감염병을 이겨내는 가장 중요한 자세임을 역사는 그대로 증명하였다. 그 자세는 공동운명의 인식과 그에 의한 공통 행동을 처방으로 만들었다. 방금 앞에서 말한 '치료'로부터 '위생'으로의 전환은 감염병을 우리 모두의 문제로 인식했을 때 가능했던 획기적인 발상이었다. 오늘날 팬데믹에 대한 가장 강력한 대책으로 작용하고 있는 것도 마찬가지다. 작년(2020년) 9월 21일 '유엔 75주년 기념 고위급회의'에서 한국의 대통령이 "연대와 협력은 바이러스가 갖지 못한 인류만의 힘이고, 코로나에 승리할 수 있는 가장 강력한 무기이기도 하다."라고 발언한 것은 그런 태도의 표현이라고 할 것이다.

이러한 대처가 실질적인 효과를 발휘하고 있음을 분명히 목도하고 있는 상황 속에서 더 말할 필요조차 못 느낄 수도 있다.

Rome in the 5th century led to a review of the link between disease and the environment. [12] It was then discovered that disease could be prevented by improving environmental conditions. Analysts realized that it is more important to manage the conditions under which a disease may occur than to deal with the disease itself once it does. This shift in perspective led to the establishment of measures that focus on sanitation rather than on treatment from the mid-18th through the 19th centuries. [13] In Korea, too, this shift was responsible for the establishment of the Korea Centers for Disease Control and Prevention (KCDC; now the Korea Disease Control and Prevention Agency, or KDCA) and its elevation to a government ministry-level organization.

Therefore, it can be said that the real impact epidemics have on humankind is that they provide occasions for a certain sense of drama—the drama of people overcoming their present reality, surviving disasters, and rising again. In these occasions, human beings not only follow the principles of evolution (adaptation), but also demonstrate their ability to influence the process of evolution itself. Camus's second and third precepts are human responses that act as key forces in these dramatic plays.

Above all, history has proven that the second precept—that people should participate as insiders in a given situation—is of paramount importance in overcoming an epidemic. This attitude prescribes that we be aware of our destiny and that our collective actions proceed from this awareness. The shift from an emphasis on treatment to one on sanitation as described above was a revolution in thinking that only became possible when humans recognized that

contagious diseases were everyone's problem. This precept also lies at the foundation of the strongest measures we have taken against our current pandemic. On September 21, 2020, at a videoconference that marked the 75th anniversary of the UN, Korean President Moon Jae-in upheld this principle in the following statement: "Solidarity and cooperation is a power unique to humans that a virus can never match. At the same time, it is the most potent weapon at our disposal that can defeat the coronavirus."

When we realize that this precept can be put into practical action, we may feel there is no need to even speak of it. However, this precept entails two corollaries. One is Camus's first precept, which focuses on the accuracy of perception. Certain collective responses may result from "bad faith" (*mauvaise foi*; a denial of personal agency that occurs when individuals act inauthentically due to social pressure), and we must guard against this. Secondly, policies focused on a common goal inevitably infringe on personal freedom, so care must be taken in their design. After all, freedom is the stepping-stone to human evolution and renewal. Camus's third precept is that in this moment, we demand vigilance of ourselves, as we are, collectively, a single flame. To face an epidemic as an insider and an outsider simultaneously means that each person must live both as someone infected by the disease and as someone free from it. Even as we fight against disease in the present, we must maintain a view of ourselves as people who have vanquished it to achieve freedom. This is in order to become these free people in the future.

Therefore, we must monitor current pandemic-related measures and codes so that they do not change into modes

그러나 여기에는 두 개의 전제가 따라야 한다. 하나는 카뮈에게서 본 첫 번째 원칙, 즉 인식의 정확성이다. 왜냐하면 공동의 대응이 잘못된 믿음(mauvais foi)에서 비롯될 수도 있기 때문이다. 또 하나의 전제는 불가피한 공동운명의 방침들이 개인들의 자유를 침해하는 데에 있어서 극도의 신중함이 요구된다는 것이다. 왜냐하면 인간의 진화와 갱신은 자유를 디딤돌로 날아오를 수 있기 때문이다. 카뮈에게서 본 세 번째 원칙이 바로 이 자리에 오롯한 촛불로 우리의 각성을 요구하는 것이니, 감염병의 사태 앞에서 내부인이자 동시에 외부인이 된다는 것은, 감염병에 갇힌 자이면서도 동시에 감염병으로부터 해방된 자로서 살아가야 한다는 것을 가리킨다. 우리는 감염병을 물리쳤을 때의 자유인의 모습을 떠올리면서, 감염병의 현장 안에서 싸워야 한다. 즉 그런 자유인이 우리의 미래가 될 수 있도록.

따라서 현재의 강령들과 시행세칙들이 자칫 억압적 기제로 변화하지 않도록 우리는 항상 감시해야 하고, 또한 우리 스스로를 거듭 점검해야 한다. 그 점에서 카뮈의 '반항인'의 고뇌는 다시 한번 우리를 깊은 성찰 속으로 인도한다. 그는 1959년 6월의 '작가수첩'에 이렇게 적는다.

나는 윤리적 관점을 포기했다. 윤리는 추상으로, 불의로 인도한다. 윤리는 광신과 맹목의 어머니다. 도덕적인 사람은 남의 목들을 잘라야 한다. 그러나 입으로는 윤리를 설파하면서도 도덕의 높이에서 살지 못하는 사람들에 대해서는 뭐라고 하면 좋은가? 목이 잘려 떨어지는데 그는 충실하지 못하게 법률을 제정한다. 윤리는 둘로 자르고 분리시키고 살을 발라낸다. 윤리를 피해야 하고 심판받는 것을 용납해야 하고 더 이상 심판하지 말아야 한다. 그렇다고 말하고 통일을 이루어야 한다.[14]

『반항인』은 그런 윤리가 압제로 전화하여, 사회의 법칙으로 자리잡는 것을 "도덕적 허무주의와 더불어 오직 권력 의지만"[15]이 날뛰는 사태로 보았었다. 이 권력화된 허무주의는 실제 감염병보다도 더 무서운 감염병이다. 우리는 그 끔찍한 재앙을 20세기의 독일과 소련에서, 더 나아가 코소보에서 여실히 보았고, 여전히 지구의 사방에서 보고 있다.

3. 우리 자신에 대해 "깨어 있으라, 놀람 있으라"

따라서 감염병이 인류에게 끼친 가장 중요한 영향은, 인류 자신이 감염병의 수원이 될 수도 있다는 자각, 그리고 공동운명과 자유 사이의 쉽지 않은 관계에 대한 깊은 성찰의 출현이라 할 것이다. 이에 대한 진지한 숙고만이 불가항력적인 사고에 휩싸인 우리를 노예화의 방향이 아니라 자유의 방향으로 난 연대의 길을 더듬게 할 것이다. 코로나 사태에 대응한 지난 해의 한 책은, "깨어 있으라, 놀래지 마라!(Be Alert, Not Alarmed!)"[16]라는 어느 웹사이트에 뜬 문구를 소개하고 있다. 코로나 앞의 인류가 취해야 할 태도를 가장 잘 압축하고 있다고 생각한다. 그러나 여기에 덧붙여야 할 것이 있다면, 이 명제는 감염병에 대해서 뿐만 아니라, 인류 자신에 대해서도 작용하여야 한다는 것이다. 인류는 감염병을 이겨낸다는 명분 하에 감염병의 숙주로 기능하는 장치가 작동하지 않도록 경계해야 한다. 그 점에서 인류는 감염병에

of oppression, and we must also examine ourselves. In this regard, the agony of Camus's "rebel" guides us once more on the path to self-reflection. Camus wrote the following passage in his notebook in June 1959.

I have abandoned the moral point of view. Morals lead to abstraction and to injustice. They are the mother of fanaticism and blindness. Whoever is virtuous must cut off the heads. But what to say of those who profess morality without being able to live up to its high standards. The heads fall and he legislates, unfaithful. Morality cuts in two, separates, wastes away. One must flee morality, accept being judged and not judging, saying yes, creating unity—and for the time being, suffering agony. [14]

In *The Rebel*, the kind of morals described above assume dominance and social rules stem from them. Camus portrays this as moral nihilism in tandem with the desire for power running rampant—a kind of hell, essentially. [15] To Camus, nihilism taking hold is much more terrifying than a contagious disease. We witnessed this kind of ethics-based power take hold in Germany and the Soviet Union, and later in Kosovo, in the 20th century and we still see it in places around the world today.

3. Be Awakened and Surprised

The greatest effects an epidemic may have on human beings is the consciousness that they may be a source of disease, and reflection on the fraught relationship between collective destiny and individual freedom. Consideration of these questions is imperative in order to move, of our own free will, along the road to solidarity rather than in the direction of slavery, helpless against the inexorable force of an outbreak. A book published last year on the response to COVID-19 drew attention to a slogan on a website: "Be Alert, Not Alarmed!" [16] This very succinctly expresses the attitude that we should take in the face of them pandemic. But if I could add something, it would be that we should apply the statement to ourselves as much as we apply it to the pandemic. Human beings should be alert in their efforts to not let something in themselves host a disease under the pretext of combating it. And instead of being afraid of a disease, they should be ready to be surprised by themselves. This is the only way of maintaining communication between destiny and freedom.

One may resist oppression by establishing communication between destiny and freedom, but additionally, one may also answer the call of human evolution and cultivate the creative expression of free will. The pandemic has brought the principles that drive society to a sudden stop, restricting the full range of human behavior to basic, instinctual motion. Psychoanalyst Jacques Lacan once likened this situation to having seen in an epidemic "a blind rabbit in the middle of a road, lifting the emptiness of his vision changed into a look toward the setting sun." He explained the analogy in the following terms:

대해서는 두려워 말아야 하지만 인류 자신에 대해서는 항상 놀람의 촉수를 세우고 있어야 할 것이다. 그것만이 운명과 자유를 상통시키는 길일 것이다.

한데 이 운명과 자유의 소통은 단순히 통제에 대한 저항만으로 그치는 것이 아니라, 거꾸로 자유의지의 창조적 실현을 발휘함으로써 인류의 진화적 소명에 부응하는 것일 수도 있다. 팬데믹의 상황은 사회적 작동이라는 관점에서 본다면, 사회 전체를 주도하는 원리의 갑작스러운 멈춤에 해당한다. 이런 상황은 인간들의 행동을 기초적인 본능적 동작들로 환원시킨다. 자크 라캉(Jacques Lacan)은 이런 상황을 전염병이 몰아친 상황에서 발견된 "눈 먼 토끼"에 비유한 적이 있다. 이 짐승은 그의 표현을 빌리면, "자신의 맹목이 시선으로 변해버리게 되어서, 길 한가운데에서 지는 해를 향해 몸을 일으킨"다. 그 비유를 두고 정신분석가는 다음과 같이 설명한다.

여기서 말은, 의식을 정돈하는 구체적 이야기로부터 추방되지만 주체의 자연적 기능들 오직 기질적 고통만이 주체의 개별적 존재와 본질 사이의 틈을 벌려놓는다면 말이다. 그러한 틈이 질병을, 생명체를 주체의 존재 속으로 도입하는 것으로 만든다―또는 주변 세계[환경]Umwelt와 내적 세계 Innenwelt 사이의 경계에서 그러한 기능들의 관계적 구조화를 조직하는 이미지들 속에서 매체를 발견한다.[17]

"의식을 정돈하는 구체적 이야기"로서의 말을 '사회 교통 원리'로서의 말이라고 할 때, 그 말을 상실했을 때라도 여전히 '말'은 작동한다는 것이다. 무의식의 차원으로 격하된 주체는 자신에게 엄습한 상황(질병의 감염상황)과 그 매개자(질병) 자체를 질료로 삼아 새로운 말을 만들어 현재의 상황을 넘어선 새로운 의식의 세계를 창출하려고 애쓴다. 이러한 과정 자체는 넓은 의미에서 보면 생존의 본능에 허덕이던 인간이 세계의 창조자로 비상하는 수행을 압축한다.

그 점에서 1918년 '스페인 독감'으로 희생된 예술가 에곤 실레(Egon Schiele)의 예는 모범적이라 할 것이다. 최소 2천만, 최대 5천만의 사망자를 초래한 이 팬데믹에서 예술가들의 희생도 적지 않았다. 구스타프 클림트(Gustav Klimt), 에곤 실레와 그의 임신 6개월 중의 아내, 시인 아폴리네르(Guillaume Apollinaire)가 대표적인 희생자들이었다. 1918년은 에곤 실레가 처음으로 "빈(Vienne)에서 대중적인 성공"[18]을 거둔 해였다. 그런데 그는 곧바로 자신과 친지들의 재앙에 직면하게 된 것이다. 그러나 화가로서의 그의 소명을 멈추지 않았다. 그는 자신의 스승 클림트의 "임종의 침상을 스케치"했고, 10월 27일, 병상에 누운 아내 에디트를 "냉정할 정도로 정직하면서도 부드러운" 화체로 소묘했다. "슬프고 겁에 질린 눈빛"으로 화폭을 지켜보던 아내는 다음날 숨졌다. 실레 역시 죽음의 습격을 벗어날 수 없었다. 한 역사학자는 실레의 최후의 나날을 이렇게 기술한다.

실레는 감염을 피하기 위해 할 수 있는 모든 일을 다 했다. 그러나 그의 몸은 너무 약했다. 1918년 10월 31일 그는 의붓어머니 집에서 죽음을 맞이했다. '전쟁[=1차세계대전]은 끝났다.' 그는 죽어가면서 이렇게 말했다. "이제 나는 가야 한다. 내 그림들은 세계의 모든 박물관들에서 전시될 것이다."[19]

Here speech is driven out of the concrete discourse that orders consciousness, but it finds its medium either in the subject's natural functions—provided a painful organic sensation wedges open the gap between his individual being and his essence, which makes illness what institutes the existence of the subject in the living being—or in the images that, at the border between the *Umwelt* and the *Innenwelt* organize their relational structuring. [17]

If we take language in the capacity of "concrete discourse that orders the subject's consciousness" to mean language that follows "the principles of social communication," then language is still operational even if speech is lost. Consciousness, downgraded to an unconscious state, uses the situation it is swept up in (the contagious aspect of a disease) and the medium (the disease itself) as the materials with which to make a new language and new consciousness to overcome the current situation. In a broad sense, this process itself shows in abridged form the extreme performance of human beings as they struggle, gasping and panting, to survive as creators in the world.

The case of Egon Schiele, an artist who died in the 1918 outbreak of Spanish flu, is exemplary in this regard. Somewhere in the range of 20 to 50 million people died in the pandemic, and many artists were among the casualties, including artist Gustav Klimt, poet Guillaume Apollinaire, and Egon Schiele and his wife, who was six months pregnant at the time. Schiele had just achieved his first taste of popularity and success in Vienna in 1918. [18] Even faced with the onslaught of the disease, he did not give up his vocation as a painter. He sketched Gustav Klimt on his deathbed, and on October 27 of that year, he drew his bedridden wife, Edith, in a sketch that was "honest to the point of cold-heartedness, even as it was also tender." Edith, who watched the canvas with "sad and frightened eyes," died the following day. Schiele could not escape death's grip, either. One historian described his final days in the following passage:

> Schiele did everything in his power to avoid getting infected. Bet he had a weak constitution and died on 31 October 1918 at his mother-in-law's house on the Hietzinger Hauptstrasse. 'The war is over,' he said as he died, 'and I must go. My paintings shall be shown in all museums of the world.' [19]

As we know, his prediction came true. One could say that his artist's consciousness enabled him to turn a terrible situation into an opportunity to follow his vocation. In art, the meaning of an artist's life and artwork is preserved and passed on in his works. This represents the ideal human attitude. It is with awakened minds that small existential beings may overcome adversity and open up future possibilities, surprising even themselves with the new existence they create.

우리가 잘 알다시피 이후의 시간은 그의 예언을 여실히 증명했다. 그 증명을 뒷받침한 것은 최악의 상황조차도 자신의 천직을 발휘할 기회로 돌리려고 모든 노력을 바친 그의 예술가 의식이었다고 할 수 있다. 화가의 실천은 그가 남긴 작품들로써 그의 삶과 예술의 뜻을 항구히 보존하고 전달한다. 그럼으로써 인류의 이상적 자세를 상징한다. 그 모습은 부단히 깨인 정신으로 역경을 이겨내고 미래를 열어나감으로써, 스스로를 스스로에게조차 놀라운 존재로 만드는 작은 존재들의 형상이다.

(1) 이 글은 계간 『문화와 나』 제 111호(삼성문화재단, 2020년 겨울)에 「전염병의 인류학」으로 발표되었던 글을 바탕으로 뒷부분을 크게 보충한 글이다.

(2) Christian W. McMillen, *Pandemics: A Very Short Introduction* (New York and Oxford: Oxford University Press, 2016), EPUB version.

(3) Jo Hays, *Epidemics and Pandemics: Their Impacts on Human History* (Santa Barbara, California: ABC-CLIO, 2006), 3.

(4) 이에 대한 좀 더 상세한 풀이는 졸고, 「의사의 윤리에 대해서―『당신들의 천국』과 『페스트』의 경우」, 정과리[정명교], 『문학이라는 것의 욕망―존재의 변증법 · 4』, 역락, 2005, 356-366쪽을 참고하기 바란다.

(5) . Albert Camus, *L'homme révolté* in *Oeuvres complètes III. 1949-1956* [coll.: Pléiade] (Paris: Gallimard, 2008), 79, 149, 276, 277, 375.

(6) 『『반항인』에 대한 옹호』(1952. 11, 생전 미출간), in *ibid.*, 375.

(7) *Ibid.*, 149; 알베르 카뮈, 『알베르 카뮈 전집 5. 작가수첩 II / 반항하는 인간』, 김화영 옮김, 책세상, 2013, 2판, 538쪽.

(8) Jean Grenier, 「서문」 in Albert Camus, *Théâtre, Récits, Nouvelles* [coll.: Pléiade] (Paris: Gallimard, 1962), XXI.

(9) James Johnson, *The Times* 기고문, in Christian W. McMillen, *op.cit.*에서 재인용.

(10) Christian W. McMillen, *op.cit.*, Chapter 4.

(11) Joseph P. Byrne, *Encyclopedia of Pestilence, Pandemics, and Plagues* (Westport, CT: Greenwood Press, 2008), 585.

(12) Jo Hays, *op.cit.*, 13.

(13) 졸고, 「프랑스 문학과 의학」, 앞의 책, 379-380쪽 참조.

(14) 알베르 카뮈, 『알베르 카뮈 전집 7. 작가수첩 III / 스웨덴 연설 / 문학비평』, 김화영 옮김, 책세상, 2013, 2판, 329-330쪽.

(15) 알베르 카뮈, 『반항하는 인간』, 앞의 책, 538쪽.

(16) Mark Davis, Davina Lohm, *Pandemics, Publics, and Narrative* (New York: Oxford University Press, 2020) 46.

(17) Jacques Lacan, *Écrits* (Paris: Seuil, 1966), 280; 번역은 한국어 번역판, 「정신분석에서의 말과 언어의 기능과 장」, 『에크리』, 조형준 외 옮김, 새물결출판사, 2019, 328쪽에서 가져 옴.

(18) Victoria Charles and Klaus H. Carl, *1000 Dessins de génie* (New York: Parkston International, 2014), EPUB version.

(19) Catharine Arnold, "The Dying Fall," *Pandemic 1918: Eyewitness Accounts from the Greatest Medical Holocaust in Modern History* (New York: St. Martin's Press, 2018), EPUB version.

(1) This article has been revised and expanded from when it first appeared as
 "The Anthropology of Contagious Diseases" in *Culture and I*111, Samsung
 Foundation of Culture, Winter 2020.

(2) Christian W. McMillen, *Pandemics: A Very Short Introduction* (New York
 and Oxford: Oxford University Press, 2016), EPUB version.

(3) Jo Hays, *Epidemics and Pandemics: Their Impacts on Human History*
 (Santa Barbara, California: ABC-CLIO, 2006), 3.

(4) For a more detailed analysis, see the following article: Myeong Kyo JEONG,
 "On the topic of medical ethics: Cases in *Your Paradise* and *The Plague*,"in
 The Desire of That Thing that is called Literature —the Dialectic of Existence 4.
 (Seoul: Yeokrak Books, 2005), 356–366.

(5) Albert Camus, *L'homme révolté in Oeuvres complètes III. 1949-1956* [coll.:
 Pléiade] (Paris: Gallimard, 2008), 79, 149, 276, 277, 375.

(6) *Support for "The Rebel"* (November 1952, published posthumously). Also in
 ibid., 375.

(7) Ibid., 149. Also in Albert Camus, *Albert Camus: The Collected Works 5.
 Notebook II / The Rebel*, trans. Kim Hwa-young (Seoul: Chaeksesang, 2013, 2
 Volumes), 538.

(8) Jean Grenier, Preface in Albert Camus, *Théâtre, Récits, Nouvelles* [coll.:
 Pléiade] (Paris: Gallimard, 1962), XXI.

(9) James Johnson, *The Times*, cited in Christian W. McMillen, op. cit.

(10) Christian W. McMillen, op. cit., Chapter 4.

(11) Joseph P. Byrne, *Encyclopedia of Pestilence, Pandemics, and Plagues*
 (Westport, CT: Greenwood Press, 2008), 585.

(12) Jo Hays, op. cit., 13.

(13) See Myeong Kyo JEONG, "French Literature and Medicine," op. cit.,
 379–380.

(14) Albert Camus, *Albert Camus: The Collected Works 7. Notebook III/Lecture
 in Sweden*, trans. Kim Hwa-young (Seoul: Chaek Sesang, 2013, 2 Volumes),
 329–330.

(15) Albert Camus, *Albert Camus: The Collected Works 5. Notebook II/The Rebel*,
 trans. Kim Hwa-young (Seoul: Chaek Sesang, 2013, 2 Volumes), 538.

(16) Mark Davis, Davina Lohm, *Pandemics, Publics, and Narrative* (New York:
 Oxford University Press, 2020), 46.

(17) Jacques Lacan, *Écrits—The First Complete Edition in English*, trans. Bruce
 Fink (New York · London: W. W. Norton & Company, 2006), 232. Korean
 Translated Version, *Écrits*, trns. Jo Hyeongjun et. al., (Seoul: Saemulgyul,
 2019), 328.

(18) Victoria Charles and Klaus H. Carl, *1000 Dessins de génie* (New York:
 Parkston International, 2014), EPUB version.

(19) Catharine Arnold, "The Dying Fall," *Pandemic 1918: Eyewitness Accounts
 from the Greatest Medical Holocaust in Modern History* (New York: St.
 Martin's Press, 2018), EPUB version.

도시를 잠시 봉쇄합니다

심소미

독립큐레이터, 문화/과학 편집위원

The City is Temporarily on Lockdown

Sim Somi

Independent Curator

도시 곳곳에 바리케이드가 등장했다. 공공기관 앞, 거리 한가운데, 공원 입구, 박물관 광장을 에워싼 구조, 공항과 기차역, 성당 입구, 관광지 곳곳에까지 사람들의 입장을 금지하는 임시 펜스가 들어섰다. 이러한 금속 재질의 임시 펜스는 대게 건설 현장이나 공사장, 그리고 시위대 인근에 설치되던 것들이다. 파리에 펜스가 등장한 지도 어느새 1년이 넘었다. 이 펜스는 팬데믹 이후 공간 통치를 위한 도구로써 도시공간과 사람들의 행동 양식을 변화시키는 역할을 해왔다. 현대도시의 질서는 애초부터 '접촉의 공포'에 반응하여 성립되어 왔다. 리차드 세넷(Richard Sennett)이 명시하듯 현대도시의 목표는 도심에 빼곡한 신체를 대중의 모습으로 곳곳에 분산시키는 것이며, 이러한 도시에서의 질서란 근본적으로 '접촉의 결핍'을 의미한다.[1] 2020년 1월 이후 전 세계를 휩쓴 코로나바이러스는 '거리 두기'의 강령이 지시하듯, 접촉에 대한 엄청난 공포를 불러일으켰다. 글로벌 네트워크로 연결된 대도시의 풍경은 코로나19가 발병하기 이전까지만 해도 사뭇 비슷해 보였다. 현대도시는 하루 만에 지구 곳곳에 도달하는 이동성이 증명하듯 서로 유사한 신자유주의적 질서를 지닌다. 그러나 팬데믹 이후 도시공간의 모습은 이에 대처하는 국가별 방역 정책에 따라 현저하게 달라지게 된다. 지난 4월 평균 확진자가 500명인 한국과 30,000명이 넘었던 프랑스를 비교해 본다면, 도시공간의 작동 방식에서 여러 차이가 목격된다. 이는 도시공간을 관리하고 통제하는 방식뿐만 아니라, 도시 공공영역의 변화와 시민들의 대응 방식에 걸쳐 살펴볼 수 있다.

Barricades began to form around the city. Temporary fences—the kind used at construction or demonstration sites—were put up in front of public institutions, in the middle of streets, at park entrances, around museum grounds, in airports and train stations, at the entrances of cathedrals, and around tourist attractions to ban entry. It's been over a year since these fences first made their appearance in Paris during the initial outbreak of the COVID-19 pandemic, and they have since modified the cityscape and the pattern of human behavior as a tool of spatial governance. The order of the modern city was built on the "fear of contact" from the very beginning. As author Richard Sennett wrote, the purpose of the modern city is to disperse the tight swarm of bodies in the center of the city outward in the form of the general public—such order fundamentally signifies "lack of contact." [1] As affirmed by "social distancing" protocols, the coronavirus that has swept across the globe since January 2020 has led to an immense fear of contact. Up until the outbreak of COVID-19, the landscapes of large cities, all part of a global network, seemed more or less similar. Modern cities, connected thanks to the kind of mobility that enables relocation to any part of the globe in less than a day, all operated on similar neoliberalist orders until the start of the recent pandemic, during which different cities' appearances began to vary significantly depending on their country's disease control policy. Comparing Korea, where there was an average of 500 confirmed cases in April, with France, where there were more than 30,000, several disparities can be observed in their operational approaches to urban space. These differences can be found not only in terms of how urban spaces have been managed and controlled but also in terms of the changes in the public sphere and civil response.

Seoul and Paris, Cities of the "New Normal"

Thinking about Seoul as an urban space over the past year, the faces of people wearing masks is the first thing to come to mind. Sixth in Bloomberg's "Covid Resilience Ranking" in April 2021, [2] Korea is considered a country whose quarantine policy has proven successful since the early onset of the pandemic. The regulations, implemented according to different levels of social distancing including the limitation of private gatherings to less than five people, business hour restrictions, and the reduction of the number of in-school students, are mainly ones that dictate behavioral patterns, and relatively speaking, Korea has placed minimal restrictions or lockdowns directly on spaces. Meanwhile, France has implemented long-term regulations and a total of three lockdown orders to date in an attempt to govern its urban spaces. [3] French citizens were advised to work from home for over a year, and for months, the city of Paris operated under strict rules that allowed residents only one hour of travel within one kilometer of their residence. The slogan "Stay home," used worldwide throughout the pandemic, can be considered just a refined version of the repressive expression "The city is blockaded," and practically has the same effect as the latter as a code of conduct and a restriction on space.

Picturing Seoul and Paris under their disparate governing guidelines, contrasting images come to mind. This

서울과 파리, 뉴노멀의 도시

서울에서 지난 1년간 도시공간을 떠올려본다면 마스크를 쓴 사람들의 얼굴부터 생각이 날 것이다. 2021년 4월 '코로나19 회복력 세계 국가 순위'[2]에서 6위에 오른 한국은 팬데믹 초반부터 방역 정책에 성공한 나라로 손꼽혀왔다. 5인 이상 사적 모임 금지, 영업시간 제한, 등교 인원 축소 등 사회적 거리 두기의 단계에 따라 시행 되어온 규범들은 주로 행동 양식을 지시하는 것들이다. 한국에서는 공간을 직접적으로 통치하고 폐쇄하는 방식은 최소한으로 시행된 편이다. 반면, 프랑스의 경우 3회에 걸쳐 봉쇄령[3]이 있을 정도로 도시공간 통치 규범이 장기간 시행되었다. 일 년이 넘게 자택 근무가 권고되고, 수개월 간 거주지에서 1km 이내에 1시간 내 이동만을 허용할 정도로 엄격한 통제 하에 도시가 작동되었다. 팬데믹 동안 전 지구인의 슬로건이었던 "집에서 머무르세요!(Stay Home)"는 "도시를 봉쇄합니다."라는 폐쇄적인 말의 순화된 표현이었을 뿐, 시민의 행동과 장소를 규제하는 강령으로서는 사실상 유사한 의미를 지닌다.

상이한 통치 규범 하에 놓인 두 도시를 떠올려 본다면, 서울과 파리의 모습은 대조적으로 연상이 될 것이다. 이는 도시경관뿐만 아니라 이를 통치하는 기술 기반의 시스템에 대한 사회적 합의부터 차이를 보인다. 한국의 경우 일찍이 멀티미디어, 디지털기기, CCTV 등 도시 통제 기술이 안전한 도시 모델을 구현하는 데 있어 주요 인프라스트럭처로서 자리를 잡아 왔다. 기술 기반의 방역 시스템은 사실상 사회적으로 보유하고 있던 디지털 기술을 적용했을 뿐이다. 하지만 방역 초기에 감염자 동선 공개 등이 개인정보 보호 차원에서 문제가 되었고, 데이터 인권에 대한 공론화 과정이 뒤늦게 일어나기도 하였다. 반면, 프랑스의 경우 팬데믹 초기 마스크 착용에 대한 정부 지침부터 큰 혼란이 있었으며, 위치추적과 같은 정보 공유 시스템은 시민들의 저항에 의해 거의 활용되지 못했다. 이러한 문제를 해결하고자 정부에서 직접 스탑코비드(Stopcovid) 앱을 개발하고 전국민적 참여를 요했으나, 2020년 8월 사용률이 인구의 3%[4] 밖에 되지 않을 정도로 시민들의 불신은 컸다. 프랑스뿐만 아니라 서구 사회에서 기술 통치에 대한 시민들의 반발은 큰 편이며, 이는 무엇보다도 개인정보 남용 및 중앙집권적 권력에 대한 우려에서 비롯한다. 이러한 기술 기반의 통치 시스템에 대해서는, 시민사회와의 합의와 논의를 통해 민주적으로 자리 잡아야 하는 과제가 남겨져 있다.

팬데믹이라는 사회적 재난은 감염자 수와 상관없이 이에 대처하는 통치 시스템 대한 논의를 불러일으켰으며, 더불어 '위기 속에서도 도시공간이 민주적으로 작동 가능한가?'라는 큰 과제를 각 사회에 남기었다. 이 글을 쓰고 있는 2021년 봄, 전 세계가 코로나 백신 접종을 통해 팬데믹을 탈출하고자 애쓰는 동안에도 도시는 여전히 방역 정책을 기조로 하여 작동되어 간다. 이러한 상황 속에서 도시공간의 민주적이고 자율적인 변화, 시민의 적극적인 대응 방식을 목격하기란 쉽지 않다. 본 글에서는 프랑스에서 수개월 간 봉쇄령을 겪은 필자의 리서치를 바탕으로 하여, '코로나19 이후 도시공간이 재조직되어가는 양상과 이에 대응하는 시민적 실천 및 대안적 모색'을 다루고자 한다.[5] 이를 통해 '재난과 위기에 처한 도시가 과연 어떠한 방식으로 민주적인 공공영역을 도모할 수 있는가?'라는 물음에 접근해보고자 한다.

discrepancy comes not only from the overall cityscape of each but also from the social consensuses on the tech-based systems that govern them. In Korea's case, urban control technology such as multimedia and digital devices and closed-circuit cameras had settled in early as a major part of the infrastructure that actualizes a safe model of a city. In fact, its tech-based disease control system is the very system by which Korean society already operated, with a few digital tweaks. However, in the early stages of Korea's disease control approach, disclosure of the travel routes of the infected persons became an issue for privacy reasons, leading to a belated public debate on data privacy. In France's case, there was much confusion regarding government guidelines on wearing masks during the early stages of the pandemic, and information-sharing technology such as location tracking went largely unutilized due to public resistance. To resolve this issue, the French government developed the specialized app StopCovid (since renamed to TousAntiCovid) and requested national participation, but the level of public distrust was so high that only three percent of the total population was using the app in August 2020. [4] Technological governance is largely rebutted by citizens not only in France but in Western societies in general, and this resistance stems from concerns about the abuse of personal information and centralization of power. For such a tech-based governance system to work, the system has to be democratically established through discussions with and with the consent of civil society.

While the pandemic left many affected, it also sparked discussions about the different systems of governance in response to social disaster and moreover, left all societies with the pressing question, "Can urban spaces operate democratically during a crisis?" As of the spring of 2021, when this essay is being written, Seoul and Paris are still operating under disease control policies as the world strives to escape the pandemic through vaccination. It isn't easy under these circumstances to witness democratic and autonomous changes in urban spaces and active modes of response from citizens. Based on my research and experience of months of lockdown in France,[5] this essay intends to shed light on aspects of the reorganization of urban space that has proceeded since the outbreak of the pandemic, as well as civic practices and alternative responses to this reorganization, as an approach to the question, "How can a city in crisis democratically accommodate a public sphere?"

Over 200 Days of Cultural Facility Shutdown

After the first half of 2020, marked by the outbreak of the pandemic, most European countries began lifting their lockdown orders. Then, after a short summer of freedom, these countries entered second-phase lockdowns with the rise of infection rates. The last time public facilities and cultural spaces were open in France—a country with one of the highest infection rates—was October 29, 2020. This was also the day that all cultural activities including concerts, movie screenings, and plays, stopped. The sum of all days on which cultural facilities opened last year amounts to just six months. Tourists—as rare as they were—would visit the

200여 일간 폐쇄된 문화공간

2020년의 초 팬데믹을 지나, 여름이 되자 유럽의 대다수 국가는 봉쇄령을 해제하기 시작했다. 여름의 자유도 잠시, 감염세가 확산하자 유럽의 각국은 2차 봉쇄령에 진입하였다. 감염자 확산이 가장 높은 나라 중 하나인 프랑스에서 공공시설과 문화공간이 마지막으로 문을 연 것은 2020년 10월 29일이다. 이날은 공연, 영화, 연극 등 모든 문화 활동이 멈춘 날이기도 하다. 작년 한 해 문화공간이 문을 연 일정이라고는 6개월밖에 되지 않는다. 건물 외관이라도 보고자 드물게 박물관을 찾은 관광객은 사진을 찍는 것으로 아쉬운 마음을 달랜다. 세계 최대의 방문객 수를 자랑하는 루브르박물관은 건물 한가운데 광장에 유리 피라미드를 두고 있다. 박물관을 방문한 사람들이 가장 사진을 많이 찍는 장소는 바로 유리 피라미드가 있는 광장 한가운데이다. 하지만, 팬데믹 기간에는 이마저도 불가능했다. 박물관을 폐쇄하는 임시 펜스가 박물관 건물 입구가 아닌, 광장 전체를 둘러싸고 설치되었기 때문이다. 피라미드가 있는 광장을 한 번에 차단하는 방식이다. 관광객은 바로 이 펜스 앞에서 박물관-피라미드-광장을 모두 배경으로 하여 사진을 찍는다. 사람들이 경험하는 도시 속 문화공간은 루브르박물관의 사례처럼 매우 엄격하고 경직된 모습으로 차단되었다.

도시를 탈출하는 사람들

제한된 활동과 폐쇄된 공간적 상황은 사람들에게 대도시 생활을 체념하게 하였고, 감염 확산세와는 상관없이 많은 사람들이 파리를 탈출하였다. 대도시의 폐쇄된 분위기에서 벗어나고자 하는 사람들은 도시에서 나와 전원주택이나 한적한 시골 등으로 떠났으며, 특히 크리스마스를 전후로 많은 사람들이 고향으로 일시적인 탈출을 감행했다. 이를 다룬 한 기사에 의하면, 1차 봉쇄령 때 파리를 탈출한 시민이 무려 45만여 명 가량으로 거의 파리 시민의 25% 가 이동했다고 밝혔다.[6] 이러한 현상이 파리에서만 있었던 것은 아니다. 뉴욕, 런던 등 팬데믹으로 위기를 겪은 여러 대도시의 주민들이 도시 밖으로 탈출했다. 어차피 갇힐 바에는 갑갑한 도시 환경이라도 탈출하고자 하는 사람들로 고속도로는 밤새 교통체증을 겪었다. 일부 전문가는 도시탈출 현상이 지방과 대도시 사이의 인구 균형을 도모하고, 대도시의 주택난 해결 및 농촌 생활의 새로운 가치를 부여하는 계기가 될 것이라는 의견을 밝힌다. 하지만, 도시탈출은 시골에 별장을 두고 있거나 이메일과 줌을 통해 노트북으로 어디서나 일을 할 수 있는 화이트 계급에 한한다. 경제적 분리에 의한 공간이동은 장기적으로는 사회적 양극화와 갈등을 증폭시킬 것이다.

고독과 분노로부터 거리로 나온 사람들

봉쇄령이 장기화되면서 이동과 활동의 자유를 잃어버린 사람들이 겪는 심리적 공황 상태는 증대되었다. 자택에서 머물러야 하는 폐쇄적인 상황에서 고립감을 떨치고자 밖으로 나온 사람들이 머무를 수 있는 유일한 장소는 거리이다. 공식적으로 바, 카페, 식당은 모두 닫아야 하지만, 테이크아웃과 배달로 음식을 파

landmarks just to see the exterior and take pictures to pacify their disappointment. The Louvre, which used to boast the world's largest number of visitors, is known for the glass pyramid at the center of its square, and this pyramid used to be the most popular photo spot for visitors of the museum. With the pandemic, however, tourists were deprived even of this opportunity due to the temporary fences put up not just at the entrance of the museum building but also around the square, blocking people entirely from the premises, including the pyramid. Now, tourists take pictures in front of these fences with the museum, pyramid, and the square as their backdrop. As with this case of the Louvre, all experiences of cultural facilities in Paris were limited in such a strict and rigid manner.

People Escape the City

Limited activity and spatial blockade resulted in the abandonment of city life, and many left Paris regardless of the infection rate. Some who sought to escape the obstructive atmosphere of the city set out to rural residences or the quiet countryside, and many also made temporary escapes to their hometowns, especially around Christmas. According to an article on this phenomenon, about 450,000 people, accounting for 25 percent of the Parisian population, fled the city during the first lockdown.[6] And this wasn't the case for Paris only. Residents of numerous metropolises hit by the pandemic, including New York and London, also migrated out of the city. With people opting to quarantine outside of

the stifling urban environment, highways suffered extreme traffic jams day after day. Some experts say that this phenomenon of people escaping the city serves to balance out the population gap between large cities and rural provinces, solve housing shortage problems in cities, and breathe new value into rural life. But the option of escaping the city is largely limited to white-collar workers who have a country home or the means to work remotely via email or Zoom using laptops, and as this migration is founded in economic division, it can exacerbate social polarization and conflict in the long run.

People Roam the Streets out of Isolation and Frustration

The prolonged lockdown in France intensified the psychological panic experienced by people who lost the freedom to travel and engage with others. For people in the closed-off environment of their homes, desperate to alleviate their sense of isolation, the streets were the only place to go. Bars, cafés, and restaurants officially had to close but takeout and delivery were allowed. Beginning in the late afternoon until curfew, people would gather around the makeshift takeout counters, loitering with a cup of coffee or beer in their hands in an attempt to blow off the day's tedium, gloom, and frustration. The next day's share of gloom and frustration would still come, but at those moments, takeout cafés embraced the people's sense of isolation and anger.

Meanwhile, people also gathered in the streets and squares to protest state power, violence, and discrimination

는 곳은 영업이 가능하다. 통금시간 이전 늦은 오후부터 하루의 분노를 떨쳐내기 위한 사람들이 테이크아웃 카페 근처로 모여든다. 별다른 장식도 없이 조촐히 마련된 간이 테이크아웃 계산대에서 커피나 맥주 한잔을 든 사람들은 하루의 권태, 우울, 분노를 해소하듯 거리에 머문다. 내일의 우울과 분노는 다시 올 것이나, 테이크아웃 카페는 사람들의 고독과 분노를 포용하는 장소로서 자리한다.

한편, 봉쇄령 속에서도 국가 권력과 폭력, 차별에 맞서 거리에 모인 사람들의 움직임은 광장에서 멈춘 적이 없다. 거리에는 사회정치적 불합리와 정부를 향해 분노에 찬 사람들이 주말마다 아우성이었다. 주발화지는 시민의 자유와 민주주의를 상징하는 장소인 바스티유 광장으로, 사회적 쟁점을 공론화하는 시민들의 시위가 주말마다 계속되었다. 이주민의 권리를 주장하는 행렬, 경찰의 공권력 남용과 프랑스 보안법 제정에 반대하는 사람들의 시위, 공연장 폐쇄에 반대하는 연극인들의 발언이 광장에서 울려 퍼졌고, 지나가던 시민들을 연대하게 하였다. 사회 안에서 잘 보이지 않는 사람들의 목소리는 집회를 통해 가시화된다. 파리뿐만 아니라 세계의 여러 도시들에서는 팬데믹 이후 불안정해진 삶의 조건을 둘러싸고 수많은 정치적 행동과 논의가 이어지고 있다.

폐쇄된 공공영역, 거리 그래피티의 발언

봉쇄령을 겪는 동안 파리의 거리 풍경은 상당히 많이 변화되었다. 6개월 이상 문을 닫고 있는 카페와 레스토랑, 문화공간으로

인해 거리의 활기와 왁자지껄함은 찾아보기 어려운 것이 되었다. 대신 굳게 닫힌 가게의 셔터들이 공간의 폐쇄감을 증폭시켰다. 이와 더불어, 일상의 마비로부터 거리의 광고 또한 전면적으로 중지되었다. 경제, 사회, 문화, 관광 등 활동이 중단된 영역을 대신하여 등장한 광고는 '방역 메시지'였다. "사회적 거리 두기", "마스크 쓰기", "5인 이상 사적 모임 금지", "집에서 머물기", "코로나 테스트 받기", "응급실 전화번호"에 최근의 백신 접종으로 등장한 "백신 예약 웹사이트"까지 도시공간에는 사람들을 훈육하는 메시지가 채워지기 시작했다.

규범의 언어가 도시공간을 에워싸는 동안, 이와 대비되는 방식으로 거리 곳곳에 사회비판적 메시지도 새롭게 등장했다. 이 메시지의 정체는 바로 그래피티이다. 팬데믹 이후 등장한 텍스트 기반의 그래피티는 동시대 사회상을 비판하고 조롱하는 동시에 시민들의 목소리를 가시화한다. 1차 봉쇄령 시기 텅 빈 도시공간에 등장한 그래피티는 다음과 같다. "그들은 드론 예산은 있지만, 코로나19 테스트 예산은 없다.", "마스크는 도대체 어디에 있는가?", "진짜 바이러스는 자본이다.", "COVID 1984", "멈춰라, 마크로나바이러스(Macronavirus)" 등 2020년 4월-5월 사이에 등장한 그래피티는 정부의 무능한 방역 대책을 비판하고 항의하는 메시지들이다. [7] 이후 팬데믹이 장기화되어 가면서, 그래피티의 메시지는 코로나19뿐만 아니라 동시대 사회가 직면한 여러 위기에 대항하는 문구로 퍼져나간다.

이후 2020년 10월 말부터 2021년 5월까지 이어진 2차, 3차 봉쇄 시에서는 심화된 사회적 문제들을 겨냥한 그래피티가 등장했다. "아마존은 우리를 로봇으로 대체할 것이다.", "나의 성별이 나의 젠더를 결정하진 않는다.", "커먼즈를 위한 방어", "이민자

that continued throughout the lockdowns. Every weekend, the streets would fill up with angry citizens clamoring against the government and sociopolitical irrationalities. The protests mainly began at the Place de la Bastille, a symbol of freedom and democracy, and continued one weekend after another, publicizing points of social contention. The plaza roared with processions advocating for immigrants' rights, protests against police abuse and the national security bill, and rallies opposing the closure of theaters, urging passersby to join in solidarity. Assembly allows the voices of those in the blind spots of society to be heard, and not only in Paris but in numerous cities around the globe, countless discussions and political movements regarding the unstable living conditions attributed to the pandemic continue.

Closed Public Spaces and Statements in the Form of Street Graffiti

The appearance of the streets in Paris changed considerably during the lockdowns. With cafés, restaurants, and cultural facilities closed, exuberance and vitality became hard to find on the streets, and the tightly shuttered stores amplified the sense of suffocation. In addition, public advertisement came to a complete halt, along with ordinary life. Messages related to disease control replaced ads on the streets of impaired economic, social, cultural, and tourism sectors. From slogans like "Maintain social distancing," "Wear a mask," "No private gatherings of more than five people," "Stay home," and "Get tested for COVID-19" to emergency contact numbers and promotions of the recently introduced vaccine reservation websites, the urban space began to fill up with instructions on how to behave.

Then, in reaction to the language of regulation encroaching upon the city, messages of social criticism began to appear on the streets in the form of vandalism. The textual graffiti that emerged with the spread of the virus criticized and ridiculed contemporary society while also materializing the voices of the citizens. The graffiti that appeared around the empty urban spaces during the first lockdown (April–May 2020) were mostly reprehensive and remonstrative of the government's incompetence in controlling the disease: "They have a budget for drones but not for COVID-19 tests," "Where the hell are the masks," "The real virus is capital," "COVID 1984," and "Stop Macronavirus." [7] Later, as the pandemic progressed, the graffiti statements gradually began to address crises beyond the virus faced by contemporary society.

Throughout the second and third lockdowns from October 2020 to May 2021, graffiti aimed at probing deeper social issues—such as laborers' working conditions, unemployment, women's rights, immigrant issues, human rights, climate change, and the environmental destruction by conglomerates—began to appear: "Amazon will replace us with robots," "My sex does not define my gender," "Defense for the commons," "Considering the problems of immigrants—that is the problem," and "Destroy patriarchy, not the Earth." [8] The format of these street expressions diversified over time to evolve from spray-painted text to text composed of A4-size sheets of paper and street exhibitions incorpo-

문제를 고려하겠다는 것, 이것이 문제이다.", "지구 행성이 아닌 가부장제를 파괴하자."⁽⁸⁾ 등 노동자의 근무조건, 비고용 문제, 페미니즘 이슈, 이주민 문제, 인권 문제, 기후 위기, 대기업의 환경 파괴 등 여러 사회적 위기에 대한 목소리가 반영된다. 거리 그래피티 형식도 점차적으로 다양해졌다. 스프레이 외에 A4 종이를 이어 붙인 문자 슬로건, 그래픽 포스터를 활용한 거리 전시 등 문학, 시각예술, 디자인, 공공미술과 같은 다양한 형식이 차용된 변화를 살펴볼 수 있다. 팬데믹 동안 거리의 그래피티는 마치 아고라 공론장과 같이 시민들의 의견을 가시화하여, 거리의 주인은 바로 '시민'임을 상기시켰다. 며칠 후면 단속반에 의해 사라지는 한시적인 그래피티는, 마치 인터넷의 피드처럼 쓰여지고 사라지고 다시 쓰여지기를 반복하며 아무도 주목하지 않던 거리 벽면을 공공영역으로 변모시켰다.

도시 공공영역의 개입과 관련해 서울을 떠올려 본다면, 시민들이 자유로이 개입할 수 있는 공공장소는 실제로 많지 않다. 더군다나 거리는 CCTV와 사유재산의 법령 아래 엄격하게 보호되고 있어, 게릴라식 예술 실천을 찾아보기는 더욱이 어렵다. 그래피티는 비법적이나 다양한 시민 주체가 도시공간과 적극적으로 소통하고자 하는 의지를 갖는다. 팬데믹 이후 파리에서 등장한 그래피티에서 주목할 점은 그래피티의 주체가 거리 예술가뿐만 아니라 시민, 지역 커뮤니티, 기후 운동 및 환경 운동가, 페미니즘 단체, 이주민 단체 등 다양한 주체들로 확장된 점이다. 또한 발언의 목소리를 공유하기 위해 시각이미지, 문학, 그래픽디자인을 전유한 형식도 특징적이다. 이렇게 팬데믹 이후 등장한 여러 형식의 그래피티는 도시공간을 주체적으로 전유하는 방식과 도시 개입의 대안적 가능성을 시사한다.

200여 일 후 도시공간의 재조직

"이 시간이 우리에게 노스텔지어로 남게 될지도 몰라." 2021년 4월 말 마크롱 대통령이 3차 봉쇄령 해제 계획을 발표한 날, 옆에 있던 프랑스인 친구가 혼잣말하듯 읊조린다. 좁은 집의 창문을 모두 열고, 봄의 햇살을 집안 깊숙이 붙잡으며 대국민 담화를 듣고 있을 때였다. 통행제한령 시간이 다가오고 친구는 파리시 공유자전거인 벨리브(Vélib)를 타고 집으로 돌아갔다. 교통체증으로 차량의 경적이 소란스러운 시간이다. 안 이달고(Anne Hidalgo) 파리 시장이 팬데믹 동안 기후 위기에 현실적으로 대응하고자 자전거 도로를 확장하고, 파리의 도로 일부를 과감하게 폐쇄한 결과이다. 한 발표에 의하면 봉쇄령 동안 프랑스의 탄소 배출량은 전년도에 비해 17%가 감소했다고 한다.⁽⁹⁾ 공장 가동의 감소, 이동성 감소, 에너지 사용이 줄어든 연유이다. 전 세계적으로도 탄소 배출량은 감소했다. 2차 세계대전 이후 한 번도 감소한 적이 없는, 매우 이례적인 상황이 발생한 것이다. 코로나 19는 인류에게 엄청난 위기를 불러일으켰으나, 한편으로는 인류의 활동이 지구환경에 미치는 영향에 대한 경각심을 일깨웠다.

6개월이 넘게 문이 닫혔던 카페, 레스토랑, 문화공간, 상점이 오픈하는 날인 2021년 5월 19일을 앞두고, 거리의 포스터와 전광판의 광고부터 전면적으로 바뀌었다. 방역 메시지만이 무미건조하게 채워졌던 광고판은 문화 활동의 재개를 예고하는 각종 홍보물로 교체되었다. 광고마다 "5월 19일 개봉", "5월 19일 개관" 등의 오픈을 알리는 문구들로 가득하다. 카페와 레스토랑의 경우 야외공간 영업이 가능하기에, 노천카페를 위한 테라스 공사로 거리는 더욱이 분주해졌다. 마침내 19일이 다가오고, 200

rating graphical posters, intruding into the realms of literature, visual art, design, and public art. During the pandemic, the streets played the role of a public sphere like the Greek agora, giving voice to citizens and reminding the country that the streets belong to the people. Graffiti, as temporary statements to be removed by anti-vandalism workers in a few days like web feeds that are repeatedly updated and erased, transformed the walls of the streets that would have otherwise gone unnoticed into a public sphere.

Thinking of Seoul in regard to civil intervention of public spaces, there are not many public spaces in the city in which people can freely intervene. The streets are heavily surveilled by closed-circuit cameras and private property laws, which makes guerilla-style artistic actions difficult and unlikely. Graffiti, despite its non-statutory nature, embodies the active will of diverse and independent citizens to communicate with the urban space. What is noteworthy about the graffiti that has emerged in Paris during pandemic is that the range of active agents of vandalism has expanded to include not only street artists but also citizens, communities, climate and environmental activists, and feminist and immigrant groups. The graffiti is also characterized by different formats appropriative of visual images, literature, and graphic design. As such, the various forms of graffiti suggest that alternative modes of urban reclamation and intervention are possible.

Reorganization of the Urban Space after 200 Days

"We might one day feel nostalgic about these times," murmured a French friend of mine who was next to me on the day President Emmanuel Macron announced the plans to lift the third lockdown in late April 2021. We were listening to the public statement at my place with every window in the tight space open, clinging dearly onto the spring sunlight that had stretched deep indoors. As curfew approached, my friend rode a Vélib (Paris's bikeshare system) bike back home. Before curfew, traffic jams and a cacophony of car horns would arise due to Anne Hidalgo, mayor of Paris, decisively closing down some of the roads in the city and expanding bike lanes as a practical response to the pandemic and the climate change. According to a Le Monde article, France's carbon emissions decreased by 17 percent compared to the previous year during the lockdown.[9] This was due to the decline in factory operation, mobility, and energy use. Global carbon emissions have also decreased—an extraordinary event witnessed for the first time since World War II. While COVID-19 brought about catastrophic consequences to humankind, it has also opened our eyes to the impact of human activities on the global environment.

After some six months of lockdown and with the reopening of cafés, restaurants, cultural facilities, and shops scheduled for May 19, 2021, the posters on the streets and advertisements on electric signs outside began to show drastic change. The quarantine messages that once occupied the billboards were replaced with promotional posters and adver-

여 일을 기다린 많은 사람들이 노천카페로 몰렸으며, 테라스 자리를 잡기 위해 줄을 선 사람들까지 거리는 축제와 같이 북적였다. 그러한 가운데 팬데믹 이후 등장한 달리기 동호회는 테라스 인파를 헤치고 거리를 지나간다. 구급차 앰블런스는 어제와 마찬가지로 위급하게 도시를 가로지르고, 방송에서는 백신 접종과 보건증명서(Pass Sanitaire)를 통한 일상의 회복을 강조하기 여념이 없다. QR코드 백신증명서로 '스탑코비드' 앱 사용률은 일 년 전 3%에서 최근 25%[10]까지 증대되었다. 이제 세계는 코로나19 이전과 이후의 일상이 뒤섞인 시간대를 관통하고 있다. 도시공간은 QR코드와 이동하는 사람들, 거리 집회와 그래피티 사이에서 또다시 재조직될 것이다.

(1) Richard Sennett, *Flesh and Stone: The Body and the City in Western Civilization* (London: Faber & Faber, 1994), 18-19 참고.

(2) 코로나19 회복력 순위 1-6위까지는 싱가포르, 뉴질랜드, 오스트레일리아, 이스라엘, 대만, 대한민국 순이다. 블룸버그 신문의 다음 기사를 참조할 것. "The Covid Resilience Ranking," *Bloomberg*, April 26, 2021. https://www.bloomberg.com/graphics/covid-resilience-ranking

(3) 프랑스에서는 팬데믹으로 인한 도시 봉쇄령(lockdown)이 1차로 2020년 3월 17일–5월 10일, 2차로 2020년 10월 30일–12월 15일, 3차로 2021년 4월 5일–5월 3일까지 세 번에 걸쳐 있었다. 2020년 10월 30일부터 '필수적이지 않은 활동'으로서 금지되었던 문화공간, 카페, 레스토랑 및 상점은 3차 봉쇄령 이후인 2021년 5월 19일부터 영업이 허용된다.

(4) 2020년 8월 15일 '스탑코비드' 앱 사용자수 2,000,000여 명 확인.

(5) 본 원고에 앞서 '팬데믹 이후 도시공간의 변화' 리서치를 주제로 한 또 다른 원고는 문화이론지『문화/과학』에 다음의 주제로 발표한 바 있다. 심소미,「시공간이 재단된 세계에서: 파리의 1킬로미터 미시-산책자」,『문화/과학』봄 통권 105호, 2021, 243-260쪽.

(6) 브누아 브레빌,「줌과 아마존에 의존한 도시탈출의 비현실성」,『르몽드』, 2020년 12월 31일 기사 참조.

(7) 본 그래피티 리서치는 컬렉티브 '리트레이싱 뷰로(Re-tracing Buro)'(심소미×줄리앙 코와네)가 2020년부터 해오고 있는 팬데믹 리서치 자료 중 일부를 참고한 것이다. 팬데믹 초기 현상에 대한 내용은 2020년 부산비엔날레의 프로그램에서 '포스트 코로나 시대의 도시공간, 공공성, 기술의 지형도'를 주제로 발표하였다. 리서치 내용은 유튜브 링크 참조. https://youtu.be/_-2QrH1hAGk

(8) 위와 동일.

(9) 코로나19 이후 이산화탄소 배출량 감소에 대해서는 다음의『르몽드』기사를 참조. https://www.lemonde.fr/planete/video/2021/03/28/le-covid-19-est-il-une-bonne-nouvelle-pour-le-climat_6074753_3244.html

(10) 2021년 5월 19일 '스탑코비드' 앱 사용자수 16,500,000여 명 확인.

tisements heralding the resumption of cultural activities, each stating May 19 as the opening or release date. Now that cafés and restaurants could seat customers outdoors, the streets began to bustle with construction as outdoor terraces were built. May 19 finally came. People who had been waiting for this day for more than 200 days poured out to outdoor cafés, and the streets took on a festive atmosphere as people lined up outside establishments for a terrace seat. Meanwhile, a runners club that had formed during the pandemic still roamed the streets, wedging through the crowded terraces. Ambulances still urgently cut across the city as they did yesterday, and TV networks are still busy emphasizing vaccination and immunity certificates for the restoration of daily life. With the advent of the QR-coded vaccination certificate, the year-over-year usage of the StopCovid app has increased from 3 percent to 25 percent. [10] Today, the world is passing through a time in which the lifestyles of the pre- and post-COVID 19 eras are intermixed. With people on the move, QR codes, street protests, and graffiti, urban spaces will be reorganized once again.

(1) Richard Sennett, *Flesh and Stone: The Body and the City in Western Civilization* (London: Faber & Faber, 1994), 18–19.

(2) Singapore, New Zealand, Australia, Israel, Taiwan, and Korea are placed first through sixth respectively on this COVID-19 resilience ranking. "The Covid Resilience Ranking," *Bloomberg*, April 26, 2021. https://www.bloomberg.com/graphics/covid-resilience-ranking

(3) There have been a total of three lockdowns in France: the first from March 17 to May 10, 2020; the second from October 30 to December 15, 2020; and the third from April 5 to May 3, 2021. The operation of cultural facilities, cafés, and restaurants, deemed "non-essential establishments," was prohibited from October 30, 2020, to May 19, 2021—weeks after the lifting of the third lockdown order.

(4) The number of confirmed users of the StopCovid app was approximately two million as of August 15, 2020.

(5) Another research-based essay on the changes in urban spaces in the COVID-19 era was published as part of the culture theory journal *Culture/Science* under the following title: Sim Somi, "In a World Where Spacetime is Tailored: The Parisian Micro-Stoller of One Kilometer," *Culture/Science*, Spring Issue 105, 2021, 243–260.

(6) Benoît Bréville, "The Dereism of Zoom and Amazon-Reliant Escape from the City," *Le Monde*, December 31, 2020

(7) This research on graffiti references parts of the pandemic research conducted by the collective Re-tracing Buro (Sim Somi and Julien Coignet) since 2020. Their findings on the phenomena witnessed in the early stages of the pandemic were presented as part of a program at the Busan Biennale 2020 under the theme "Reorganization of Urban Space, Publicness, and Technology after COVID-19." For more on this research, refer to the following YouTube link: https://youtu.be/_-2QrH1hAGk

(8) Above research.

(9) Refer to the following *Le Monde* article for more on the post-pandemic reduction of carbon dioxide emissions: https://www.lemonde.fr/planete/video/2021/03/28/le-covid-19-est-il-une-bonne-nouvelle-pour-le-climat_6074753_3244.html

(10) The number of confirmed users of the StopCovid app was approximately 16.5 million as of May 19, 2021.

황금두꺼비를 떠나 보내며:
기후 변화와 생물 다양성

최재천
이화여자대학교 에코과학부 석좌교수
생명다양성재단 대표

A Farewell to the Golden Toad:
Climate Change and Biodiversity

Choe Jae Chun

Distinguished Chair Professor of EcoScience, Ewha Womans University
President, Biodiversity Foundation

어느 작은 연못에 작은 물벼룩 한 마리가 살고 있었다. 수컷의 도움 없이 단위생식을 하는 이 물벼룩은 정오에 한 마리가 있었는데 1분에 한 번씩 분열해 12시 1분에는 두 마리, 2분에는 네 마리, 3분에는 여덟 마리로 늘어나더니 자정에는 온 연못을 꽉 채우며 결국 모두 죽고 말았다. 그렇다면 연못의 절반만 채워져 있을 때는 언제인가? 바로 자정의 1분 전인 11시 59분이었다. 물벼룩들이 아무 일도 하지 않은 채 죽음을 맞이한 것은 아니었다. 날로 늘어만 가는 물벼룩 수와 그에 따라 점점 심각해지는 연못의 환경 문제를 두고 자못 진지한 논쟁을 벌였다. 이대로 가면 조만간 걷잡을 수 없는 대재앙이 닥칠 것이라고 경고하는 몇몇 물벼룩들이 있는가 하면 "우리의 기술이 빠르게 발전하고 있으니 곧 해결책을 찾을 수 있을 것"이라던가 "연못 전체가 곧 우리들 살로 꽉 찰 것이라고 예측하기에는 아직 데이터가 충분하지 않다."거나 "미래가 너무 불투명해 어떤 극단적인 행동을 취하기에는 아직 이른 것 같다." 등등 의견이 분분했다. 그러는 동안 시계바늘은 재깍재깍 자정에 거의 다가서고 있었다. 운명의 시간이 무심하게 다가오고 있었다.

이는 실제로 벌어진 일은 아니고 머리 속으로 상상해본 일종의 생각 실험이다. 그런데 실제로 이런 일은 절대로 벌어지지 않을까? 2020년 6월 3일 서울시가 주최한 '글로벌 서밋 2020'에서 대담 세션의 진행을 맡았던 나는 다음과 같은 마무리 발언을 했다.

"눈에 보이지도 않는 바이러스라는 존재에게 이처럼 처참하게 당할 줄 누가 알았겠습니까? 자고 일어나면 쑥쑥 올라가는 사망자 수에 겁나시죠? 언제 어디서 누구에게서 옮을지 참 두려우시죠? 그렇지만 전염성 바이러스나 세균은 결코

There once lived a tiny water flea in a small pond. Able to reproduce without a mate, the flea cloned itself once every minute, starting one day at noon. One minute past noon, the single flea had become two; at two minutes past, four; at three minutes, eight; and so on. By midnight, the entire pond was so choked full of fleas that they all died. But how long before this collective demise had the pond been only half full? The answer is one minute before midnight—11:59 PM. To their credit, the fleas did not simply wait around to die. Recognizing the grave threat their ever-growing numbers posed to the little pond they called home, they argued earnestly amongst themselves. While some warned of certain and irrevocable disaster if the current trend continued unchanged, others offered assurance that a solution could be found as their technology grew increasingly sophisticated. Others maintained that the data was insufficient to support the postulation of inevitable overcrowding, and still others simply declared the future too uncertain to warrant extreme action. While they argued away, the seconds continued ticking, inching towards midnight. Their fated hour drew indifferently near.

This is a story I just made up, in a thought experiment of sorts. But who can say it wouldn't actually happen someday? I'm reminded of the closing remarks I made at the end of a session I moderated for the Cities Against COVID-19 Global Summit 2020 held by the Seoul Metropolitan Government on June 3, 2020: "Who could have known an invisible virus would do us such terrible harm? It's frightening, isn't it, to wake up in the morning and see the death toll still rising? To not know when or from whom you might contract the virus? But I can tell you for certain: no infectious virus or disease can destroy humankind. After it has taken enough lives, those remaining will naturally engage in social distancing, and the virus won't be able to spread. Remember, even the [Bubonic] plague only took a third of all of Europe. It could not kill more, though it may have tried, because it couldn't spread. Climate change is a different story. It can take every last one of us. It is a far more terrifying disaster, one that cannot even be compared to COVID-19. We must prepare ourselves."

Former US vice president Al Gore was awarded the Nobel Peace Prize in 2007 for his efforts to alert the world to the seriousness of climate change through the documentary film and book *An Inconvenient Truth*. Unfortunately, the truth about climate change is becoming much more inconvenient than Mr. Gore warned us it was years ago. According to the World Meteorological Organization, the five years between 2015 and 2019 were the hottest on record. Earth's surface temperature rose 0.2 degrees between 2011 and 2015 alone, compared to 1.1 degrees in the two centuries since the Industrial Revolution. And if we consider that carbon dioxide emissions between 2015 and 2019 were some 20 percent higher than those between 2011 and 2015, it is obvious that Earth's temperature is rising in tandem with them.

As temperatures rise, the Earth's glaciers are melting at a startling rate. Roughly 252 trillion kilograms of ice melted in the South Pole between 2009 and 2017, over six times the total 40 trillion kilograms of ice that melted between 1979 and 1990. Sea levels, in turn, have risen at a quickening pace; while it rose a yearly average of approximately 3.2 millime-

우리 인류를 멸절하지 못합니다. 충분히 많이 죽이고 나면 사람들 사이에 저절로 사회적 거리가 형성되어 더 이상 감염시키지 못합니다. 그 옛날 흑사병도 유럽 인구의 1/3밖에 죽이지 못했습니다. 나머지 2/3도 죽이려 했겠지만 감염시킬 수 없어 죽이지 못했습니다. 그러나 기후 변화는 다릅니다. 마지막 한 사람까지 깡그리 죽일 수 있습니다. 기후 변화는 코로나19와는 비교도 되지 않을 만큼 훨씬 더 무서운 재앙입니다. 대비하셔야 합니다."

전 미국 부통령 앨 고어(Al Gore)는 '불편한 진실(An Inconvenient Truth)'이라는 다큐멘터리와 책을 내며 기후 변화의 심각성을 알린 공로를 인정받아 2007년 노벨평화상을 수상했다. 그러나 불행하게도 기후 변화의 진실은 그가 얘기한 것보다 훨씬 더 불편해지고 있다. 세계기상기구에 따르면 2015–2019년은 우리가 기상을 관측한 이래 가장 더운 5년이란다. 지구의 대기 온도는 산업혁명 이후 지난 200여 년 동안 1.1도가 올랐는데, 2011–2015년에만 0.2도나 올랐다. 그런데 2015–2019년 동안의 이산화탄소 증가율이 2011–2015년에 비해 20%나 증가했으니 기온도 그에 비례해 오르고 있을 것이다.

기온이 오르며 빙하가 무서운 속도로 녹고 있다. 1979–1990년 남극에서만 4×10^{13}킬로그램의 얼음층이 녹았는데, 2009–2017년에는 이보다 6배 이상인 2.52×10^{14}킬로그램이 녹아 내렸다. 이에 따라 바닷물 수위도 1993년 이래 매년 평균 3.2mm 정도 오르던 것이 2007–2017년 10년 동안에는 매년 4mm, 그리고 2014–2019년 5년 동안에는 매년 5mm씩 상승하고 있다. 최근 들어서는 폭염과 가뭄으로 인한 대형 산불이 엄청난 재산 피해와 생태계 파괴를 일으킨다. 산불로 인한 경제 손실 중 가장 큰 네

번이 모두 지난 5년 동안에 일어났다. 대규모 산불은 엄청난 양의 이산화탄소를 대기 중으로 뿜어내 기후 변화를 가속화한다. 2019년 9월부터 2020년 3월까지 일어난 호주 산불은 무려 900메가톤(Mt)의 이산화탄소를 방출했으며 경제적 손실은 적어도 750억 달러에 이르는 것으로 추산됐다. 우리가 겪는 자연재해의 90% 이상이 기후와 관련되어 나타난다.

2018년부터 나는 졸지에 '앨 고어 아바타'가 되어 세계 여러 곳으로 불려 다니다 코로나19 때문에 주춤하고 있다. UN기후변화협약(UNFCCC)에서 필리핀의 여성 국회의원, 통가(Tonga)의 여성 환경운동가, 이집트의 친환경 기업인과 더불어 나를 국가적응계획(NAP: National Adaptation Plan) 분야의 챔피언으로 선정했다. 일종의 명예대사로서 나의 임무는 UNFCCC 회의가 열리는 곳이면 어디든 달려가 기후 변화의 심각성을 알리는 강연을 하는 것이다. 내 첫 임무는 2018년 4월 이집트에서 열린 행사 마지막 날 기조 강연을 하는 것이었다. 이 강연에서 나는 기후 변화의 위험에 대해 얘기한 후 어쩌면 기후 변화보다 그로 인해 벌어질 생물 다양성의 감소가 더 직접적이고 급박한 위협이 될지 모른다고 경고했다. 강연이 끝난 뒤 나는 뜻밖의 경험을 했다. 국내에서는 강연을 마친 후 사인도 해주고 사진도 함께 찍는 일이 종종 있지만 외국에서는 그런 일이 좀처럼 일어나지 않는다. 그런데 이날 강연이 끝난 뒤 거의 스무 명 가까운 사람들이 줄을 서서 나를 기다리는 이변이 연출됐다. 얼떨떨해 하는 내게 그들은 한결같이 기후 변화의 심각성은 익히 알고 있었지만 정작 생물 다양성의 중요성에 대해서는 생각해보지 못했다며 고마움을 전했다.

ters from 1993 to 2007, this has since increased to around 4 millimeters from 2007 to 2017, and again to 5 millimeters between 2014 and 2019. Recently, we've seen massive wildfires caused by extreme heat and drought ravage properties and destroy ecosystems. History's four most economically damaging wildfires are said to have happened in the last five years. All of these fires unleash a tremendous amount of carbon dioxide into Earth's atmosphere, further accelerating climate change. The fires that raged through Australia from September 2019 to March 2020 released roughly 900 megatons of carbon dioxide and inflicted estimated damages of at least 75 billion US dollars. Over 90 percent of the natural disasters we are currently experiencing are related to climate change.

In 2018, I suddenly found myself being whisked around the world as a sort of Al Gore stand-in; this continued until COVID-19 broke out and put everything on hold. Along with a Filipina congresswoman, a Tongan women's rights activist, and an Egyptian business leader and advocate for environmentally friendly business practices, I was named a champion by the United Nations Framework Convention on Climate Change (UNFCCC) to advance their national adaptation plans (NAPs). In a role similar to that of an honorary ambassador, my duty was to attend UNFCCC meeting, wherever and whenever they took place, and give lectures emphasizing the seriousness of climate change. I assumed this role in April 2018 in Egypt, where I was slated to give a keynote address on the last day of the meeting's proceedings. I talked then about the threat of climate change but also about the potentially far more direct and imminent threat of biodiver-

sity loss as a consequence of climate change. After the event was over, something surprising happened. I rarely get asked for autographs and photos when I speak abroad, although I do quite frequently at speaking engagements in Korea. So it was extraordinary to discover that close to 20 people waited in line to meet me after my talk in Egypt. Although I was somewhat dazed, I remember that every single person there thanked me, telling me they had known about the threat of climate change but had never given thought to the importance of biodiversity.

As a biologist whose research focuses on the evolution of nature, I've been a part of various international bodies and events relating to biodiversity for much of my life. I even served as chair of the Convention on Biological Diversity for two years, from 2014, when I was head of Korea's National Institute of Ecology, to 2016. I know that telling people about the threat of climate change and telling them about the threat of biodiversity loss are two very different things. People quite readily acknowledge the importance of climate change because they can literally feel it happening. It's not too difficult to get people to recognize the changes in the Earth's climate when they're already asking questions like, "What's wrong with the weather?" and, "Where have spring and autumn gone?" On the other hand, getting people to really appreciate, on an emotional level, the erosion of biodiversity as a serious issue is far more challenging. We may feel genuine sorrow at the glimpses we get from news reports of thin, haggard polar bears in the Arctic facing extinction, but we forget in a matter of seconds when the next news story appears. Unlike with climate change,

나는 자연의 진화를 연구하는 생물학자로서 자연스레 생물 다양성 분야의 국제기구나 회의에 참여하며 살아왔다. 국립생태원 초대 원장으로 일하던 2014년에서 2016년까지 2년 동안에는 국제생물다양성협약(CBD: Convention on Biological Diversity)의 의장을 맡기도 했다. 기후 변화와 생물 다양성은 그 심각성을 알리는 데 있어서 상당한 차이가 있다. 사람들은 기후 변화의 중요성만큼은 아주 쉽게 받아들인다. 그야말로 피부로 느끼기 때문이다. "무슨 날씨가 이래?", "요즘은 봄가을이 아예 없는 것 같아."라고 말하는 사람들에게 지구의 기후가 변화하고 있다는 사실을 알리며 이해시키는 일은 그리 어렵지 않았다. 그러나 생물 다양성 고갈의 심각성을 시민들 마음에 각인시키는 일은 매우 어렵다. 저녁 뉴스 시간에 북극곰이 멸종 위기에 놓였다는 보도를 접하며 수척해진 모습을 지켜보는 순간에는 우리 모두 진정으로 안타까워하지만 불과 몇십 초 후 다음 뉴스로 넘어가면 이내 까맣게 잊고 만다. 기후 변화처럼 늘 피부로 느끼는 게 아니고 대부분 내 일상 공간이 아닌 먼 곳에서 벌어지는 일이다 보니 생물 다양성의 문제로 공감대를 이끌어내기는 상대적으로 어려울 수밖에 없다. 생물 다양성 분야의 국제기구나 회의에 모이는 사람들은 기후 변화에 대해 잘 알고 있다. 기후 변화가 생물 다양성을 파괴하는 주요 원인이기 때문이다. 그러나 의외로 기후 변화 관련 국제기구나 회의에 모여드는 사람들은 기후 변화 이슈에만 천착할 뿐 그로 인해 벌어질 생물 다양성 감소 문제에는 그리 큰 관심이 없었던 것이다. 기후 위기와 생물 다양성 감소는 떼려야 뗄 수 없는 관계로 묶여 있다.

생물학자들은 지금 수준의 환경 파괴가 계속된다면 2030년 경에는 현존하는 동식물의 2%가 절멸하거나 조기 절멸의 위험에 처할 것이라고 추정한다. 이번 세기가 끝날 무렵이면 절반이 사라질지도 모른다고 경고한다. 기후 변화는 이 같은 추세에 가속 페달을 밟고 있다. 기후 변화는 분명히 심각한 문제이다. 그러나 지구온난화에 따른 기온의 상승 자체는 우리가 해결하지 못할 문제가 아닐지도 모른다. 온도를 강제로 낮추거나 아니면 그 온도에 맞춰 주로 실내에서 생활하는 극단적인 방법도 고려할 수 있다. 더 심각한 문제는 기후 변화로 인해 벌어질 수 있는 엄청난 생물 다양성의 감소이다. 그래서 유엔(UN)은 2010년을 '국제 생물다양성의 해(The International Year of Biodiversity)'로 제정한 데 이어 아예 2011–2020년을 '생물다양성을 위한 10년(United Nations Decade on Biodiversity)'으로 정하고 생물 다양성의 중요성을 알리려 노력했다. 그러나 어느덧 그 10년도 허무하게 다 흘러가 버렸다. 나는 이제 우리가 '생물다양성을 위한 100년(United Nations Century on Biodiversity)'을 도모해야 한다고 생각한다.

1980년대 내내 나는 코스타리카와 파나마의 열대우림에 들락거렸다. 코스타리카 몬테베르데(Monteverde) 운무림에서 아즈텍개미의 행동과 생태를 연구하던 시절 어느 날 밤 숲속에서 나는 난생처음 황금두꺼비(golden toad)를 만났다. 어른 한 사람이 눕기도 비좁을 정도로 작은 물웅덩이에 눈이 부시도록 아름다운 오렌지색 두꺼비들이 옹기종기 모여 있었다. 언뜻 세어 봐도 족히 스무 마리는 넘을 듯한 두꺼비들이 마치 우리 전래동화 '선녀와 나무꾼'에 나오는 선녀들처럼 멱을 감고 있었다. 그들에게 방해가 될까 두려워 숨소리마저 죽인 채 나무 뒤에 숨어 그들을 관찰하는 내 모습은 영락없는 나무꾼이었다. 다만 그들이 수컷 선녀, 아니 선남들이란 게 못내 아쉬운 점이었다. 암컷은 오

whose effects we feel on a daily basis, biodiversity loss is often far removed from our immediate surroundings and is thus harder, understandably so, to get people to recognize as a cause. Those who attend gatherings of international bodies and other events on biodiversity know and understand climate change very well. They have to, as climate change is one of the major causes of biodiversity loss. However, as hard as it is to believe, many who gather in the name of climate change at a global level are focused solely on climate change issues. They are much less interested in the damage that climate change causes to biodiversity. And yet, climate change and the diversity of life on Earth are inextricably linked.

Biologists predict that, at this rate, two percent of animal and plant species on Earth will be extinct or face extinction by 2030. They warn that half of all species will disappear by the end of the century. Climate change is pressing the pedal on these changes. No one can dispute the importance of climate change. But higher temperatures in and of themselves are not necessarily a problem we cannot solve. We may find ways to artificially reduce temperatures or even go to such lengths as to move our lives indoors. What is a bigger problem is the enormous loss of biodiversity that will be a consequence of climate change. This is why the United Nations has been working to publicize the importance of biodiversity, declaring 2010 the International Year of Biodiversity before declaring an entire decade, from 2011 to 2020, the United Nations Decade on Biodiversity. But those 10 years have come and gone with little to show. I believe it is now time to seek the proclamation of a United Nations Century on Biodiversity.

In the 1980s, I made frequent trips to the tropical rainforests of Cost Rica and Panama. It was on one such trip to the Montverde Cloud Forest Reserve in Costa Rica (I was studying Azteca ant behavior and ecology at the time) that I first encountered, in the dark evening forest, the golden toad. A throng of them huddled together in small pool of water, too small even for a grown adult to lie in, their skin glowing a brilliant, beautiful orange. By my count, there were over 20, and like the fairies in the Korean folktale "The Fairy and the Woodcutter," they were bathing themselves. And, in an exact parallel to the titular woodcutter, I observed the bathing toads in secret from behind a tree, trying to silence the sound of my breathing so as not to disturb them. Alas, though it was as stunning a sight as the bathing fairies might have been, these were male toads; females displayed a darker, muddier coloring. I would see golden toads only two more times after that; scientists' last recorded sighting of the species was on May 15, 1989. In 2004, the International Union for Conservation of Nature declared the golden toad extinct. It had survived a mere 38 years following its first discovery, inhabiting a small, high-altitude stretch of land no bigger than 10 square kilometers, before disappearing from Earth forever. It's enough to make me wonder if the small creature I beheld in the glow of my flashlight that dark night in the forest ever actually existed. In my 2003 essay collection, *An Ode to the Tropics*, I reflected on this experience with a regret akin to that of the woodcutter, whose fairy bride returned to heaven after he gave back her winged robe that he had hidden away, without which she could not fly: "If I had known, I might have hidden the clothes they left by the waterside as they

히려 우중충하고 거무튀튀한 몰골을 하고 있었다. 그 후 나는 그들을 딱 두 번 더 보았을 뿐이다. 그런 그들을 과학자들이 마지막으로 본 것은 1989년 5월 15일이었다. 결국 국제자연보호연맹(IUCN)은 2004년 그들을 완전히 절멸한 것으로 보고했다. 처음 발견된 시점으로부터 불과 38년 동안 그저 $10km^2$ 넓이의 고산지대에서 살다가 영원히 사라지고 만 것이다. 깜깜한 열대 숲속에서 손전등으로 비춰보는 황금두꺼비는 진정 그들이 이 세상에 실존하는 동물인가 묻게 한다. 나는 2003년에 출간한 내 에세이집 『열대예찬』에서 "이럴 줄 알았으면 그들이 벗어 놓은 옷가지 한두 개라도 숨겨둘 걸" 하는 나무꾼의 한탄을 늘어놓았다. 기후 변화가 너무 많은 두꺼비와 개구리를 하늘나라로 떠나보내고 있다.

황금두꺼비와 강제로 작별한 후 내게는 엉뚱한 버릇이 생겼다. 세계 어느 곳이든 새로운 숲에 가면 객없이 숲속을 배회한다. 한참을 그렇게 돌아다니다 불현듯 쓸쓸한 미소를 짓고 만다. 객적게 황금두꺼비를 찾고 있는, 결코 이성적이지 못한 내 행동에 멋쩍어 한다. 중미 코스타리카에서 멸종한 두꺼비가 동남아시아나 아프리카 숲속에 살고 있을 리 만무하지만 허전한 마음에 괜히 두리번거린다. 일반인들은 이런 내 마음을 헤아리지 못할 것이다. 하지만 내게는 절절하다. 내 두 눈으로 분명히 보았고 너무 좋아 수많은 밤을 패며 찾으러 다녔던 존재가 더 이상 이 지구 어느 곳에도 남아 있지 않다는 사실을 나는 믿고 싶지 않다. 과학자로서 데이터를 보면 받아들여야 하지만 왠지 지구 어디엔가 아직도 숨어 있을 것 같아 마음의 끈을 놓지 못한다. 이런 경험을 한 나는 자연을 해치라고 누가 등을 떠밀어도 하지 못한다. 어느덧 내 이마에 써 붙이고 다니는 구호처럼 되어 버린 "알면 사랑

한다!"라는 문구는 바로 이런 경우를 두고 하는 말이다. 나는 황금두꺼비에 대해 알기 때문에 그들을 사랑할 수밖에 없다. 그냥 어설프게 아는 게 아니라 속속들이 알고 따라다녔다. 나는 보다 많은 사람들이 나처럼 이런 지극히 개인적인 경험을 할 수 있으면 얼마나 좋을까 생각해본다. 그러면 자연은 저절로 보호될 것이다. 나는 바로 이 일을 예술이 해줬으면 하며 그리 되기를 기대한다. 자연을 아끼고 사랑하는 일은 이제 과학의 영역을 벗어나 예술의 손길을 기다리고 있다. 이성의 영역에서 감성의 영역으로 옮아가야 한다.

우리는 지금 우리 삶에서 가장 힘든 시기를 보내고 있다. 거의 1년 반 동안 눈에 보이지도 않는 바이러스에게 속수무책 당하고 있다. 게다가 이 어려움만 극복하면 좋은 세상이 펼쳐질 것이라는 기대보다 앞으로 이런 재앙이 끊임없이 그리고 더욱 빈번하게 일어날 것이라는 우려가 우리의 마음을 더욱 무겁게 짓누른다. 우리 현생 인류 즉 호모 사피엔스가 이 지구생태계에 등장한 것은 지금으로부터 약 25만 년 전이었다. 우리 인간은 탄생과 함께 만물의 영장 자리를 꿰차며 화려하게 등장한 게 아니었다. 거의 24만 년 동안 우리는 존재감조차 없는 하찮은 한 종의 영장류에 지나지 않았다. 사자의 눈을 피해 아프리카 초원을 헤매며 하이에나가 먹다 버린 동물 뼈에서 살점을 뜯어먹고 살던 참으로 미미한 존재였다. 그러다가 불과 1만여 년 전 농경을 시작하며 폭발적으로 숫자가 늘어난 동물이다. 그렇다면 우리가 농사를 짓기 이전으로 되돌아가 그 당시 지구생태계에서 우리가 차지하고 있던 상대적 지위를 가늠해보자. 그 무렵 우리 인간 전체의 무게에다 우리를 따라다니던 개나 고양이 등의 무게를 합쳐본들 그 당시 포유류와 조류 전체에서 우리가 차지하는 비율은

bathed." Too many toads and frogs have been returned to heaven by the forces of climate change.

Since the bereavement of this forced farewell, I have developed an odd habit. Whenever I enter a new forest for the first time, I end up roaming. After some time, it dawns on me what I'm doing, and I smile to myself sadly. I feel a bit sheepish to have thought I might find them again, the golden toads, and have forsaken all sense to try. Of course, I know that an extinct species of toad native to Costa Rica will not be discovered living in the forests of Southeast Asia, or Africa, but in the ache of my loss, I find myself looking all the same. Perhaps the average person will find it difficult to understand me. But there is a desperation inside me. I do not want to believe that a creature I saw clearly with my own eyes, that so delighted me that I spent countless nights searching for it, hoping to see it again, no longer exists anywhere on this Earth. As a scientist, I must accept what the data suggests, but somewhere in my mind, I cannot stop hoping that the golden toad is still hidden in some pocket of the world. And so, even if someone were to force me, I would never do anything to destroy nature. It can only be described with an axiom that might as well be emblazoned on my forehead: "To know someone is to love them." Because I came to know the golden toads, I cannot help but to love them. And I never contented myself with a vague sort of knowing. I knew them intimately; I sought them out. I hope that many people will come to have a personal experience with nature similar to the one I had with the golden toads. After an experience like mine, they will find themselves protecting nature without a second thought. I hope that art can continue to, as it already does, become a medium for such experiences. The act of valuing and loving nature must go beyond science; this is where art is needed. To go from being a matter of the head to a matter of the heart.

The present moment may be one of the most trying we have ever faced. For over a year and a half, we have been defenseless against the encroachment of an invisible virus. And instead of feeling anticipation for the future that awaits once we overcome our current challenges, we feel a heavy dread at the thought that this is not the end, but rather the beginning, of continuing and more frequent disasters. Humankind, *Homo sapiens*, first emerged on Earth 250,000 years ago. And this was not the triumphant arrival of a species claiming their birthright rule to the Earth. No, for close to 240,000 years, humankind was merely one group of many utterly unremarkable primates. We were creatures of no special significance, fleeing the lion in the African savannah, surviving on the bits of meat clinging to the bones of a hyena's leftover meal. Only with the advent of agriculture some 10,000 years ago did our numbers begin to multiply on a massive scale. Let's think back, then, to before we began to cultivate crops, and get a sense of the place we occupied in Earth's ecosystem. Even by the most generous estimates, humans, in terms of our collective mass and even including the cats and dogs that tagged along in our midst, made up less than 1 percent of all mammals and birds alive at the time. In an extraordinary turn of events, and in a testament to the success of human achievement, these calculations yield exactly the opposite result 10,000 years later. Multiply the roughly 7.8 billion humans alive today by an

아무리 넉넉하게 잡아도 1% 미만이었다. 그러던 우리가 지난 1만여 년 동안 얼마나 성공했으면 2021년 현재 그 계산을 다시 해보면 참으로 놀라운 반전이 기다린다. 현재 약 78억 명의 인간이 살고 있으니 거기에 60~65킬로그램을 곱하고 우리가 기르고 있는 소, 돼지, 양, 염소, 오리, 닭 등 가축의 무게를 합해보자. 우리가 기르는 동물의 범주를 어디까지 잡는가에 따라 계산이 달라지겠지만, 지금 우리 인간과 우리가 기르는 동물의 무게를 모두 합하면 자연계 포유류와 조류 전체의 무게에서 우리가 차지하는 비율은 무려 96~99%에 달한다. 자연계에서 일찍이 이런 반전은 없었다. 그러니 야생동물의 몸에 기생하며 살고 있는 바이러스나 박테리아가 어느 순간 이주를 단행하면 거의 백발백중 우리 인간 아니면 우리가 기르는 가축의 몸에 내려앉게 된다. 그들은 그들의 존재 역사에서 지금처럼 어마어마한 대호황을 누려본 적이 없다. 우리나라는 벌써 10년이 넘도록 해마다 조류독감에 시달리고 있고 지금도 우리 산야에서는 아프리카돼지열병 때문에 애꿎은 멧돼지를 사살하고 있다. 우리 인간의 숫자가 획기적으로 줄지 않는 한, 아니면 야생동물들이 편안하게 살 수 있도록 그들의 생활 공간인 자연생태계를 지금보다 훨씬 쾌적하고 넓게 확보해주지 않는 한, 다시 말해서 이 엄청난 생물 다양성의 불균형을 바로잡지 않는 한 이런 전염병 재앙은 앞으로도 계속될 것이다. 지금보다도 훨씬 자주.

나는 천주교인도 아니지만 지금 이 순간 내가 가장 존경하는 분이 누구냐 물으면 조금도 머뭇거리지 않고 프란치스코 (Francis) 교황님이라고 답한다. 2013년 그가 제266대 교황으로 선출되었을 때부터 나는 은근히 기대했다. 그가 교황으로서 사용할 이름을 아시시의 성 프란치스코(Saint Francis of Assisi)

에서 따 온다고 밝힐 때부터 어딘가 남다르다고 생각했다. 2019년 그는 '하느님, 다른 사람들, 공동체, 그리고 환경에 반하는 행동 또는 태만'을 '생태적 죄(ecological sin)'로 규정하고, 이를 천주교 교리에 포함한다고 선언했다. 다 같은 피조물 간의 연대 체계를 끊는 행위는 자연의 상호 의존성 원칙에 어긋나는 원죄라는 것이다. 2015년 한국천주교주교회의가 프란치스코 교황의 회칙을 엮어 발행한 『찬미받으소서』라는 책에는 이 선언의 이론적 배경이 상세하게 적혀 있다. 시간과 공간도 서로 동떨어진 것이 아니며 이 세상 모든 존재가 서로 밀접한 관계를 맺고 있기 때문에 "자연계 자체의 상호작용과 더불어 자연계와 사회 체계의 상호작용을 고려"해야만 생태적 해결책을 찾을 수 있다. 그 옛날 프란치스코 성인은 일찍이 이른바 '통합 생태론'이 수학과 생물학의 언어를 초월해 우리를 인간다움의 핵심으로 이끌 것이라고 설명했다.

코로나19 팬데믹은 프란치스코 교황이 생태적 죄를 규정한 지 두 달도 채 안 돼 일어났다. "자연 세계에 저지른 죄는 우리 자신과 하느님을 거슬러 저지른 죄"라는 교황의 말씀과 한 치의 어긋남도 없다. 프란치스코 교황은 환경 위기에 대한 구체적인 해결책을 찾으려는 우리의 노력이 힘 있는 자들의 이익 추구 일변도와 사람들의 관심 부족으로 효과를 내지 못했다고 지적한다. 그는 이미 오래 전부터 이런 끔찍한 재앙을 예견하고 통렬한 '생태 회개'를 주문한 것이다. '공동의 집'을 함께 돌보기는커녕 자꾸 허물기만 하는 인간은 회개해야 한다. 지구가 걱정스럽다는 사람들이 있다. 천만에. 지구는 살아남는다. 비록 만신창이가 될지라도. 그저 인간이 사라질 뿐이다. 우리가 이 아름다운 행성에서 오랫동안 행복하게 살려면 '생태적 전환(ecological turn)'을

average weight of 60 to 65 kilograms, and add to that the mass of the livestock we breed—our cows, pigs, sheep, goats, ducks, and chickens. The calculations may vary depending on the animals we include in this category, but at any rate, we and the animals we raise account for some 96 to 99 percent of all mammals and birds on Earth. This is a twist never before seen in the natural world. But for this very reason, when viruses and bacteria that reside in the bodies of wild animals are spread, their new hosts are almost always either humans or the animals we raise for food. Viruses have never flourished as they do now. In Korea, avian influenza has been an unwelcome yearly visitor for over 10 years, and in the countryside, wild hogs are slaughtered to stop the spread of African swine flu. Unless the human population is drastically reduced or measures are taken to ensure that the natural habitats of wild animals are protected and sufficiently enlarged—that is, unless something is done to somehow correct the vast imbalances in Earth's biodiversity—disasters caused by infectious disease will only continue, and with much more regularity.

I am not Catholic, but if you were to ask me who I most respect in the world today, I would choose Pope Francis without hesitation. I have been watching him expectantly since he was announced as the 266th pope back in 2013. I was struck, for one, by his decision to choose Saint Francis of Assisi as his namesake. In 2019, Pope Francis defined the concept of ecological sin—an action or omission against God, against one's neighbor, the community, and the environment—and announced it would be included in the *Catechism of the Catholic Church*. The principle behind this is that such actions, in their destruction of the bonds of solidarity among creatures, and transgressions against the principles of interdependence among all living things, constituted sin. The theoretical underpinnings of this declaration are explained in greater detail in *Laudato si*, the environmental encyclical of Pope Francis, published in Korea in 2015 by the Catholic Bishops' Conference of Korea. Given the interconnectedness of all living things, according to which even time and space cannot be considered apart from one another, to seek solution to the problems of ecology, we must, as Pope Francis writes, "consider the interactions within natural systems themselves and with social systems." The original Francis of Assisi, writes the Pope, "helps us to see that an integral ecology calls for openness to categories which transcend the language of mathematics and biology, and take us to the heart of what it is to be human."

The COVID-19 pandemic broke out only two months after Pope Francis defined ecological sin. It makes the truth of his statement, "To commit a crime against the natural world is a sin against ourselves and a sin against God," resoundingly clear. He points out that our efforts to find solutions to the threats facing our environment have failed to be effective for the simple reasons that those in power continue to seek their own interests and those who should care more do not. I imagine that it is today's crisis that he envisioned when he called on believers to have an "ecological conversion." We must collectively repent for how we have not only failed to protect our common home but continuously engage in its destruction. I hear people say they are concerned for the Earth. Earth? Earth will survive. Destroyed

이뤄내야 한다. 생태학을 앞세운 과학과 더불어 종교와 예술이
인류를 이 수렁에서 건져 내리라 기대한다.

and marred beyond recognition, perhaps, but it will continue. It is humans who will disappear. If we are to continue to lead long, happy lives on this beautiful planet, we must make an ecological turn. United under the common banner of ecology, may the powers of science, religion, and the arts rescue us from this pit of destruction.

포스트휴먼이 포스트 코로나 시대를 살아가는 법

송은주

이화여자대학교 인문과학원 연구교수

How Post-humans Live in the Post-COVID-19 Era

Song Eun-ju

Research Professor at Ewha Institute for the Humanities, Ewha Womans University

어느 날 갑자기 도래한 재난, 팬데믹

2003년 개봉한 대니 보일(Danny Boyle) 감독의 영화 〈28일 후〉는 텅 빈 런던 시내 한복판을 넋 나간 듯 터벅터벅 걸어가는 한 남자의 모습으로 시작한다. 시민들과 관광객으로 밤이나 낮이나 발 디딜 틈 없이 붐비던 국회의사당 앞 거리에 살아있는 것이라곤 흔적조차 보이지 않고 휴지 조각만 날린다. '분노 바이러스'가 온 세상을 휩쓸고 간 세계의 스산하다 못해 불길한 모습은 오프닝 장면부터 상당한 충격으로 다가온다. 2021년, 우리는 세상의 종말을 연상시키는 그런 장면들을 재난영화가 아니라 뉴스에서 보고 있다. 인적이 끊어진 유럽 대도시의 유명 관광지들, 시체가 떠다니는 갠지스강의 모습은 너무 낯설어서 도무지 현실 같지가 않다. 코로나19라는 생소한 이름을 처음 들었을 때만 해도 마스크 쓰기와 거리 두기가 삶의 새로운 규칙이 된 여름을 두 번째로 맞게 되리라고는 아무도 상상하지 못했을 것이다. 이것이 적어도 우리가 꿈꾸고 기대했던 미래는 아니었다.

우리가 기다리던 미래는 팬데믹의 공포로 마비된 디스토피아적 세계가 아니라 과학기술의 발달로 불가능이 현실이 되는 '멋진 신세계'였을 것이다. 나노기술, 로봇공학, 자율주행자동차, 사물인터넷, 유전자복제…. SF에서나 보았을 법한 첨단 과학기술들은 4차 산업혁명을 통해 펼쳐질 무한한 가능성의 미래를 약속했다. 최근 몇 년 사이 심심찮게 들려오기 시작한 '포스트휴먼(Posthuman)'이라는 신조어는 이러한 미래의 전망을 상징하는 하나의 기표로 사람들의 호기심과 기대감을 자극했다. 접두사 '포스트'는 보통 '~이후', 또는 '탈'의 의미로 번역된다. 그러니까 포스트휴먼은 '인간 이후의 인간', 혹은 '인간을 벗어난 인간' 정도가 될 것이다.

Pandemic: A Sudden Disaster

The 2003 film *28 Days Later*, directed by Danny Boyle, opens with a scene of a man plodding absent-mindedly through the vacant streets of London. No trace of life can be seen as scraps of paper blow through the streets in front of the House of Parliament that used to be bustling with people day and night. The bleak and ominous cityscape of a world ravaged by a sickness called the "Rage Virus" shocks viewers in the opening scene. Now, in 2021, we see scenes that are reminiscent of the end of the world not in disaster movies but on the news. Desolate streets and famous tourist sites in major European cities; bodies floating down the Ganges River—these sights look strange and unreal. When we first heard the unfamiliar term COVID-19, none of us imagined not one, but two summers dictated by the new rules of life that require mask-wearing and social distancing. This was not the future that we dreamed of or anticipated.

The future that we looked forward to was a "brave new world" in which scientific and technological development would have turned once-impossible ideas into reality, not a dystopian world paralyzed by the fear of pandemic. Cutting-edge innovation like nanotechnology, robotics, automatic vehicles, the Internet of things (IoT), and genetic cloning, all of which we may have only encountered in science fiction, promised us a future with infinite possibilities that would have unfolded with the Fourth Industrial Revolution. The newly coined term "posthuman," which has been frequently discussed over the past few years, served as a symbol of the outlook of this new future, stimulating people's curiosity and expectations. The prefix "post-" means "after" or "posterior to." Hence, posthuman refers to a "humanity to come after the present humanity" or "human beyond human."

However, posthumanism cannot be defined singularly. How the term "human" is defined in relation to historical contexts and surrounding environments may determine the meanings and ultimate goals of posthumanism. Then, what does posthuman mean to us in the current pandemic era? Is the pandemic an obstacle that we have encountered on our way to the posthuman—human evolution's final destination? Or is it a warning that the ideal of the posthuman is itself an unreachable illusion? We need not be drawn into apocalyptic pessimism; however, it is also dangerous to be excessively optimistic that civilization is progressing and science and technology will eventually save us regardless of the problems we face. Philosopher Rosi Braidotti argues that we are standing at a crossroads, facing the sixth mass extinction due to the Fourth Industrial Revolution and climate change. At this crossroads, with the fear of the pandemic engulfing the entire world, we must revisit the questions of what it means to be human and what kind of posthuman world we should dream of.

The Posthuman in the Anthropocene

The course of human history has been one of endless struggles against the limitations and restrictions imposed on humans by nature. Our physical abilities are not outstand-

사실 포스트휴먼은 한 가지 의미로만 정의될 수 없다. 역사적 맥락과 주변 환경과의 관계 속에서 인간을 어떻게 정의하는가에 따라 포스트휴먼의 의미와 궁극적인 지향점은 달라진다. 그렇다면 지금의 팬데믹 시기에 포스트휴먼은 우리에게 어떤 의미일까? 팬데믹은 포스트휴먼이라는 인류 진화의 최종 목적지로 가는 길 위에서 잠시 맞닥뜨린 장애물에 불과한가? 아니면 포스트휴먼의 이상 자체가 인간이 도달할 수 없는 신기루 같은 허상임을 일깨우는 일종의 경고일까? 세상이 당장이라도 망할 것처럼 종말론적 비관주의에 휘둘릴 필요는 없지만, 어떤 문제가 있더라도 문명은 진보하고 있으며 과학기술이 결국은 우리를 곤경에서 구해 주리라는 과도한 낙관 또한 위험하다. 철학자 로지 브라이도티(Rosi Braidotti)는 우리가 4차 산업혁명과 기후변화로 인한 여섯 번째 대멸종의 갈림길에 서 있다고 말했다. 팬데믹의 공포가 전 세계를 뒤덮은 지금, 그 갈림길 위에서 인간이 어떤 존재이며, 우리는 어떤 포스트휴먼을 꿈꾸는가를 다시 물어야 한다.

인류세의 포스트휴먼

인간의 역사는 자연이 부여한 한계와 제약에 맞선 끝없는 투쟁의 역사였다. 인간은 다른 동물에 비해 신체 능력 면에서는 그다지 특별할 것이 없었지만, 두뇌의 힘으로 생물학적 한계를 극복하며 능력의 지평을 끊임없이 확장해 왔다. 호모사피엔스가 3 4만 년 전 처음 지구상에 출현한 이래 1만 년 전 농경이 시작되었을 당시 인구수는 약 530만 명으로 추산되지만, 현재 세계 인구

수는 78억 명에 이른다. 로마제국의 평균 수명은 21세였지만 지금은 80세 이상으로 네 배 가까이 늘어났다. 이렇게 인간이 다른 모든 생물 종들을 압도하고 지구의 최강 지배 종이 될 수 있었던 데에는 자연의 비밀을 파헤치고 자연을 인간에게 유용한 자원으로 활용할 수 있게 해 준 과학기술의 공이 컸다.

'포스트휴먼'은 이러한 인간 능력의 확장이 자연의 한계를 넘어서서 완전히 새로운 차원으로 진입하게 됨을 의미한다. 포스트휴먼은 타고난 한계를 과학기술의 힘으로 초월하여 우리가 지금까지 인간이라고 생각했던 존재와는 완전히 달라진, 다시 말해 특이점을 넘어간 새로운 인간이다. 이 미래의 인간이 실제로 어떤 모습일지는 아직은 상상의 영역이다. 유전자공학 같은 최첨단 생명과학의 힘으로 영원히 20대의 젊음과 아름다움을 유지하며 살아가는 모습일 수도 있고, 신체 기관을 부품 갈아 끼우듯 더 기능 좋고 튼튼한 인공 부속으로 교체한 사이보그일 수도 있다. 아이언맨처럼 신체 기능을 강화하는 특수 장비의 힘을 빌릴 수도 있고, 〈트랜센던스〉에서처럼 아예 뇌를 컴퓨터에 업로딩하여 옷을 바꿔입듯 그때그때 마음에 드는 신체로 바꿔가며 영생을 누리고 자유로이 우주를 누비는 모습일지도 모른다. 어쨌든 포스트휴먼의 꿈은 결함 많고 거추장스러운 몸의 굴레를 벗어나 노화와 죽음이라는 숙명적인 한계를 극복하는 것이다. 유발 하라리(Yuval Noah Harari)가 말한 '호모 데우스', 신이 된 인간이다.

그러나 이러한 포스트휴먼 개념을 어떻게 받아들일지는 보는 관점에 따라 차이가 있다. 포스트휴먼의 꿈을 좇는 대표적인 사상인 트랜스휴머니즘은 지금 우리 인간은 포스트휴먼으로 진화해 가는 길 위에 있으며, 궁극적으로는 포스트휴먼이 되는 것

ing compared to those of other animals, but with our brain power, we have overcome our biological limitations and endlessly expanded the scope of our abilities. *Homo sapiens* first appeared on the planet 30,000 to 40,000 years ago; 10,000 years ago, when they began to develop agriculture, its population is estimated to have been 5.3 million; and now, the world's current human population is 7.8 billion. In the Roman Empire, the average life expectancy was 21 years old, but now it is nearly four times that at over 80 years old. Humanity owes its dominance over other species to its grasp of science and technology, which allowed has allowed us to uncover nature's secrets and take advantage of its useful resources.

The term posthuman signifies the expansion of human abilities into an entirely new dimension, one that moves beyond the limitations of nature. A posthuman being transcends human limitations with the power of science and technology to become entirely different from what we have long perceived as human—in other words, it is a new being that has moved beyond the singularity of being human. What this future human will really look like still remains in the territory of imagination. Such people may permanently maintain the youth and beauty of their 20s thanks to the power of cutting-edge life science technology such as genetic engineering; they could be cyborgs who have replaced their organs with more durable and functional artificial organs as if changing out machine parts. They might use special equipment to enhance their physical abilities, or, like in the film *Transcendence* (2014), they might upload their brains onto computers, enabling them to change bodies depending on the situation as if changing clothes and travel through space at will for all eternity. At any rate, the dream of the posthuman is to free oneself from the restraints of the burdensome human body and overcome the fateful limitations of aging and death. This dream mirrors a term coined by Yuval Noah Harari—"*Homo deus*," humans that have become gods.

However, there are different perspectives on the acceptance of the notion of the posthuman. Transhumanism, a representative ideology that pursues posthuman existence, believes that it is evolution's final destination and the inevitable conclusion of human history for us to ultimately become posthuman. The idea that human minds will conquer nature and free humanity from the fetters of the material world has been a major axis that has supported Western civilization from the Age of Enlightenment to date. Transhumanism can be said to have expanded faith in human abilities in the 21st century and fueled scientific progress.

The power of humanity to dominate nature has, in the end, left indelible human marks on the planet's surface. Nobel Prize-winning atmospheric chemist Paul Jozef Crutzen argued in 2000 that humans have become a geological force that has altered the global environment, and thus the geological epoch we live in should be called the Anthropocene instead of the Holecene. Since the industrial revolution, as the use of fossil fuels began to cause a rapid increase of carbon dioxide in the atmosphere and bring about climate change, human activities have left permanent physical marks on our planet. Like the posthuman dream of an infinite expansion of human abilities, to some, the term Anthropocene may sound like a proclamation of victory that humans

이 인류 역사의 필연적 전개이며 진화의 최종 목표라고 믿는다. 위대한 인간의 정신이 자연을 정복하고 물질세계의 구속으로부터 인간을 해방한다는 이상은 근대 계몽주의 시대부터 지금까지 서구 문명을 지탱해 온 주요한 축이었다. 트랜스휴머니즘은 이러한 인간 능력에 대한 근대적 신념을 과학의 발전과 더불어 21세기에 와서 더욱 확장했다고 할 수 있다.

자연을 지배하는 인간의 힘은 급기야 지구의 지층에 지워지지 않을 인간의 흔적을 남기는 데까지 나아갔다. 노벨상을 수상한 대기화학자 파울 크뤼첸(Paul Jozef Crutzen)은 2000년 인간이 지구 환경을 바꾸는 지질학적 힘이 되었으며, 현재 우리가 살고 있는 지질학적 시대 구분을 기존의 홀로세에서 인류세로 바꿔야 한다고 주장했다. 산업혁명 이후 화석연료의 사용으로 대기 중 탄소 비율이 급격히 올라가고 기후변화가 일어나면서, 인간의 활동이 지구의 지층에까지 영구적인 변화의 흔적을 남기게 되었다는 것이다. 끝없는 인간 능력의 확장을 믿는 포스트휴먼의 꿈처럼, 인류세라는 명칭은 어떤 이들에게는 인간이 이제 환경을 자신의 의지대로 바꿀 수 있는 막강한 힘을 갖게 되었다는 승리의 선언으로 들릴지도 모른다. 그러나 그것은 우리가 처한 현실의 한쪽 면만을 본 것이다. 우리가 도구와 기술을 사용함으로써 한계를 극복하게 되었다는 것은 사실이지만, 이를 인간이 자연을 완전히 지배 하에 두고 마음대로 통제할 수 있게 된다는 뜻으로 받아들인다면 곤란하다.

코로나바이러스의 출현은 인간에 의한 지구 환경의 변화와 무관하지 않다. 인간이 거주와 자원 채취, 식량 재배를 위해 무분별하게 자연을 개발하면서 야생동물의 서식지가 크게 감소했고, 이는 인간과 야생동물의 거주지 경계가 무너지고 접촉이 늘어나면서 인수공통 전염병의 발생이 증가하는 결과를 가져왔다. 1997년 홍콩 조류독감, 2009년 미국에서의 돼지독감, 2012년 메르스, 서아프리카의 에볼라 바이러스 등 이미 수 차례의 비슷한 인수공통 전염병 발병 사례들이 있었다. 전염병의 발생 주기가 점차 짧아지고 전파력은 강해지는 상황에서 팬데믹의 발생은 예고된 것이었다. 이는 과학기술의 발전이 인간을 더 자유롭고 안전하게 만들어주는 한편으로 새로운 위험을 초래하는 역설적인 상황이다. 사회학자 울리히 벡(Ulrich Beck)은 『위험사회』에서 현재의 위험은 과학기술의 결핍이 아니라 발전 그 자체에서 나온다고 말했다. 과거의 위험이 불량한 위생 상태나 식량 부족과 같이 기술이 충분히 발전하지 못한 탓이었다면, 현재의 위험은 핵전쟁이나 환경오염, 신종 바이러스의 출현처럼 과학기술의 발전에서 비롯된다는 것이다.

팬데믹의 경우에서 보듯이 과학의 발전은 인간을 기존에 없던 새로운 위험에 노출시킨다. 전 지구적인 교통망과 운송 수단의 발달로 이동성이 강화되지 않았다면 바이러스가 이렇게 급속히 전 세계로 퍼져나가지는 못했을 것이다. 자연에 대한 인간의 지배력 강화는 한편으로 자연의 역습을 불러오기도 한다. 팬데믹을 해결하기 위해 백신을 개발하면 된다고 생각하겠지만, 백신이 개발되는 와중에도 끊임없이 새로운 변종 바이러스들이 출현한다. 어찌어찌해서 코로나19는 종식된다 해도, 언제 또 새로운 바이러스가 우리를 위협할지 알 수 없다. 코로나19와 같은 인수공통감염병 외에도 지구온난화로 극지방의 빙하가 녹으면서 페스트 균과 같이 오래 전 자취를 감추었던 치명적인 바이러스가 다시 출현할지 모른다는 경고마저 나오고 있다. 코로나19의 출현 배경이 된 인류세의 환경 변화가 그대로인 한, 근본적인 해

have gained the power to alter the environment. Yet, this is a one-sided view of our reality. It is true that we have overcome limitations by using tools and technology, but this must not be understood as humans having the absolute authority to place nature under our complete control and have everything obey our command.

The COVID-19 pandemic is not unrelated to the global environmental changes caused by humans. As humans began to recklessly manipulate nature to provide food, shelter, and other resources, wildlife habitats have decreased significantly, resulting in the collapse of boundaries between human settlements and wildlife habitats and increasing the occurrence of zoonoses (diseases or infections that can be transmitted between species). There have been a number of zoonotic outbreaks, including the 1997 bird flu outbreak in Hong Kong, the 2009 swine flu outbreak in the US, the 2012 MERS outbreak, and the West African Ebola outbreak. With new diseases emerging at rapidly shortening intervals and infection rates increasing, the current pandemic was inevitable. This is a paradoxical situation in which science and technology both liberate and safeguard human life while at the same time causing new risks. Sociologist Ulrich Beck wrote in *Risk Society* that risk these days is not caused by lack of technology or progress, but is derived from them. While risk in the past, such as that which resulted from poor hygiene or food shortages, was ascribable to insufficient technology, today's risks of nuclear war, environmental pollution, and disease outbreaks are derived from the advancement of science and technology.

As is demonstrated by the current pandemic, scientific progress exposes humans to risks that have not existed before. If our ability to travel around the world had not been enhanced by the development of global traffic networks and transportation, COVID-19 would not have spread at the rate that it has on a global level. Thus, humankind's strengthening chokehold on nature may cause nature to retaliate. One may think that the development of vaccines is a simple solution to pandemics, but new virus variants are constantly appearing even as we develop vaccines for the initial strand. Even if we were to somehow end COVID-19, there is no knowing when another virus will emerge to threaten us. Some warn that in addition to zoonoses such as COVID-19, long-vanished lethal viruses like the bubonic plague may reappear if the glaciers keep melting due to global warming. It is difficult to escape the bleak outlook that there is no fundamental solution and similar events will repeat themselves like a song on loop if the environmental changes of the Anthropocene that caused the outbreak of COVID-19 persist.

Who is Human in a Posthuman World?

The pandemic demands that we, both as victims suffering from a catastrophe and the culprits that caused it, contemplate what humanity is, fundamentally. The empowered human in the posthuman world follows a legacy of humanism from the Western Age of Enlightenment. In other words, the concept of this human is not a universal one, unbound by period and region, but one established under certain histor-

결이란 존재하지 않을 것이고 끝없는 되돌이표처럼 비슷한 사태가 반복되리라는 암울한 전망을 피할 수 없다.

포스트휴먼의 '휴먼'은 누구인가

팬데믹의 위기는 우리에게 이러한 대재앙의 원인을 제공한 장본인이면서 또한 그로 인해 고통받는 인간이 어떤 존재인가에 대한 근본적인 성찰을 요구한다. 포스트휴먼의 강화된 '휴먼'은 서구 근대 계몽주의 휴머니즘의 유산이다. 다시 말해서 이 인간은 시대와 지역을 막론하고 통하는 보편적인 개념이 아니라, 특정한 역사적, 사회적 상황 속에서 구성된 인간 개념이다. 휴머니즘의 인간은 세계의 유일한 주인이며 인간 외의 모든 것을 지배하고 이용할 권능을 가진 존재이다. 또한 이 인간은 외부 환경의 영향으로부터 독립적이고, 합리적 이성과 의지의 힘으로 스스로의 운명을 결정할 수 있는 자율적인 주체이다. 이러한 계몽주의 휴머니즘의 인간 개념을 계승하는 트랜스휴머니즘은 인간 이성의 힘과 자율성을 신뢰하며 과학 기술로 이러한 능력을 더욱 강화해야 한다고 주장하기 때문에 '스테로이드 휴머니즘'이라고도 불린다. 스테로이드제를 과다 투여해 근육이 터질 듯 부풀어 오른 이 초인간은 남성/여성, 자연/문화, 이성/감성, 정신/물질로 분리하고 위계화하는 이분법적 범주들을 자신의 존재 기반으로 삼는다. 나와 다른 '차이'는 나보다 열등하다는 '차별'을 정당화하는 근거가 된다. 나 아닌 세상 모든 것을 이 틀에 가두어 나와 타자의 관계를 지배와 복종의 관계로 바꾸어 놓는 것이다.

그러나 팬데믹을 겪으면서 우리는 나와 타인의 관계, 나아가 우리와 우리를 둘러싼 환경의 관계를 다시 돌이켜 생각해 보게 된다. 이제 타인은 나에게 언제 바이러스를 옮길지 모르는 잠재적인 위협이 되었다. 타인과의 접촉과 친밀한 관계는 되도록 피해야 한다. 그러나 내가 타인을 불신과 의심의 눈초리로 훑을 때, 그 날카로운 눈길은 상대에게서 나에게로 고스란히 되돌아온다. 나 또한 상대에게 위협적인 존재이다. 우리는 서로를 위협하는 동시에 서로를 보호해야 한다는 점에서 위험과 안전을 공유하게 된다. 우리나라에서는 2021년부터 불법체류 외국인들에게도 비자 확인 없이 무료로 코로나 검사를 해 주는 조치가 시행되었다. 왜 불법체류자들에게 세금을 낭비하느냐는 반대 여론도 있었지만, 싱가포르에서 기숙사에 공동 거주하던 이민자들 사이에 코로나 감염이 폭증한 사례가 있었다. 불법체류 사실이 드러날까 두려워 검사를 기피하면서 방역에 구멍이 뚫린 것이다. 불법체류자들에 대한 무료 검사와 백신 접종은 가난한 자들에게 마음 내키면 베풀 수도 있는 선택적 시혜가 아니라 우리 모두의 안전을 위한 필수적 조치이다. 고립을 선택한다고 감염을 완벽히 차단할 수는 없으며, 어떻게 해도 나 혼자만 안전해질 수 있는 방법은 없다. 나의 존재는 세계 속에서 다른 모든 것들과 연결되어 있으며, 나는 세계를 구성하는 그 일부이기도 하다. 곧 어느 정도까지는 세계가 나이고 내가 곧 세계이다. 세계와 나의 경계는 칼로 무 자르듯 명확하게 나뉘어지지 않는다.

이러한 나와 세계의 뒤섞임은 역사적으로 진화 과정에서도 그 예를 찾아볼 수 있다. 인간의 진화는 자연선택과 적자생존의 법칙에 따라서가 아니라, 동물, 식물, 미생물을 비롯한 모든 비-인간 존재들과 공생함으로써 가능했다. 세포 속의 미토콘드리아

ical and social conditions. In humanist thought, the human is the sole master of this world, possessing the authority to use and control everything except other humans. Also, this human exists independent from the external influence of its environment as an autonomous agent that can determine its own fate with the power of reason and volition. Transhumanism, which borrows this concept from the humanism of the Enlightenment, is also referred to as "humanism on steroids" because it trusts the power of human reason and autonomy and argues that this power should be enhanced by science and technology. The resulting superhuman, whose muscles are pumped to bursting with steroids, uses the dichotomous categories that divide and hierarchize men and women, nature and culture, reason and emotion, and mind and material as the basis of its existence. The differences that set others apart from oneself become the grounds for justifying discrimination. By confining everything besides oneself in this framework, one turns the relationship of self and the other into that of domination and subordination.

While undergoing the current pandemic, however, we have been compelled to reflect on the relationship between the self and others, and furthermore, the relationship between the self and one's surrounding environment. Suddenly, others pose the latent threat of infection to us. Coming in contact or forming intimate relationships with others must be avoided if possible. However, when we cast suspicious gazes upon others, it is that same acute gaze that will be thrown back to us. We are as much a threat to others as they are to us. We simultaneously share risk and safety in that we both pose a threat to and are responsible for others' well-being. In Korea, a new measure to provide free COVID-19 testing to undocumented immigrants without checking their visa status was implemented in early 2021. Some opposed this decision on the grounds that it was a waste of taxpayer money; however, the decision referenced a case in Singapore in which COVID-19 spread rapidly among migrant workers living in dormitories. Their fear of having their undocumented status revealed prevented them from seeking testing and created a tear in Singapore's quarantine efforts. Providing COVID-19 tests and vaccines to undocumented immigrants for free is not a selective dispensation of resources to the disadvantaged with little rhyme or reason, but an indispensable measure to keep everyone safe. Infection cannot be completely contained by individual isolation, and there is no way that individual people can stay safe alone. We are connected to everything in the world and make up its fabric. Hence, to an extent, the world is us and we are the world. The boundaries between humans and the world cannot be clearly demarcated.

The entanglement of the world and the self can be seen in the process of evolution. Human beings were able to evolve not by following the "survival of the fittest" logic of natural selection but through symbiosis with nonhuman beings such as animals, plants, and microorganisms. Two billion years ago, mitochondria were independent cells before they were consumed by other cells. However, both became dependent on each other as mitochondria could create energy by intaking oxygen and the cells that consumed them could use that energy. Intercellular symbiosis, in which two cells evolve into one individual cell, was the result. As such, human beings

는 원래 20억 년 전에는 독립된 세포였지만 다른 세포에게 잡아 먹히게 된다. 그런데 미토콘드리아는 산소로 호흡하여 에너지를 만들어낼 수 있는 박테리아였기 때문에 잡아먹은 세포가 이것의 에너지를 이용하면서 둘은 서로 의존하게 되었다. 그 결과 두 개의 세포가 하나의 개체 세포로 진화하는 세포내공생 관계가 만들어졌다. 이처럼 인간은 경계 바깥의 다른 존재들과 소통하고 상호 의존하며 공진화해 왔다. 2012년 미 국립보건국이 수행한 '인간 미생물군집체 프로젝트(Human Microbiome Project)'는 인간 몸 안의 미생물 수가 인간 세포보다 많다는 연구 결과를 내놓았다. 미생물이 곧 우리 자신이며, 우리의 존재에 더 책임이 있다는 것이다. 특정 미생물군집이 우리 기분, 행동, 인격에까지 영향을 줄 수 있다. 이러한 연구 결과들은 인간의 몸이 외부로부터 밀봉되고 차단된 것이 아니라, 인간과 외부 환경을 나누는 경계가 투공성(porous)이 있으며 유동적이고 매 순간 변화한다는 것을 보여준다. 우리의 피부는 내부와 외부를 가르는 경계라기보다는 물질들이 들고 나는 막이다.

이러한 상호의존과 공생의 관계는 인간과 미생물의 관계에서만이 아니라 기계와의 관계에서도 마찬가지이다. 이제는 스마트폰 덕분에 수백 개의 전화번호를 외울 필요가 없게 되었고, 자질구레한 정보들을 머릿속에 담지 않아도 언제든 인터넷에 접속해 구글에서 검색하기만 하면 된다. 기계들 덕분에 우리의 능력은 과거와는 비할 수 없이 커졌지만, 한편으로는 기계에 대한 의존성도 그만큼 커진다. 인간의 능력이 확장된 것은 우리가 수많은 비인간 존재들과 접속할 수 있게 된 덕분이다. 스마트폰과 컴퓨터에 내가 기억해야 할 정보들을 저장해 두고 내가 해야 할 계산을 대신 맡기면서 나의 인지 기능을 기계에 분산하게 된다. 인

지 과학에서는 이를 '확장된 마음(extended mind)'이라고 부른다. 나아가 스마트폰과 컴퓨터 또한 단독으로 일하는 것이 아니라 전력망에서 에너지를 공급받고 와이파이에 접속하여 거대한 정보 생태계의 일부로 작동한다. 이 생태계는 온갖 기계만이 아니라 인간까지 인지적 행위자로 포괄하는 '정보권(infosphere)'이다. 이 네트워크에 접속할 수 없게 될 때 우리는 몸 어느 한 부분의 기능을 잃고 불완전한 존재가 된 듯한 당혹감과 불안을 느낀다. 우리 '포스트휴먼'은 홀로 존재하지 않는다. 우리는 거대한 네트워크의 일부이다. 네트워크 외부에서 고고하게 비-인간들을 관찰하고 통제하고 조종하는 유일한 행위자가 아니라, 그 안에 다른 모든 비-인간들과 함께 뒤엉켜서 서로 영향을 주고받으며 살아간다.

그런 점에서 포스트휴먼은 과학기술로 강화되어 물질세계를 지배하고 종국에는 초월하는 인간이 아니라, 물질세계에 자신의 존재를 뿌리박고 비-인간들과 상호접속을 통해 자신의 행위하는 능력을 분산하고 확장하는 인간이다. 나의 존재를 포스트휴먼으로 인식한다는 것은 나의 생존이 나를 둘러싼 다른 모든 존재들에게 빚지고 있음을 잊지 않는다는 의미이다. 이러한 인간 존재에 대한 새로운 인식은 인간이 과학기술의 발달에 따라 점점 더 많은 기계와 접속하며 강화될 미래를 예상한다 할지라도, 비인간 존재와 환경에 대한 인간의 지배력 확대를 기대하는 트랜스휴머니즘의 관점과는 궤를 달리한다. 트랜스휴머니즘이 지향하는 포스트휴먼의 '포스트'가 자연의 구속에 묶인 인간으로부터의 탈출을 의미한다면, 이에 반대하는 '비판적 포스트휴머니즘'은 고전적인 휴머니즘의 인간 주체 개념으로부터의 탈출을 지향한다. 트랜스휴머니스트들이 이성과 정신의 초월적인 힘으로 물

have undergone coevolution with other beings by communicating and maintaining mutually dependent relationships with them. The Human Microbiome Project conducted by the US National Institutes of Health published research results that indicated that there are more microorganisms in the human body than human cells. This shows that microorganisms are, in fact, us; they are responsible for our existence. Particular microbiomes can affect our feelings, behavior, and even personalities. According to these research results, human bodies are not sealed off from the outside world. The boundaries that separate humans from their external environment are porous, flexible, and constantly changing. Our skin is not so much a boundary between inside and outside, but a membrane through which materials can enter and exit.

This mutually dependent, symbiotic relationship does not only exist between humans and microorganisms, but also between humans and machines. Thanks to smartphones, we no longer have to memorize hundreds of phone numbers and there is no need to fill our heads with mundane information because we can access it via the internet and Google anytime. Owing to technology, our abilities have risen to unparalleled levels, but at the same time, our dependence on machines has increased just as much. The reason that human abilities have increased to this extent is because we have been able to connect with numerous technological entities. We delegate our cognitive functions to machines by storing information that we need to remember on computers and smartphones or entrusting them to do important calculations. In cognitive science, this is called the "extended mind." Furthermore, smartphones and computers do not work on

their own but operate through accessing wireless networks as part of an enormous information ecosystem supplied with energy from the electrical grid. This ecosystem is an "infosphere" that includes humans as well as a variety of machines as cognitive actors. When we are unable to access this network, we experience frustration and anxiety as if we have become incomplete or lost some of our fundamental functions. We posthuman beings do not stand alone. We exist as part of an enormous network. Humans are not aloof, individual actors that observe, control, and manipulate nonhuman objects from the outside, but live entangled with nonhuman objects, mutually influencing one another.

In this sense, posthuman beings do not dominate and ultimately transcend the material world by being enhanced by science and technology, but exist rooted in the material world and disperse and extend their abilities through mutual access to nonhuman objects. To recognize our existence as posthuman beings means that we do not forget that we owe our survival to all the beings that surround us. Thus, the posthuman perception of humanity veers away from the transhumanist perspective that expects humans to expand control over nonhumans and the environment, even if both ideologies share the idea of a future for enhanced human beings in which they are connected to machines and rely on scientific progress. While the prefix post- in the posthuman pursued by transhumanism signifies an escape from a humankind fettered by nature, critical posthumanism opposes this, seeking to flee from the concept of human agency in traditional humanism. While transhumanists dream of soaring through outer space, shaking off physical restrictions with

질적 구속을 벗어나 우주 공간으로 솟아오를 꿈을 꿀 때, 이 새로운 포스트휴먼은 지구의 땅과 공기와 물 속에서 바이러스와 동물과 로봇들과 뒤엉킨 존재로서 함께 살아갈 방법을 찾는다. 브라이도티는 포스트휴머니즘의 새로운 주체성 이론은 탈인간중심적 관계들을 따라 주체성의 틀과 영역을 확대해야 하며, 인간과 (유전자라는 면에서 우리 이웃인) 동물 그리고 지구 전체를 포괄할 수 있어야 한다고 말한다. 우리는 "우리가 책임질 수 없는 우연한 만남들, 상호작용들, 정서적 변용과 욕망의 누를 수 없는 흐름들의 효과"[1]이다.

팬데믹 시대, 포스트휴먼의 꿈과 짐

비판적 포스트휴머니즘은 인간 주체를 외부 환경의 영향으로부터 독립된 자율적인 개체로 보는 전통적인 주체 개념에 의문을 제기하며, 인간의 행위성이 미생물을 비롯하여 무수히 많은 인간과 비-인간 행위자들과의 상호작용 속에서 제한받는다고 본다. 인간 주체성은 동물, 식물, 기계와 같은 비-인간에 이르기까지 인간 이외의 모든 존재들과 상호접속하는 상호주체성(intersubjectivity)이며, 외부의 힘과 균들이 통과하는 횡단-주체성(trans-subjectivity)이다. 인간이 더 큰 물질적 세계로 열려있고 온갖 물질과 행위자들에 의해 관통당한다는 사실은 인간의 무방비함과 취약함을 의미하기도 하지만, 이러한 인식은 주변 세계와의 상호공존을 추구하는 윤리적이고 정치적인 행동의 기반이 될 수 있다. 지구의 운명이 인간의 운명과 얽혀 있으며 지구에 대한 책임감으로 우리 자신을 도덕적 존재로 규정해야 한

다는 사실은 인류세에 인간의 새로운 윤리에 대해 성찰할 필요성을 제기한다. 기후변화에 대해 이야기할 때마다 등장하는 단골 메뉴가 빙하가 녹아서 삶의 터전을 잃어가는 북극곰들이지만, 우리는 녹은 빙하수로 우리 발밑의 땅도 잠겨가고 있다는 사실은 쉽게 잊는다. 빙하가 사라진 세상에서는 북극곰만이 아니라 인간도 살 수 없다. 역사학자 디페시 차크라바르티(Dipesh Chakrabarty)는 우리는 인류세에 인류를 하나의 종(種)으로 사고하는 법을 배워야 한다고 말한다. 우리는 지구라는 하나밖에 없는 우주선에 함께 탄 하나의 종, 인류로서 다 함께 살아남던가 아니면 다 함께 죽게 될 것이다.

인류 전체가 동시적으로 접한 재난인 팬데믹은 '접속되고 연결된 존재'로서 포스트휴먼의 진정한 의미를 되새기게끔 한다. 철학자 슬라보예 지젝(Slavoj Žižek)은 팬데믹이 전 지구적 연대와 협력에 우리 모두와 우리 개개인의 생존의 이해관계가 걸려 있음을 증명함으로써 브레이크 없이 내달리던 자유시장식 지구화에 제동을 거는 계기가 될 수 있다고 기대한다. 자유시장식 지구화가 각 개인이 원하는 것을 자유로이 선택할 수 있다는 신자유주의의 환상과 함께 이 개인들 간의 무한경쟁을 부추겨 왔다면, 팬데믹은 그것이 우리 삶의 지속가능한 원리가 될 수 없음을 보여주었다. 지젝은 우리가 "늘 위협에 시달리는 훨씬 더 취약한 삶을 사는 법을 배워야 할 것"[2]이라고 주장한다. 그에게 팬데믹의 진정한 의미는 우리가 삶을 대하는 태도, 다른 생명체들 가운데서 살아가는 존재로서 우리 실존을 대하는 태도 전부를 바꾸는 것이다. 이제 인류세에 우리가 포스트휴먼으로서 생존하기를 바란다면, 다른 모든 것들과의 공생을 위한 새로운 삶의 가치와 양식을 만들어내야 할 때이다.

the transcendental power of reason, the posthuman beings in critical posthumanism seek ways to live with viruses, animals, and robots as beings that jointly occupy the land, the air, and the water of this planet. Braidotti writes that the theory of new subjectivity for posthumanism ought to expand its framework and sphere of subjectivity based on the decentralization of relationships, and should include humans, animals (who are our genetic neighbors), and the Earth in its entirety. We are "the effect of irrepressible flows of encounters, interactions, affectivity and desire, which one is not in charge of." [1]

The Pandemic Era and Posthuman Dreams and Burdens

Critical posthumanism questions the conventional concept of subjectivity that views humans as autonomous agents independent from the effects of their environment. It considers human activities to be limited by the innumerable interactions among human and nonhuman actors, including microorganisms. Human intersubjectivity connects them to all nonhuman beings and objects, ranging from animals and plants to machines; trans-subjectivity is penetrated by external forces and viruses. The fact that humans can access a larger material world and are vulnerable to material threats could be seen to signify defenselessness and weakness; but this perception can also form a basis for ethical and political movements to pursue mutual coexistence with the world. That the fate of the planet is intertwined with that of humanity, and that we must use our responsibility to protect the planet to define ourselves as moral beings, arouse the need to reflect on new human ethics in the Anthropocene. Polar bears being deprived of their homes as the glaciers melt is a frequently discussed example of climate change, but we easily forget that the land beneath us is also sinking as the sea level rises. In a world where glaciers have vanished, humans as well as polar bears cannot survive. Historian Dipesh Chakrabarty says that in the Anthropocene, we must learn to think of humanity as one species. We as one species on the one and only spaceship called Earth can either survive as one or die together.

The pandemic, a catastrophe that all of humanity is facing at the same time, reminds us to revisit the true meaning of posthuman beings as "connected beings." Philosopher Slavoj Žižek hopes that the pandemic, which would prove that our survival as individuals and as a whole depends on global solidarity and cooperation, will put a brake on the free-market globalization that has thus far been speeding out of control. While free-market globalization has encouraged infinite competition among individuals with the neoliberal illusion that every person is free to make one's own choices and do what one desires, the pandemic has shown us that this principle cannot lead to sustainable living. Žižek argues that "we will have to learn to live much more fragile life with constant threats." [2] To him, the true meaning of the pandemic lies in changing the way we think about human life and the attitude with which we treat our existence as beings that live among other creatures. If we want to survive as posthuman beings in the Anthropocene, it is high time we created new values and modes of life to achieve symbiosis with all other beings.

(1) 로지 브라이도티, 『포스트휴먼』, 이경란 옮김, 아카넷, 2015, 131쪽.

(2) 슬라보예 지젝, 『팬데믹 패닉: 코로나19는 세계를 어떻게 뒤흔들었는가』, 강우성 옮김, 북하우스, 2020.

(1) Rosi Braidotti, *The Posthuman* (Cambridge: Polity, 2013), 100.

(2) Slavoj Žižek, *Pandemic!: COVID-19 Shakes the World* (Cambridge: Polity, 2020), EPUB version.

코로나19와 전시 기획 방법론:
미술관이 다시 멈추더라도.

강수정

국립현대미술관 현대미술 2과 과장

COVID-19 and Exhibition Curating Methods:
Even If the Museums Close Again …

Kang Soojung

Senior Curator, Head of Contemporary Art Department 2,
National Museum of Modern and Contemporary Art, Korea

현재 동시대의 삶은 코로나19로 인해 심각한 위기를 맞고 있는 상황이다. 미술관들도 예외가 아니다. 그럼에도, 미술관이 사회 구성체 안에서 공공영역으로서 공중(公衆)을 위한 문화의 재분배 등을 통해 시대와 삶을 다양한 형태로 함께 해 왔다면, 이 위기조차 삶과 예술이 동행해 왔던 사회와 예술의 관계를 더 집중해서 바라봐야 할 시기라고 해야 할 것이다. 비대면 사회는 생활 형태의 변화를 가져왔고, 특히 온라인 접촉의 폭발적인 증가를 불러왔다. 이 가운데 미술관들은 존재 방식과 역할에 대한 본질적인 질문을 마주하게 되었다. 이에 국제박물관협의회(ICOM)는 뮤지엄의 행동 강령을 제안하는 8가지 방향성을 발표했다.[1] 이 재앙의 시기를 자료화하고 전시하는 기본적인 활동뿐만 아니라, 불안, 고통 등 트라우마를 되돌아보며 더 나은 세상을 위한 적극적인 활동을 독려 하였다.[2]

이 글은 국립미술관의 공적 지향점을 토대로 전시 기획이 재난의 시기를 '미술관', '관람객', '작가'와 풀어나가는 방법에 대해 이야기하고자 한다.

1. 미술관의 '멈춤'과 가치의 재발견

일시에 시행된 사회적 '멈춤'은 재앙의 현신(現身)이자, 예견하지 못한 충격이었다. 특히 '공공 영역'인 미술관은 늘 그 자리에 존재할 것 같았던 '공중(公衆)'이 사라지는 기이한 경험을 하게 된 것이다. 이러한 현실을 담은 전시 기획은 동시대의 사회적 소통과 아픔을 함께 하고자 하는 문화적 실천으로 의미가 있다. 그 방식은 첫째, 미술관의 본질적인 역할을 기반으로 사회적 상황

Contemporary life is facing a serious crisis in the COVID-19 pandemic, and art museums have been no exception. Yet if museums contribute to their era and people's lives in various ways—for instance, by distributing culture to everyone as a public realm within society's structures—then even this crisis may be seen as a moment that compels us to focus more on examining the relationship between society and art in which art moves in tandem with individual lives. Today's non-contact society has brought changes to our living patterns and ushered in an explosive rise in digital and online interaction. In the process, museums have found themselves facing essential questions about their role and ways of being. In response, the International Council of Museums shared eight steps to adapt museum activities. [1] In addition to the basic activities of archiving and developing exhibitions about the pandemic era, these steps encouraged reflection on trauma, anxiety, and pain, and active efforts to achieve a better world. [2]

This essay considers how exhibition curation can address catastrophe in a way that combines the museum, visitors, and artists and is rooted in the public-oriented nature of a national art museum.

1. The Art Museum's Pause and the Rediscovery of Values

When society underwent a pause due to the pandemic, many people were shocked by this unforeseen manifestation of the catastrophe. For art museums, as institutions that represent the public sector, it was odd to find themselves without the public that they had assumed would always be present. The curation of an exhibition that reflects this reality holds significance as a form of cultural practice with the aim of communicating with contemporary society and sharing in its difficulties. Approaching this, we first decided that we should reflect on and respond to types of simultaneous practice as cultural forms within a particular social situation, based on the essential role that an art museum plays. Secondly, we wanted the exhibition to capture the never-before-experienced catastrophe in artistic language, looking within it to identify problems and alternative modes of relief that might have been overlooked. This was made possible by the collaboration between the curatorial team and experts and artists from different areas. At the same time, it was also carried out in connection with the public art museum's mission as a setting of social practice, and the need for exhibition curating in which the humanities and arts work together to address and share contemporary issues and related perspectives. These collaborations show that contemporary art can no longer remain confined to the realm of visual arts—and that it needs to seek broader answers through approaches that are multilayered and pluralistic. Besides, the exhibition groups these discussions together into programs, and the artworks selected for the exhibition try to embody them in physical form. The biggest difficulty in curating this exhibition had to do with the anxiety and fear triggered by the pandemic and the concern that the museum might find itself shut down once again.

The empty museum and the artworks within it formed a surreal image, like stars floating in a serene universe. This

에 동시적 실천의 형태를 문화의 형태로 담아내고, 응답하고자 방향을 잡았다. 둘째, 미처 경험해 보지 못했던 재앙의 상황을 기획을 통해 조형 언어로 담아내고, 이 속에서 간과되었던 문제점과 위로의 대안을 찾아보고자 하였다. 이는 큐레이터 팀과 여러 분야의 전문가들, 작가들과의 협업으로 가능했다. 동시에 공공 미술관의 사회적 실천의 장으로서 전시 기획이 동시대의 문제와 이에 대한 시각을 인문학과 예술이 함께 풀어나가고, 공유해야 한다는 소명과 연결되어 진행되었다. 이 협업들은 현대 미술이 더 이상 시각예술의 범주에서 머물지 않고 다층적이고, 다원화된 방식을 통해 확장된 답을 찾아야 한다는 것을 증명하고 있다. 또 전시는 이러한 담론들을 프로그램 형식의 총체적 집합체로 묶어내고, 전시에 선택된 작품들은 이를 물리적인 형태를 빌어 표상화 하고자 하였다. 그러나 이 큐레이팅의 가장 큰 어려움은 미술관의 기능이 또다시 멈출 수 있다는 팬데믹이 주는 불안감, 공포의 상황이었다.

텅 빈 미술관, 그 속의 작품들은 고요한 우주를 부유하는 별 같은 초현실적인 모습을 연출하였다. 그것은 예견하지 못했던 비일상적인 모습이었고, 관람객이 없는 미술관의 존재 가치를 되돌아보게 했다. 동시에 이 전시의 가장 실험적인 부분을 시도하게 된 동기가 되었다. 즉, 미술관이 멈추더라도, 관람객이 머물 수 있도록 하자는 것이다. 이는 견고한 공간 운영 시스템을 깨고자 하는 시도이기도 하였다.

"미술관이 다시 멈추더라도 관람객들이 감상할 수 있도록 하자."

첫 기획 회의에서 로비와 1전시실 등 일정 공간을 열어 두고, 안전한 안내를 통해 일부 작품을 감상하는 방법 등을 고려하였으나, 제도적으로 이는 불가능한 일로 확인 되었다. 정부의 방역 지침은 청정 지표나 소독 여부가 아니라, '현관문'이 기준이었기 때문이다. 특정 방역 단계가 되면 관람객의 신체가 문을 통과해서는 안 되었다.[3] 즉, 미술관 안으로 들어가는 출입문과 양쪽의 유리벽은 정말 "유리 천정"이 되어버린 것이다. 원래 이곳은 미술관의 안과 밖을 분리하는 곳이며, 관람객들의 통로였을 뿐이었다. 그러나 '멈춤'의 기간을 대비하여 이 곳은 공존을 위한 새로운 공간으로 해석되었다.

서승모 건축가는 이 유리벽을 기준으로 안과 밖을 관통하는 삼각형의 건축 구조물을 설치하여, 새로운 공간을 만들어 내었다. 〈소실선. 바다.〉(2021, 혼합재료, 250×2,380×2,065cm)는 사각의 본 건물을 삼각으로 파고 들어가는 형태로 새 공간을 창작한 작품이지만, 여전히 그 안은 원(原) 유리벽으로 막혀있다. 그러나 이러한 안과 밖의 분리는 관람자들의 신체와 시선들로 결국 연결된다. 미술관이 다시 멈추더라도 '밖'의 공간에 마련된 '안'에서, 유리벽을 통해 미술관의 '안'을 마주 볼 수 있다는 점은 미술관은 늘 함께 하는 공공영역임을 작품을 통해 보여주는 것이다. 특히 세모난 하늘이 그려지도록 설계된 구조물의 벽은 가상으로 그어지는 세 가지의 소실선을 통해 유리벽의 너머로 펼쳐지는 안과 밖의 공간이 마주치는 어느 소실선을 상상하게 해준다. 미술관이 폐쇄되더라도 외부 공간에서 유사한 내부의 공간을 경험하며, 명상과 위안을 받을 수 있는 것이다.

unexpected and extraordinary sight forced us to reflect on the value of a museum without visitors. It motivated us to attempt the most experimental aspect of this exhibition: making it possible for viewers to "remain" in the museum space even if it had to close. In some ways, this was also an attempt to break the rigidity of established spatial management systems.

"Let's make it so that viewers can appreciate artwork even if the museum shuts down again."

At our first curation meeting, we considered opening up certain spaces, such as the lobby and Gallery 1, and enforcing safety guidelines to allow viewers to appreciate selected artworks. Institutionally, this proved to be impossible: the government's disease control guidelines are based on the concept of every space having a "door," rather than other factors such as cleanliness or sterilization. Once a specific social distancing level was reached, visitors could not physically be allowed through the museum's door.[3] In effect, the entrance to the museum and the glass walls on either side became a barrier rather than an entranceway. In the past, this was merely a place that separated the museum's interior and exterior, a passageway for visitors. In anticipation of another endless pause, it was reinterpreted as a new space for coexistence.

Architect Seungmo Seo installed a triangular structure that passed in and out of the glass barrier. *Vanishing Line. Sea.* (2021, mixed media, 250×2,380×2,065cm) creates new space as the triangle digs into the rectangular building, but inside, it is still sealed off by the glass. Yet the separation of "interior" from "exterior" connects ultimately with the bodies and gazes of the visitors. From the "interior" established in the "exterior" space, visitors can still see "inside" the museum through the glass partition, even if the museum closes its doors—artistically illustrating how the art museum represents part of the public realm that is always present. With its three imaginary vanishing lines, the wall of the structure, which is designed to present a triangular image of the sky, allows us to imagine another vanishing line where the interior and exterior spaces meet beyond the glass barrier. Even if the museum remains closed, people can still experience one of its interior spaces outside of it, and enjoy meditation and consolation there.

2. Lighthearted Imagination as a Source of Comfort during Catastrophe

These days, many museums are getting back on their feet after the initial shockwaves of COVID-19, resuming activities consistent with their role. In themed exhibitions, many share serious messages about tasks related to "disaster" and "healing" in contemporary society. But such methods need not always be solemn. Therefore, through lighthearted imagination, some works suggest roles for museums and artwork as well as ways of finding comfort in the face of reality. [4] While the exhibition itself was designed in a typical way consistent with its theme, the accompanying *The Poseidon Adventure* project was devised as a kind of orbiting satel-

2. 재난을 위로하는 유쾌한 상상력

현재 여러 미술관은 코로나19의 충격에서 벗어나며 고유한 기능에 부합하는 활동을 다시 시작하고 있다. 특히, 주제전을 통해 '재난'과 '치유'에 대한 동시대의 사회적 과제에 대해 진지하게 발언하는 것처럼 보인다. 그러나 그 방법이 반드시 비장할 필요는 없을 것이다. 그래서 예술 작품의 유쾌한 상상력을 통해 미술관의 기능과 작품의 역할을 제시하며, 현실을 위로하는 방법을 제안하였다.[4] 본 전시가 주제에 충실히 따라가는 일반적인 방식으로 설계된 반면, '포세이돈 어드벤처 프로젝트'는 행성 주위를 도는 위성처럼 외부 기획자 협업 및 관람객 참여형 프로젝트로 짜여졌다. 그중에서도 박길종 작가의 ‹거리두기 항해사›(2021, 스테인리스 스틸, 200×200×100cm(3))와 김환, 이슬아 작가의 ‹전시 전기수›는 눈여겨 볼만하다.

우리는 매일 뉴스에 발표되는 방역 지침 아래 살고 있다. 그리고 마스크와 함께 2미터 거리 유지는 이제 생활이 되었다. ‹거리두기 항해사›는 이런 시대에 미술관에서 작품 관람은 어떤 방식일 수 있을까 하는 의문에서 시작된 작품이다. 2미터가 물리화된 거치대를 장착한 관람객은 미술관 전 공간을 돌아다니며 다른 전시실에서 열리고 있는 전시들을 감상할 수 있다. 이를 통해 감상을 할 수 있는 몸의 경험치를 눈과 신체로 명확하게 인지하게 된다. 과연 2미터의 거리는 전시장에서는 그 의미가 달라질 수 있을까? 답은 현장에서 확인될 것 같다. 또 김환, 이슬아 작가의 ‹전시 전기수›는 미술관이 다시 멈추었을 때를 대비하며, 작품을 포함한 전시장 정경들을 읽어 주는 작품이다.[5] 이는 미술관의 전통적인 감상 방식을 전복 시키는 행위로서 의

미가 있다. 미술관에서의 감상은 물리적인 공간을 직접 걸어 다니며 시지각적으로 경험하는 것이다. 디지털 기술의 발달과 팬데믹의 상황이 맞물려 온라인 프로그램들의 영향력이 가파른 고지를 찍고 있지만, 이 역시 전시 공간에 존재하는 작품들을 감상하기 위한 유입을 위한 것이 본질이다. 그러나 한 순간 '멈춤' 판정을 받은 이후, 미술관의 수백 점의 작품들은 누구도 볼 수 없는 존재들이 되었다. 즉, 공공의 재원을 관람 형태를 통해 문화적으로 분배하는 공공미술관의 기능 또한 이 순간 멈춘 것이다.[6] 이 작품은 그 분배 받은 관람의 형식에 전복을 시도한다. 미술관이 멈췄을 때, 작품을 포함한 전시 전반을 읽어주고 서술함으로써 볼 수 없는 공간을 청각을 통해 인지 영역을 자극하여 상상하도록 하였다. 즉, 상상력만으로 풀어내는 자신만의 작품들, 공간들이 가득한 미술관을 짓도록 하는 것이다. 이는 관람이라는 형태로 개인의 몸이 공공영역으로 스며드는 방식을 전치 시켜, 오히려 공공의 영역이 개별체인 개인의 귀, 인지, 상상, 손을 거치며 자신만의 전시로 재해석되고, 창작되는 형태로 만든 것이다. 이 감상법은 사운드 크라우드를 통해 어디에서나 접속하는 방식을 채택함으로써 '새로운 일상'의 한 단면을 엿보게 하지만, 돌이켜 보면 전적으로 새로운 발상이라고 할 수는 없다. 왜냐하면, 이는 에듀케이터들이 시각 장애인들에게 미술관 방문을 위해 마련한 설명 프로그램과 유사하기 때문이다.[7] 그러므로 이 작품은 보다 보편적인 사회적 가치를 획득하게 되었는데, 대재앙의 앞에서는 일상적 삶에서 구별되어 왔던 장애/비장애의 경계도 없어질 수 있다는 뜻으로 해석될 수 있다. 그동안 미술관은 사회적으로 미술관 방문이 어려운 취약 계층을 위하여 '문화 접근성 향상' 프로그램들을 운영해 왔다. 그러나 이제 모두가 접근할 수

lite—combining a collaboration with outside curators with audience participation activities. Particularly notable examples include the work *Distancing Navigator* (2021, stainless steel, 200×200×100 cm(3)) by Kiljong Park and *Exhibition Travelogue* by Kim Hwan and Seula Lee.

In our day-to-day lives, we follow disease control guidelines that are shared every day on the news. Wearing masks and maintaining two meters' distance have now become part of our lives. *Distancing Navigator* originated in the question: in what sorts of ways can artwork be viewed in a museum in such an era? Fitted with a device that physically enforces two meters' distance from others, viewers can travel through the museum's different spaces and observe other exhibitions. In the process, they can gain a clear visual and physical sense of the "experience points" in the body that allow them to appreciate the artwork they encounter. Can two meters' distance take on a different meaning within an exhibition setting? The answer is something that may be able to be learnt first-hand. *Exhibition Travelogue* by Kim Hwan and Seula Lee includes a work that reads out descriptions of the gallery space in addition to the artwork in anticipation of the museum potentially having to close its doors again. [5] This is significant as an act that turns the traditional approach to museum viewing on its head. Under this approach, people walk around a physical space, experiencing things visually. With the combination of digital technology advancements and the pandemic, the influence of online programs has been rapidly growing, but these too, at their essence, are about bringing people inside an exhibition space to see the artworks within. But once the decision was made to pause museum activities, its hundreds of artworks became virtually invisible, with no one around to see them. At that moment, the role of the public museum— that of the public distribution of cultural resources largely through viewing—also came to a halt. [6] This work attempts to subvert that format of distribution and viewing. By reading out and narrating an entire exhibition, including its artworks, Lee and Kim stimulate perception and allow listeners to imagine a space that cannot be seen when the museum is closed with an auditory approach rather than a visual one. In other words, listeners build their own museum, filled with their own unique imagined artworks and spaces. Transposing the approach in which an individual's body permeates the public realm through the act of viewing, the artists facilitate a situation in which the public realm becomes reinterpreted and recreated into a unique exhibition through each individual listener's ears, perception, imagination, and hands. While this method of appreciation offers a glimpse at a new everyday life that can be accessed from anywhere through Sound Cloud, a look back suggests that it cannot be called entirely new. In fact, it is similar to programs devised by educators for visually impaired persons visiting museums. [7] As a result, the work takes on a more universal social value, and could be seen as suggesting that in the face of catastrophe, the boundaries between disability and non-disability that exist in our ordinary lives may be broken down. In the past, some museums have offered "cultural access improvement" programs for socially vulnerable groups that may face difficulty in visiting. Through the representation of artwork that can be shared by everyone—in museums that are equally inaccessible to everyone—this piece "improves access" in an

없게 된 미술관에서, 모두가 공유할 수 있는 작품이 재현됨으로써, 더 폭넓은 접근성 향상이 가능하게 된 셈이다. 재난의 시기, 우리가 무엇을 어떻게 더 노력해야 할 지 시사해 주는 점이다.

3. 오래 전, 예견된 미래가 반성될 때

이제 전조(前兆)에 대해 이야기 할 필요가 있을 것이다. 예상치 못한 상황에서 야기되었고, 이는 '새로운 일상'이 시작될 것이라는 많은 예측을 동반하고 있다. 하지만 '새로운'은 가능할 것일까? 이것은 아래의 질문과 맞닿아있다.

정말 어느 날 '갑자기' 세상이 멈춰버린 것일까?

사람들은 코로나19가 야기한 팬데믹과 이 때문에 발생한 고립, 분리와 경제 침체, 공포, 빈곤 등을 끊임없이 이야기하며, '새로운 일상'이란 용어로 그 이후를 이야기하고 있다. 그러나 사회와 삶을 파탄 시키는 것은 코로나19 때문만은 아니다. 그 다양한 바이러스들의 전조는 수 많은 다양한 모습으로, 반복적으로 일상 속에 스며들어 있었다. 이것은 감염의 형태로 우리의 두뇌, 몸을 자연스럽고 특정하게 취향화 시키고, 행동하게 만드는 그런 것들일 수 있다. 현재는 또 다른 미래의 전조일 수 있다.

이에 대해, 전시 기획의 의도를 가시화시키고 있는 공간 디자인의 중요한 지점에 배치된 작품을 통해 문제 제기와 답을 살펴보고자 한다. [8] 첫 마중하는 공간인 다큐멘터리 작가들의 <신디

케이트: 코로나 에디션>은 실제 언론 사진 기자들의 연합체에서 담아낸 작품들로서 동시대 현장에 대한 생생한 기록이다. 플라스틱 용기의 증가, 배달 노동의 문제, 돌봄의 파괴, 경제 파탄, 취약계층 등에 대해 전달하며, 현재의 문제의식과 과제에 대한 화두를 던지고 있다. 반면 그리드 체계로 구성된 전시 공간 속 삼각 구도로 개입된 영역 '유보된 일상, 막간에서 사유하기'의 봉준호 감독은 <인플루엔자>(2004, 단채널 비디오, 컬러, 사운드, 30분) [9] 에서 이미 '감염'이라는 키워드를 통해 우리 사회의 본질적인 측면을 다루었다. 이 작품은 일상에서 쓰는 칼이 바이러스의 전도체가 되어 몰락한 소시민을 숙주 삼아 사회 전체가 폭력에 감염되어 가는 모습을 담았다. 폭력은 숙주에 의해 지하철, 은행의 ATM 인출기, 아파트 지하 주차장 등에서 다양한 폭력의 형태를 보이며 이동하는데, 감시 카메라, CCTV 특유의 부감법을 이용하여 다큐멘터리 같은 사실성을 확보하였다. [10] 이 때문에 관람자의 눈은 CCTV와 일치되며 마치 이 모든 상황을 지켜보는 입장이 된다. 이 감시의 시선은 현재 감염자 경로를 파악할 수 있는 도구로 CCTV가 사용되는 것까지 용인되고 있지만, 한편 국가가 안전을 빌미로 새로운 감시체계를 도입할 수 있다는 우려도 불러일으킨다. 영상 속에서 사람들은 폭력에 대항하기도 하고, 경찰이 출동하기도 하지만 마침내 정의, 도덕 등을 망각한 채 모두가 폭력에 잠식된 모습을 보인다. 현재 안전 가이드를 잘 지켜, 재난의 상황을 잘 이겨내야 하는 것은 당연하다. 하지만 건강한 사회를 구성하는 것은 공동체에 대한 본질적인 덕목을 잃어버리지 않는 것이라는 것을 이 폭력의 에피소드들을 보며 되새기게 된다. 이 지점을 놓치면 오늘도 어떤 불행한 미래의 전조일 수 있는 것이다. 불행은 '갑자기' 시작되지 않는다.

even broader sense. It alludes to the things that we require more effort in an era of catastrophe.

3. Reflecting on a Long-Foreseen Future

At this point, it is necessary to talk about omens. They emerge from unexpected circumstances, accompanied by many predictions about the advent of a "new everyday life." But is "new" truly possible? It is a matter that ties in with the following question:

"Can we really say that the world came to a halt 'all of a sudden'?"

The discussion about the COVID-19 pandemic and the isolation, separation, economic stagnation, fear, and poverty that have resulted from it is endless. "New everyday life" is a term that has been used to talk about what comes next. But it is not COVID-19 alone that has bankrupted our societies and lives. Foretokens of these various viruses have infiltrated our daily lives in innumerable forms. These may be the sorts of things that "infect" us to naturally instill particular inclinations in our minds and bodies, causing us to act in certain ways. The present may be an omen of a different future.

We have attempted to raise and answer such questions with artwork positioned at important points within the spatial layout, which visualizes the intent behind the exhibition's curation. [8] In the first space, visitors encounter *Syndicate: COVID-19 Ed.*, a work by documentary artists that provides a vivid record of the contemporary situation through photographs taken by a coalition of actual media photojournalists. Conveying messages about rising plastic use, issues regarding delivery workers, the collapse of caregiving, economic disaster, and vulnerable groups, it addresses present-day issues and tasks. Within "Daily Life Deferred, Contemplations during a Pause," a triangular space inside of the exhibition setting's grid system, director BONG Joon-ho's *Influenza* [9] (2004, single-channel video, color, sound, 30 min.) focuses on the essential aspects of a society through the keyword "infection." In this work, an everyday knife becomes a vector for a virus that infects a run-down working-class man in a society generally infected with violence. This violence takes on different forms as the virus is transported by its host to subways, ATMs, and an apartment's underground parking garage, which the film captures with documentary-like realism through the use of surveillance cameras and the characteristic bird's-eye view of closed circuit-camera footage. [10] While watching, viewers come to identify with the closed-circuit camera, so that we feel like we are surveying the whole situation. This surveilling gaze is tolerated in Korea today, as closed-circuit cameras are used as tools for tracking people who are infected with the virus, but it has also spawned concerns that governments could introduce new surveillance systems in the interest of "safety." In the film, people fight back against the violence, and police are mobilized to combat it. But in the end, all people seem to be consumed by the violence, losing sight of justice or morality completely. It stands to reason that we should follow safety guidelines so that we can make it through the current catastrophe. As we

전시의 갈무리 영역의 에이샤-리사 아틸라(Eija-Liisa Ahtila)의 〈사랑의 잠재력〉(2018, 무빙이미지 조각들, 가변크기)은 인간과 인간이 아닌 존재들과의 경계를 탐색하고 관계를 재설정하여 상생을 준비해야 함을 말한다. 이는 마중 공간의 신디케이트가 제기한 문제에 대한 일종의 해답으로, 미래를 준비한다면 희망은 가능하다는 기획 의도를 가시화 한 것이다.

4. 당신과 나의 안전한 집으로 돌아오기를

이번 기획에서 확인된 것은 공공 미술관이 멈춘다는 것은 사회적으로 모든 일상이 정지 된다는 것을 공인하는 척도 중 하나라는 것이다. 그러나 작품과 작가들의 창작은 멈추지 않는다. 이것을 담아내는 그릇인 미술관은 그래서 멈출 수 없는 것이다. 또 방역 지침에 의해 사람들이 자유롭게 집합할 수 없는 장소가 되었음에도 불구하고, 사람들은 미술관은 안전할 것이라는 믿음을 보인다.[11] 이것은 공적 영역에 대한 사회 구성원들이 합의한 신의를 의미한다. 또 미술관은 불안하고 폐쇄된 일상에서 일탈하여, 잠시 안전하게 문화를 누릴 수 있는 곳이기도 하다는 뜻이다. 이렇게 삶과 예술이 만나는 접점에서 전시는 예술이 도달하여 만날 수 있는 실천의 또 다른 형태로 관람객들과 조우(遭遇)하게 되는 것이다. 그리고 작품들을 통해 예술가들과 함께 우려, 걱정 그리고 위안을 건넨다.

이 전시는 '달콤한 나의 집(home, my sweet home)'으로 쓰인 기획서에서 시작되었다. 돌아올 수 있는 가장 안전하고 단란한 나의 집과 같은 장소로 공공미술관은 존재하기를, 전시는 위기의 상황에서 말 걸기, 들어주기, 치유하기의 방식으로 상징 가치를 스스로 쌓아나가기를 바랬던 첫 마음은 그 모양새가 어떻게 발전했든 선연한 층위로 물들어 있다.

view these episodes of violence, however, we come to reflect on how a healthy society is one in which we do not sacrifice essential community virtues. When we lose sight of them, our present day may end up being an omen for some unfortunate future, as this sort of misfortune does not happen "all of a sudden."

In the final section of the exhibition, Eija-Liisa Ahtila's *POTENTIALITY FOR LOVE* (2018, moving image sculptures, dimensions variable) explores the boundaries between human and non-human beings, recalibrating their relationship to convey a message about our need to prepare for coexistence. Representing a kind of answer to the issues raised by *Syndicate: COVID-19 Ed.* at the exhibition's opening, it visualizes the idea behind the exhibition's curation: that hope is possible if we prepare for the future.

4. Returning to "Our" Safe Home

Through curating this exhibition, we learned that when a public museum pauses its operation, it is one of the measures of how all everyday life is subject to suspension at the societal level. But artwork and artists' creative activities do not come to a stop, and as a vessel to contain them, neither does the art museum. Even when disease control guidelines dictate that it is a place where people cannot freely congregate, people continue to display faith that the museum will be a safe place. [11] This signifies a certain trust in the museum's public realm that is agreed upon by members of society. It also means that the museum is a place where people can

escape an uncertain everyday experience that is full of obstacles and safely enjoy culture for a brief moment. At this juncture between life and art, the exhibition encounters viewers as another channel through which art can reach them. Through the artwork, they can share their fears and worries, as well as comfort, with the artists.

The curation of this exhibition originated with the concept of "home, my sweet home." The original hope was that the public museum might exist as the safest of places, like a home to which we can return, as the exhibition acquired its own symbolic value through an approach of speaking, listening, and healing in a crisis situation. Whatever that wish developed into, it still exists as a vivid layer just below the surface of the exhibition.

(1) 이 제안은 코로나19의 위기 시기에도 뮤지엄의 전시, 수집 등의 역할 수행을 독려할 뿐만 아니라 직원들의 건강과 안녕, 온라인 커뮤니케이션 수단의 다양화, 지역 커뮤니티를 위한 사회적 실천 등을 강조하고 있다. 국제박물관협의회, 「뮤지엄과 코로나 위기: 커뮤니티의 회복을 돕는 8단계(Museums and the Covid-19: 8 steps to supporting community resilience)」, 2020년 4-5월.

(2) 빅토리아 앨버트 박물관이 기획한 《Pandemic Objects Exhibition》은 팬데믹으로 인해 평범한 사물들이 새로운 의미를 가지게 된 것을 보여주는 온라인 프로젝트이다. 재난 상황에서 필요성이 높아진 '화장실 두루마리 휴지', '빵 반죽'(코로나 시대에 집에서 하는 중산층 활동의 예시) 같은 것들을 에디토리얼 아카이브 형식으로 보여주고 있다.

(3) '국립현대미술관 코로나19 관련 인원 제한 등 조치사항 안내', 「메모보고」, 행정지원과, 국립현대미술관, 2021년 2월 24일. 「코로나바이러스감염증-19, 집단시설·다중이용시설 대응 지침」, 코로나바이러스 감염증-19 중앙방역대책본부·중앙사고수습본부, 2020년 2월 26일.

(4) 국립현대미술관의 전시가 주로 대규모 매체와 작가들로 기획되는 방향을 비틀어 대안적 형태의 프로젝트로 전시의 다양성과 유연한 동시성을 구축하고자 고안된 설계이다. 총 3명의 청년 기획자들과 함께 현재의 재난과 치유의 방향을 위한 작가 협업, 관람객 참여 프로그램으로 기획되었다. 다만 이 프로젝트의 조건으로 제시 된 것은 물리적으로 공간을 점유하지 않고, 미술관의 전시들과 프로그램을 가볍고 유기적으로 넘나드는 것이었다. 강수정, 이수연, 양옥금, 「전시기획회의」, 현대미술1과, 국립현대미술관, 2021년 1월 13일.

(5) '전기수(傳奇叟)'는 조선 후기 소설을 전문적으로 읽어주었던 직업 낭독가를 의미한다.

(6) 강수정, 「공공미술관의 문화정치학적 특성과 실천행위로서 전시의 역할」, 홍익대학교 박사 학위 논문, 2016, 198-199쪽 참조.

(7) 「미술관을 듣다」, 시각장애인용 보조자료 앱, 교육문화과, 국립현대미술관, 2015. 「시각장애인을 위한 작품 감상 프로그램」, 국립현대미술관 50주년 기념전 《광장》 1, 2, 3부 전시 연계 전시해설 어플리케이션에 시각장애인용 음성해설 콘텐츠 개발(한국시각장애인연합회 미디어접근센터 협력) 및 운영, 교육문화과, 국립현대미술관, 2019. 동 전시에도 제공되고 있다.

(8) 이외에도 2미터를 모듈화하여 가벽들을 설계하여 사회적 거리 두기의 위치 값을 정하였고, 기존 전시의 패널들을 재활용하는 등, 디자인적인 실천을 시도하였다. 《유강열과 친구들: 공예의 재구성》, 《올림픽 이펙트: 한국건축과 디자인 8090》 전의 종료 후, 가벽을 해체하여 동 전시를 위하여 모자이크 방식으로 일부 벽면을 재 구조화시켰다. 이때 새 전시의 서사구조와 조형적인 미감을 잃지 않도록 주의를 기울였다. 김용주 인터뷰, 2021년 5월 25일.

(9) 이 작품은 제5회 전주국제영화제(2004)에서 발표된 〈거울에 비친 마음: 디지털 삼인삼색〉의 단편 영화 3편(봉준호, 유릭와이, 이사이 가쿠류 감독) 중의 하나이다.

(10) 촬영을 서울의 감시카메라와 폐쇄회로 CCTV 시스템을 이용한 것이 특징이다. 방대한 양의 실제 화면 자료에서 배우들의 연기가 포착된 장면들을 포착, 정리하여 전체 영상을 만들어내었다.

(11) 손영옥, 「애먼 미술관만 잡는 K방역」, 『국민일보』, 2020년 6월 18일. 이현경, 「코로나 재 확산에 무기휴관한 국립박물관 미술관, 재개관 언제쯤」, 『뉴스핌』, 2020년 7월 13일. 이명옥, 「[컬쳐아고라] 코로나에 뺏긴 '문화향유권' 이제는 다시 돌려줄 때...」, 『헤럴드경제』, 2020년 7월 6일. 김가연, 「박물관 미술관은 안 되고 룸살롱은 되나, 들쑥날쑥 기준에 시민들 '반발'」, 『아시아경제』, 2020년 6월 17일. 홍영진, 「지역 문화예술인들 '전시장 일괄 휴관' 불만 목소리」, 『경상일보』, 2020년 8월 25일. 이동연, 「[기고]극장, 박물관, 미술관, 도서관을 열어라」, 『경향신문』, 2020년 6월 10일. 김서현, "코로나19로 박물관, 도서관은 문 닫는데 룸살롱은 괜찮나?」, 『여성신문』, 2020년 6월 15일. 전성민, 「포스트 코로나 시대 고민하는 서울시립미술관」, 『아주경제』, 2021년 2월 2일.

(1) The proposed steps emphasize not only the performance of the museum's exhibition and collection roles during the COVID-19 era, but also areas such as employee health and well-being, diversification of online communication methods, and social practice to benefit local communities. ICOM, "Museum and the Covid-19: 8 steps to supporting community resilience," April–May 2020.

(2) *Pandemic Objects*, organized by the Victoria and Albert Museum is an online project that shares ordinary objects that have taken on new meaning as a result of the pandemic. In editorial archive form, it presents things like toilet paper rolls (items that were perceived as more essential amid the catastrophe) and dough (as an example of baking, a middle-class at-home activity during the COVID-19 era).

(3) "MMCA Guide on Measures Including Restrictions on Admission in Connection with COVID-19," memo, MMCA Administration Department, Feb. 24, 2021; "COVID-19 Response Guidelines for Group Facilities and Multiple User Facilities," COVID-19 Central Disease Control Headquarters and Central Disaster Management Headquarters, Feb. 26, 2020.

(4) As a twist on the typical approach to MMCA exhibition, which are generally devised in terms of large-scale media and artists, the alternative project was developed to contribute an element of diversity and flexible simultaneity to the exhibition. It was planned in conjunction with three young curators as an artists' collaboration and audience participation program focusing on the present catastrophe and avenues toward healing. One condition presented for the project was that it should not physically occupy space, but interweave with the museum's exhibitions and programs in a light and organic way. Kang Soojung, Sooyon Lee & Okkum Yang, "Exhibition Curation Meeting," Contemporary Art Department 1, MMCA, Jan. 13, 2021.

(5) In late Joseon Korea, storytellers known as *jeongisu* (the term referenced in the work's Korean title) specialized in performing works of literature out loud.

(6) Kang Soojung, "The Cultural Political Characteristics of the Public Museum and the Role of Exhibitions as The Practice," Hongik University doctoral dissertation, 2016, 198–199.

(7) "Hearing the Museum" app for visually impaired persons, MMCA Education Department, 2015; "Artwork Appreciation Program for Visually Impaired Persons" (audio commentary content developed for the visually impaired [in conjunction with the Korea Blind Union's media access center] for a commentary application linked to Parts 1, 2, and 3 of the MMCA 50th anniversary exhibition *The Square*), MMCA Education Department 2019. Similar services have also been provided for this exhibition.

(8) In addition, experiments in design practice involved devising modular two-meter false walls to establish positions according to social distancing guidelines and recycling panels from previous exhibitions. After the completion of the exhibitions *Yoo Kangyul and His Friends: Reframing Crafts* and *Olympic Effect: Korean Architecture and Design from 1980s to 1990s*, the false walls were taken apart and restructured in mosaic fashion to construct some of the walls for this exhibition. Particular care was taken not to detract from the new exhibitions' narrative structure or formative aesthetic (interview with Kim Yongju, May 25, 2021).

(9) This work was originally part of *Digital Short Films by Three Filmmakers*, a trio of short films (the other two by Nelson Lik-wai Yu and Sogo Ishii) that was shown at the 5th JEONJU International Film Festival in 2004.

(10) A defining characteristic is the use of actual surveillance cameras and closed-circuit camera systems in Seoul for filming. The overall film was created by going through vast volumes of actual footage to locate and edit together the scenes showing the actors' performances.

(11) Son Youngok, "Disease control measures mainly targeting innocent museums," *Kukmin Ilbo*, June 18, 2020; Lee Hyeongyeong, "After indefinite closure amid COVID-19 resurgence, when will national museums reopen?," *NewsPim*, July 13, 2020; Savina Lee, "[Culture Agora] Time to give back 'cultural appreciation rights' taken away by COVID-19," *Korea Herald Business*, July 6, 2020; Kim Gayeon, "'Museums no, room salons yes': Citizen outcry against inconsistent standards," *Asia Business Daily*, June 17, 2020; Hong Yeongjin, "Local culture and arts professionals disgruntled over across-the-board exhibition venue closures," *Kyungsang Ilbo*, Aug. 25, 2020; Lee Dongyeun, "[Column] Reopen theaters, museums, and libraries," *Kyunghyang Shinmun*, June 10, 2020; Kim Seohyeon, "Museums and libraries closed due to COVID-19, but room salons OK?," *The Women's News*, June 15, 2020; Jeon Seongmin, "Seoul Museum of Art Wrestling with Post-COVID Era," *Aju Business Daily*, Feb. 2, 2021.

위성 프로젝트 Satellite Project

위성 프로젝트:
포세이돈 어드벤처

이수연

국립현대미술관 학예연구사

Satellite Project:
The Poseidon Adventure

Sooyon Lee

Curator, National Museum of Modern
and Contemporary Art, Korea

재난은 사회 시스템의 한계와 취약성을 일깨우고, 더 나아가 개인 윤리와 양심에 대한 신뢰를 뿌리부터 흔든다. 재난영화의 걸작, ‹포세이돈 어드벤처(The Poseidon Adventure)›(1972)는 바다 한가운데에서 불타는 배를 배경으로 예측할 수 없는 상황을 맞이한 사람들의 광기와 무력감을 그려낸 영화이다. 영화 속에서 예기치 않은 재난은 통제 불가능한 상황을 맞이하여 어쩔 수 없는 선택을 해야 하는 조건 속에서 인간성에 대한 회의와 공포, 희망을 드러내며 인간다움의 본질을 질문한다. 지난 1년여간 전 지구적 재앙인 코로나19 재난을 겪으며 근대 문명을 이룩해 낸 전제 조건들은 뒤집어지고, 현대 사회를 지배해 온 질서 체계는 의심을 받기 시작하였다. 국경이 폐쇄되고, 학교가 닫히고, 대륙 간 인적 교류가 끊기며, 대중문화를 지배해 온 공통의 문화적 경험들을 생산하는 근대적 의미의 문화 교육 기관들—영화관, 오페라하우스, 미술관 등이 작동하지 않는 상황 속에서 인류는 사회 시스템과 개인의 윤리적 가치 체계를 뒤흔드는 경험들을 공유하였다.

스티븐 J. 잭슨(Steven J. Jackson)은 기술의 사회학적 의미를 탐색한 논문 「고치기에 관한 생각(Rethinking Repair)」에서 이처럼 부서지고 망가진 상황에서야 비로소 드러나는 본질을 고찰하며 분붕, 비정상, 손괴의 양태와 회복의 방식을 고민한다. 계몽적이고 이상적인 사회제도와 기반 시설들이 더이상 작동하지 않을 때, 우리는 실제로 얼마나 부서지기 쉬운 연약한 세상에 살고 있었는지 깨닫게 된다. 동시에, 세상은 견고한 실체가 없이 끊임없는 변화하는 과정에 있으며, 부서진 것들을 원래대로 복구할 수 없는 비가역 기관이라는 것을 재발견한다. 일상의 연속성과 생활의 제기능이 사라진 세상에서, 스티븐이 제시하는 삶의 방식은 “원 상태로의 회복”이 아닌 “끊임없이 고치며 앞으로, 혹은 옆으로, 뒤로, 나아가는 방식의 고침”이다. 재난으로 “끊임없이 고쳐 나가는 세상” 속에서 오래된 모델을 재발견하고, 미처 보이지 않았던 경계의 새로운 가능성과 틈을 발견할 수 있을 것이다.

본 위성 프로젝트는 거대한 기관의 작동이 멈춘 재난 상황에서 현대미술의 가치와 생산 조건들을 고민하며 미술이 “끊임없이 고치고, 앞으로 나아갈 수 있도록” 동력을 제공하는 젊은 외부 기획자들을 초청하여 재난의 상황을 함께 고민하도록 의도된 기획이다. 기획자들은 전시, 제도와 기관, 더 나아가서 인간의 정상성이 작동하지 않는 현실을 드러내고, 경험하고, 나눌 수 있는 플랫폼을 작동시키고, 새로운 플랫폼이 일상의 관습이 쌓아온 현실의 벽을 넘어설 수 있을지 질문을 던진다. 남선우가 기획한 ‹고쳐 쓰는 관습들›은 전시 읽기(혹은 듣기)와 전시 공간을 맴도는 향, 전시 관람 도구를 이용하여 당연하게 여겨지던 전시의 관습들에 도전하고 새로운 방식의 전시 감상 회복 가능성을 제시한다. 권태현은 온라인 스트리밍 영상 프로젝트 ‹영구소장›을 통해 보편적이고 합리적인 인류 문명의 상징적 기관인 미술관의 기능에 대해 질문을 던진다. 김신재 기획의 ‹반향하는 동사들›은 바이러스가 전 인류의 일상적 기능을 마비시킨 상황 속에서 장애와 비장애, 정상과 비정상성의 구분을 다시 질문하고, 관람자에게 능동적인, 혹은 수동적인 실천을 연습 하도록 하는 작업들을 선보인다. 청각적 묘사와 향, 촉각적 인지, 온라인 스트리밍과 참여와 같은 대안적 플랫폼으로 구성된 위성프로젝트는 장소와 시간, 작업의 플랫폼을 다양하게 실험함으로써 재난 속에서 끊임없이 고치며 변화해 나갈 수 있는 방향을 고민해왔던 예술의 역할을 다시 한번 수행할 것이다.

Catastrophes remind us of the limitations and fragility of social systems and foundationally undermines collective trust in individual ethics and conscience. *The Poseidon Adventure* (1972), a masterpiece of a disaster movie, portrays the madness and helplessness of people who are faced with the unpredictable situation of being on a burning ship in the middle of the ocean. As the characters are forced to make choices when an unforeseen disaster arises during an already uncontrollable situation, the film shows skepticism towards, fear of, and hope for humanity while also questioning its essence. Over the past year or so, the global catastrophe COVID-19 has led us to question the preconditions to modern civilization and the systems and order that govern modern society. Undergoing situations in which borders and schools have been closed, human interaction between continents has been cut off, and the cultural institutions that produce the common experiences that dominate popular culture in the modern sense, such as movie theaters, opera houses, and museums, have ceased operating, humanity has weathered the shared experience of our social systems and individual ethics being shaken at their core.

In his paper "Rethinking Repair," in which he explores the sociological meaning of technology, Steven J. Jackson grapples with modes of breakdown, abnormality, and damage as well as ways of recovery, while examining the world-disclosing properties of things which are revealed in the moment of breaking and destroying. When our rational and ideal social systems and infrastructure no longer work, we realize how fragile and vulnerable the world we live in is. At the same time, these situations lead us to find the underlying strata of the reality that the world is not a fixed entity; rather, it is an irreversible institution in a state of constant change in which broken things cannot be restored to their original form. In a world in which the continuity and functions of daily life have stopped, the way of life proposed by Jackson does not aim for the restoration of the original state but a manner of constant repair through which the world moves forward, sideways, or backward. In a world that is being constantly repaired from catastrophe, we will rediscover an old model as well as discover new possibilities and previously invisible cracks in the limitations that bind us.

This satellite project was designed to contemplate the current crisis with young curators who provide the momentum for art "to constantly repair and move forward" by shedding light on the values inherent in and conditions for producing contemporary art during a time of crisis in which large institutions have stopped working. These curators reveal and share the reality in which art exhibitions, systems, institutions, and even everyday human norms are no longer operational, and ask questions about whether or not new platforms can overcome the walls of reality built up by daily customs. *Rewriting Customs*, curated by Sunwoo Nam, challenges exhibitions' conventional customs that have been taken for granted by reading (or listening to) an exhibition, and, using the scent lingering in the exhibition space and tactical tools for exhibition viewing, proposes the possibility of introducing a new manner of viewing exhibitions. Through the online streaming video project *Permanent Collection*, Kwon Taehyun questions the function of the museum as a symbolic institution of rational human civilization. Shinjae Kim's project *Verb, Reverb* questions

the distinction of disability and non-disability, normality and abnormality in a world where a virus has put a halt to the daily functions of all of humankind, and presents works that allow visitors to practice active or passive exercises. This satellite project, involving alternative media and channels such as auditory description, fragrance, tactile recognition, online streaming, and physical participation, will once again serve the role of art in its struggle to find direction and constantly repair, change, and move forward amid the pandemic by experimenting with location, time, and platform in various manners.

고쳐쓰는 관습들

남선우
참여작가: 이슬아, 김환, 꽁티드툴레아, 박길종

Rewriting Customs

Sunwoo Nam

Participating artists: Seula Lee, Kim Hwan, Conte de Tulear,
and Kiljong Park

프로젝트 ‹고쳐쓰는 관습들›은 1년여간 지속된 팬데믹 아래, 개막식과 오프라인 프로그램 등 이전에 당연하다고 여겨졌던 전시의 관습들이 빠르게 사라지고 방문 제한과 거리 두기 등 새로운 관습들이 등장한 상황을 함께 감각해 보고자 한다. 달라진 상황은 당연했던 관습들이 과연 당연했는지를 생각하게 하고 그동안 인지하지 못했던 부분들을 드러내 주었다. 그렇기에 지난 관습 중 어떤 것들은 재난 상황이 종료되면 환향할 것이고, 부재의 아쉬움을 느끼지 못했던 것들은 그대로 지워질 것이다. 새로 생긴 관습들 또한 어떤 것들은 감격적으로 사라질 것이고, 어떤 것들은 정착할 것이다.

본 프로젝트는 미술가, 작가, 조향사, 디자이너 등 다양한 분야 예술의 생산자이자 향유자인 참여 작가들과 함께 계속해서 생겨나고 사라지는 감상의 관습들을 재고하고, 변화하는 상황에 따라 이를 어떻게 고쳐갈 수 있을지 함께 생각하기를 제안한다. 시각 중심주의 또한 미술의 오랜 관습이므로 이번 프로젝트는 '보는 것' 이외의 방법으로 듣고 맡고 부딪혀 보고자 한다.

전시 전기수

지금보다 식자율이 낮고 책값이 무척 비쌌던 조선시대에는 직업으로 소설을 읽어주는 '전기수(傳奇叟)'가 있었다고 한다. 한자어를 그대로 풀이 하면 '전해주는 기특한 노인' 정도가 될 전기수는 단순히 소설을 읽어주기만 하는 것이 아니라 본인의 해석과 감정을 담아 낭독의 완급과 강약을 조절했다고 한다. 글을 읽지 못하고 책을 사지 못하는 사람들에게 전기수는 자신이 먼저 본 세계를 전달해 주는 사람이었을 것이다.

팬데믹 시대에 전시는 적은 수의 사람들이 예약을 통해 접할 수 있는 매체가 되었다. 물리적인 관객 수의 제한과 누군가에게는 어려운 예약시스템의 도입으로, 사람들에게 전시는 읽지 못하는 소설처럼 한 걸음 더 먼 존재가 된 것이다. 이러한 상황에서 글 쓰는 이슬아와 그림 그리는 김환을 전시에 전기수로 초대한다. 사정의 원인은 다르지만 전처럼 전시를 볼 수 없게 된 사람들에게 이 둘은 자신들이 먼저 본 세계를 다른 완급과 강약을 가진 목소리로 전달해 줄 것이다. 이 주관적인 오디오 가이드는 전시 중 공개될 QR코드를 통해 원하는 장소에서 청취할 수 있다.

Rewriting Customs observes the pandemic, in which existing exhibition customs that had been taken for granted, such as exhibition openings and some offline programs, have quickly vanished, and the new customs, including admission limits and social distancing, that have emerged over the last year. These altered conditions made us rethink these customs and revealed certain aspects that had previously gone unnoticed. Some of the pre-pandemic customs will return after this catastrophe passes, while others, whose absence has not evoked any sense of regret, will be erased. As for the new customs, people will be thrilled to see some of them go, but others will stay.

In collaboration with the participating artists, including an artist, author, perfumer, and designer, who produce and enjoy diverse fields of art, this project will revisit the ever emerging and disappearing customs of exhibition viewing and propose consideration about how they can be altered depending on changing situations. Since ocularcentrism (the privileging of vision over the other senses) is a long-standing custom in art, this project prompts visitors to enjoy art in ways other than viewing it, such as by listening to, smelling, and bumping into the featured works.

Exhibition Travelogue

During the Joseon Dynasty, when literacy rates were much lower and books were far more expensive than they are now, there were *jeongisu*: those who read novels as a profession. While the literal translation of the word is "praiseworthy old man who conveys," *jeongisu* did not simply recite novels, but controlled the tempo and dynamics by adding their own interpretation and emotions. To those who could not read or afford to buy books, *jeongisu* conveyed the worlds that they had seen first.

In the pandemic era, exhibitions have become something that only a small number of people can access, often requiring reservation. With the introduction of reservation systems and limitations on number of visitors, which can be considerable barriers for some, exhibitions have become distant, like novels that cannot be read. Under these circumstances, writer Seula Lee and painter Kim Hwan have been invited as *jeongisu* to this exhibition. While the circumstances that keep people from visiting exhibitions differ for each and every person, the two will use their voices to dynamically convey to visitors the worlds that they have seen first. This subjective audio guide will be available for listening anywhere by scanning a QR code that will be released with the opening of the exhibition.

향으로 쓴 편지

조향 콜렉티브 꽁티드톨레아는 팬데믹의 원인 중 하나인 환경파괴가
일어나기 이전 청량한 자연의 상태에서 영감을 받아 ‹13963›을 제작했다.
‹13963›의 주요 모티프인 이끼는 얼핏 균처럼 보이지만 정화력과
회복력이 뛰어난 식물이다. 전시 기간 중, 매주 목요일에는 미술관이 이
향으로 채워진다. 사물함 한 켠, 에어컨 송풍기, 난간 손잡이, 미술 서점
등 곳곳에 뿌려진 향기는 전시의 시간이 쌓일 수록 공간에 배어 전시의
감각을 다층적으로 구성할 것이다.

한편, 만일 미술관을 열 수 없는 상황이 닥친다면 꽁티드톨레아의
‹13963›은 전시의 리플렛 또는 티켓에 배어 방문을 희망하는 관객들에게
배송될 예정이다. ‹13963›은 전시 «재난과 치유»를 상징하고 현상태의
회복을 염원하는 향기로서 관객의 후각을 통해 미술관에 대한 감각적
기억을 불러일으키고, 미술관의 안과 밖을 연결할 예정이다.

거리두기 항해사

희망적인 미래에 팬데믹이 종료되고 바이러스의 위험이 사라지면 우리는
현재를 어떻게 기억하게 될까? 미술관의 매표 줄, 공연장과 기차의 좌석
등에서 지켜온 거리 두기는 빠른 시간 안에 새로운 관습으로 자리잡았다.
사람이 가득한 밀집 지역에 가면 불편함보다 불안함이 더 큰 지금,
앞으로의 상황에 따라 우리는 비말과 바이러스를 차단하기 위해 마스크를
쓰는 것처럼 물리적 거리 두기를 위한 도구를 사용하게 될지도 모른다.

디자이너 박길종은 전시 관람 시 2미터라는 안전거리가 신체에 강제될
때의 '불편함'을 촉각적으로 경험할 수 있도록 하는 일종의 관람 도구를
제안한다. 도구란 으레 무언가를 편안하게 수행하도록 돕는 수단이지만,
물리적으로 안전거리를 발생시킬 이 도구는 적극적으로 관객의 불편을
조장하며 팬데믹의 상황을 온몸으로 감각하고 기억하게 할 것이다.

이 '안전지대 발생기'는 매주 수요일 착용 가능하며, 미술관 안내
데스크에서 대여할 수 있다.

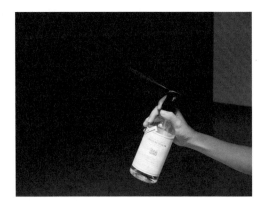

꽁티드톨레아, ‹13963›
2021.
작가 소장. 국립현대미술관 지원으로 제작.
사진: 김경태

Conte de Tulear, *13963*
2021.
Courtesy of the artist. Commissioned by
MMCA, Korea.
Photo by Kyoungtae Kim

Letter Written in Scent

Inspired by the pure state of nature that existed before environmental destruction, which is considered a cause of pandemic, perfumer collective Conte de Tulear created the scent *13963*. Moss, a primary note in *13963*, looks like a virus at a glance, but it is in fact a plant that possesses the incredible power of purification and restoration. Every Thursday during the exhibition, the museum will be filled with this scent. Fragrance sprayed in every nook and cranny of the museum, from a corner of a locker to air conditioners, handrails, and the museum bookstore, will permeate all spaces as time passes to create another layer of this multifaceted exhibition.

Meanwhile, if a situation occurs in which the museum cannot open, Conte de Tulear's *13963* will be sprayed on leaflets and tickets and mailed to those who wished to visit the museum. *13963*, as the scent that symbolizes the exhibition *Catastrophe and Recovery* and reflects the longing for a recovery of the status quo, will arouse subtle memories of the museum through the visitors' sense of smell and connect the interior of the museum with the outside world.

Distancing Navigator

In a hopeful future in which the pandemic is over and the risk of virus is gone, how will we remember the current moment? Social distancing, which we have maintained in ticketing lines at museums, or at the theater or on trains, has quickly settled in as a new custom. Depending on the future situation, we might feel anxiety rather than discomfort when we go to overcrowded places, and we might use certain tools to keep physical distance like when we wear masks to prevent the spread of droplets or viruses.

Designer Kiljong Park proposes a sort of viewing tool with which visitors can tactilely experience the discomfort of a two-meter safety distance imposed on their bodies. Tools usually aid people to perform something comfortably, but this tool, while it physically keeps users at a safe distance, actively induces discomfort so that users can sense and remember the pandemic with every fiber of their body.

This 'Safety Zone Generator' will be available to rent at the museum information desk every Wednesday.

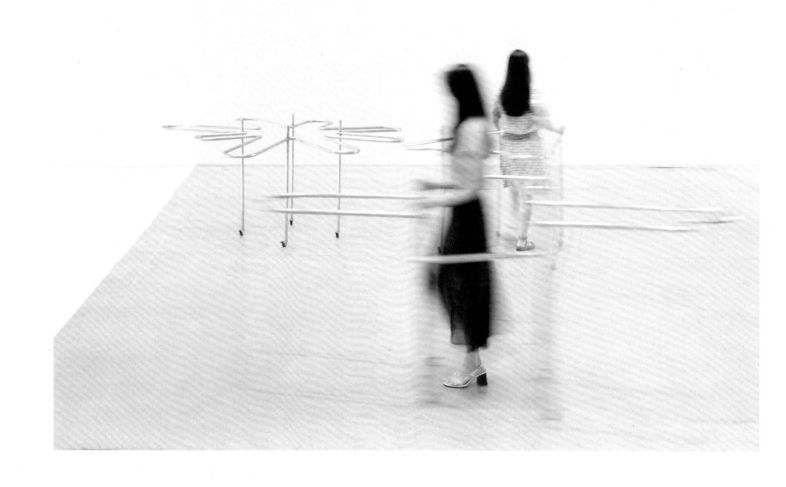

박길종, ‹거리두기 항해사›
2021, 스테인리스 스틸, 200×200×100cm(3).
작가 소장. 국립현대미술관 지원으로 제작.
사진: 김경태

Kiljong Park, *Distancing Navigator*
2021, Stainless steel, 200×200×100cm(3).
Courtesy of the artist. Commissioned by MMCA, Korea.
Photo by Kyoungtae Kim

영구소장

권태현
참여작가: 최이다, 주현욱, 장성건, 최수빈, 박유진

Permanent Collection

Kwon Taehyun

Participating artists: iida Choi, Joo Hyunwook, Sunggun Jang,
Choi Subin, and Eugene Hannah Park

미술관은 이례적인 장소다. 무엇이든 끊임없이 소비해야 돌아가는 세계에서 특정 사물을 영원히 보존하기 위한 기관이기 때문이다. 미술관의 소장품은 영원히 보존될 것이라는 믿음과 함께 수장고에 보관된다. 영구 소장이라는 그 끝이 보이지 않는 시간성은 쉽게 가늠이 되지 않는다. 흥미로운 점은 세상의 끝을 그리는 소위 포스트 아포칼립스 세계관에서 미술관의 모습이 등장하는 경우가 더러 있다는 것이다. 모든 인류가 불임이 되어 절멸을 앞둔 세계를 그린 알폰소 쿠아론(Alfonso Cuarón Orozco) 감독의 2006년 영화 ‹칠드런 오브 맨(Children of Men)›에는 런던의 테이트모던 미술관이 전 세계의 중요한 미술품들을 보관하는 장소로 나온다. 그곳을 방문한 주인공은 질문을 던진다. 사람들이 모두 없어지면 이게 다 무슨 의미가 있겠냐고. 그곳의 관리인은 "난 그런 거 그냥 생각하지 않아"라며 냉소적으로 웃어 넘겨버리지만, 그 질문은 미래의 미술품, 나아가 미술관 자체에 대한 근본적인 질문이 된다. 그리고 지금과 같은 재난의 상황은 그런 상상력에 더욱 힘을 싣는다. 미술관은 소장품을 정말로 영구히 보존할 수 있을까? 지금보다 더 위험한 바이러스가 창궐하여 미술관 운영이 완전히 불가능 해진다면? 혹은 세계대전이 다시 터진다면? 무엇보다 국가라는 체제가 아예 무너져버리면 '국립'현대미술관은 어떻게 되는 것일까? 하는 질문들이 이어진다. 이 프로그램은 이런 질문들을 두고서 다양한 분야의 예술가들과 다중적 협업을 통해 아티스틱 리서치를 전개한다.

국립현대미술관의 소장품 정책과 재난 대책, 전쟁 시 프로토콜을 조사하고, 오랜 시간 국립현대미술관의 수장고를 지켜온 분들의 목소리를 담아내는 작업을 먼저 진행할 것이다. 여기에 참여 예술가들은 현실과 허구를 오가면서 다른 이미지나, 파운드 푸티지, 사운드 작업 등을 충돌시키며 리서치에 미학적으로 개입한다. 이렇게 함께 그린 이미지들의 지도는 온라인으로 송출되어 또 다른 시간들의 접합을 제안할 것이다.

A museum is an exceptional place. In a world that runs on constant consumption, it is an institution that is dedicated to preserving specific objects permanently. Museum collections are kept in storage with the faith that they will be preserved eternally. The endless temporality of a permanent collection is not something that can be easily assessed. Interestingly, museums occasionally appear in post-apocalyptic worldviews. In Alfonso Cuarón's 2006 film *Children of Men*, which portrays a world on the brink of extinction caused by the infertility of all of humankind, London's Tate Modern is used as an ark for important artworks from all over the world. When the protagonist visits the museum, he asks what the meaning of collecting artworks would be when all humans are gone. The owner laughs this question off, saying, "I just don't think about it." Yet, this question becomes a fundamental one about the art of the future and, furthermore, the institution of the museum itself. In catastrophic situations like the current pandemic, this idea gains more strength and similar questions ensue: can museums really preserve collections permanently? What happens when a virus even more dangerous than this one spreads and museums can no longer operate at all? What if another world war breaks out? Most of all, what would happen to the National Museum of Modern and Contemporary Art—keyword "national"—if the state were to collapse entirely? This project carries out artistic research on these questions in a multifaceted collaborative endeavor with artists in various fields.

It will start off by investigating the MMCA's collection policy, disaster countermeasures, and wartime protocols and recording the voices of those who have long safeguarded the MMCA's storage. The participating artists will aesthetically intervene in the research by introducing images, found footages, sound works, that overlap, break, clash, crossing reality and fiction. A map of these co-created images will be transmitted online and propose an integration with different times.

반향하는 동사들

김신재
참여작가: 이은희, 김지연·이강일

Verb, Reverb

Shinjae Kim

Participating artists: Eunhee Lee
and Jiyeon Kim and Gangil Yi

팬데믹으로 이동과 교류가 가로막히면서 우리의 일상 역시 멈추거나 느려지고, 우회하는 데에 익숙해졌다. 이러한 사태의 지속은 일부 기술 발전을 가속화하기도 했지만, 우리가 손상과 장애, 질병과 더불어 살아간다는 사실과 함께 '정상적'인 삶이란 실은 얼마나 취약하고 부서지기 쉬운 것인지 재차 돌아보게 했다. 이 프로젝트는 위기가 상기한 '결함'에 반향하여 신체와 감각, 행위의 정상성과 비정상성을 둘러싼 여러 프레임과 질문들을 살핀다.

이은희의 ‹디딤기와 흔듦기›(2021)는 재활 기술을 둘러싼 의료산업에 주목해 인간의 신체와 기계, 기술과 노동 사이의 상호의존적인 관계를 들여다본다. 제목에 사용된 '디딤기'와 '흔듦기'는 정상적인 보행 동작을 세분화한 신체 운동학 용어이다. 우리가 걸을 때 한쪽 발이 지면을 디뎌 체중을 지지하면(디딤기), 다른 쪽 발이 공중에 떠서 나아간다(흔듦기). 두 발이 번갈아 가며 전진하는 것처럼 인간과 기계는 때로 결합하고 서로 지지하며, 기계와 노동 역시 상호보완적이고도 순환적인 관계를 맺는다. 영상은 웨어러블 로봇과 최첨단 의족을 다루는 보조기술 연구소, 트라우마 극복에 VR을 활용하는 재활훈련장 등을 비추며, 과학과 기술이 장애의 극복과 자립을 강조할 때 신체를 비장애 중심의 이데올로기에 편입시키는 것은 아닌지 질문하는 한편, 노동과 기술이 교차하는 물리적이고 정치적인 공간으로서의 신체-기계를 환기한다.

이은희, ‹디딤기와 흔듦기›
2021, 3채널 비디오 설치, 컬러, 사운드, 32분 14초.
작가 소장.
사진: 김경태

Eunhee Lee, *Stance Phase, Swing Phase*
2021, 3-channel video installation, color, sound,
32min. 14sec.
Courtesy of the artist.
Photo by Kyoungtae Kim

With mobility and interpersonal interaction being barred by the pandemic, we have become accustomed to stopping, slowing down, and making detours in our daily lives. The continuation of this state of affairs has accelerated some technological development, but also enabled us to reflect on how fragile and vulnerable our "normal" lives are and awakened us to the fact that we live with impairment, disability, and disease. Resonating with the aforementioned points of vulnerability, this project captures various frameworks surrounding normality and abnormality in relation to the body and senses.

Eunhee Lee's *Stance Phase, Swing Phase* (2021) examines the mutually dependent relationship between human bodies and machines, and technologies and labor, by focusing on the medical industry surrounding rehabilitation technology. "Stance" and "swing" are kinesiological terms that subdivide the actions in a standard walking motion. In walking, when one foot stands on the ground to support one's weight (stance), the other foot moves forward through the air (swing). Just as two feet take turns to move a person forward, humans and machines are at times combined, supporting one another; machines and labor also have a complementary, cyclical relationship. The work follows exoskeleton robots, state-of-the-art prosthetic legs, and a rehabilitation center that utilizes virtual reality treatments for trauma recovery in relation to rehabilitation engineering and assistive technology, through which the artist questions whether or not science and technology are trying to incorporate the body into an ideology that prioritizes non-disability by stressing conquest and independence, while bringing attention to the body-machine as a physical and political site where labor and technology intersect.

Artists Jiyeon Kim and Gangil Yi's *Listening Session: Listen Loudly* (2021) appropriates the form of a "listening session" and proposes we reimagine the position and capacity as a listener: someone performing the act of listening. Here, "listening" is an active practice that occurs through the interaction between sound and listener. Just as human ears cannot hear sounds at inaudible frequencies, this is an act of questioning the selective adjustments that position the sounds of minoritized people and beings ecologically cohabitating with. *Listening Session* redefines sound and listening while allowing us to understand the difference between "hearing" and "listening." Some sounds can be heard by penetrating through the inaudible zone, at which point listening resonates with the possibility of activism beyond activity.

김지연·이강일의 ‹리스닝 세션: 크게 듣기›(2021)는 '리스닝
세션'이라는 형식을 전유해, 듣기에 있어 청자로서의 위치와 행위
능력을 재설정해보기를 제안한다. 이때 '듣기'란 소리와 듣는 이 사이의
상호작용을 통해 이루어지는 능동적인 실천에 가깝다. 또한 인간의
청력이 비가청 주파수 대역의 소리를 들을 수 없는 것처럼, 우리 안에서
생태적으로 동거해온 존재와 소수자들의 소리를 배경에 위치시키는
선택적 조정이 끊임없이 이뤄지는 데 대해 재고하는 일이기도 하다.
'리스닝 세션'은 소리와 듣기를 다시 정의하면서 들리는 것과 듣는 것의
차이를 감각하게 한다. 어떤 소리는 때로 비가청 영역을 뚫고 들려오는데,
이때 듣기는 능동성을 넘어 액티비즘의 가능성과 공명한다.

김지연·이강일, ‹리스닝 세션: 크게 듣기›
2021, 단채널 비디오, 컬러, 사운드, 24분 39초.
작가 소장.

Jiyeon Kim and Gangil Yi, *Listening Session: Listen Loudly*
2021, Single-channel video, color, sound, 24min. 39sec.
Courtesy of the artist.

위성 프로젝트: 포세이돈 어드벤처

기획
이수연

진행
유채린

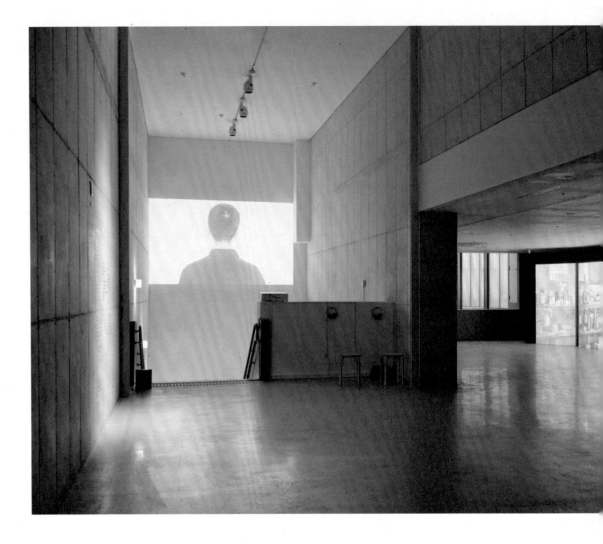

Satellite Project: The Poseidon Adventure

Curator
Sooyon Lee

Curatorial Assistant
Chaerin Yoo

고쳐쓰는 관습들

기획
남선우

참여 작가
이슬아, 김환, 꽁티드툴레아, 박길종

영구소장

기획
권태현

영상
최이다

퍼포먼스
주현욱

사운드
장성건

리서치
박유진

그래픽디자인
최수빈

반향하는 동사들

기획
김신재

참여 작가
이은희, 김지연·이강일

Rewriting Customs

Curator
Sunwoo Nam

Artist
Seula Lee, Kim Hwan, Conte de Tulear,
Kiljong Park

Permanent Collection

Curator
Kwon Taehyun

Video
iida Choi

Performance
Joo Hyunwook

Sound
Sunggun Jang

Research
Eugene Hannah Park

Graphic Design
Choi Subin

Verb, Reverb

Curator
Shinjae Kim

Artist
Eunhee Lee, Jiyeon Kim·Gangil Yi

작가 약력					Biography

Kim Beom

Lives and works in Korea

Education

M.F.A. School of Visual Arts (SVA), New York, USA

M.F.A. Department of Painting, Seoul National University, Seoul, Korea

B.F.A. Department of Painting, Seoul National University, Seoul, Korea

Selected Solo Exhibitions

2017 *Random Life*, STPI, Singapore

2016 *Kim Beom*, Contemporary Art Gallery, Vancouver, Canada

Other solo exhibitions at major art museums in and outside Korea

Selected Group Exhibitions

2020 *Artists in Their Times: Korean Modern and Contemporary Art*, National Museum of Modern and Contemporary Art, Gwacheon, Korea

2019 *Take () at Face Value,* Korean Cultural Centre Australia, Sydney, Australia

2017 *Postmodern Real,* Museum of Art, Seoul National University, Seoul, Korea

Other group exhibitions at major art museums and biennales in and outside Korea

Selected Collections

National Museum of Modern and Contemporary Art

Seoul Museum of Art

Other collections at major art museums and institutes in and outside Korea

Jiana Kim

Lives and works in Korea

Education

Ph. D. Craft &Design, Completed a Course, Seoul National University, Seoul, Korea

M.F.A. Fine Arts, Montclair State University, Upper New Jersey, USA

B.F.A. Product Design, Parsons School of Design, New York, USA

Selected Solo Exhibitions

2020 *Jiana Kim Solo Exhibition*, Black Stone, Icheon, Korea

2019 *The Alchemist of Clay*, Art'Loft, Brussels, Belgium

2018 *INSIDE*, Dongwon Gallery, Daegu, Korea etc.

Selected Group Exhibitions

2020 *LEAF*, Villa Empain, Brussels, Belgium

2019 *Gwangju Design Biennale*. Gwangju Biennale Exhibition Hall, Gwangju, Korea

2018 *Nonunifiable Heterogeneous Individuals*, Gyeonggi Creation Center, Gyeonggido, Korea etc.

Selected Collections

Gyeonggi Museum of Modern Art

Government Art Bank

Boghossian Foundation etc.

Eun Nim Ro

Lives and works in Germany

Education

Fine Art, Hamburg Academy of Fine Arts, Germany

Selected Solo Exhibitions

2019 Gana Art Center, Gana Art Hannam, Seoul, Korea

2018 Museum Villa Haiss, Zell, Germany

2016 Korean Cultural Center, Berlin, Germany

Other solo exhibitions at major art museums in and outside Korea

Selected Group Exhibitions

2018 *SIMPLE 2018: Chang Ucchin · Eun Nim Ro*, Chang Ucchin Museum of Art, Yangju, Korea

2016 *Flux*, Barom Gallery, Seoul, Korea

2007 *Noah's Ark*, National Museum of Modern and Contemporary Art, Gwacheon, Korea

Other group exhibitions at major art museums and biennales in and outside Korea

Selected Collections

National Museum of Modern and Contemporary Art

Museum Villa Haiss

Museum Ratingen

Other collections at major art museums and institutes in and outside Korea

김범

한국 거주 및 작업

학력

서양화과 석사, 스쿨 오브 비주얼 아트(SVA), 뉴욕, 미국
서양화과 석사, 서울대학교, 서울, 한국
서양화과 학사, 서울대학교, 서울, 한국

주요 개인전

2017 «무작위 인생», STPI, 싱가포르
2016 «김범», 현대미술갤러리, 벤쿠버, 캐나다 등 국내외
 주요 미술관 개인전 다수 개최

주요 단체전

2020 «시대를 보는 눈: 한국근현대미술전», 국립현대미술관,
 과천, 한국
2019 «액면가로 () 받아들이기», 주시드니한국문화원,
 시드니, 호주
2017 «포스트모던 리얼», 서울대학교미술관, 서울, 한국 등
 국내외 주요 미술관, 비엔날레 등 다수 참여

주요 소장처

국립현대미술관
서울시립미술관 등 국내외 주요 미술관 및 기관 다수 소장

김지아나

한국 거주 및 작업

학력

공예과 박사 수료, 서울대학교 미술대학, 서울, 한국
순수미술과 석사, 몬트클레어 주립대학교, 뉴저지, 미국
제품디자인과 학사, 파슨스 스쿨 오브 디자인, 뉴욕, 미국

주요 개인전

2020 «김지아나 개인전», 블랙스톤, 이천, 한국
2019 «The Alchemist of Clay», 아트 로프트, 브뤼셀,
 벨기에
2018 «INSIDE», 동원화랑, 대구, 한국 등

주요 단체전

2020 «LEAF», 빌라엉팡, 브뤼셀, 벨기에
2019 «광주디자인비엔날레», 광주비엔날레전시관, 광주,
 한국
2018 «통합 불가능한 이질적 개체들», 경기창작센터, 경기도,
 한국 등

주요 소장처

경기도미술관
정부미술은행
보고시안재단 등

노은님

독일 거주 및 작업

학력

순수 미술전공, 함부르크 국립 미술대학, 독일

주요 개인전

2019 가나아트센터, 가나아트 한남, 서울, 한국
2018 뮤지엄 빌라 하이스, 첼, 독일
2016 한국문화원, 베를린, 독일 등 국내외 주요 미술관 개인전
 다수 개최

주요 단체전

2018 «SIMPLE 2018: 장욱진 · 노은님»,
 양주시립장욱진미술관, 양주, 한국
2016 «FLUX», 바롬갤러리, 서울, 한국
2007 «노아의 방주», 국립현대미술관, 과천, 한국 등 국내외
 주요 미술관, 비엔날레 등 다수 참여

주요 소장처

국립현대미술관
뮤지엄 빌라 하이스
라팅엔 뮤지엄 등 국내외 주요 미술관 및 기관 다수 소장

Liam Gillick

Lives and works in USA

Education

B.A. (Hons.), Goldsmiths, University of London,
London, UK

Hertfordshire College of Art, University of Hertfordshire,
Hertfordshire, UK

Selected Solo Exhibitions

2021 *The Work Life Effect*, Gwangju Museum of Art,
Gwangju, Korea

2019 *Standing on Top of a Building: Films 2008-2019*,
Museo d'Arte Contemporanea Donnaregina
(Madre Museum), Naples, Italy

2017 *The Lights are No Brighter at the Centre*,
Contemporary Art Centre (CAC) Vilnius,
Lithuania

Other solo exhibitions at major art museums in and
outside Korea

Selected Group Exhibitions

2020 *Museum for Preventive Imagination—Editorial*,
MACRO, Museum of Contemporary Art of
Rome, Rome, Italy

2019 *Gelatin and Liam Gillick*, Stinking Dawn,
Kunsthalle Wien, Vienna, Austria

2018 *Soziale Fassaden: Ein Dialog der Sammlungen
des MMK und der DekaBank*, MMK, Frankfurt,
Germany

Other group exhibitions at major art museums and
biennales in and outside Korea

Selected Collections

Tate Modern

The Museum of Modern Art

Fonds Régional d'Art Contemporain (FRAC)

Other collections at major art museums and institutes
in and outside Korea

Liu Wa

Lives and works in USA and China

Education

M.S. in Art, Culture and Technology, Massachusetts
Institute of Technology, Cambridge, USA

B.A. in Anthropology & B.A. in Art, Yale University,
New Haven, USA

Selected Solo Exhibitions

2020 *Moon Milk* (joint exhibition), Madeln Gallery,
Shanghai, China

2019 *Glimpse*, Asia Now, Paris, France

2018 *Glimpse: A Passing Look*, Sabsay Gallery,
Copenhagen, Denmark

Other solo exhibitions at major art museums in and
outside Korea

Selected Group Exhibitions

2021 *Duration: Chinese Art in Transformation*,
Beijing Minsheng Art Museum, Beijing, China

2020 *Busan Biennale*, Museum of Contemporary Art
Busan, Busan, Korea

*Immaterial/Re-material: A Brief History of
Computing Art*, UCCA Center for Contemporary
Art, Beijing, China

2019 *Porsche Young Chinese Artist of the Year 2018-
2019*, Beijing Exhibition Centre, Beijing, China

Other group exhibitions at major art museums and
biennales in and outside Korea

Moojin Brothers

Mujin Jung Hyoyoung Jung Youngdon Jung

Lives and works in Korea

Education

Mujin Jung

B.F.A. Dept. of Creative Writing, Myongji University, Seoul, Korea

Hyoyoung Jung

M.F.A. Dept. of Sculpture, Hongik University, Seoul, Korea

B.F.A. Dept. of Sculpture, Hongik University, Seoul, Korea

Youngdon Jung

M.F.A. Dept. of Fine Art Photography, Chung-Ang University, Korea

B.F.A. Dept. of Fine Art Photography, Chung-Ang University, Korea

Selected Solo Exhibitions

2019 *The old man was dreaming about the lions*,
Art Space Pool, Seoul, Korea

2018 *The Door into Summer* (Random Access Project),
Nam June Paik Art Center -Mezzanine Space, Yongin,
Korea

The Trace of the Box, Archive Bomm, Seoul, Korea

Other solo exhibitions at major art museums in and outside Korea

Selected Group Exhibitions

2020 *London Korean Film Festival x LUX Moving Image
(LKFF x LUX)*, London, UK

2019 *Dear Cinema: Difference and Repetition*, National Museum
of Modern and Contemporary Art, Seoul, Korea

2018 *Flip Book: The Revolutionary Animation of the 21th
Century*, Ilmin Museum of Art, Seoul, Korea

Other group exhibitions at major art museums and biennales in and
outside Korea

Selected Collections

Seoul Museum of Art

Museum of Contemporary Art Busan

Han Nefkens Foundation

Other collections at major art museums and institutes in and
outside Korea

리암 길릭
미국 거주 및 작업

학력
학사 졸업, 골드스미스 런던대학교, 런던, 영국
예술학과 학사, 허트포드셔 대학교, 영국

주요 개인전
2021 «워크 라이프 이펙트», 광주시립미술관, 광주, 한국
2019 «Standing on Top of a Building: Films 2008-
 2019», 나폴리현대미술관, 나폴리, 이탈리아
2017 «The Lights are No Brighter at the Centre»,
 빌누스현대미술센터, 빌누스, 리투아니아 등 국내외
 주요 미술관 개인전 다수 개최

주요 단체전
2020 «Museum for Preventive Imagination—
 Editorial», 로마현대미술관, 로마, 이탈리아
2019 «Gelatin and Liam Gillick, Stinking Dawn»,
 쿤스트할레 빈, 비엔나, 오스트리아
2018 «Soziale Fassaden: Ein Dialog der Sammlungen
 des MMK und der DekaBank»,
 프랑크푸르트현대미술관, 프랑크푸르트, 독일 등
 국내외 주요 미술관, 비엔날레 등 다수 참여

주요 소장처
테이트 모던
뉴욕현대미술관
현대미술재단(파리) 등 국내외 주요 미술관 및 기관 다수 소장

리우 와
미국과 중국 거주 및 작업

학력
예술문학기술대학원 석사, 매사추세츠공과대학교(MIT),
 케임브리지, 미국
인류학 전공 및 예술 전공 학사, 예일대학교, 뉴헤이븐, 미국

주요 개인전
2020 «Moon Milk»(공동 전시), 메이드인갤러리, 상하이,
 중국
2019 «Glimpse», 아시아 나우, 파리, 프랑스
2018 «Glimpse: A Passing Look», 샵사이갤러리,
 코펜하겐, 덴마크 등 국내외 주요 미술관 개인전
 다수 개최

주요 단체전
2021 «Duration: Chinese Art in Transformation»,
 베이징민생현대미술관, 베이징, 중국
2020 «부산비엔날레», 부산현대미술관, 부산, 한국
 «Immaterial/Re-material: A Brief History of
 Computing Art», UCCA현대미술센터, 베이징, 중국
2019 «Porsche Young Chinese Artist of the Year
 2018-2019», 베이징전시관, 베이징, 중국 등 국내외
 주요 미술관, 비엔날레 등 다수 참여

무진형제
정무진 정효영 정영돈
한국 거주 및 작업

학력
정무진
문예창작학과 학사, 명지대학교, 서울, 한국
정효영
조소과 석사, 홍익대학교, 서울, 한국
조소과 학사, 홍익대학교, 서울, 한국
정영돈
조형예술학과 순수사진 석사, 중앙대학교, 서울, 한국
사진학과 학사, 중앙대학교, 서울, 한국

주요 개인전
2019 «노인은 사자 꿈을 꾸고 있었다», 아트 스페이스 풀,
 서울, 한국
2018 «여름으로 가는 문»(랜덤 액세스 프로젝트),
 백남준아트센터-메자닌 스페이스, 용인, 한국
2018 «궤적», 아카이브 봄, 서울, 한국 등 국내외 주요 미술관
 개인전 다수 개최

주요 단체전
2020 «London Korean Film Festival x LUX Moving
 Image»(LKFF x LUX), 런던, 영국
2019 «디어시네마: 차이와 반복», 국립현대미술관
 필름앤비디오, 서울, 한국
2018 «플립북: 21세기 애니메이션의 혁명», 일민미술관,
 서울, 한국 등 국내외 주요 미술관, 비엔날레 등
 다수 참여

주요 소장처
서울시립미술관
부산현대미술관
한네프켄 재단 등 국내외 주요 미술관 및 기관 다수 소장

Tatsuo Miyajima

Lives and works in Japan

Education

Honorary Doctorate, University of the Arts, London, UK

M.A. Fine Arts Department, Tokyo University of the Arts, Tokyo, Japan

B.A. Fine Arts Department, Tokyo University of the Arts, Tokyo, Japan

Selected Solo Exhibitions

2020 *Tatsuo Miyajima: Chronicle 1995-2020*, Chiba City Museum of Art, Chiba, Japan

2019 *Tatsuo Miyajima: Being Coming*, Shanghai Minsheng Art Museum, Shanghai, China

2016 *Tatsuo Miyajima: Connect with Everything*, Museum of Contemporary Art Australia, Sydney, Australia

Other solo exhibitions at major art museums in and outside Korea

Selected Group Exhibitions

2020 *STARS: Six Contemporary Artists from Japan to the World*, Mori Art Museum, Tokyo, Japan

2019 *24/7*, Somerset House, London, UK

2018 *Minimalism: Space, Light, Object*, National Gallery Singapore, Singapore

Other group exhibitions at major art museums and biennales in and outside Korea

Selected Collections

British Museum

San Francisco Museum of Modern Art

Museum of Contemporary Art Tokyo

Other collections at major art museums and institutes in and outside Korea

Park Young Gyun

Lives and works in Korea

Education

M.F.A. Painting, Kyung Hee University, Seoul, Korea

B.F.A. Painting, Kyung Hee University, Seoul, Korea

Selected Solo Exhibitions

2020 *A View from the Hill*, Planned Exhibition Hall, Busan Democracy Park, Busan, Korea

2018 *Adult Fairy Tale*, Hampyeong Museum of Art, Hampyeong, Korea

2015 *The Fold of Layers*, Kwanhoon Gallery, Seoul, Korea

Other solo exhibitions at major art museums in and outside Korea

Selected Group Exhibitions

2019 *Locus and Focus: Into the 1980s through Art Group Archives*, Gyeonggi Museum of Modern Art, Ansan, Korea

2018 *The 10th DMZ Special Exhibition*, Gimpo Art Village, Gimpo, Korea

2017 *A Journey into Community, Facing the Far Side*, Jeju Museum of Art, Jeju, Korea

Other group exhibitions at major art museums and biennales in and outside Korea

Selected Collections

National Museum of Modern and Contemporary Art

National Museum of Korean Contemporary History

Daejeon Museum of Art

Other collections at major art museums and institutes in and outside Korea

BONG Joon-ho

Lives and works in Korea

Selected Screenings

2020 London Korean Film Festival, London, UK

2019 The Bong Show, Film at Lincoln Center, New York, USA

2015 Belfort Entrevues Film Festival, Belfort, France

Other major international film festivals and institutes

Selected Collections

JEONJU International Film Festival

미야지마 타츠오
일본 거주 및 작업

학력
명예박사, 런던예술대학교, 런던, 영국
예술대학 석사, 도쿄예술대학, 도쿄, 일본
예술대학 학사, 도쿄예술대학, 도쿄, 일본

주요 개인전
2020 «미야지마 타츠오: 연대기1995-2020»,
 치바시립미술관, 치바, 일본
2019 «Tatsuo Miyajima: Being Coming»,
 민생현대미술관, 상하이, 중국
2016 «미야지마 타츠오: 모든 것은 연결된다»,
 시드니현대미술관, 시드니, 호주 등 국내외 주요
 미술관 개인전 다수 개최

주요 단체전
2020 «STARS: Six Contemporary Artists from Japan
 to the World», 모리미술관, 도쿄, 일본
2019 «24/7», 서머셋 하우스, 런던, 영국
2018 «Minimalism: Space, Light, Object»,
 싱가포르국립미술관, 싱가포르 등 국내외 주요 미술관,
 비엔날레 등 다수 참여

주요 소장처
대영박물관
샌프란시스코현대미술관
도쿄도현대미술관 등 국내외 주요 미술관 및 기관 다수 소장

박영균
한국 거주 및 작업

학력
회화과 학사, 경희대학교, 서울, 한국
회화과 석사, 경희대학교, 서울, 한국

주요 개인전
2020 «들여다 듣는 언덕», 부산민주공원 기획전시실, 부산,
 한국
2018 «어른동화, 함평군립미술관 초대전», 함평군립미술관,
 함평, 한국
2015 «레이어의 겹», 관훈갤러리, 서울, 한국 등 국내외 주요
 미술관 개인전 다수 개최

주요 단체전
2019 «시점時點·시점視點: 1980년대 소집단 미술운동
 아카이브», 경기도미술관, 안산, 서울, 한국
2018 «제10회 DMZ특별기획전: 물은 자유로이 남북을
 오가고 새는 바람으로 철망을 넘는다»,
 김포아트빌리지, 김포, 한국
2017 «회향(回向), 공동체와 예술의 길», 제주원도심, 제주,
 한국 등 국내외 주요 미술관, 비엔날레 등 다수 참여

주요 소장처
국립현대미술관
대한민국역사박물관
대전시립미술관 등 국내외 주요 미술관 및 기관 다수 소장

봉준호
한국 거주 및 작업

주요 상영 이력
2020 제15회 런던한국영화제, 런던, 영국
2019 봉준호 특별전, 링컨센터, 뉴욕, 미국
2015 제30회 벨포르국제영화제, 벨포르, 프랑스 등
 주요 세계 영화제 및 기관

주요 소장처
전주국제영화제

Do Ho Suh

Lives and works in UK

Education

M.F.A. Sculpture, Yale University School of Art,
New Haven, CT, USA

B.F.A. Painting, Rhode Island School of Design,
Providence, RI, USA

M.F.A. Oriental Painting, Seoul National University,
Seoul, Korea

B.F.A. Oriental Painting, Seoul National University,
Seoul, Korea

Selected Solo Exhibitions

2019 *Do Ho Suh: 348 West 22nd Street*, Los Angeles
County Museum of Art, Los Angeles, CA, USA

2018 *Do Ho Suh: Passage/s*, Towada Art Center,
Towada, Japan

2017 *Do Ho Suh*, Madison Museum of
Contemporary Art, Madison, WI, USA

Other solo exhibitions at major art museums in and
outside Korea

Selected Group Exhibitions

2021 *When Home Won't Let You Stay: Migration
Through Contemporary Art*, Iris & B. Gerald
Cantor Center for Visual Arts at Stanford
University, Stanford, CA, USA

2020 *Likeness and Legacy in Korean Portraiture*,
Asian Art Museum, San Francisco, CA, USA

2019 *Boundless Encounters: the 3rdHangzhou
Triennial of Fiber Art*, Zhejiang Art Museum,
Hangzou, China

Other group exhibitions at major art museums and
biennales in and outside Korea

Selected Collections

The Museum of Modern Art

National Museum of Modern and Contemporary Art

Tate Modern

Other collections at major art museums and institutes
in and outside Korea

Seungmo Seo

Lives and works in Korea

Education

M.F.A. Tokyo University of the Arts, Tokyo, Japan

Selected Group Exhibitions

2020 *Stepping on the Ground, the Floor Is Raised*,
Arumjigi, Seoul, Korea

2019 *Contemporary Korean Architecture,
Cosmopolitan Look 1989-2019*, Korean Cultural
Center, Budapest, Hungary

2016 *Line*, Prismic Gallery, Tokyo, Japan etc.

Sung Neung Kyung

Lives and works in Korea

Education

B.F.A. Painting, Hongik University, Seoul, Korea

Selected Solo Exhibitions

2001 *The Korean Culture and Arts Foundation Series
2001*, Marronnier Art Center, Seoul, Korea

1991 *S's Posterity: A Botched Art is More Beautiful*,
Samduck Gallery, Daegu, Korea

1988 *Sung Neung Kyung's Performance Art*, Cheongpa
Theater, Seoul, Korea

Other solo exhibitions at major art museums in and
outside Korea

Selected Group Exhibitions

2020 *The 4th International Festival of Homar, Video and
Photo Exhibition, Light Art Performance—With
Approach the Nature*, The Arta Contemporary Art
Institute, Adab Art Educational Center,
Khorramabd, Iran

2019 *Awakening : Art in Society in Asia 1960s-1990s*,
National Museum of Modern and Contemporay
Art, Gwachen, Korea; National Gallery Singapore,
Singapore, The National Museum of Modern Art,
Tokyo, Japan

2018 *Digital Promnade*, Seoul Museum of Art, Seoul,
Korea

Other group exhibitions at major art museums and
biennales in and outside Korea

Selected Collections

National Museum of Modern and Contemporary Art

Gyeonggi Museum of Modern Art

Seoul Museum of Art

Arko Art Center

Other collections at major art museums and institutes
in and outside Korea

서도호
영국 거주 및 작업

학력
조각 석사, 예일대학교 미술대학원, 뉴헤이븐, 코네티컷, 미국
회화 학사, 로드아일랜드디자인스쿨, 프로비던스,
　　　로드아일랜드, 미국
동양화 석사, 서울대학교, 서울, 한국
동양화 학사, 서울대학교, 서울, 한국

주요 개인전
2019　«Do Ho Suh: 348 West 22nd Street»,
　　　로스앤젤레스카운티미술관, 로스앤젤레스,
　　　캘리포니아, 미국
2018　«Do Ho Suh: Passage/s», 도와다시현대미술관,
　　　도와다, 일본
2017　«Do Ho Suh», 매디슨현대미술관, 매디슨,
　　　위스콘신, 미국 등 국내외 주요 미술관 개인전 다수 개최

주요 단체전
2021　«When Home Won't Let You Stay: Migration
　　　Through Contemporary Art», 스탠포드대학교
　　　캔토시각예술센터, 캘리포니아, 미국
2020　«Likeness and Legacy in Korean Portraiture»,
　　　동양미술관, 샌프란시스코, 캘리포니아, 미국
2019　«Boundless Encounters: the 3rd Hangzhou
　　　Triennial of Fiber Art», 저장미술관, 항저우, 중국 등
　　　국내외 주요 미술관, 비엔날레 등 다수 참여

주요 소장처
뉴욕현대미술관
국립현대미술관
테이트 모던 등 국내외 주요 미술관 및 기관 다수 소장

서승모
한국 거주 및 작업

학력
건축 전공 석사, 동경예술대학 미술연구과, 도쿄, 일본

주요 단체전
2020　«바닥, 디디어 오르다», 아름지기, 서울, 한국
2019　«한국현대건축, 세계인의 눈 1989-2019»,
　　　한국문화원, 부다페스트, 헝가리
2016　«금», 프리스믹갤러리, 도쿄, 일본 등

성능경
한국 거주 및 작업

학력
서양화과, 홍익대학교 미술대학, 서울, 한국

주요 개인전
2001　«2001 한국 현대미술 기획초대전», 문예진흥원
　　　미술회관, 서울, 한국
1991　«S씨의 자손들—망친 사진이 더 아름답다»,
　　　삼덕갤러리, 대구, 한국
1988　«성능경의 행위예술»(행위예술가협회 기획),
　　　청파소극장, 서울, 한국 등 국내외 주요 미술관 개인전
　　　다수 개최

주요 단체전
2020　«제 4회 호마르 국제 페스티발 비디오 & 사진 전시,
　　　라이트 아트 퍼포먼스—With approach the
　　　Nature», 아르타현대예술인스티튜트,
　　　아답예술교육센터, 호라마바드, 이란
2019　«세상에 눈뜨다: 아시아 미술과 사회 1960s-1990s»,
　　　국립현대미술관, 과천, 한국/싱가포르 국립미술관,
　　　싱가포르/도쿄국립근대박물관, 도쿄, 일본
2018　«디지털 프롬나드», 서울시립미술관, 서울, 한국 등 국내외
　　　주요 미술관, 비엔날레 등 다수 참여

주요 소장처
국립현대미술관
경기도미술관
서울시립미술관
아르코미술관 등 국내외 주요 미술관 및 기관 다수 소장

Syndicate: COVID-19 Ed.

Lives and works in Korea

Formed according to different agendas, Syndicate is a project group dedicated to finding and visualizing hidden links in today's fragmented world from which narrative has disappeared.
COVID-19 Ed. of the group was established to collect images of the malfunctioning world since the outbreak of COVID-19 in March 2020.

Sunny Kim

Lives and works in Korea and USA

Education

M.F.A. Combined Media, Hunter College, New York, NY, USA
B.F.A. Painting, The Cooper Union for the Advancement of Science and Art, New York, NY, USA
Exchange Program for Fine Arts, Rietveld Academe, Amsterdam, Netherlands

Selected Solo Exhibitions

2020 *If Different Day is a Same Day…*, A-Lounge, Seoul, Korea (curated by Enna Bae)
2013 *Second Thought*, Space bm, Seoul, Korea
2010 *Rolling Fog*, Gallery Hyundai 16 Bungee, Seoul, Korea
Other solo exhibitions at major art museums in and outside Korea

Selected Group Exhibitions

2020 *Ogamdo*, Manarat Al Saadiyat (VR exhibition), Abu Dhabi, UAE
2019 *The Grey of Jihye*, White Block Art Center, Paju, Korea
2017 *Korea Artist Prize 2017*, National Museum of Modern and Contemporary Art, Seoul, Korea
Other group exhibitions at major art museums and biennales in and outside Korea

Selected Collections

National Museum of Modern and Contemporary Art
National Museum of Art (Osaka)
Seoul Museum of Art
Other collections at major art museums and institutes in and outside Korea

Anicka Yi

Lives and works in USA

Selected Solo Exhibitions

2019 *We Have Never Been Individual*, Gladstone Gallery, Brussels, Belgium
2017 *The Hugo Boss Prize 2016: Anicka Yi, Life Is Cheap*, Solomon R. Guggenheim Museum, New York, USA
2016 *Jungle Stripe*, Fridericianum, Kassel, Germany
Other solo exhibitions at major art museums in and outside Korea

Selected Group Exhibitions

2020 *Psychic Wounds: On Art & Trauma*, The Warehouse, Rachofsky Collection, Dallas, USA
2019 *New Order: Art and Technology in the Twenty-first Century*, Museum of Modern Art, New York, USA
2018 *In Tune with the World*, Fondation Louis Vuitton, Paris, France
Other group exhibitions at major art museums and biennales in and outside Korea

Selected Collections

Solomon R. Guggenheim Museum
Museum of Modern Art
Fondation d'entreprise Galeries Lafayette
Aïshti Foundation
Other collections at major art museums and institutes in and outside Korea

신디케이트: 코로나 에디션
한국 거주 및 작업

신디케이트는 아젠다별로 결성되는 프로젝트팀이다.
서사가 사라지고 파편화된 세계의 숨겨진 연결고리를 찾아
시각화한다. 코로나 에디션은 2020년 3월 코로나로 인해
오류를 일으키기 시작한 세계의 이미지를 수집하기 위해
조직되었다.

써니킴
한국과 미국 거주 및 작업

학력
종합매체과 석사, 헌터대학원, 뉴욕, 미국
회화과 학사, 쿠퍼유니온대학교, 뉴욕, 미국
회화과 교환학생프로그램, 릿트벨드아카데미, 암스테르담,
　　　네덜란드

주요 개인전
2020　«다른날이 같은날이었으면…», 에이라운지,
　　　서울, 한국 (기획: 배은아)
2013　«제 2의 생각», 스페이스비엠, 서울, 한국
2010　«롤링호그», 갤러리현대 16번지, 서울, 한국 등 국내외
　　　주요 미술관 개인전 다수 개최

주요 단체전
2020　«오감도», 마나랏알사디야트 미술관(VR전시),
　　　아부다비, 아랍에미리트
2019　«회색의 지혜», 화이트블럭아트센터, 파주, 한국
2017　«올해의 작가상 2017», 국립현대미술관, 서울, 한국 등
　　　국내외 주요 미술관, 비엔날레 등 다수 참여

주요 소장처
국립현대미술관
오사카국립국제미술관
서울시립미술관 등 국내외 주요 미술관 및 기관 다수 소장

아니카 이
미국 거주 및 작업

주요 개인전
2019　«We Have Never Been Individual»,
　　　글래드스톤갤러리, 브뤼셀, 벨기에
2017　«The Hugo Boss Prize 2016: Anicka Yi, Life Is
　　　Cheap», 솔로몬R. 구겐하임미술관, 뉴욕, 미국
2016　«Jungle Stripe», 프리데리치아눔미술관, 카셀, 독일 등
　　　국내외 주요 미술관 개인전 다수 개최

주요 단체전
2020　«Psychic Wounds: On Art & Trauma»,
　　　더웨어하우스, 라코프스키컬렉션, 댈러스, 미국
2019　«New Order: Art and Technology in the Twenty-
　　　first Century», 뉴욕현대미술관, 뉴욕, 미국
2018　«In Tune with the World», 루이비통재단미술관,
　　　파리, 프랑스 등 국내외 주요 미술관, 비엔날레 등
　　　다수 참여

주요 소장처
솔로몬 R. 구겐하임미술관
뉴욕현대미술관
갤러리 라파예트 재단
아이쉬티 재단 등 국내외 주요 미술관 및 기관 다수 소장

Andrea Zittel

Lives and works in USA

Education

M.F.A. Sculpture, Rhode Island School of Design,
 Providence, USA
B.F.A. Painting/Sculpture (Honors), San Diego State
 University, San Diego, USA

Selected Solo Exhibitions

2020 *Works on Paper*, Sprüth Magers Berlin, Germany
2018 *Clutch by Andrea Zittel*, Kunsthall Stavanger,
 Stavanger, Norway
2017 *Andrea Zittel: The Flat Field Works*, New Art
 Centre, Wiltshire, UK
Other solo exhibitions at major art museums in and
 outside Korea

Selected Group Exhibitions

2021 *Garmenting: Costume and Contemporary Art*,
 Museum of Arts and Design, New York, NY, USA
2020 *Penumbral Age*, Museum of Modern Art in
 Warsaw, Warsaw, Poland
2019 *The Foundation of the Museum: MOCA's
 Collection*, Museum of Contemporary Art,
 Los Angeles, CA, USA
Other group exhibitions at major art museums and
 biennales in and outside Korea

Selected Collections

National Gallery of Australia
Solomon R. Guggenheim Museum
Tate Modern
Other collections at major art museums and institutes
 in and outside Korea

Eija-Liisa Ahtila

Lives and works in Finland

Education

University of California, Los Angeles, USA
American Film Institute, Los Angeles, USA
The London College of Printing, London, UK
The University of Helsinki, Helsinki, Finland

Selected Solo Exhibitions

2019 *Sculpture in the Age of Posthumanism*,
 LEHMBRUCK MUSEUM, Duisburg, Germany
2018 *Eija-Liisa Ahtila*, M-MUSEUM LEUVEN, Belgium
2017 *Studies on the Ecology of Drama*, Australian
 Centre for the Moving Image, Melbourne,
 Australia
Other solo exhibitions at major art museums in and
 outside Korea

Selected Group Exhibitions

2021 *Diversity United*, Tempelhof Airport, Berlin,
 Germany
2020 *Axis of Horizon*, National Museum of Modern
 and Contemporary Art, Seoul, Korea
2019 *Momentum10: The Emotional Exhibition*,
 Momentum Kunsthall, Moss, Norway
Other group exhibitions at major art museums and
 biennales in and outside Korea

Selected Collections

National Museum of Modern and Contemporary Art
Centre Pompidou
The Museum of Modern Art
Tate Modern
Other collections at major art museums and institutes
 in and outside Korea

Ji Hye Yeom

Lives and works in Korea

Education

(Distinction) M.F.A. Fine Art, Goldsmiths College,
 London, UK
M.A. Fine Art, Central Saint Martins College of Art and
 Design, London, UK
B.A. Fine Art, Seoul National University, Seoul, Korea

Selected Solo Exhibitions

2021 *[~]*, SongEun Art Space, Seoul, Korea
2018 *Total Perspective Vortex*, Daegu Art Museum,
 Daegu, Korea
2015 *All Exiles Have a Hidden Luck*, Art Sonje Center
 Project Space, Seoul, Korea
Other solo exhibitions at major art museums in and
 outside Korea

Selected Group Exhibitions

2021 *Dear Amazon: Anthropocene*, Korean Cultural
 Center, São Paulo, Brazil
2020 *The Future of Silence: When your tongue
 vanishes*, Nam June Paik Art Center, Yongin,
 Korea
2019 *Nothing Twice*, Buk-Seoul Museum of Art, Seoul,
 Korea
Other group exhibitions at major art museums and
 biennales in and outside Korea

Selected Collections

Museum of Contemporary Art Busan
National Museum of Modern and Contemporary Art
Seoul Museum of Art
Other collections at major art museums and institutes
 in and outside Korea

안드레아 지텔
미국 거주 및 작업

학력
조소 석사, 로드아일랜드스쿨오브디자인, 프로비던스, 미국
회화/조소 학사, 샌디에이고주립대학교, 샌디에이고, 미국

주요 개인전
2020 «Works on Paper», 스프루스마거스, 베를린, 독일
2018 «Clutch by Andrea Zittel», 쿤스트홀스타방에르,
 스타방에르, 노르웨이
2017 «Andrea Zittel: The Flat Field Works»,
 뉴아트센터, 윌트셔, 영국 등 국내외 주요 미술관 개인전
 다수 개최

주요 단체전
2021 «Garmenting: Costume and Contemporary
 Art», 뉴욕아트디자인박물관, 뉴욕, 미국
2020 «Penumbral Age», 바르샤바현대미술관, 바르샤바,
 폴란드
2019 «The Foundation of the Museum: MOCA's
 Collection», 로스앤젤레스현대미술관, 캘리포니아,
 미국 등 국내외 주요 미술관, 비엔날레 등 다수 참여

주요 소장처
호주국립미술관
솔로몬 R. 구겐하임미술관
테이트 모던 등 국내외 주요 미술관 및 기관 다수 소장

에이샤-리사 아틸라
핀란드 거주 및 작업

학력
UCLA, 미국
아메리칸필름인스티튜트(AFI), 로스앤젤레스, 미국
런던컬리지 오브 프린팅, 런던, 영국
헬싱키대학교, 헬싱키, 핀란드

주요 개인전
2019 «Sculpture in the Age of Posthumanism»,
 렘브루크미술관, 뒤스부르크, 독일
2018 «Eija-Liisa Ahtila», 루벤시립미술관, 벨기에
2017 «Studies on the Ecology of Drama», 호주
 국립무빙이미지센터, 멜버른, 호주 등 국내외 주요
 미술관 개인전 다수 개최

주요 단체전
2021 «Diversity United», 템펠호프공항, 베를린, 독일
2020 «수평의 축», 국립현대미술관, 서울, 한국
2019 «Momentum10: The Emotional Exhibition»,
 모멘툼쿤스트홀, 모스, 노르웨이 등 국내외 주요 미술관,
 비엔날레 등 다수 참여

주요 소장처
국립현대미술관
퐁피두센터
뉴욕현대미술관
테이트 모던 등 국내외 주요 미술관 및 기관 다수 소장

염지혜
한국 거주 및 작업

학력
순수예술 석사 우수졸업, 골드스미스대학교, 런던, 영국
순수예술 석사, 센트럴 세인트 마틴스대학교, 런던, 영국
서양화과 학사, 서울대학교 미술대학, 서울, 한국

주요 개인전
2021 «[~]», 송은아트스페이스, 서울, 한국
2018 «모든 관점 볼텍스», 대구미술관, 대구, 한국
2015 «모든 망명에는 보이지 않는 행운이 있다»,
 아트선재센터 프로젝트 스페이스, 서울, 한국 등 국내외
 주요 미술관 개인전 다수 개최

주요 단체전
2021 «디어 아마존: 인류세», 주브라질 한국문화원,
 상파울루, 브라질
2020 «침묵의 미래: 하나의 언어가 사라진 순간»,
 백남준아트센터, 용인, 한국
2019 «두 번의 똑같은 밤은 없다», 북서울시립미술관,
 서울, 한국 등 국내외 주요 미술관, 비엔날레 등
 다수 참여

주요 소장처
부산현대미술관
국립현대미술관
서울시립미술관 등 국내외 주요 미술관 및 기관 다수 소장

Oh Wonbae

Lives and works in Korea

Education
Ecole Nationale Superieure des Beaux-Arts de Paris,
 France
M.F.A. Dongguk University, Seoul, Korea
B.F.A. Dongguk University, Seoul, Korea

Selected Solo Exhibitions
2019 Artside Gallery, Seoul, Korea
2017 OCI Museum of Art, Seoul, Korea
2016 Gallery Meme, Seoul, Korea
Other solo exhibitions at major art museums in and
 outside Korea

Selected Group Exhibitions
2021 *Residency Festa*, Gyeongju Arts Center,
 Gyeongju, Korea
2020 *The Human*, Jung Moon-Kyu Art Museum,
 Ansan, Korea
2019 *Korean Modern and Contemporary Drawings*,
 Seoul Olympic Museum of Art, Seoul, Korea
Other group exhibitions at major art museums and
 biennales in and outside Korea

Selected Collections
National Museum of Modern and Contemporary Art
Seoul Museum of Art
SOMA Museum of Art
Other collections at major art museums and institutes
 in and outside Korea

Joseph Beuys

B.1921, Krefeld, Germany
D.1986, Düsseldorf, Germany

Education
Kunstakademie Düsseldorf

Selected Solo Exhibitions
2021 *Joseph Beuys: Denken. Handeln. Vermitteln.*,
 Belvedere 21, Vienna, Austria
2020 *Kraftwerk Block Beuys*, Hessisches
 Landesmuseum Darmstadt, Darmstadt,
 Germany
2019 *Joseph Beuys – Gestempelte Multiples,
 Drucksachen, Fotografien – Joseph Beuys und
 die Mail Art in der DDR*, Museum Schloss
 Moyland, Bedburg-Hau, Germany
Other solo exhibitions at major art museums in and
 outside Korea

Selected Group Exhibitions
2021 *Mataré + Beuys + Immendorff.* Begegnung
 der Werke von Lehrer und Schüler, Akademie-
 Galerie – Die neue Sammlung, Kunstakademie
 Düsseldorf, Düsseldorf, Germany
 Technoschamanismus, Hartware
 MedienKunstVerein, Dortmund, Germany
 Beuys und Duchamp. Künstler der Zukunft (with
 Staatliches Museum Schwerin), Kaiser Wilhelm
 Museum – Kunstmuseen Krefeld, Krefeld,
 Germany
Other group exhibitions at major art museums and
 biennales in and outside Korea

Selected Collections
Tate Modern
Solomun R. Guggenheim Museum
Leeum, Samsung Museum of Art
Other collections at major art museums and institutes
 in and outside Korea

Lee Bae

Lives and works in Korea

Education
M.F.A. Department of Fine Arts, Hongik University
 Graduate School of Art, Seoul, Korea

Selected Solo Exhibitions
2021 *Union*, Phi Foundation, Montreal, Canada
2020 *The Sublime Charcoal Light*, PERROTIN Gallery,
 Tokyo, Japan
2019 *Venice Wood Water*, Wilmotte Foundation,
 Venice, Italy
Other solo exhibitions at major art museums in and
 outside Korea

Selected Group Exhibitions
2020 *Dang Dai Taipei*, Johyun Gallery, Taipei, Taiwan
2019 *Venice Wood Water*, Wilmotte Foundation,
 Venice, Italy
2018 *Overstated & Understated*, Paradise Art Space,
 Incheon, Korea
Other group exhibitions at major art museums and
 biennales in and outside Korea

Selected Collections
Musée National des Arts Asiatiques-Guimet
Privada Allegro Foundation
National Museum of Modern and Contemporary Art
Seoul Museum of Art
Other collections at major art museums and institutes
 in and outside Korea

오원배

한국 거주 및 작업

학력

파리국립미술학교 수료, 파리, 프랑스
미술학과 석사, 동국대학교, 서울, 한국
미술학과 학사, 동국대학교, 서울, 한국

주요 개인전

2019 아트사이드 갤러리, 서울, 한국
2017 OCI미술관, 서울, 한국
2016 갤러리 밈, 서울, 한국 등 국내외 주요 미술관 개인전
 다수 개최

주요 단체전

2021 «국제레지던시아트페스타», 경주 예술의 전당,
 경주, 한국
2020 «인간전», 정문규 미술관, 안산, 한국
2019 «素畵-한국근현대드로잉», 소마미술관, 서울, 한국 등
 국내외 주요 미술관, 비엔날레 등 다수 참여

주요 소장처

국립현대미술관
서울시립미술관
소마미술관 등 국내외 주요 미술관 및 기관 다수 소장

요제프 보이스

출생 1921년, 크레펠트, 독일
사망 1986년, 뒤셀도르프, 독일

학력

뒤셀도르프 미술대학

주요 개인전

2021 «Joseph Beuys: Denken. Handeln. Vermitteln»,
 벨베데레 21, 빈, 오스트리아
2020 «Kraftwerk Block Beuys», 다름슈타트 헤센 주립
 박물관, 다름슈타트, 독일
2019 «Joseph Beuys—Gestempelte Multiples,
 Drucksachen, Fotografien: Joseph Beuys
 und die Mail Art in der DDR», 모일란트 궁전
 미술관, 베트부르크하우, 독일 등 국내외 주요 미술관
 개인전 다수 개최

주요 단체전

2021 «Mataré + Beuys + Immendorff. Begegnung der
 Werke von Lehrer und Schüler», 아카데미
 갤러리–디 노이에 잠룽, 뒤셀도르프 미술대학,
 뒤셀도르프, 독일
 «Technoschamanismus», 하르트바레 미디어
 예술협회, 도르트문트, 독일
 «Beuys und Duchamp. Künstler der Zukunft»,
 카이저 빌헬름 박물관–크레펠트 미술관(슈베린
 주립미술관 공동 주최), 크레펠트, 독일 등 국내외 주요
 미술관, 비엔날레 등 다수 참여

주요 소장처

테이트 모던
솔로몬 R. 구겐하임미술관
삼성미술관 리움 등 국내외 주요 미술관 및 기관 다수 소장

이배

한국 거주 및 작업

학력

회화과 학사, 홍익대학교 미술대학교, 서울, 한국

주요 개인전

2021 «Union», 피 파운데이션, 몬트리올, 캐나다
2020 «The Sublime Charcoal Light», 페로탕갤러리,
 도쿄, 일본
2019 «Venice Wood Water», 빌모트 파운데이션,
 베니스, 이탈리아 등 국내외 주요 미술관 개인전
 다수 개최

주요 단체전

2020 «Dang Dai Taipe», 조현화랑, 타이페이, 대만
2019 «Venice Wood Water», 빌모트파운데이션,
 베니스, 이탈리아
2018 «무절제 & 절제», 파라다이스 아트스페이스, 인천, 한국
 등 국내외 주요 미술관, 비엔날레 등 다수 참여

주요 소장처

국립기메동양박물관
쁘리바도 알레그로 재단
국립현대미술관
서울시립미술관 등 국내외 주요 미술관 및 기관 다수 소장

Young Joo Lee

Lives and works in USA

Education

M.F.A. in Sculpture, Yale University, New Haven, CT,
 USA
M.F.A. (Meisterschülerin) in Film, Academy of Fine Arts
 Städelschule Frankfurt, Germany
B.F.A. in Painting, Hongik University, Seoul, Korea

Selected Solo Exhibitions

2021 *Lizardians*, Post Territory Ujeongguk, Seoul,
 Korea
 We are never going to be the same, Viewing
 room - Ochi Projects, Los Angeles, USA
 (upcoming)
2018 *Shangri-La*, Alternative Space Loop, Seoul,
 Korea etc.

Selected Group Exhibitions

2021 *Refugia* (Public Art Project, Curated by Ji-Yoon
 Yang, TBS TV & Radio, 2), Alternative Space
 Loop, Seoul, Korea
2020 *Tiger Lives*, Coreana Museum of Art, Seoul,
 Korea
2019 *Wasteland*, Open Sessions 16, Drawing Center,
 New York, USA etc.

Jiwon Lee (archetypes)

Lives and works in Korea

Education

M.A. in Dept. of Industrial Design at Seoul National
 University of Science and Technology, Seoul,
 Korea

Selected Group Exhibitions

2017 *Archiving Project on Future*, Oil Tank Culture
 Park, Seoul, Korea
2016 *Activating the City: Urban Gastronomy*,
 National Museum of Modern and
 Contemporary Art, Seoul, Korea etc.

Lee Jinju

Lives and works in Korea

Education

M.F.A. Department of Oriental Painting, College of
 Fine Arts, Hongik University, Seoul, Korea
B.F.A. Department of Oriental Painting, College of
 Fine Arts, Hongik University, Seoul, Korea

Selected Solo Exhibitions

2020 *The Unperceived*, Arario Museum Inspace,
 Seoul, Korea
2019 *Tilted*, Triumph Gallery, Moscow, Russia
2018 *Synapses*, Edwin's Gallery, Jakarta, Indonesia
Other solo exhibitions at major art museums in and
 outside Korea

Selected Group Exhibitions

2021 *The 13th Hesitation*, Arario Gallery, Cheonan, Korea
2020 Dancing Queen, Arario Gallery, Cheonan, Korea
2019 *Following for no reason : Lee Jeongbae x Lee Jinju*,
 Nook Gallery, Seoul, Korea
Other group exhibitions at major art museums and
 biennales in and outside Korea

Selected Collections

National Museum of Modern and Contemporary Art
Seoul Museum of Art
Gyeongnam Art Museum
Other collections at major art museums and institutes
 in and outside Korea

이영주

미국 거주 및 작업

학력

조소과 석사, 예일대학교, 뉴헤븐, 미국

영상과 석사 (마이스터 슐러), 슈테델미술학교, 프랑크푸르트,
　　독일

회화과 학사, 홍익대학교, 서울, 한국

주요 개인전

2021　《리자디언》, 탈영역 우정국, 서울, 한국

　　　《We are never going to be the same》,
　　　온라인 전시, Ochi Projects, 로스앤젤레스, 미국

2018　《샹그릴라》, 대안공간루프, 서울, 한국 등

주요 단체전

2021　《레퓨지아》(공공미술프로젝트, 양지윤 기획,
　　　TBS TV & 라디오), 대안공간루프, 서울, 한국

2020　《호랑이는 살아있다》(서지은 기획), 코리아나미술관,
　　　서울, 한국

2019　《Wasteland, Open Sessions 16》, 드로잉센터,
　　　뉴욕, 미국 등

이지원(아키타입)

한국 거주 및 작업

학력

디자인학과 석사, 서울과학기술대학교, 서울, 한국

주요 단체전

2017　《미래기지: 내일에 대한 프로젝트 아카이브》,
　　　문화비축기지, 서울, 한국

2016　《미각의 미감》, 국립현대미술관, 서울, 한국 등

이진주

한국 거주 및 작업

학력

동양화과 졸업 및 동대학원, 홍익대학교, 서울, 한국

주요 개인전

2020　《사각死角》, 아라리오뮤지엄 인스페이스, 서울, 한국

2019　《Tilted》, 트라이엄프 갤러리, 모스크바, 러시아

2018　《Synapses》, 에드윈즈 갤러리, 자카르타, 인도네시아
　　　등 국내외 주요 미술관 개인전 다수 개최

주요 단체전

2021　《13번째 망설임》, 아라리오갤러리, 천안, 한국

2020　《댄싱퀸》, 아라리오갤러리, 천안, 한국

2019　《쫓아가는 이유 없이》, 누크갤러리, 서울, 한국 등 국내외
　　　주요 미술관, 비엔날레 등 다수 참여

주요 소장처

국립현대미술관

서울시립미술관

경남도립미술관 등 국내외 주요 미술관 및 기관 다수 소장

Hyein Lee

Lives and works in Korea

Education

B.F.A. in Painting, Seoul National University, Seoul, Korea

M.F.A. in Painting, Seoul National University, Seoul, Korea

Selected Solo Exhibitions

2020 *One day, stepping on the weather*, Gallery Kiche, Seoul, Korea

2018 *Sync*, Sindoh Art Space, Seoul, Korea

2016 *A Travel Journal, Sophie's Tree*, New York, USA

Other solo exhibitions at major art museums in and outside Korea

Selected Group Exhibitions

2020 *You have witchcraft in your lips_Y*, Y+Artist Project 2013-2018, Daegu Art Museum, Daegu, Korea

2019 *Night turns to day*, Art Sonje Center, Seoul, Korea

2018 *Will you be there?*, Project Fulfill Art Space, Taipei, Taiwan

Other group exhibitions at major art museums and biennales in and outside Korea

Selected Collections

National Museum of Modern and Contemporary Art

Busan Museum of Art

Daegu Art Museum

Other collections at major art museums and institutes in and outside Korea

JEON, IN-KYUNG

Lives and works in Korea

Education

B.A. Painting, Sungshin Women's University, Seoul, Korea

Dancheong and Buddist Painting, Manbong Monk (Intangible Cultural Asset no. 48: LEE Chi-ho)

Selected Solo Exhibitions

2021 *The Universe and Cell*, Jaha Art Museum, Seoul, Korea

2018 *Neuro Mandala - Hommage to Cajal*, SPACE 41, Seoul, Korea

2017 *Heterophony's*, Gallery Sai, Seoul, Korea etc.

Selected Group Exhibitions

2020 *Flower, Earth, Star and Sky*, Kumsan Gallery, Seoul, Korea
 Sexual Politics, Gallery Emu, Seoul, Korea

2019 *EAPAP 2019: Song of Islsand*, Jeju 4.3 Peace Memorial Museum, Jeju, Korea etc.

Selected Collections

Ara Art Center and many private collections

Jonathan Horowitz

Lives and works in USA

Education

B.A. Philosophy, Wesleyan University, Middletown, USA

Selected Solo Exhibitions

2020 *We Fight to Build a Free World: And Exhibition by Jonathan Horowitz*, The Jewish Museum, New York, USA

2019 *Pre-Fall '17*, Sadie Coles HQ, London, UK

2016 *Occupy Greenwich*, The Brant Foundation Art Study Center, Greenwich, Connecticut, USA

Other solo exhibitions at major art museums in and outside Korea

Selected Group Exhibitions

2020 *Brainwashed*, Haus der Kunst, Munich, Germany

2019 *Never Again. Art against War and Fascism in the 20th and 21st Centuries*, Museum on the Vistula, Warsaw, Poland

2018 *Michael Jackson: On the Wall*, National Portrait Gallery, London, UK

Other group exhibitions at major art museums and biennales in and outside Korea

Selected Collections

Museum of Modern Art

Museum Ludwig

Centre Pompidou

Other collections at major art museums and institutes in and outside Korea

이혜인
한국 거주 및 작업

학력
서양학과 석사, 서울대학교, 서울, 한국
서양학과 학사, 서울대학교, 서울, 한국

주요 개인전
2020 «어느 날, 날씨를 밟으며», 갤러리 기체, 서울, 한국
2018 «Sync», 신도문화공간, 서울, 한국
2016 «A Travel Journal, Sophie's Tree», 뉴욕, 미국 등 국내외 주요 미술관 개인전 다수 개최

주요 단체전
2020 «당신 속의 마법_Y, Y+아티스트 프로젝트 2013-2018», 대구미술관, 대구, 한국
2019 «밤이 낮으로 변할 때», 아트선재센터, 서울, 한국
2018 «Will you be there?», Project Fulfill Art Space, 타이베이, 대만 등 국내외 주요 미술관, 비엔날레 등 다수 참여

주요 소장처
국립현대미술관
부산시립미술관
대구미술관 등 국내외 주요 미술관 및 기관 다수 소장

전인경
한국 거주 및 작업

학력
서양화 학사, 성신여자대학교 미술대학, 서울, 한국
불화/단청, 만봉스님(무형문화재 48호: 이치호) 사사, 한국

주요 개인전
2021 «우주와 세포», 자하미술관, 서울, 한국
2018 «뉴로 만다라 - 오마주 투 카잘», 공간41, 서울, 한국
2017 «헤테로포니», 벽과나사이갤러리, 서울, 한국 등

주요 단체전
2020 «꽃땅별하늘», 금산갤러리, 서울, 한국
«성의 정치학», 복합문화공간 갤러리에무, 서울, 한국
2019 «EAPAP 2019: 섬의 노래», 제주4.3평화기념관, 제주, 한국 등

주요 소장처
아라아트센터 외 개인 소장 다수

조나단 호로비츠
미국 거주 및 작업

학력
철학 학사, 웨슬리언대학교, 미들타운, 미국

주요 개인전
2020 «We Fight to Build a Free World: And Exhibition by Jonathan Horowitz», 유대인미술관, 뉴욕, 미국
2019 «Pre-Fall '17», 사디콜즈 HQ, 런던, 영국
2016 «Occupy Greenwich», 브랜트재단 미술교육센터, 그리니치, 코네티컷, 미국 등 국내외 주요 미술관 개인전 다수 개최

주요 단체전
2020 «Brainwashed», 하우스 데어 쿤스트, 뮌헨, 독일
2019 «Never Again. Art against War and Fascism in the 20th and 21st Centuries», 비스툴라미술관, 바르샤바, 폴란드
2018 «Michael Jackson: On the Wall», 내셔널포트레이트갤러리, 런던, 영국 등 국내외 주요 미술관, 비엔날레 등 다수 참여

주요 소장처
뉴욕현대미술관
루트비히미술관
퐁피두센터 등 국내외 주요 미술관 및 기관 다수 소장

Gillian Wearing
Lives and works in UK

Education
B.A. Fine Art (Honors), Goldsmiths, University of
 London, UK, 1990
B.TECH, Art & Design, Chelsea School of Art, UK, 1987

Selected Solo Exhibitions
2021 *Gillian Wearing: Wearing Masks*, Solomon R.
 Guggenheim Museum, New York, NY, USA,
 November 5, 2021
2020 *Gillian Wearing: Lockdown*, Maureen Paley,
 London, UK, September 16 – November 1, 2020
2019 *Gillian Wearing: Rock 'n' Roll 70*, Moody Center
 for the Arts, Rice University, Houston, TX, USA,
 June 1 – August 31, 2019
Other solo exhibitions at major art museums in and
 outside Korea

Selected Group Exhibitions
2020 *Summer Exhibition*, Royal Academy of Arts,
 London, UK, October 6, 2020 – January 3, 2021
2019 *MASK: The Art of Transformation*, Kunstmuseum
 Bonn, Bonn, Germany, May 30 – August 25,
 2019; travels to Istanbul Modern, Istanbul,
 Turkey, November 2019 – January 2020
2018 *The Artist is Present*, Curated by Maurizio
 Cattelan, Yuz Museum, Shanghai, China,
 October 11 – December 16, 2018
Other group exhibitions at major art museums and
 biennales in and outside Korea

Selected Collections
Arts Council of Great Britain
Hamburger Kunsthalle
Solomon R. Guggenheim Museum
Other collections at major art museums and institutes
 in and outside Korea

Jeamin Cha
Lives and works in Korea

Education
M.A. Chelsea College of Design and Arts, London, UK
B.F.A. Korea National University of Arts, Seoul, Korea

Selected Solo Exhibitions
2020 *Troubleshooting Mind I, II, III*, KADIST,
 San Francisco, USA
2018 *Love Bomb*, Samyook Bldg., Seoul, Korea
2015 *hysterics*, DOOSAN Gallery, New York, USA
Other solo exhibitions at major art museums in and
 outside Korea

Selected Group Exhibitions
2021 *Banal Objects/DIY Aesthetics: A Remotely
 Organized but Self-entertaining Exhibition*,
 OCAT Institute, Beijing, China
2020 *Solidarity Spores*, Asia Culture Center, Gwangju,
 Korea
2019 *Making the City—LOOP Barcelona Discover
 Awards*, GlogauAir gGmbH, Berlin, Germany
Other group exhibitions at major art museums and
 biennales in and outside Korea

Selected Collections
KADIST
Seoul Museum of Art
National Museum of Modern and Contemporary Art
Other collections at major art museums and institutes
 in and outside Korea

Taeyoon Choi
Lives and works in USA and Korea

Education
B.F.A. in Department of Performance, Film, Video and
 New media, The School of the ArtInstitute of
 Chicago (SAIC), IL, USA

Performance and Workshop
2013-2021 *School for Poetic Computation*, New York, USA
2019 *Distributed Web of Care*, The Whitney Museum of
 American Art, New York, USA
2018 *Poetic Computation and Non-Binary Futures*, M+,
 Hong Kong, China etc.

Exhibitions
2020 *The Care of the Self: Journals and Letters*, Factory2,
 Seoul, Korea
2018 *Istanbul Design Biennale*, Istanbul, Turkey
2017 *Seven Futures*, Collaboration with Christine Sun Kim,
 Harvestworks, New York, USA
Other group exhibitions at major art museums and
 biennales in and outside Korea

Selected Collections
Casco Art Institute: Working for the Commons
Los Angeles County Museum of Art
Other collections at major art museums and institutes
 in and outside Korea

질리언 웨어링
영국 거주 및 작업

학력
순수예술 학사 (우등졸업), 골드 스미스 런던대학교, 영국
B.TECH 미술&디자인, 첼시예술대학, 영국

주요 개인전
2021 «Gillian Wearing: Wearing Masks»,
 솔로몬 R. 구겐하임미술관, 뉴욕, 미국
2020 «Gillian Wearing: Lockdown», 모린페일리,
 런던, 영국
2019 «Gillian Wearing: Rock 'n' Roll 70»,
 라이스대학교 무디센터포아츠, 휴스턴, 미국 등 국내외
 주요 미술관 개인전 다수 개최

주요 단체전
2020 «Summer Exhibition», 왕립미술아카데미, 런던,
 영국
2019 «MASK: The Art of Transformation»,
 본미술관, 본, 독일; 투어전시 이스탄불현대미술관,
 이스탄불, 터키
2018 «The Artist is Present», (큐레이션: 마우리치오
 카텔란), 유즈미술관, 상하이, 중국 등 국내외 주요
 미술관, 비엔날레 등 다수 참여

주요 소장처
대영예술위원회
함부르크미술관
솔로몬 R. 구겐하임미술관 등 국내외 주요 미술관 및 기관
 다수 소장

차재민
한국 거주 및 작업

학력
순수예술 석사, 첼시 컬리지 오브 디자인 앤 아츠, 런던, 영국
조형예술 학사, 한국예술종합학교, 서울, 한국

주요 개인전
2020 «마음 1, 2, 3의 문제해결», 카디스트, 샌프란시스코,
 미국
2018 «사랑폭탄», 삼육빌딩, 서울, 한국
2015 «히스테릭스», 두산갤러리, 뉴욕, 미국 등 국내외 주요
 미술관 개인전 다수 개최

주요 단체전
2021 «Banal Objects/DIY Aesthetics: A Remotely
 Organized but Self-entertaining Exhibition»,
 OCAT 인스티튜트, 베이징, 중국
2020 «연대의 홀씨», 국립아시아문화전당, 광주, 한국
2019 «Making the City—룹 바르셀로나 디스커버 어워즈»,
 글러스고우 에어 지 지엠비 에이치, 베를린, 독일 등 국내외
 주요 미술관, 비엔날레 등 다수 참여

주요 소장처
카디스트
서울시립미술관
국립현대미술관 등 국내외 주요 미술관 및 기관 다수 소장

최태윤
미국과 한국 거주 및 작업

학력
시카고 예술대학교, 시카고, 미국

퍼포먼스 및 워크숍
2013-2021 ‹시적연산학교(School for Poetic
 Computation)›, 뉴욕, 미국
2019 ‹Distributed Web of Care›, 휘트니미술관, 뉴욕,
 미국
2018 ‹Poetic Computation and Non-Binary Futures›,
 M+, 홍콩, 중국 등

전시
2020 «자신을 돌봄: 일기와 편지», Factory2, 서울, 한국
2018 «이스탄불 디자인 비엔날레», 이스탄불, 터키
2017 «Seven Futures», 크리스틴 선 킴과의 협업,
 하베스트웍스 디지털 미디어 아트 센터, 뉴욕, 미국 등
 국내외 주요 미술관, 비엔날레 등 다수 참여

주요 소장처
카스코아트 인스티튜트
로스앤젤레스 카운티 미술관 등 국내외 주요 미술관 및 기관
 다수 소장

Candida Höfer
Lives and works in Germany

Education
Photography class of Bernd Becher Kunstakademie
 Düsseldorf, Düsseldorf, Germany
Film class of Ole John Kölner Werkschule, Cologne,
Germany

Selected Solo Exhibitions
2020 *Candida Höfer: Enlightened Spaces*, Matthew
 Liu Fine Arts, Shanghai, China
2019 *Candida Höfer*, The Hall Art Foundation |
 Schloss Derneburg Museum, Derneburg,
 Germany
2018 *Portraits of Spaces*, Les Rencontres d'Arles,
 Arles, France
Other solo exhibitions at major art museums in and
 outside Korea

Selected Group Exhibitions
2020 *MONOCULTURE*, Museum van Hedendaagse
 Kunst, Antwerpen, Belgium
2019 *The New Photography. Upheaval and new
 beginnings 1970–1990*, Kunsthaus Zürich,
 Zürich, Switzerland
2018 *Photography + Books. Out of the Retina and
 Into the Brain: The Art Library of Aaron and
 Barbara Levine*, The Art Institute of Chicago,
 Chicago, USA
Other group exhibitions at major art museums and
 biennales in and outside Korea

Selected Collections
National Museum of Modern and Contemporary Art
Centre Pompidou
Museum of Modern Art
Other collections at major art museums and institutes
 in and outside Korea

Thomas Struth
Lives and works in Germany and USA

Education
Kunstakademie Dusseldorf (studio of P. Kleeman,
Gerhard Richter and Bernd Becher) Dusseldorf, Germany

Selected Solo Exhibitions
2019 *Thomas Struth: Figure Ground*, Guggenheim
 Museum Bilbao, Spain
2018 *Thomas Struth*, Aspen Art Museum, Aspen, USA
2017 *Thomas Struth: Nature & Politics*, Moody Center
 for the Arts, Houston; SaintLouis Art Museum,
 St. Louis, USA
Other solo exhibitions at major art museums in and
 outside Korea

Selected Group Exhibitions
2019 *This Place*, Jewish Museum Berlin, Germany
2018 *The Flaneur: From Impressionism to the Present*,
 Kunstmuseum Bonn, Germany
2017 *Ettore Sotsass: Design Radical*, Metropolitan
 Museum of Art, New York, Minsheng Art
 Museum, Beijing
Other group exhibitions at major art museums and
 biennales in and outside Korea

Selected Collections
National Museum of Modern and Contemporary Art
21st Century Museum of Contemporary Art
Centre Pompidou
Other collections at major art museums and institutes
 in and outside Korea

Francis Alÿs
Lives and works in Mexico

Education
Università Iuav di Venezia, Venice, Italy
Institut d'Architecture de Tournai, Tournai, Belgium

Selected Solo Exhibitions
2021 *Francis Alÿs: As Long as I'm Walking*,
 Musée cantonal des Beaux-Arts, Lausanne,
 Switzerland [forthcoming]
2020 *Francis Alÿs, Wet feet_dry feet: borders and games*,
 Tai Kwun Center for Heritage & Art, Hong Kong
2019 *Francis Alÿs: Children's Game*, Musée d'art
 contemporain de Montréal, Québec, Canada
 [in collaboration with MOMENTA | Biennale de
 l'image, Montreal]
Other solo exhibitions at major art museums in and
 outside Korea

Selected Group Exhibitions
2021 *Comics Trip!*, Collection Lambert, Avignon, France
 [forthcoming]
2020 *00s. Cranford Collection: The 2000s*, MO.CO.
 Montpellier Contemporain, France
 [collection display]
2019 *Convex/Concave: Belgian Contemporary Art*,
 TANK Shanghai [organized by WIELS Centre d'art
 Contemporain, Brussels, Belgium]
Other group exhibitions at major art museums and
 biennales in and outside Korea

Selected Collections
21st Century Museum of Contemporary Art
Centre Georges Pompidou
Tate Gallery
Other collections at major art museums and institutes
 in and outside Korea

칸디다 회퍼
독일 거주 및 작업

학력

사진학, 베른트 베허 쿤스트아카데미 뒤셀도르프, 뒤셀도르프,
　　　독일
영화학, 올레 존 퀼너 베르크슐레, 퀼른, 독일

주요 개인전

2020　«Candida Höfer: Enlightened Spaces»,
　　　매튜리우파인아트, 상하이, 중국
2019　«Candida Höfer», 할 아트 파운데이션/
　　　쉴로스데르네부르크무제움, 데르네부르크, 독일
2018　«Portraits of Spaces», 아를 국제사진전, 아를,
　　　프랑스 등 국내외 주요 미술관 개인전 다수 개최

주요 단체전

2020　«MONOCULTURE», 앤트워프현대미술관, 앤트워프,
　　　벨기에
2019　«The New Photography. Upheaval and new
　　　beginnings 1970–1990», 쿤스트할레 취리히,
　　　취리히, 스위스
2018　«Photography + Books. Out of the Retina and
　　　Into the Brain: The Art Library of Aaron and
　　　Barbara Levine», 시카고미술관, 시카고, 미국 등
　　　국내외 주요 미술관, 비엔날레 등 다수 참여

주요 소장처

국립현대미술관
퐁피두센터
뉴욕현대미술관 등 국내외 주요 미술관 및 기관 다수 소장

토마스 스트루스
독일과 미국 거주 및 작업

학력

쿤스트아카데미, 뒤셀도르프, 독일

주요 개인전

2019　«Thomas Struth: Figure Ground»,
　　　구겐하임미술관, 빌바오, 스페인
2018　«Thomas Struth», 아스펜미술관, 아스펜, 미국
2017　«Thomas Struth: Nature & Politics»,
　　　무디예술센터, 휴스턴; 세인트루이스미술관,
　　　세인트루이스, 미국 등 국내외 주요 미술관 개인전
　　　다수 개최

주요 단체전

2019　«This Place», 유태인미술관, 베를린, 독일
2018　«The Flaneur: From Impressionism to the
　　　Present», 본미술관, 본, 독일
2017　«Ettore Sotsass: Design Radical»,
　　　메트로폴리탄미술관, 뉴욕, 미국; 민생현대미술관,
　　　베이징, 중국 등 국내외 주요 미술관, 비엔날레 등
　　　다수 참여

주요 소장처

국립현대미술관
21세기미술관
국립현대예술재단 등 국내외 주요 미술관 및 기관 다수 소장

프란시스 알리스
멕시코 거주 및 작업

학력

베네치아건축대학교, 베네치아, 이탈리아
투르네건축대학교, 투르네, 벨기에

주요 개인전

2021　«Francis Alÿs: As Long as I'm Walking»,
　　　로잔주립미술관, 로잔, 스위스 [예정]
2020　«Francis Alÿs, Wet feet_dry feet: borders and
　　　games», 타이쿤유산&예술센터, 홍콩
2019　«Francis Alÿs: Children's Game»,
　　　몬트리올현대미술관, 퀘벡, 캐나다[협력: 모멘타
　　　(MOMENTA) | 이미지비엔날레, 몬트리올, 캐나다] 등
　　　국내외 주요 미술관 개인전 다수 개최

주요 단체전

2021　«Comics Trip!», 랑베르컬렉션, 아비뇽, 프랑스[예정]
2020　«00s. Cranford Collection: The 2000s»,
　　　몽펠리에현대미술관, 프랑스[소장품 전시]
2019　«Convex/Concave: Belgian Contemporary Art»,
　　　상하이탱크(TANK)(전시관), 중국[현대미술관
　　　(WIELS) 주최, 브뤼셀, 벨기에] 등 국내외 주요 미술관,
　　　비엔날레 등 다수 참여

주요 소장처

21세기현대미술관
퐁피두센터
테이트갤러리 등 국내외 주요 미술관 및 기관 다수 소장

Yun-hee Huh
Lives and works in Korea

Education

Meisterschüler in Painting, University of Arts Bremen,
Germany

M.F.A. Graduated in Painting, University of Arts Bremen,
Germany

B.F.A. Graduated in Painting, Ewha Womans University,
Korea

Selected Solo Exhibitions

2021 *Coming up for air*, Sejong National Arboretum,
Sejong, Korea

2020 *Desire*, Youngeun Museum of Art, Gwangju,
Kyunggi, Korea

2019 *Forest of Time*, Lotte Gallery, Seoul, Kyunggi,
Korea

Other solo exhibitions at major art museums in and
outside Korea

Selected Group Exhibitions

2020 *Memory, Record*, Jeondeungsa, Gangwha,
Korea

2019 *Resent Work Project*, Asia Culture Center,
Gwangju, Korea

2018 *Artist's Meditation*, Savina Museum of Art,
Seoul, Korea

Other group exhibitions at major art museums and
biennales in and outside Korea

Selected Collections

Seoul Museum of Art

Youngeun Museum of Art

Seoul Olympic Museum of Art

Other collections at major art museums and institutes
in and outside Korea

Jinhwon Hong
Lives and works in Korea

Selected Solo Exhibitions

2018 *Random Forest*, Art Space Pool, Seoul, Korea

2016 *Write Protect Mode*, Nowhere, Seoul, Korea

2015 *Last Nights*, Space O'NewWall, Seoul, Korea

Other solo exhibitions at major art museums in and
outside Korea

Selected Group Exhibitions

2019 *The Square: Art and Society in Korea 1900-2019
Part 3*, National Museum of Modern and
Contemporary Art, Seoul, Korea

2018 *Double Negative*, Arko Art Center, Seoul, Korea

2017 *25.7*, Buk-Seoul Museum of Art, Seoul, Korea

Other group exhibitions at major art museums and
biennales in and outside Korea

허윤희
한국 거주 및 작업

학력
브레멘예술대학교 마이스터슐러 졸업, 독일
회화 석사, 브레멘예술대학교 및 대학원, 독일
서양화과 학사, 이화여자대학교 미술대학, 서울, 한국

주요 개인전
2021 «숨 쉬러 나가다», 국립세종수목원 사계절전시온실,
 세종, 한국
2020 «소망을 품다», 영은미술관, 경기 광주, 한국
2019 «내가 숲에 갔을 때», 롯데갤러리, 서울/일산, 한국 등
 국내외 주요 미술관 개인전 다수 개최

주요 단체전
2020 «기억, 기록», 전등사 정족산사고 특별전시장, 강화,
 한국
2019 «리센트워크프로젝트», 아시아문화전당, 광주, 한국
2018 «그리하여 마음이 깊어짐을 느낍니다», 사비나미술관,
 서울, 한국 등 국내외 주요 미술관, 비엔날레 등
 다수 참여

주요 소장처
서울시립미술관
영은미술관
소마미술관 등 국내외 주요 미술관 및 기관 다수 소장

홍진훤
한국 거주 및 작업

주요 개인전
2018 «랜덤 포레스트», 아트 스페이스 풀, 서울, 한국
2016 «쓰기금지모드», 지금여기, 서울, 한국
2015 «마지막 밤(들)», 스페이스 오뉴월, 서울, 한국 등 국내외
 주요 미술관 개인전 다수 개최

주요 단체전
2019 «광장: 미술과 사회 1900-2019, 3부»,
 국립현대미술관, 서울, 한국
2018 «더블 네가티브», 아르코미술관, 서울, 한국
2017 «25.7», 서울시립 북서울미술관, 서울, 한국 등 국내외
 주요 미술관, 비엔날레 등 다수 참여

Catastrophe and Recovery

22 May – 1 August, 2021.
Gallery 5, 6 and Public Spaces,
National Museum of Modern and Contemporary Art, Seoul

Director
Youn Bummo

Chief Curator
Gim Jungi

**Head of Contemporary Art
Department 1**
Park Mihwa

Senior Curator
Lee Chuyoung

Curated by
Okkum Yang

Coordinated by
Shin Kihye

Coordination Assisted by
Miju Lim, Eunha Chang (Preparatory
Workshop Coordination)

Satellite Project: The Poseidon
Adventure

Curated by
Sooyon Lee

Coordinated by
Chaerin Yoo

Exhibition Design
Kim Yong-ju

Graphic Design
Kim Dongsu

Space Construction
Yun Haeri

Technical Coordination
Jeong Jaehwan, Han Jiyoung

Collection Management
Kwon Sungoh, Kim Chinsook

Conservation
Beom Daegeon, Cho Inae, Yoon Bokyung,
Kwon Hyeonju, Jeon Sangwoo

Education
Han Jung-in, Chung Sangyeon,
Kim Heijeoung, Sun Jina, Jeong Eunju

Public Communication and Marketing
Lee Sunghee, Yun Tiffany, Park Yulee,
Chae Jiyeon, Kim Hongjo, Kim Minjoo,
Lee Minjee, Ki Sungmi, Shin Narae,
Jang Layoon

Customer Service
Lee Eunsu, Chu Hunchul, Ju Daran

Translation
Seoul Selection

Revision
Yumi Kang

Film
Cocoa Pictures

Film Subtitled by
JINMEDIA

Supported by
Park Deoksun
Jun-Sung Kwon, Kim Yejin (Hansol Paper)
Jaeho Jung (Johyun Gallery Director)
Chloe Choi (Gallery Baton Director)

Acknowledgements

The MMCA would like to express our sincere
thanks to Leeum, Samsung Museum of
Art, Hansol Paper, Gallery Hyundai, Gana
Foundation for Arts and Culture, Arario
Gallery, Gladstone Gallery, Sprüth Magers,
Gallery Baton, Maureen Paley, Sadie Coles
HQ, Johyun Gallery, JEONJU International
Film Festival, private collectors, and all of
whom generously loaned their works and
supported this exhibition.

재난과 치유

2021. 5. 22. – 8. 1.
국립현대미술관 서울 5, 6 전시실 및 공용공간

관장
윤범모

학예연구실장
김준기

현대미술1과장
박미화

학예연구관
이추영

전시 기획
양옥금

전시 진행
신기혜

진행 보조
임미주 장은하(사전 워크숍 진행)

위성 프로젝트: 포세이돈 어드벤처

기획
이수연

진행
유채린

전시 디자인
김용주

그래픽 디자인
김동수

공간 조성
윤해리

운송·설치
정재환 한지영

작품 출납
권성오 김진숙

작품 보존
범대건 조인애 윤보경 권현주 전상우

교육
한정인 정상연 김혜정 선진아 정은주

홍보·마케팅
이성희 윤승연 박유리 채지연 김홍조
김민주 이민지 기성미 신나래 장라윤

고객 지원
이은수 추헌철 주다란

번역
서울 셀렉션

교정·교열
강유미

영상
코코아 픽쳐스

영상 자막
진미디어

도움
박덕선
권준성 김예진(한솔제지)
정재호(조현갤러리 디렉터)
최윤정(갤러리바톤 이사)

감사의 말씀

삼성미술관 리움, 한솔제지, 갤러리현대,
가나문화재단, 아라리오갤러리, 글래드스톤
갤러리, 스프루스 마거스, 갤러리바톤,
모린 페일리, 사디 콜즈 HQ, 조현갤러리,
전주국제영화제 그리고 익명을 요구하신 개인
소장가분들께 진심으로 감사의 말씀을 드립니다.

국립현대미술관
National Museum of
Modern and Contemporary Art, Korea

Catastrophe and Recovery

Publisher
Youn Bummo

Production Director
Gim Jungi

Managed by
Park Mihwa, Lee Chuyoung

Edited by
Okkum Yang

Sub-edited by
Shin Kihye

Translation
Seoul Selection

Revision
Yumi Kang

Photography
Yoonjae Kim

Design
kontaakt

Printing & Binding
Top Process, Seoul

First Publishing Date
16 July, 2021

Published by
National Museum of Modern and
Contemporary Art, Korea
30 Samcheong-ro, Jongno-gu, Seoul 03062,
Korea
+82 2 3701 9500
www.mmca.go.kr

ISBN 978-89-6303-272-6 (93600)
Price 33,000 KRW

Cover Image:
Eija-Liisa Ahtila, *POTENTIALITY FOR LOVE*
2018, Moving image sculpture in 3 silent parts
Photos © 2018 Crystal Eye, Helsinki.
Courtesy of Marian Goodman Gallery, New York, Paris.
Photo by Malla Hukkanen